The Spring Creek Chronicles

Dick Kettlewell

FARCOUNTRY
PRESS

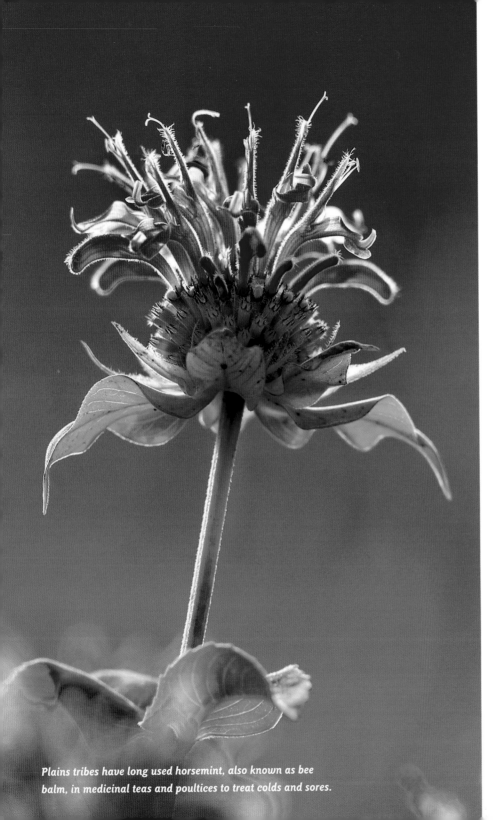

Plains tribes have long used horsemint, also known as bee balm, in medicinal teas and poultices to treat colds and sores.

For Mom and Dad, who would have strongly encouraged me to do this book. In Loving Memory.

ISBN: 978-1-56037-636-1

© 2015 by Farcountry Press
Text and photography © 2015 by Dick Kettlewell

For more information about our books, write Farcountry Press, P.O. Box 5630, Helena, MT 59604; call (800) 821-3874; or visit www.farcountrypress.com.

Library of Congress Cataloging-in-Publication Data

Kettlewell, Dick.
 The Spring Creek chronicles / by Dick Kettlewell.
 pages cm
 Summary: "Collection of essays on the northern prairie ecosystem, accompanied by photographs"-- Provided by publisher.
 ISBN 978-1-56037-636-1 (softcover)
 1. Biotic communities--West (U.S.) 2. Biotic communities--Middle West. 3. Biotic communities--West North Central States. 4. Natural history--West (U.S.) 5. Natural history--Middle West. 6. Natural history--West North Central States. I. Title.
 QH104.5.W4K48 2015
 577.8'2--dc23
 2015019317

Produced in the United States of America.
Printed in China.

19 18 17 16 15 1 2 3 4 5

TABLE OF CONTENTS

Choosing the Prairies. 7

Sympathy with the Seasons 13

Grasslands Music. 19

Catching the Rhythm. 29

Nice to Be Here. 37

A Morning with Wordsworth 47

The Landscape of Our Minds 55

A Sort of Homecoming. 65

Walking in the Honey Wind 75

A Clash of Centurions 83

Chasing an Icy Beauty 93

The Big Showoff 101

Livin' the High Life 109

An Isle of Tranquility. 119

Lingering Cautions 129

Awaiting the King 139

Among the Ancients 147

The Color of Optimism. 157

Catching the Wave 165

Buck Fever . 177

October's Song 187

Speaking for Solitude. 195

Those Winter Walks 203

Close Enough to Smell Him 211

Little Coyote . 221

Mozart and Meadowlarks 231

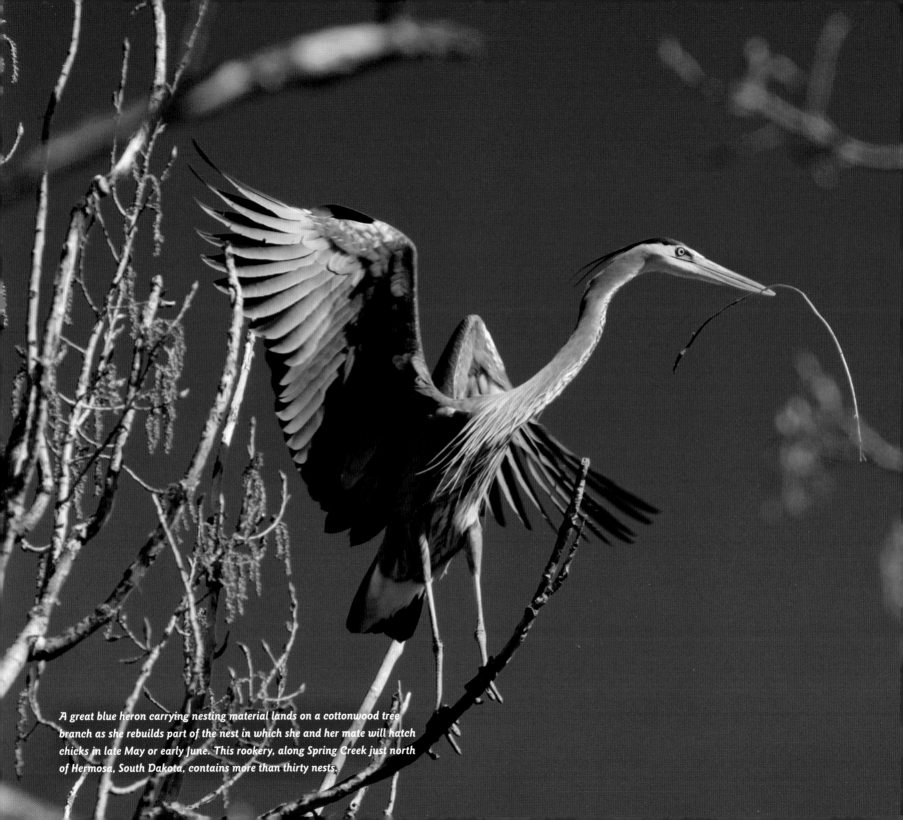

A great blue heron carrying nesting material lands on a cottonwood tree branch as she rebuilds part of the nest in which she and her mate will hatch chicks in late May or early June. This rookery, along Spring Creek just north of Hermosa, South Dakota, contains more than thirty nests.

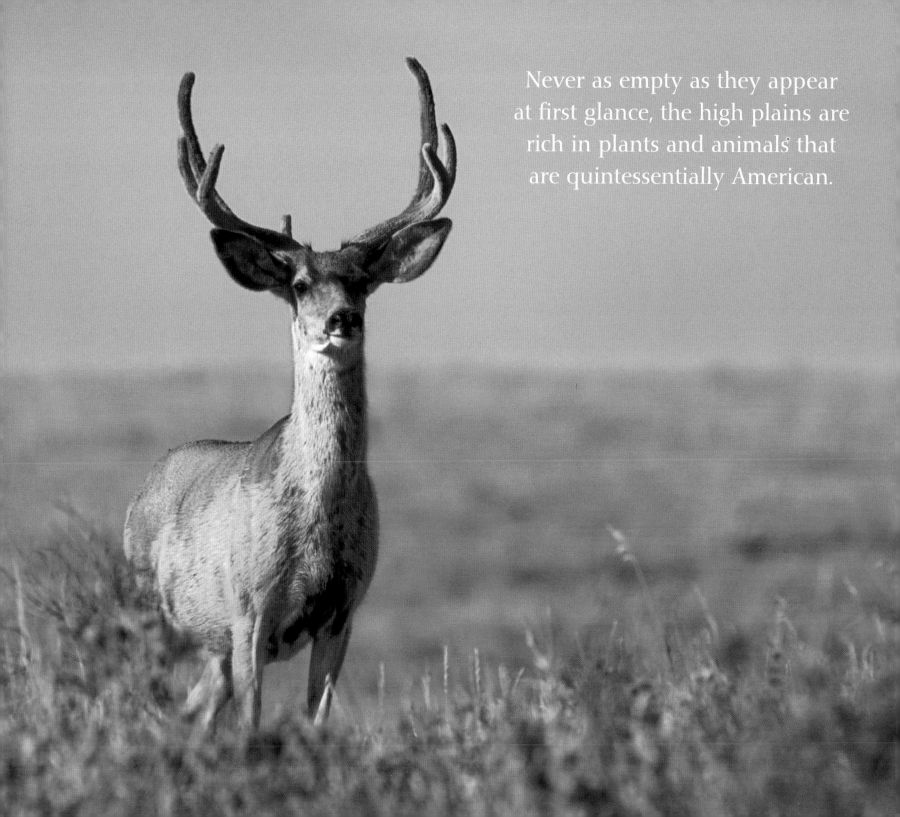

Never as empty as they appear at first glance, the high plains are rich in plants and animals that are quintessentially American.

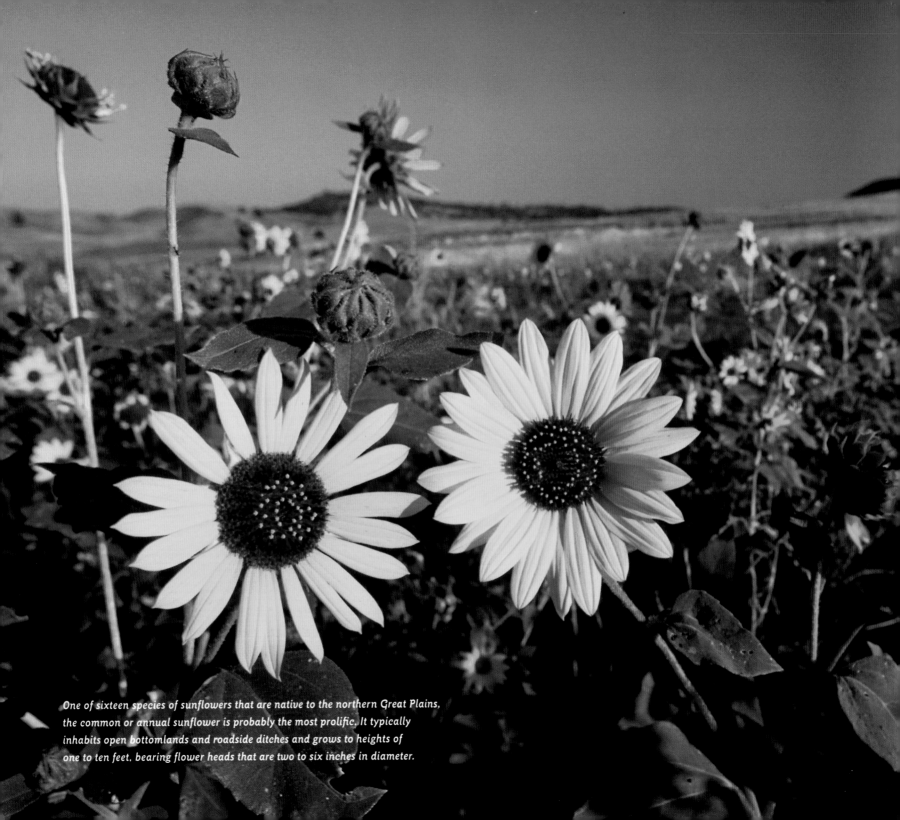

One of sixteen species of sunflowers that are native to the northern Great Plains,
the common or annual sunflower is probably the most prolific. It typically
inhabits open bottomlands and roadside ditches and grows to heights of
one to ten feet, bearing flower heads that are two to six inches in diameter.

CHOOSING THE PRAIRIES

Unlike many of the grasslands' writers and photographers, I was neither born nor raised on the prairies. My father's career in the Central Intelligence Agency took us to points all over the globe as I was growing up. We either lived in the Washington, D.C., area or somewhere overseas—Germany, Japan, and the Philippines.

I first came to the high plains as a young adult to start college at Chadron State in western Nebraska, and that story is told in the chapter beginning on page 65. Despite the initial shock described in that story, my attraction and curiosity for this fabled land and its inhabitants began almost immediately.

After college, I left the prairies for about twenty years, learning my trade as a photojournalist while working for several daily newspapers. Primarily a sports photographer, I spent many years covering athletics from high school to professional, including NCAA Division I sports and the National Football League.

During that time, I kept this place in my pocket as it certainly continued to tug at my sleeve. Whenever I

contemplated one of those career moves to some place like Dallas, Los Angeles, or Philadelphia—an eventual necessity for any ambitious sports photographer—I felt that tug all the more acutely. Soon I would find myself

(above) In midsummer, yucca flowers cluster on tall stalks against a prairie horizon.

7

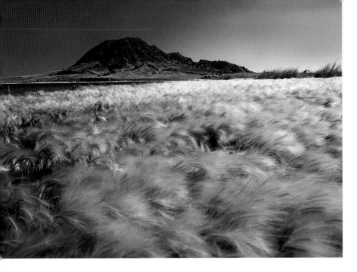

(above) The wind is made visible as it bends prairie bunchgrasses.

(right) The igneous rock of Devils Tower stands tall above the pine forest of northeastern Wyoming.

(facing page) A distant storm bruises the sky over grassland wildflowers.

looking at maps of this area, as though I was making sure that it was still there.

Finally, in the mid-1990s I could no longer deny my heart and so followed it. I returned to the prairies and have never once regretted or lamented my decision in the slightest way.

I went to work as a staff photographer for the regional newspaper, the *Rapid City Journal,* and continued my career as a photojournalist, though I changed my focus a bit. And during my own time, I began shooting and assembling a picture library of the landscapes and wildlife throughout the Black Hills and across the grasslands. In Thoreau's words, I became "a self-appointed inspector of snow-storms and rain-storms, and did my duty faithfully."

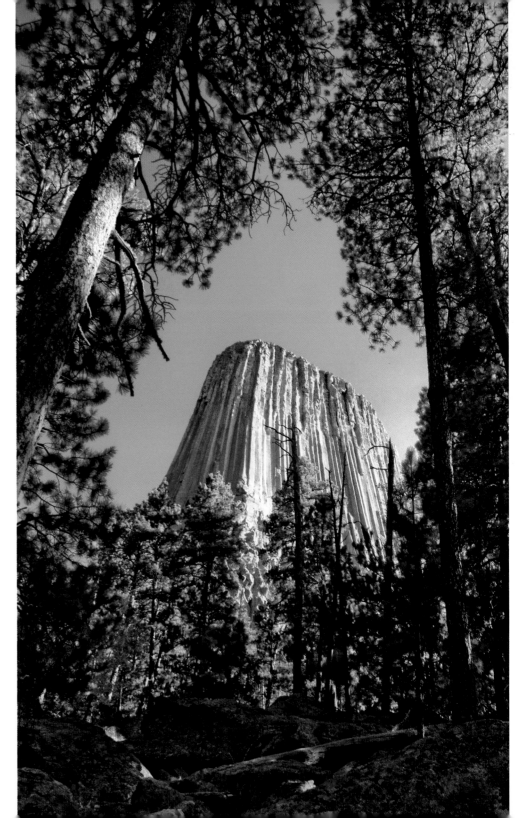

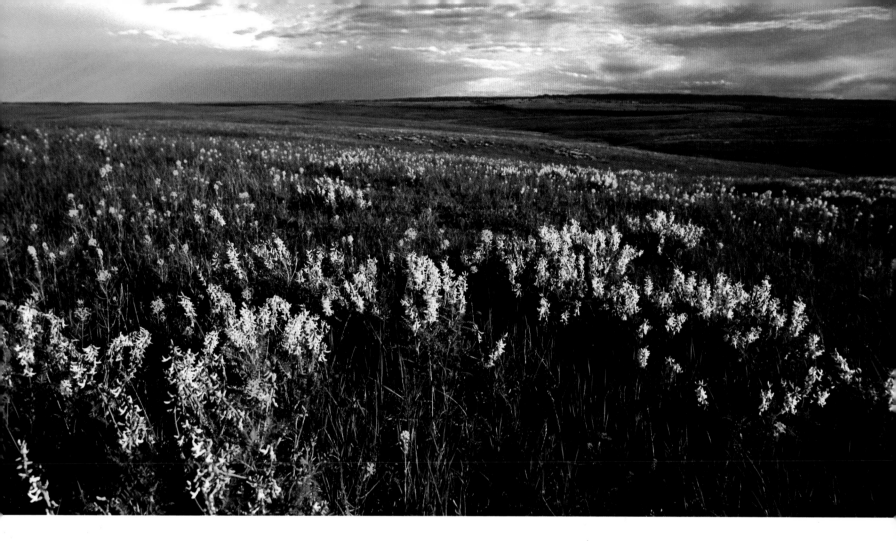

After a few years, I developed a photo column for the paper entitled "The Spring Creek Chronicles." In it, I used my images and combined them with essays to illustrate the changing seasons of the region and the effect of those seasons on all life that dwells here. This column became an instant hit with the paper's readers, and I continue to produce it today, twelve years later, though I left the paper a few years ago to pursue my own work full time.

This book uses what I consider to be some of the best issues of "The Spring Creek Chronicles," or at least some of the best ideas. It covers a two-year period, beginning and ending with the spring of the year. As a preface, I use what was the inaugural issue of the column, entitled "Sympathy with the Seasons."

I have rewritten many of the essays simply because I believe that I am a better writer now, although I still don't really think of myself as a writer. I am first a photographer and write only to support picture projects. I have also shot additional photos for most of the stories, while still using many of the originals as well.

It should also be noted that this book includes excursions to environments and ecosystems that are

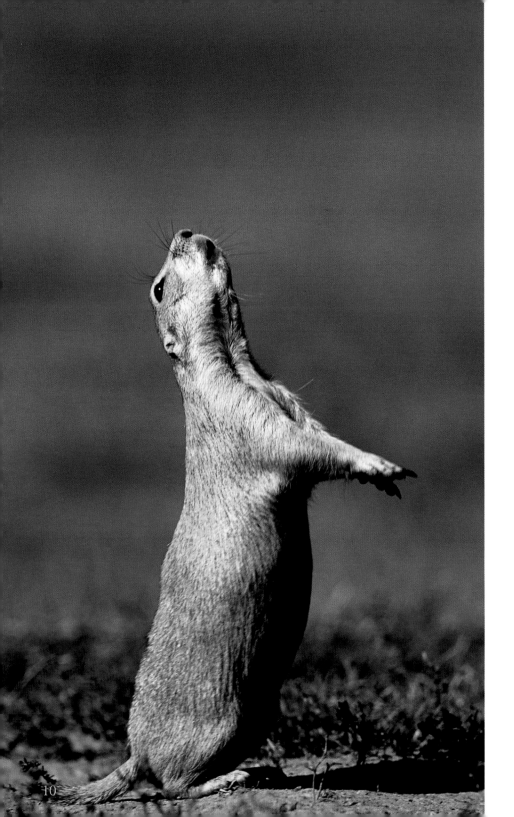

radically different from those of the high plains. These journeys include expeditions to a Texas swampland preserve and a glacial wilderness in Alaska, to help demonstrate what a remarkably diverse life has been led by our region, considering that it has also looked very similar to each of those other ecosystems. Also, a trip to a major waterfowl wintering ground in New Mexico illustrates the migratory life of many of the birds that either reside on the prairies at other times of the year or pass through it during migration.

My hope is that this book exemplifies the theme and idea of "The Spring Creek Chronicles," and that many will enjoy it. I would also like to express my gratitude to the column's many faithful readers over the years. I have cherished your wonderful feedback.

We need the tonic of wilderness—to wade sometimes in marshes where the bittern and meadow-hen lurk. We need to witness our own limits transgressed, and some life pasturing freely where we never wander.

HENRY DAVID THOREAU

(left) Prairie dogs such as this one have a vocabulary of warning whistles and calls as diverse as the threats posed by snakes, coyotes, and raptors.

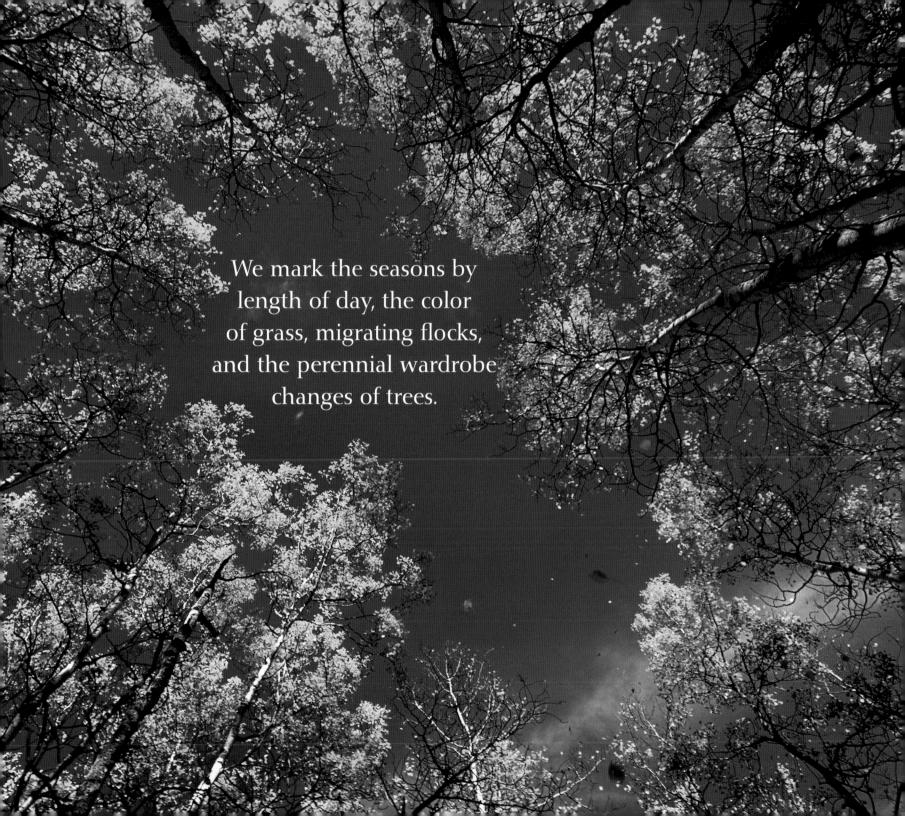

We mark the seasons by
length of day, the color
of grass, migrating flocks,
and the perennial wardrobe
changes of trees.

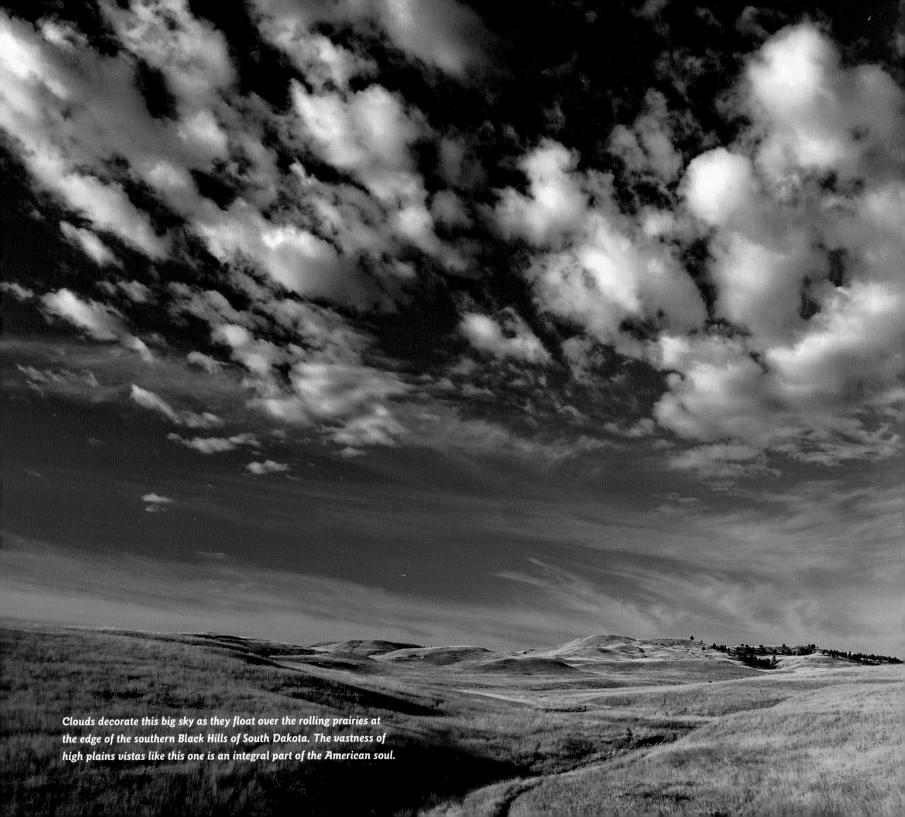

Clouds decorate this big sky as they float over the rolling prairies at the edge of the southern Black Hills of South Dakota. The vastness of high plains vistas like this one is an integral part of the American soul.

SYMPATHY WITH THE SEASONS

When Henry Thoreau first took up his now famous abode in the woods at Walden Pond, he called that excursion an experiment. "I went to the woods because I wished to live deliberately," he said, "to front only the essentials of life, and see if I could not learn what it had to teach, and not, when I came to die, discover that I had not lived."

"Live in each season as it passes," advised Thoreau, "breathe the air, drink the drink, taste the fruit, and resign yourself to the influences of each. Open all your pores and bathe in all the tides of Nature, in all her streams and oceans, at all seasons. For all Nature is doing her best each moment to make us well. She exists for no other end. Do not resist her."

With this end in mind, we embark today on an experiment of our own: *The Spring Creek Chronicles*.

This endeavor will be a journalistic excursion or project in which we will attempt to "keep sympathy with the seasons." Through a combination of pictorial and written essays, *The Spring Creek Chronicles* will observe the cycle of the seasons in a way similar to what Thoreau did at Walden and in his subsequent work, *On Walden Pond*, but with one obvious difference.

Rather than the backdrop of New England that Thoreau's writings usually featured, our setting will be one

(above) *Autumn gilds the prairie beneath a mackerel sky.*

13

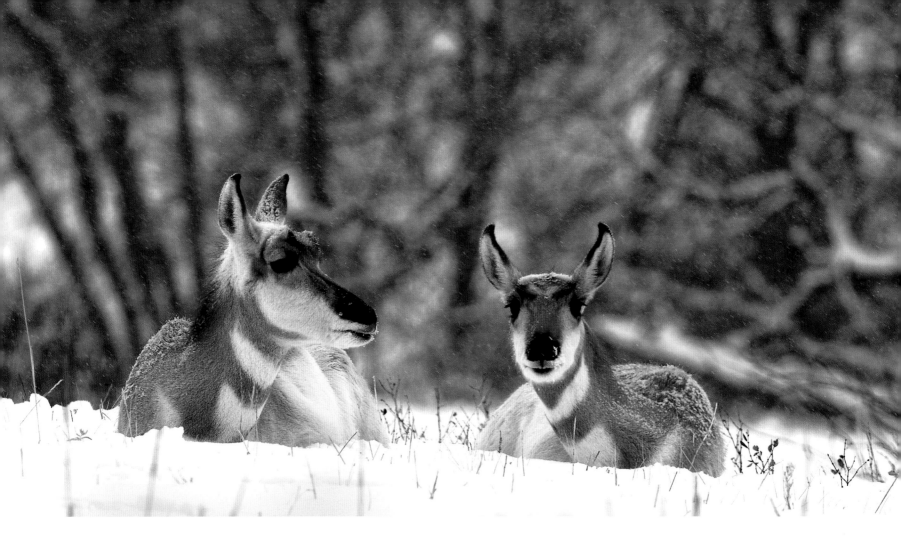

of the most storied and legendary landscapes of North America: the high plains and mixed grasslands of the Dakotas, Wyoming, Montana, and Nebraska. The rugged and rolling panoramas of these northern prairies have long been a fixture in the imagination of Americana as they are found throughout our literature, music, films, and folklore.

The wild creatures that inhabit these wondrous vistas are also a focus of that imagination. Having become an international symbol of the American West, the bison is now an attraction that excites and brings people from all around the globe. Sharing these grasslands are the speedy pronghorn, mule deer, and white-tailed deer, and the majestic elk. Smaller mammals include the clever coyotes, badgers, prairie dogs, foxes, and jackrabbits.

The birds of the high plains are no less magnificent. Too numerous to mention all, the list includes ground dwellers like grouse, prairie chickens, and wild turkeys, with hawks, eagles, falcons, and vultures cruising the skies overhead. Great blue herons, geese, cranes, trumpeter swans, and countless species of ducks comprise the list of waterfowl and wading birds. And during the warm months, the prairies never lack for music with the

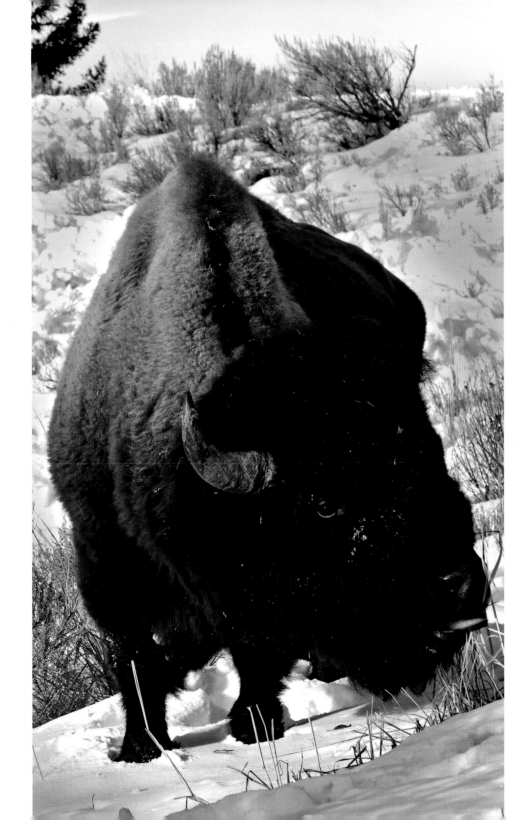

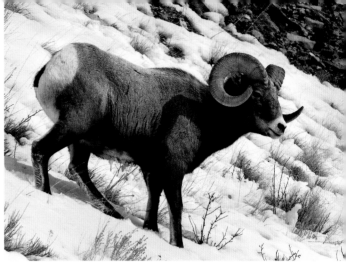

(above) A bighorn ram picks its way through the deepening snow to less-covered sources of food.

(left) Bison like this huge bull settle for dried and meager fare during mid-February in Yellowstone National Park's Lamar Valley.

(facing page) For a pronghorn doe and her fawn from last summer, ash and cottonwood groves like this one along South Dakota's Lame Johnny Creek provide protection from the winds.

distinctive songs of the western meadowlark, American goldfinch, and mourning dove.

Always, each chapter of *The Chronicles* is anchored by a strong visual presentation as it moves from month to month through the year. Accompanying each set of photographs is a short supporting essay. The theme is nature, and what it means to humanity.

It seems fitting that the last work of Henry Thoreau, *Faith in a Seed*, should center on seeds—how nature uses and disperses them and the miracles that are derived from them. For, in a sense, Thoreau and Ralph Waldo Emerson were also seeds that germinated and blossomed to give shape to a unique genre and expression of American literature and one of its most important contributions to the literary world: the nature essay.

It was these two men who—by bringing about a synthesis of dissimilar and, previously, distant elements, such as private diaries, extended letters, scientific data, and conventional essay forms—sowed the seeds that eventually paved the way for important twentieth- and twenty-first-century writers such as Aldo Leopold, Norman Maclean, Edward Abbey, Linda Hasselstrom, Terry Tempest Williams, Dan O'Brien, and Barry Lopez.

The nature essay has become, as author and book editor John Murray describes, "a remarkably diverse and elastic literary form that is natural, loose, and open in its structure with boundaries much broader than they have ever been previously. . . . Just as nature grows, the literature is also growing. The three major themes of Walden—communion, renewal, and liberation—continue to pervade the genre even now, at the dawn of the twenty-first century."

As we journey through the seasons of the years to come, it is my belief that if *The Spring Creek Chronicles* can help us to better appreciate Thoreau's assessment of his own "experiment," then something wonderful will have been accomplished.

I learned this, at least, by my experiment; that if
one advances confidently in the direction of his dreams,
and endeavors to live the life which he has
imagined, he will meet with a success unexpected
in common hours . . . the laws of the universe
will appear less complex, and solitude will not
be solitude, nor poverty poverty, nor weakness
weakness. If you have built castles in the air,
your work need not be lost; for that is where they
should be. Now put the foundations under them.

HENRY DAVID THOREAU

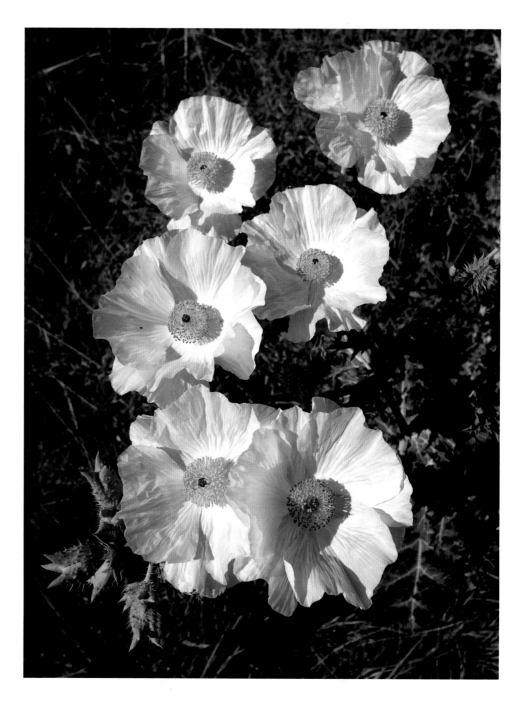

(above) Few animals feed on bluestem pricklypoppy, but quail and doves enjoy the seeds, which have a high oil—and caloric—content.

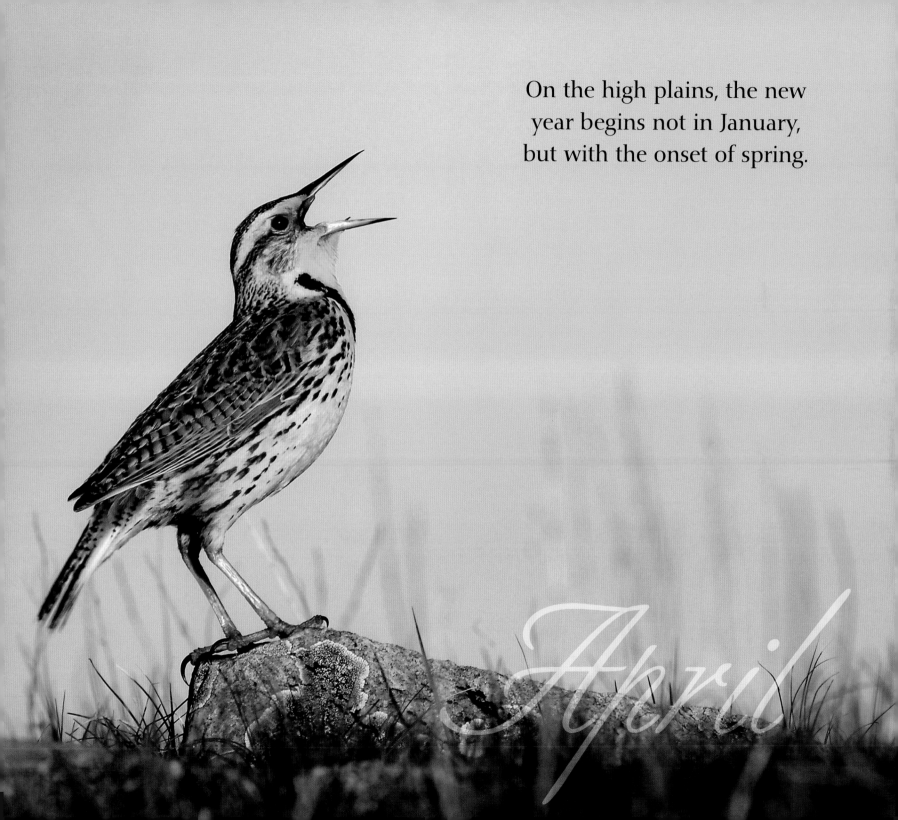

On the high plains, the new
year begins not in January,
but with the onset of spring.

April

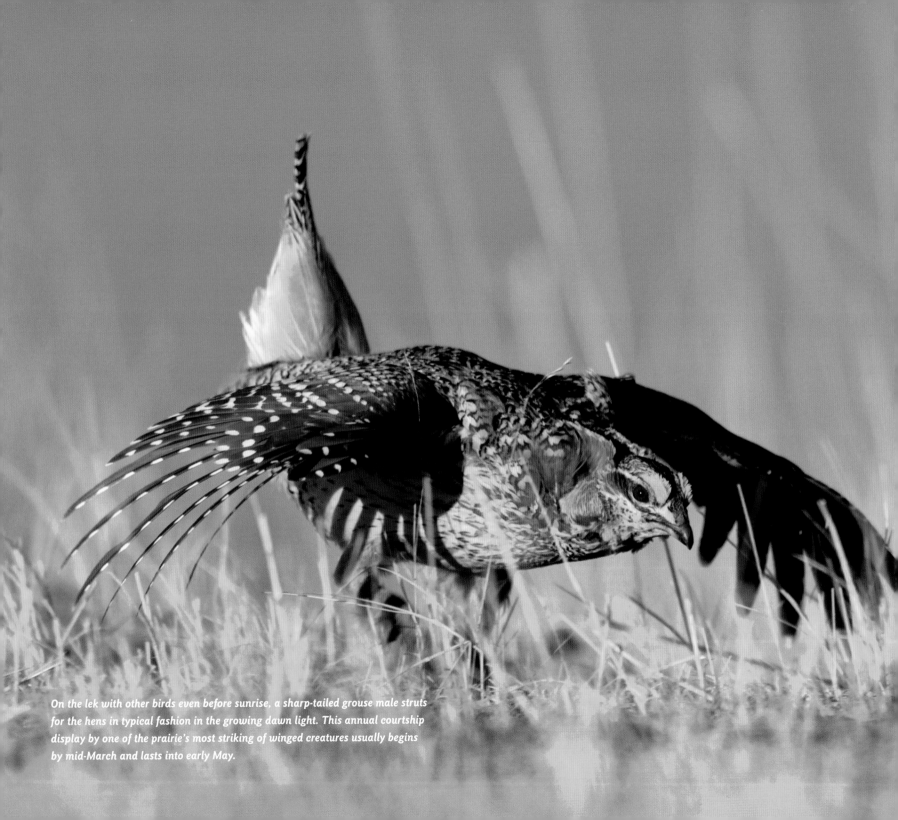

On the lek with other birds even before sunrise, a sharp-tailed grouse male struts for the hens in typical fashion in the growing dawn light. This annual courtship display by one of the prairie's most striking of winged creatures usually begins by mid-March and lasts into early May.

GRASSLANDS MUSIC

A trace of light steals across the broad prairie sky, emanating from a slight amber radiance growing slowly over the eastern horizon. The mantle of darkness lifts. Vague outlines of familiar forms—a distant tree against the eastern sky, the line of a far ridge—emerge from the dark's obscurity. Most things still remain enshrouded to the eye.

Laying my head back against the wall of my plywood blind, I close my eyes and shut down my visual senses for the moment, drifting into the ongoing production.

The prairie is awake—and alive—with a symphony of sound that is stereophonic as it broadcasts from the waning night. The song of a meadowlark here answers a chorus of howls from a coyote pack over there. The gobbling of a tom turkey mixes with the occasional bray of a wild burro in nearby Custer State Park. It is a time for the ears.

Muffled drumbeat-like sounds merged with others begin to dominate the predawn chorale, reverberating from the darkness just outside my wooden walls on this remote prairie ridge at the edge of South Dakota's southern Black Hills. Fuh-duh-duh-duh-duh-dit. Fuh-duh-duh-duh-duh-dit. Chuk-chuk-chuk. Chuk-chuk-chuk. Chuk-chuk-chuk. Coo-oo. Coo-oo. Coo-oo. The music seems to be growing.

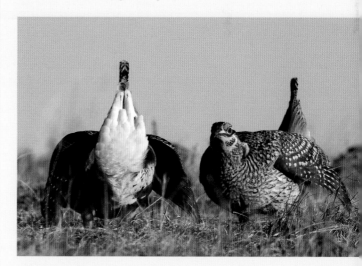

(above) These two cocks strut about each other with "mad dogging" stares, reminiscent of a couple of junior high school kids egging each other on for a fight.

19

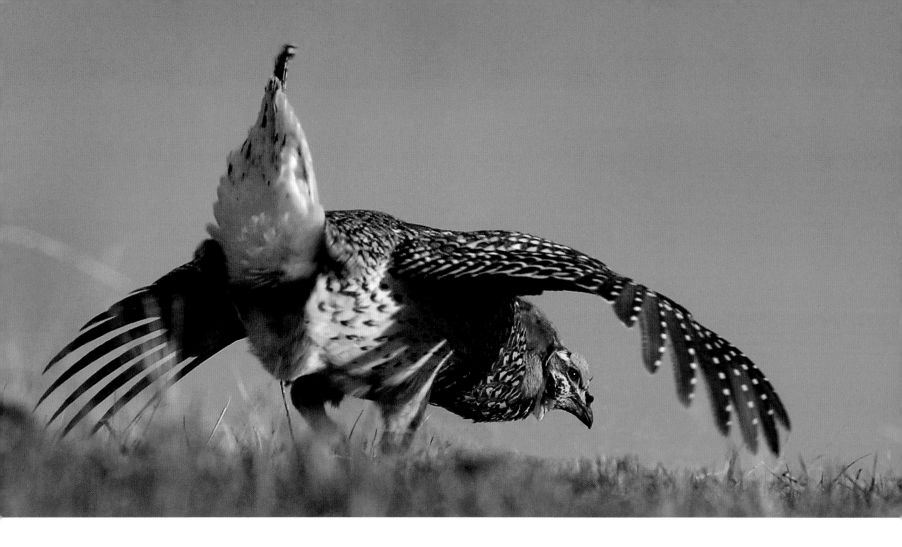

Suddenly the piercing howl of a single coyote knifes through the darkness—this one much closer. Panic ensues. I hear the furious beat of many wings mixing with a more urgent version of chuk-chuk-chuk, chuk-chuk-chuk, chuk-chuk-chuk—all quickly fading away into the night. Then . . . silence. Not even a meadowlark.

Knowing that the music will return, I shift my cramped feet out in front of me and go on sipping coffee from my plastic car cup. To get here, I dragged myself out of bed at 3:30 A.M. and then hiked half a mile through the dark of a moonless night at a chilly thirty degrees so I could be in this blind an hour before sunrise. Why? To watch and photograph the mating displays of sharp-tailed grouse.

One of the real treats of early spring across the grasslands of Nebraska, Wyoming, and the Dakotas is the opportunity to observe these very striking birds as they put on one of nature's most spectacular displays of courtship behavior, usually beginning in mid-March and running into May.

During the first hours of the day, the cocks and hens gather on a prairie ground called a lek—typically the top of a knoll or hill with good visibility in all directions. Here

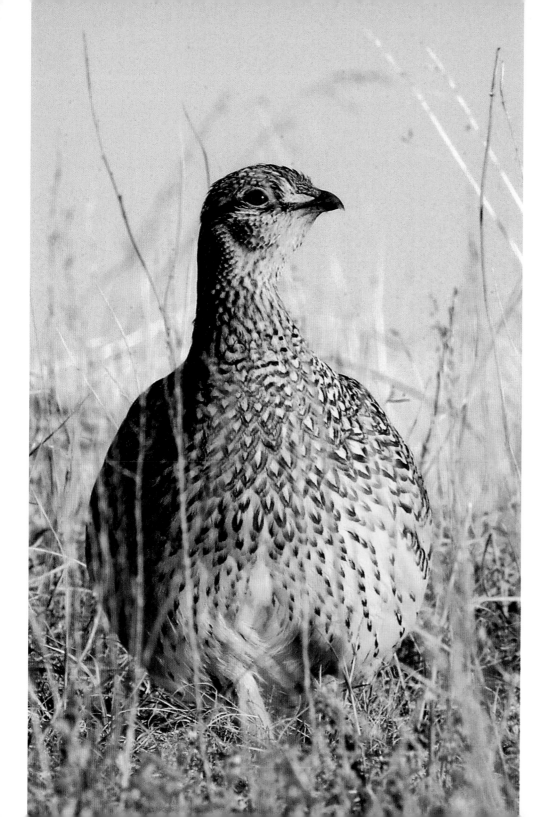

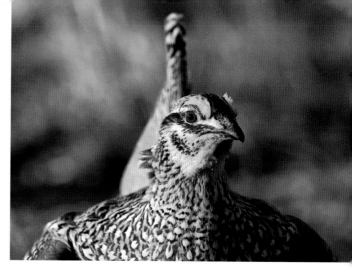

(above) The brilliant yellow of the cock's eyebrows contrasted with the red of his eyes gives the males a unique appearance.

(left) The hen's plainer plumage allows her to blend more readily into her surroundings while she is nesting and raising chicks, escaping the notice of predators.

(facing page) As is typical with ground-nesting birds and many other birds in general, the sharp-tailed male possesses a much brighter colored and more ornate plumage than the hen. These features become very pronounced during courtship displays.

the males perform a spring dance in which they extend their white-spotted wings and six-inch tail feathers, inflate purplish neck sacks, and stamp their feet, hence the fuh-duh-duh-duh-duh-dit drumbeat sound as they shoot back and forth across the ground like little powered toy cars. All this to impress and gain favor with the hens. In other words: "pick me, pick me, not him." At times this competition becomes more than just mere display as the cocks go into fits of jealous rage and engage in pitched battles, jumping on and even pecking each other.

In early May, the hens begin nest building in areas

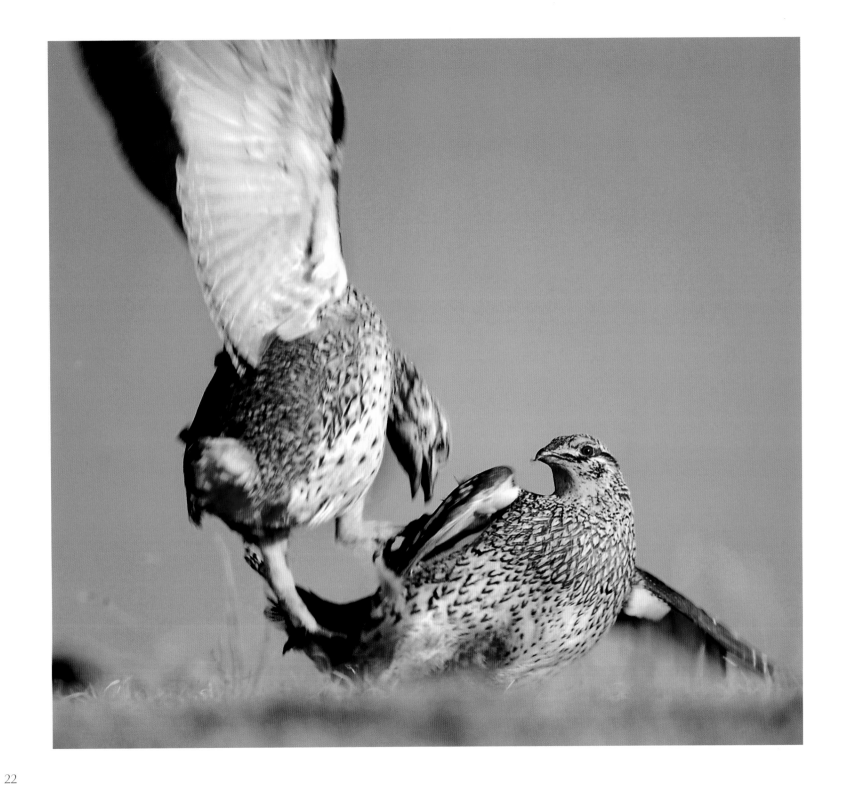

with taller grass than what is generally found on the lek. After a twenty-four-day incubation period, they hatch a brood in early June of twelve to fourteen chicks. Soon after hatching, the hen will move her brood back into areas of shorter grass where the youngsters will quickly grow while feeding on a diet of grasses, seeds, and insects. As with most ground-nesting birds, the males play no role in raising the chicks.

The silence that had fallen around the blind is cut once again by the familiar beat of wings as the birds return to the lek and resume their business. Once more the music grows. I hear the meadowlarks and of course . . . fuh-duh-duh-duh-duh-dit. Fuh-duh-duh-duh-duh-dit . . . chuk-chuk-chuk. Chuk-chuk-chuk. Coo-oo. Coo-oo.

I can now see color in the eastern sky as well as silhouetted figures scurrying about in the grass in front of the blind. There is the usual chill of a mid-April dawn on the northern prairies and a slight breeze, but none of the heavy spring wind gusts that tend to cut down the birds' activities. A good photo day is coming.

Fuh-duh-duh-duh-duh-dit. Fuh-duh-duh-duh-duh-dit. Chuk-chuk-chuk. Chuk-chuk-chuk.

Even so, if I fail to get a single usable image this morning, the time is well spent just listening to the music of the grasslands.

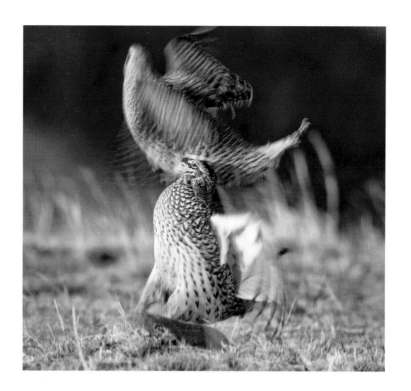

(facing page) Although much of the lek activity is merely display and ritualistic, serious fights do sometimes break out between the cocks. They jump, scratch, and peck at each other—even drawing a little blood on some occasions. Serious or fatal injuries are rare.

(this page) A certain amount of acrobatics and even ballet movements are included in the birds' display, with some of their antics coming almost faster than the camera can follow.

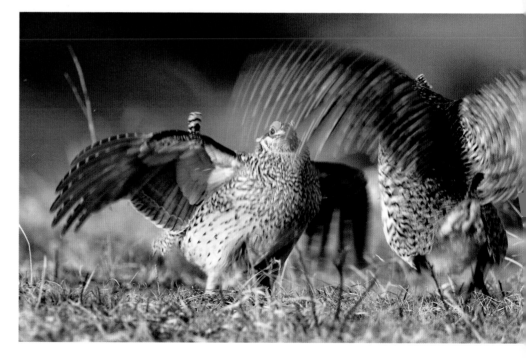

23

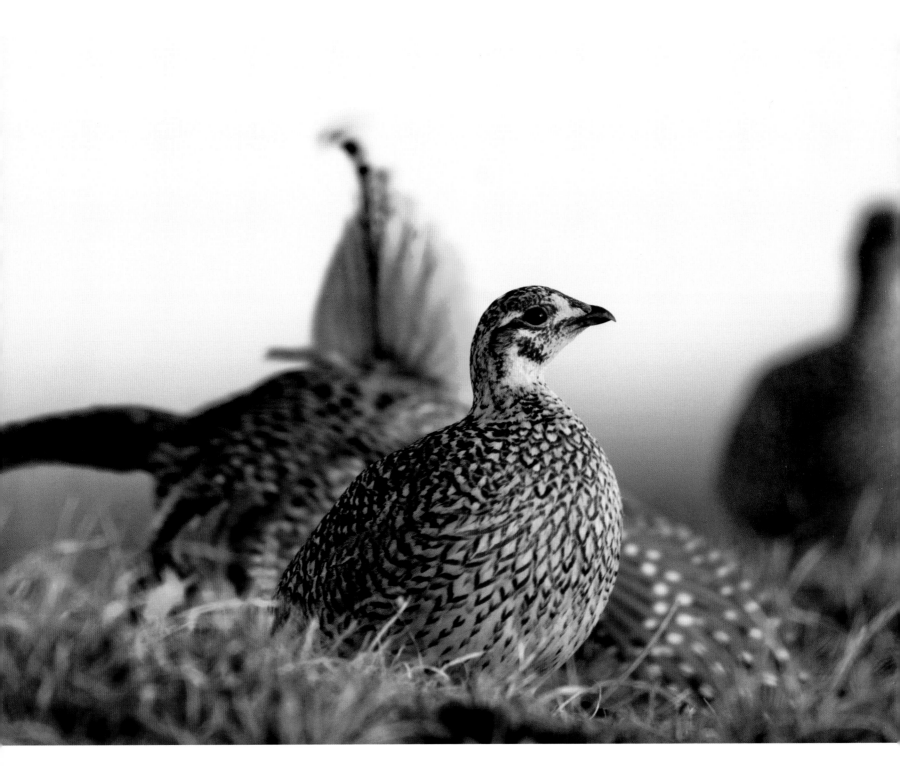

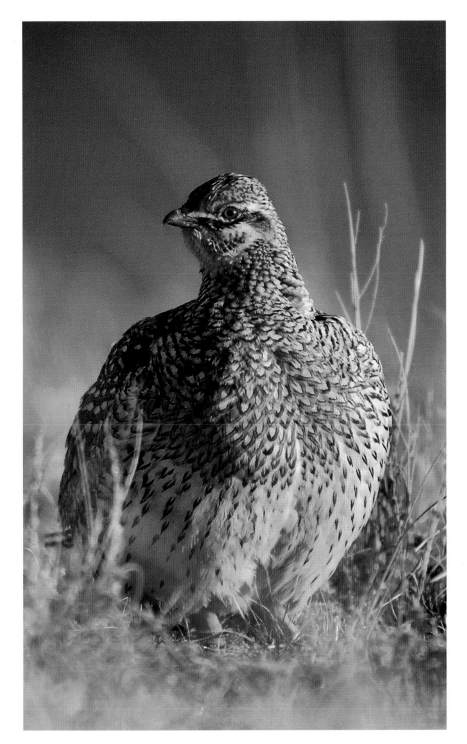

(facing page) A hen stands passively while this cock puts on his best show for her. Should the hen decide on this male, she will prostrate herself before him belly down, indicating her readiness to breed. The sharp-tailed hen is slightly smaller than the male and lays twelve to fourteen eggs in a ground nest that is very simple in design.

(left) The breast of the sharp-tailed grouse is characteristically marked with dark vees, while the abdomen is mostly white.

(below) The sharply pointed tail of this male grouse, hence its name, is formed by the middle tail feathers being more than one inch longer than the ones on either side.

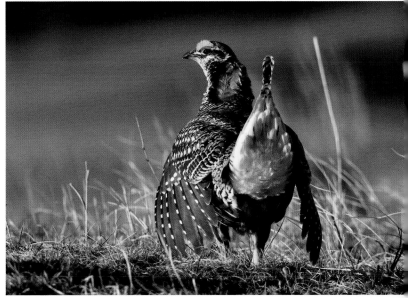

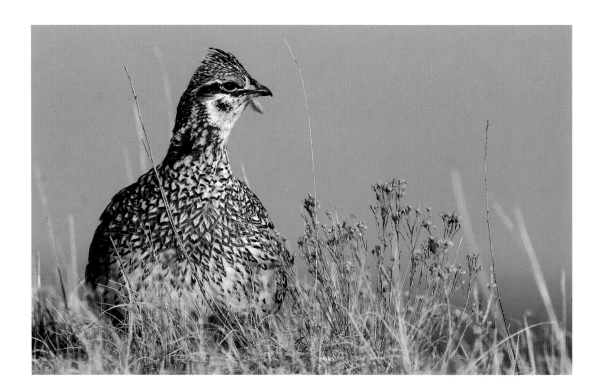

(right) With a defeated rival's feathers still hanging from his mouth, this sharp-tailed male dares others to answer his challenge.

(below) Two hens cautiously wander onto the lek as the morning activity grows.

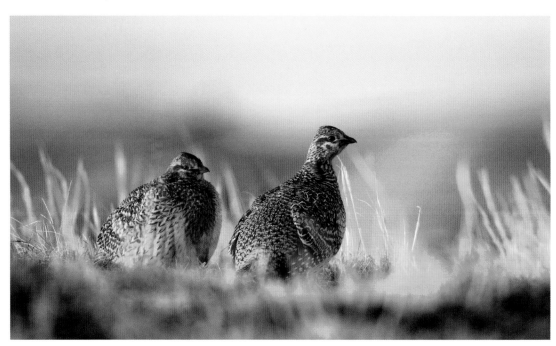

May is a month for new
life, whether wildflowers
or pronghorn.

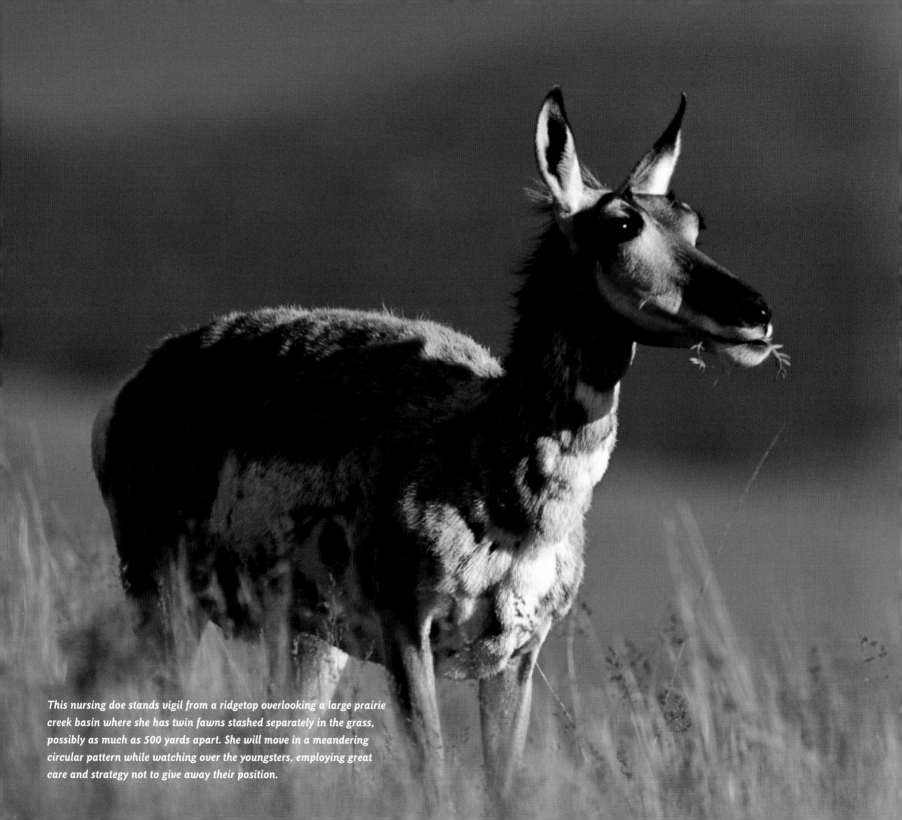

This nursing doe stands vigil from a ridgetop overlooking a large prairie creek basin where she has twin fawns stashed separately in the grass, possibly as much as 500 yards apart. She will move in a meandering circular pattern while watching over the youngsters, employing great care and strategy not to give away their position.

CATCHING
THE RHYTHM

The wily little pronghorn doe ambles on ahead through the dense prairie shrubbery, stopping periodically to nibble at something or to shake off the pesky flies that are a constant for her species at this time of year.

For nearly two hours now I have watched that unmistakable style in her behavior—exaggerated stares to a distant ridge, quick glances back over her shoulder, first at me and then beyond. Occasionally she breaks into a trot, covering maybe forty or fifty yards, and then stops to begin the cycle again.

This doe has a secret.

Somewhere in the sea of grass surrounding me is new and vulnerable life awaiting the return of motherly care—two buck fawns, born during the night. Only a few hours old, each is in a state of near helplessness and faces the most critical period of its young life. Though they first stood up when only ten or fifteen minutes old, they possess little stamina and can easily become a predator's meal, especially that of the swift and ever-present coyote.

The doe has stashed each fawn in a different spot, as

much as 500 yards or more apart, thereby enhancing the odds that at least one will survive the next few weeks. By

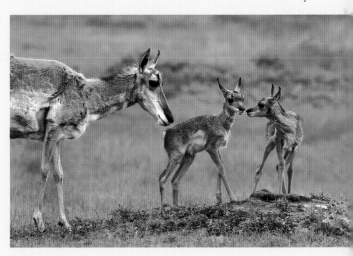

(above) During most of their first two weeks, these sibling fawns will see very little of each other as their mother keeps them bedded separately for the most part. About twenty-four hours old, these fawns together constitute about eighteen percent of their mother's weight. A human female giving birth to twins at that percentage of her weight would have babies weighing more than twelve pounds each.

29

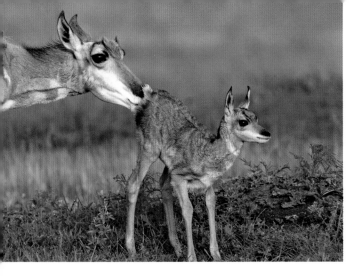

(above) This doe licks her fawn's genital and anal regions, consuming its urine and feces and thereby reducing the scent that a predator can follow.

(right) On her feet when she was barely twenty minutes old, this little doe at four days of age can now easily outrun a human. She still lacks the stamina to distance herself from swift predators like coyotes, but by the tender age of eight to ten weeks, she'll be ready to outrun any animal on the continent.

(facing page) Even as she nurses, the doe keeps an ever watchful vigilance in all directions. Contributing to the pronghorn fawn's rapid development are the doe's extremely rich milk, which contains about two-thirds more fat than that of a domestic cow, and its long gestation period of 252 days—considerably longer than several larger animals like mule deer (196 days) or bighorn sheep (180 days).

then, the youngsters' legs will be strong enough to carry them from the reach of the coyote's jaws. For the time being, the infants must lie alone most of the day in tall grass or shrubs, with mamma periodically stopping by for care and feeding. But she is never far away.

This doe and I are playing what has been described as an elaborate shell game. I know exactly where one of the fawns is, concealed in a patch of shrubs about fifteen

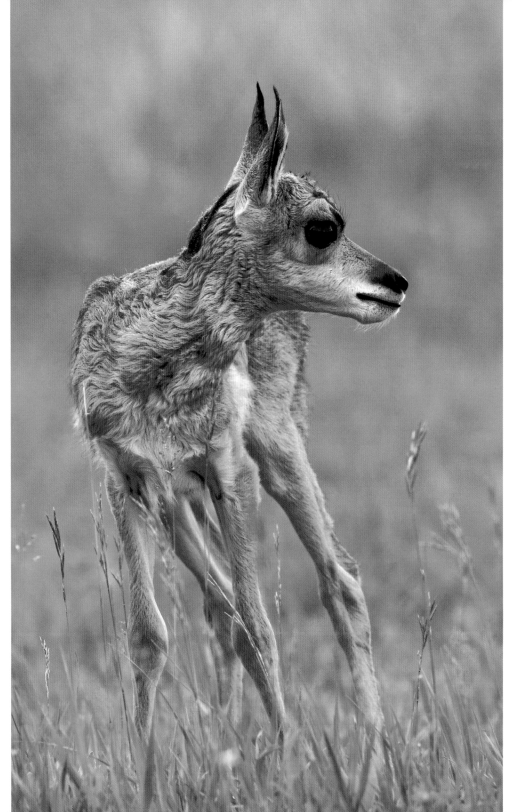

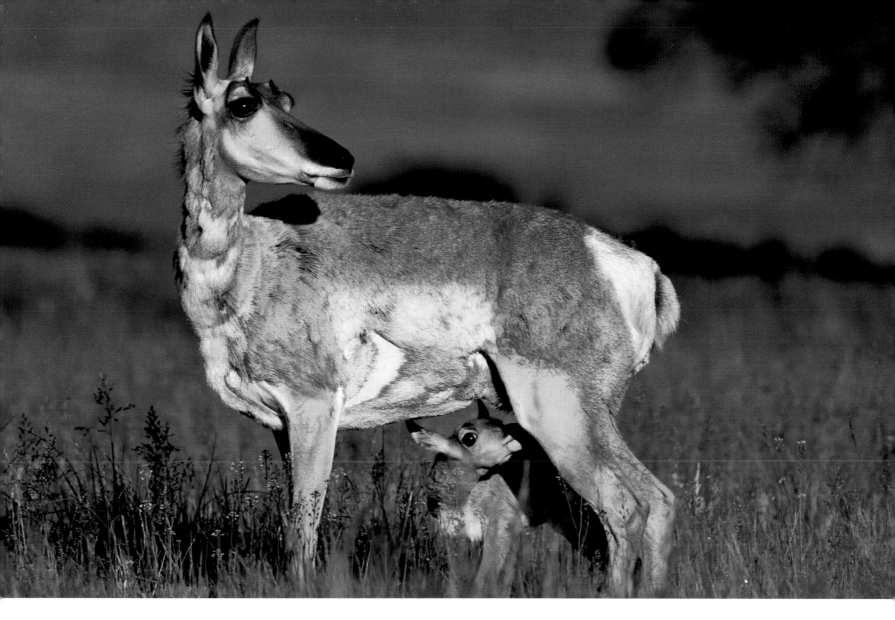

yards away. I can see the tops of his long ears occasionally turn and twitch. From atop a distant ridge, I had watched the doe lead him to this spot in a small ravine where he is now bedded.

Now for nearly two hours each of us has feigned ignorance. I have pretended that I haven't the slightest idea as to the fawn's location or that I am even interested.

The doe has gone through the motions of feeding, lying down to ruminate, and then getting up to walk a wide circle around the ravine, even disappearing for a while, probably to check on the other fawn. She doesn't really trust me, but she's figured out that I'm not a predator. I'm not there to eat her babies.

I just sit still, careful not to do anything that would

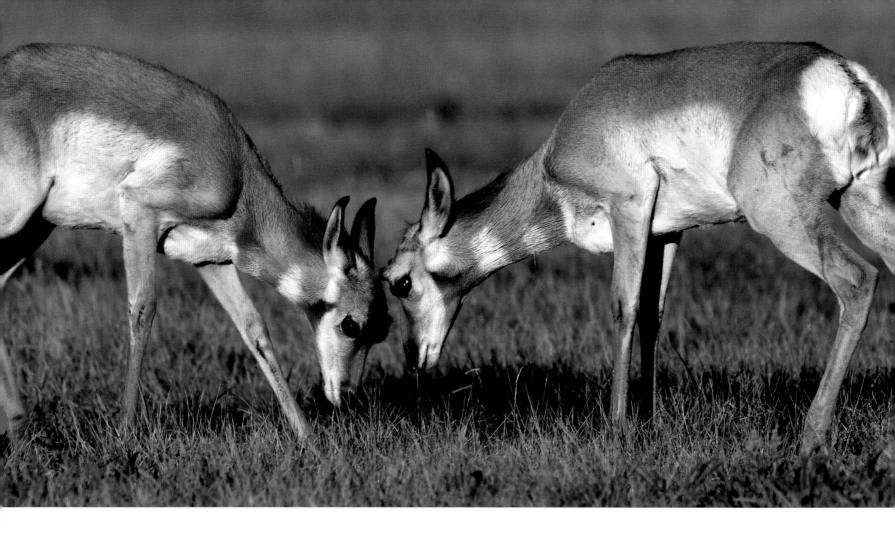

cause the fawn near me to bolt. I never know who else is watching, such as a coyote. And they do well enough on their own without my help.

If I'm willing to wait long enough—possibly several hours—the doe will eventually approach the infant and get him up for feeding and care, giving me some wonderful images of interaction between the two in an otherwise secretive moment. Of course there is no guarantee with wild animals that follow their own schedules. Time and motion are different to them, a difference that I have had to learn.

It is what Isak Dinesen called "catching the rhythm" in her great work *Out of Africa*. "No domestic animal can be as still as a wild animal," Dinesen wrote. "The civilized people have lost the aptitude of stillness and must take lessons in silence from the wild before they are accepted by it. The art of moving gently, without suddenness, is the first to be studied by the hunter, and more so by the hunter with the camera. One must fall in with the wind, and the colours and smells of the landscape, and you must make the tempo of the ensemble your own."

Movement—instantly drawing my attention back to

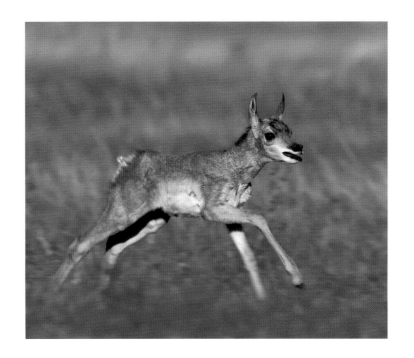

(facing page) The play of pronghorn fawns is actually a feature of behavioral development and involves sparring, head butting, and chasing, along with many other activities. Mock battles like this one between two buck fawns are common and can get very aggressive as they learn some of the hierarchical laws of pronghorn society, although injuries are rare.

(right) Fawns like this little buck will suddenly break into a sprint, dashing back and forth several times over a distance as much as thirty to forty yards, and then stand panting. This play helps develop strong legs that will save his life more than once in the years to come.

(below) After a morning of play, these sibling fawns return to nearby mama for a big lunch.

the fawn. Finally, a reward for my efforts to catch the rhythm.

Being ready with the camera, I hold perfectly still as the fawn's head pokes up from the grass. His wide eyes begin to scan the surroundings for his mother as he comes completely to his feet. Cramped from the hours of stillness, the youngster stretches his legs that are still a bit shaky and takes a couple of very unsure steps, trying not to look at me. Raising his head, he lets out a high-pitched bleat for his mother.

The doe has been moving toward the fawn since he first began to rise, but with his bleating she breaks into a trot and is quickly at the infant's side. She nuzzles him in the usual way and then begins his feeding as I begin shooting.

Catching the rhythm is part of what makes this time of the year so special.

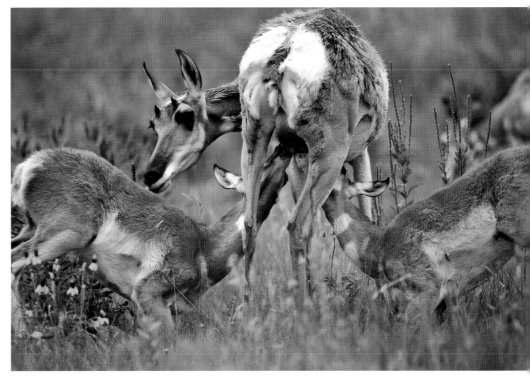

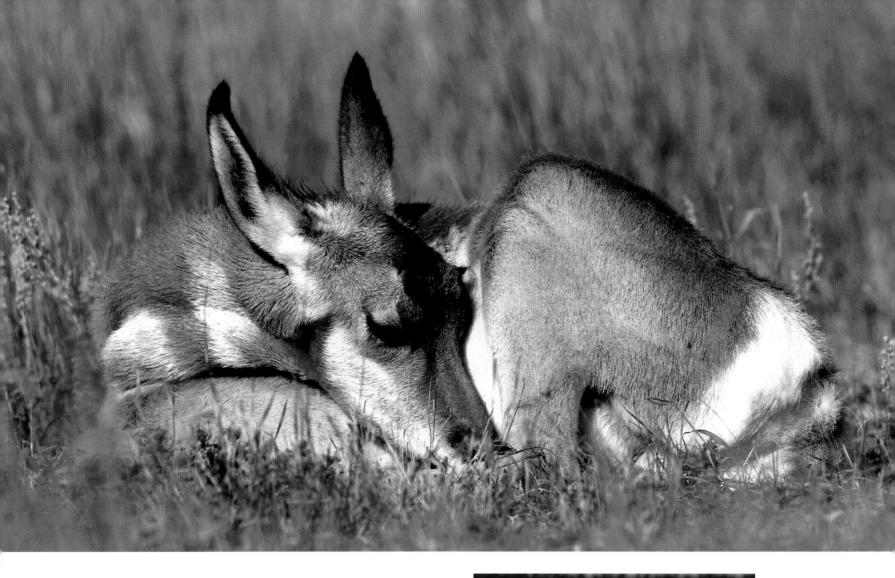

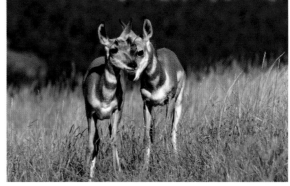

(this page) After a couple of moments of nudging and bonding, each of them settles in for a long nap—the end to a perfect pronghorn morning.

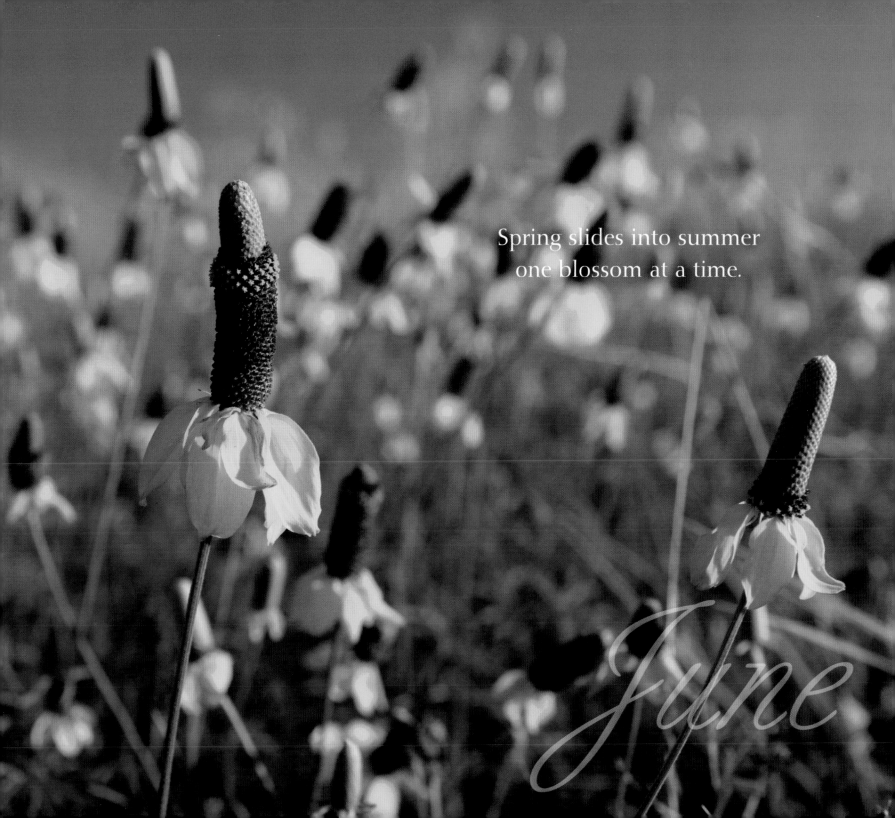

Spring slides into summer
one blossom at a time.

June

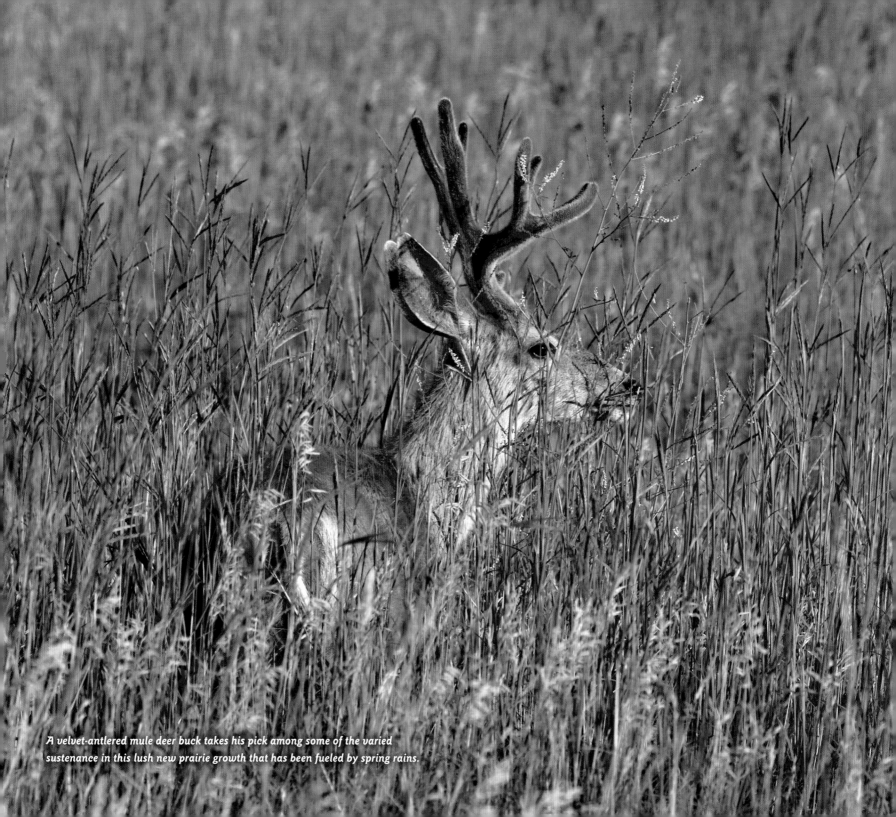

A velvet-antlered mule deer buck takes his pick among some of the varied sustenance in this lush new prairie growth that has been fueled by spring rains.

NICE TO BE HERE

A cool and easy breeze works its way through the tops of the cottonwood and ash trees growing up along both sides of Lame Johnny Creek, heralding in a delightful summer's morning—in fact, the day of the solstice.

The gentle rain that began about midnight is now spent as the clouds break on the eastern horizon, with the sun peeking through periodically to create a luster of beautiful tones in the prairie sky. It's the kind of light that teaches a photographer patience, to await the window of opportunity. A wonderful dawning for the year's longest day.

Spring was wet but cold this year, with much of the moisture coming as snow, even in May. For several weeks, summer seemed so elusive. Now the sweet fragrance of new growth fused with that of last night's rain is heavy across the prairie and pleasantly fills the senses, giving rest to fears that a morning like this one would never come.

And color. So many hues. Yellow, purple, blue, red, white, and so much green—everywhere green. Tall grasses, shrubs of every kind, healthy soils, and running water. The huge blossoms and striking graphics of the bluestem pricklypoppy along with clusters of spiderwort, western salsify, and coneflowers have become a staple sight, emerging to dominance in creekside meadows like this one.

These are among the hundreds of things that I can never again take for granted. It is truly a prairie renaissance.

Much of the twenty-first century's first decade saw what was probably the worst drought across the Dakotas and

(above) A monarch butterfly gathers a sweet reward from the unique blossom of a Flodman's thistle.

37

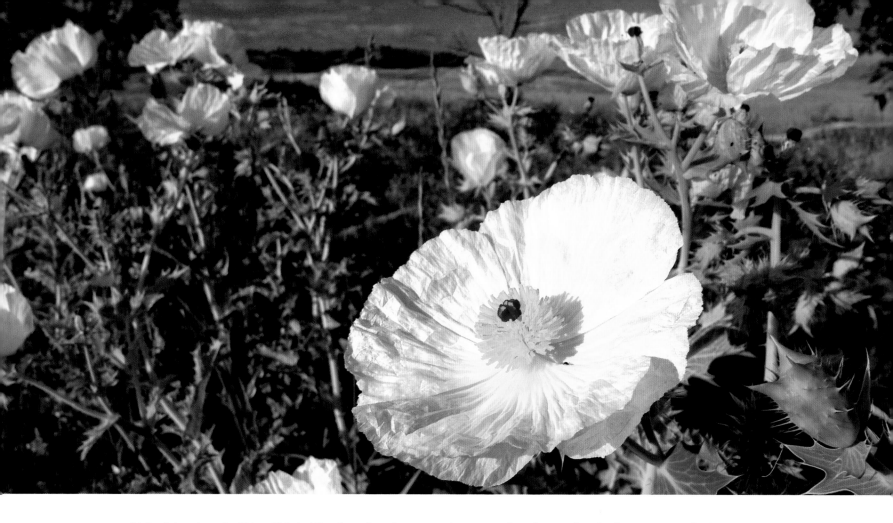

high plains since the "Dirty Thirties." Ponds and creeks went dry as the land cracked and broke, producing little grass of any kind. Rivers and lakes fell to levels lower than anyone could remember, making this time painful for those of us who know and love the prairies. We kept telling ourselves that all other droughts had ended and so too would this one, but even that logic seemed doubtful at times.

This morning, water runs off my boots and my pant legs are soaked up to my knees as I make my way through the thick and lush grasslands. Everything around me is dripping wet. Lame Johnny Creek runs faster and deeper than at any other time during the past seven or eight years when frequently it had no water at all. The gurgling sound is wonderful.

Water. Covering seventy percent of our Earth, it is the basis of life on this planet. And yet those of us here choose to live in a land where out of every ten years it is a given that at least three will be very dry. We know that dry years and droughts are part of life on the prairie—they will come and go, again and again. We accept that every generation or so a drought will persist, as did the one this past decade.

About a mile behind me is a large mule deer buck—with antlers in velvet of course—that I had met in the

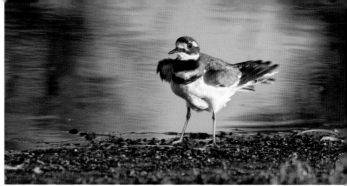

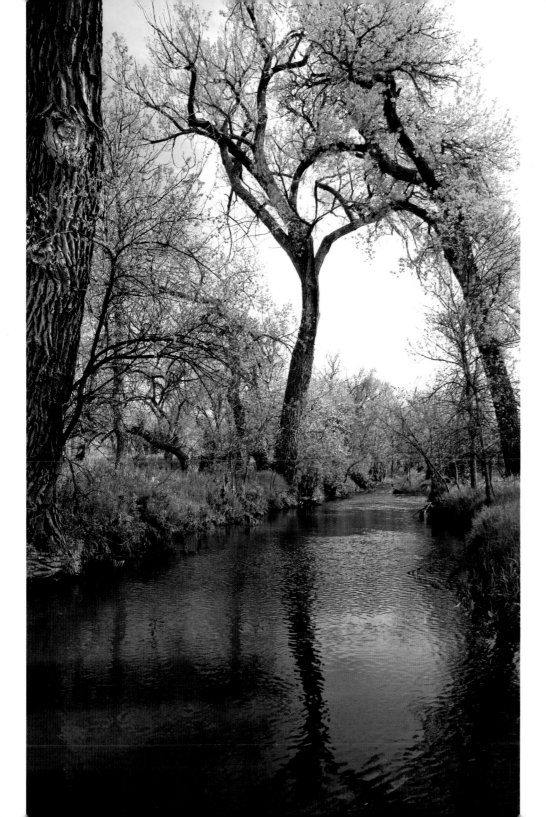

(above) Seen frequently on the banks of the prairie's creeks and ponds during spring and summer, a killdeer shakes water from its brilliantly colored plumage.

(left) During this wet year, Lame Johnny Creek flows near the top of its banks, with deep pools like this one all along its course.

(facing page) With blossoms up to four inches in diameter, the bluestem pricklypoppy is one of the largest wildflowers growing on the high plains. Typically, the blossoms open at dawn and close during the hot part of the day. Growing about three feet high, the plants have sharp spines and prefer very sandy soils. Animals generally avoid this plant because of its spines and bitter juices. The Lakota used its yellow sap to make paint.

waning darkness. For about an hour, this wild animal had accepted my intrusion into his world and allowed me to share his experience as I followed him through the grass already growing tall enough to nearly engulf creatures his size. At times we had lounged together in the open grasslands no more than twenty yards apart, as though fellow travelers on a common sojourn.

Now as I hike through the grass back to my truck, still about a mile away, I am content to occasionally settle down in areas where I can enjoy the flowers and leisurely collect images—another of the summer's condiments. Soon I am whistling the melody of an old Moody Blues tune from the late 1960s—"Nice to Be Here." It seemed like the perfect theme for summer's advent.

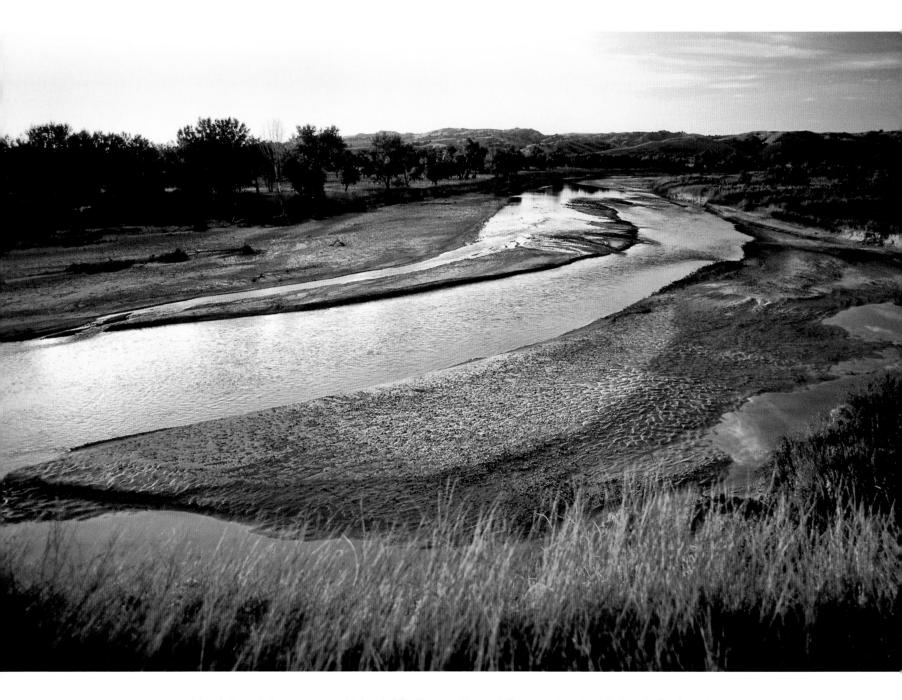

(above) Dawn light creeps across this bend of the Cheyenne River as it flows out of the South Dakota Badlands not far from the tiny village of Wasta. Many believe the Cheyenne to be one of the most beautiful prairie rivers found anywhere.

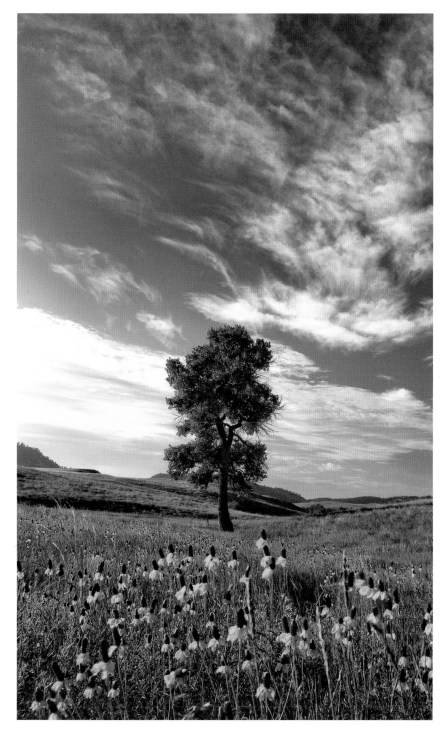

Upright prairie coneflowers (left) decorate this grasslands meadow in front of a lone cottonwood tree on South Dakota's Lame Johnny Ranch. Other prairie perennials such as horsemint (below top) and western salsify (below bottom) also flourish, providing nourishment to various insects like bumblebees and grasshoppers.

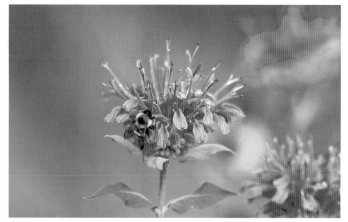

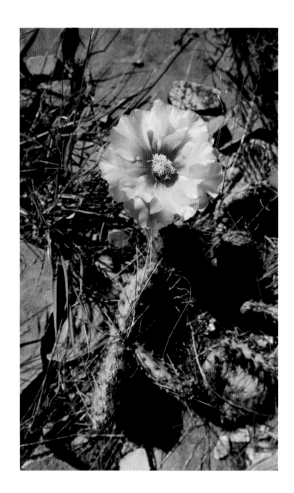 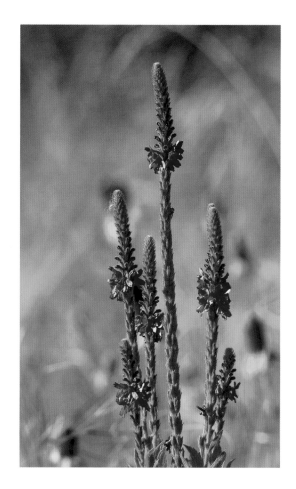

(left) The huge yellow blossoms of the pricklypear cactus are everywhere.

(middle) A white-tailed doe stands on her hind legs to nibble at the extensive vegetation.

(right) Sporting blossoms that are less than a half inch across, the wooly
verbena's deep roots give it drought protection.

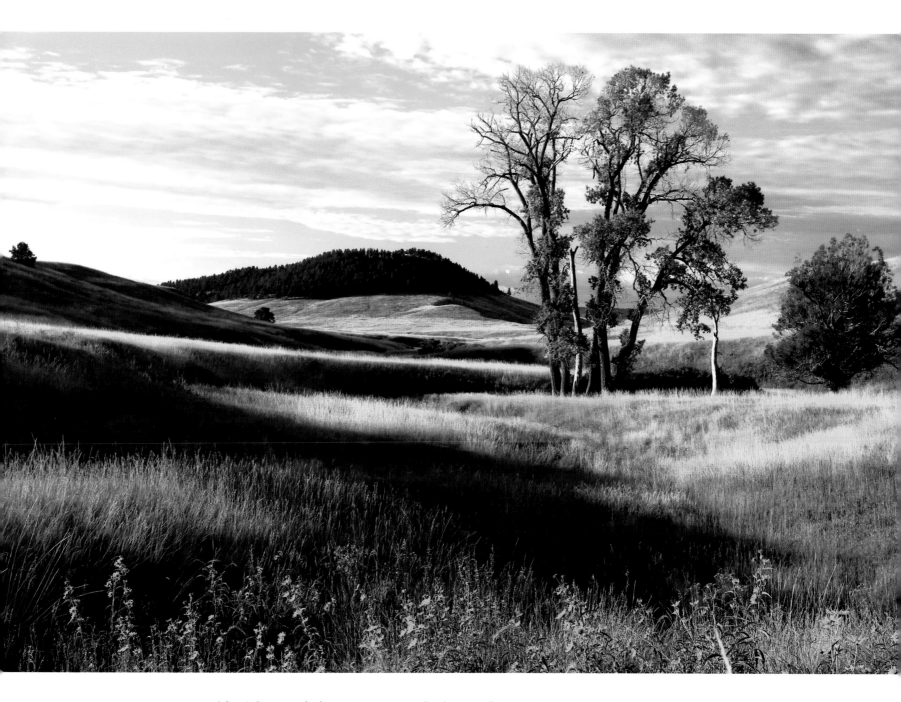

(above) Grasses and other prairie vegetation already grow tall in this Wind Cave National Park ravine.

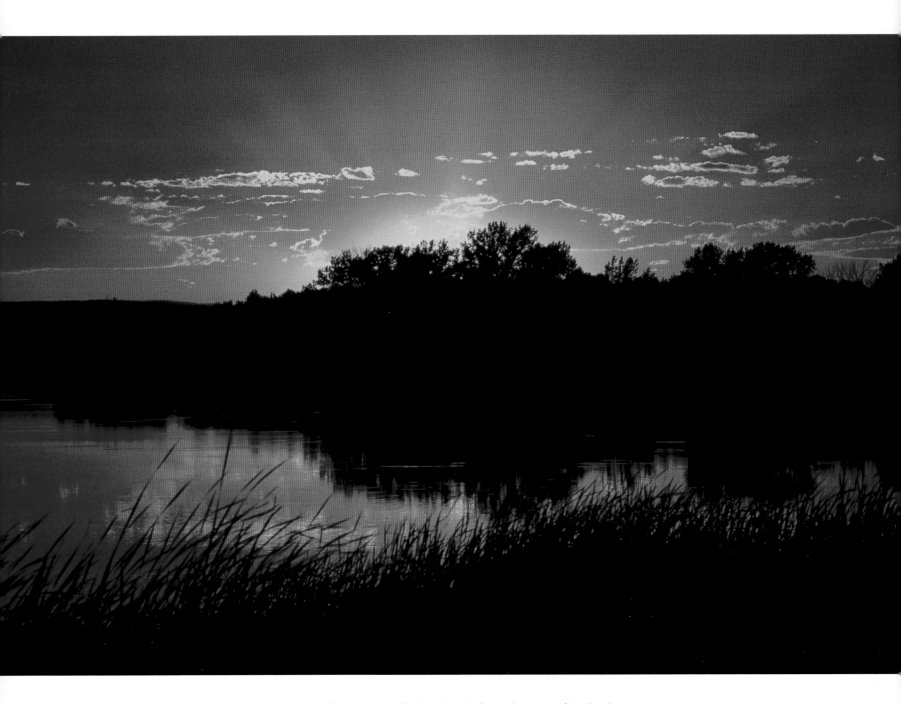

*(above) The sun takes a final peek at the day as the waters of Smith Lake
reflect the red sky above the Nebraska panhandle just south of Rushville.*

The night sky is a welcome
reminder that our daily
concerns pale against the
grand scale of nature.

July

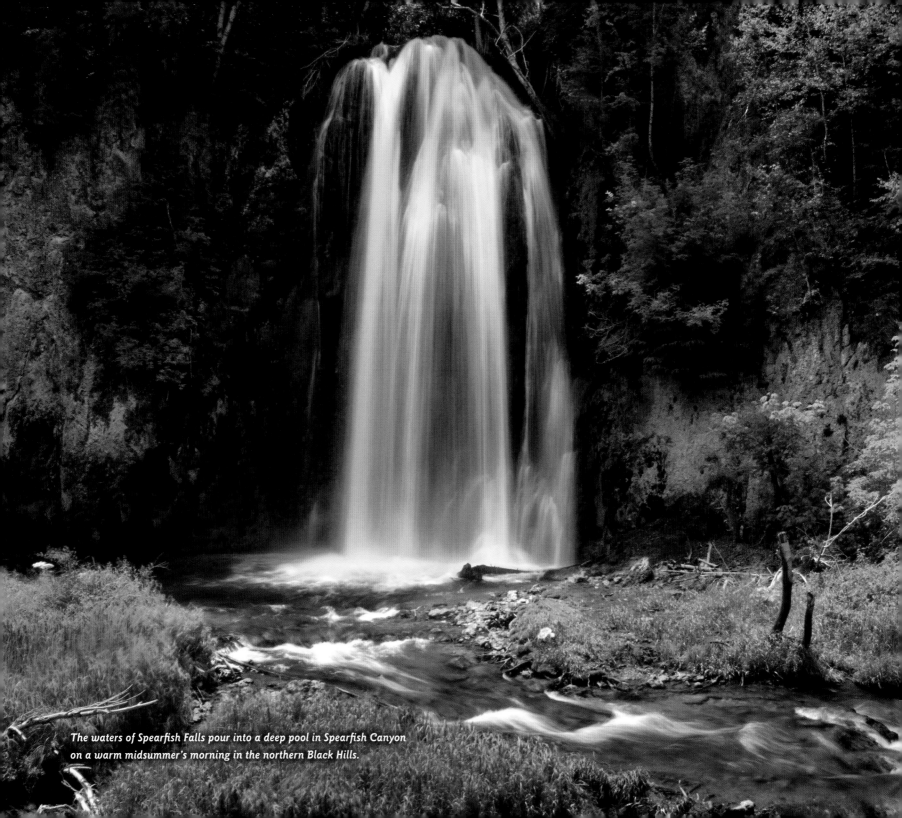

The waters of Spearfish Falls pour into a deep pool in Spearfish Canyon on a warm midsummer's morning in the northern Black Hills.

A MORNING WITH WORDSWORTH

The soothing sounds of tumbling water fill my senses as the growing sunlight made soft by a wispy, thin cloud cover stretches across the canyon bottom about an hour after dawn. This morning's light is made to order for the subject at hand, Spearfish Falls. Not harsh, but still bright so as to allow for small *f*-stops and slow shutter speeds that will accent the water's motion and yet preserve all of the surrounding details of the scene.

Though some consider it noisy, the waterfall's resonance is melodious to me and easy on my ears. There is noise and there is sound. It is for us to know the difference.

The water's subtle fragrance mixes with the wonderful scent of pine forests and meadows of wildflowers now in full bloom. Even though the day begins here with a damp chill caused by frequent sprays of mist from the cascading waters, a growing warmth will soon chase that nip as the morning progresses. Summer has come to the Black Hills high country.

Mornings like this one were not wasted on the sensibilities of the English poet William Wordsworth. Along with Samuel Taylor Coleridge, Wordsworth is generally credited with launching the Romantic Age of English literature. Originating in Europe toward the end

(above) The aptly named aromatic aster is found on sunny slopes throughout the northern Great Plains and in the Black Hills. Blossoms span up to one inch in diameter and may be pink or lavender-blue.

(right) Many Midwest and Black Hills high-country meadows go yellow by midsummer with the blossoms of this lovely wildflower called the black-eyed Susan. It is native to North America, growing in open areas with plenty of sunlight.

(facing page) Like many plants and animals on the North American continent, the oxeye daisy is an immigrant, being native to Eurasia. Spreading both by prolific seeds and underground by rhizome—an elongated, bulb-like root system—it is now found in all fifty states, classified as a noxious weed by some.

of the eighteenth century, this era was in part a reaction to the Industrial Revolution and also a revolt against certain aristocratic social and political norms of the time. It was most strongly manifested in the visual arts, music, and literature.

Reaching the shores of this country during the early 19th century, European Romanticism quickly became popular in American politics, philosophy, and art. We can see its earliest appearance in American literature through the works of Washington Irving and James Fenimore Cooper, and later having a strong influence on the Transcendentalist writers like Thoreau and Emerson.

Wordsworth believed that the source of poetic truth lay in the direct experience of the senses, "that poetry originated from emotion recollected in tranquility, that scenes and events of everyday life were the raw material of which poetry could and should be made." To Wordsworth, God was everywhere manifest in the harmony of nature. He felt deeply the kinship between nature and the soul of humankind.

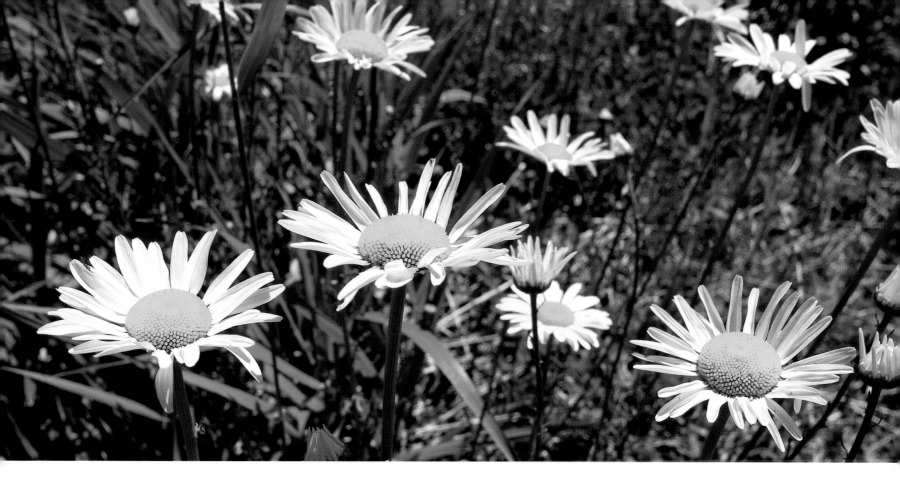

Today is July 4—Independence Day. I do celebrate this day, but not always in the traditional ways. Sure, the picnics, fireworks, and other festivities are fun and have their place. However, the thoughts and contemplations that come during a solo hike in places like Spearfish Canyon are, I believe, even more of what this day is truly about.

As we venture out on this Independence Day, we should also seek that kinship felt by Wordsworth rather than become completely absorbed by events and sales. For that is real independence.

Though Wordsworth never walked the forests and meadows of the Black Hills high country, he no doubt would have understood the melody of the waterfall.

I wandered lonely as a cloud
That floats on high o'er vales and hills,
When all at once I saw a crowd,
A host of golden daffodils;
Beside the lake, beneath the trees,
Fluttering and dancing in the breeze.

Continuous as the stars that shine
And twinkle on the milky way,
They stretched in never ending line
Along the margin of a bay:
Ten thousand saw I at a glance,
Tossing their heads in sprightly dance.

WILLIAM WORDSWORTH

(right) The translucent waters of Bridal Veil Falls in Spearfish Canyon cascade down a granite wall in the northern Black Hills.

(below) Stems of aquatic vegetation poke above the surface of Deerfield Lake in the Black Hills high country west of Hill City.

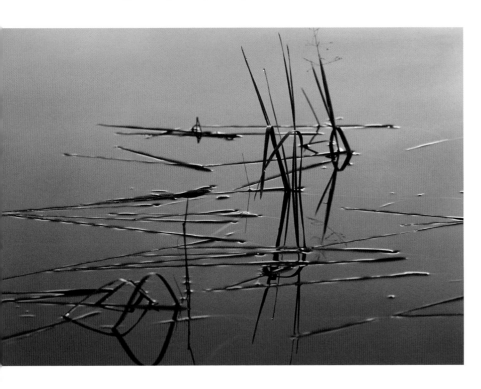

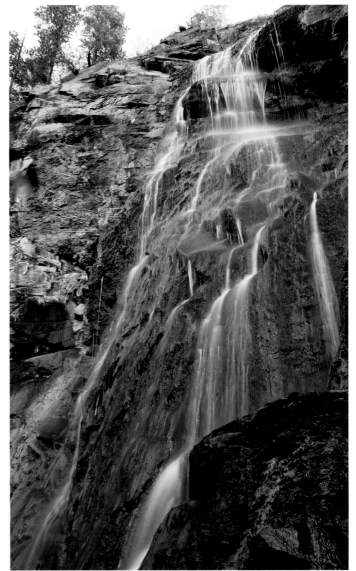

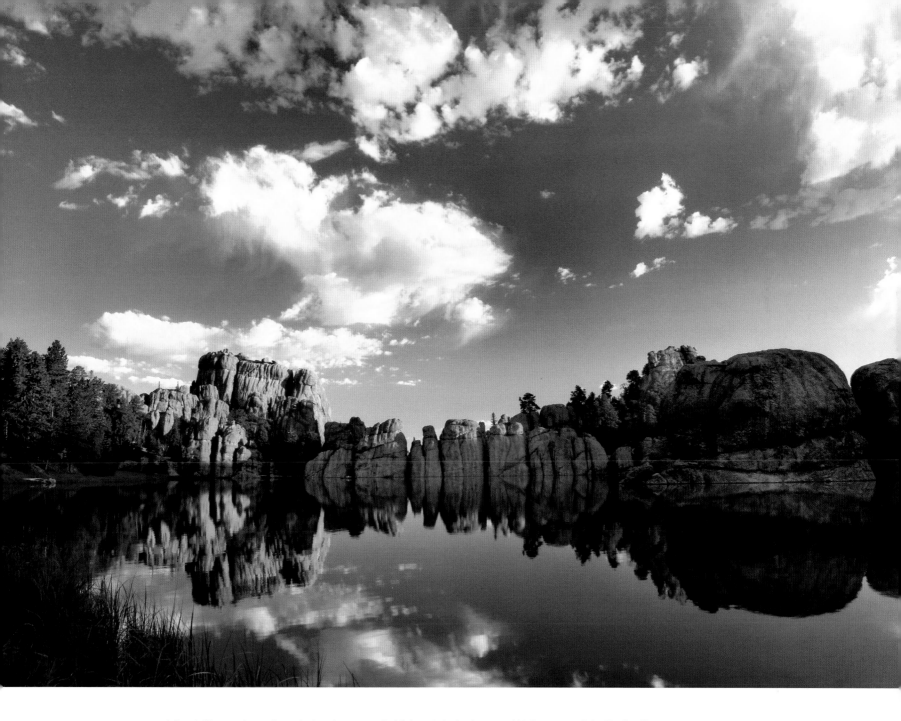

(above) The granite walls enclosing the west end of Sylvan Lake in the central high country of the Black Hills give it a look that is reminiscent of England's Stonehenge, making it one of the region's most unique landscapes. As always at this time of year, the first peek from the sun lights the main monolith on this Fourth of July morning.

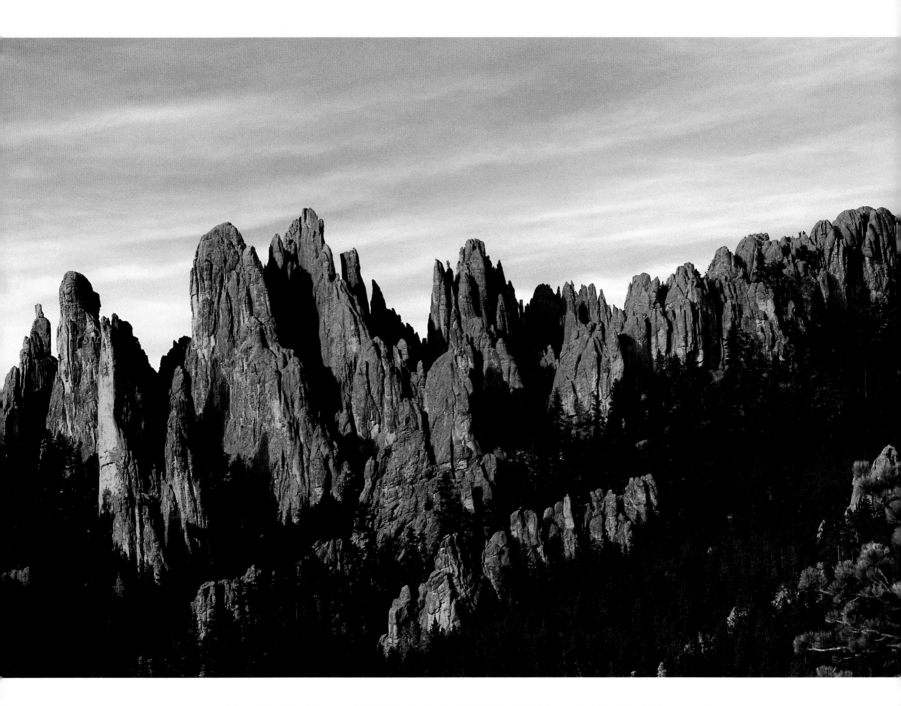

(above) Another striking and distinctive landmark of the Black Hills high country is Cathedral Spires, named for their obvious resemblance to church steeples. The geological events that formed the Black Hills began about 100 million years ago, making them about 25 million years older than the Rocky Mountains.

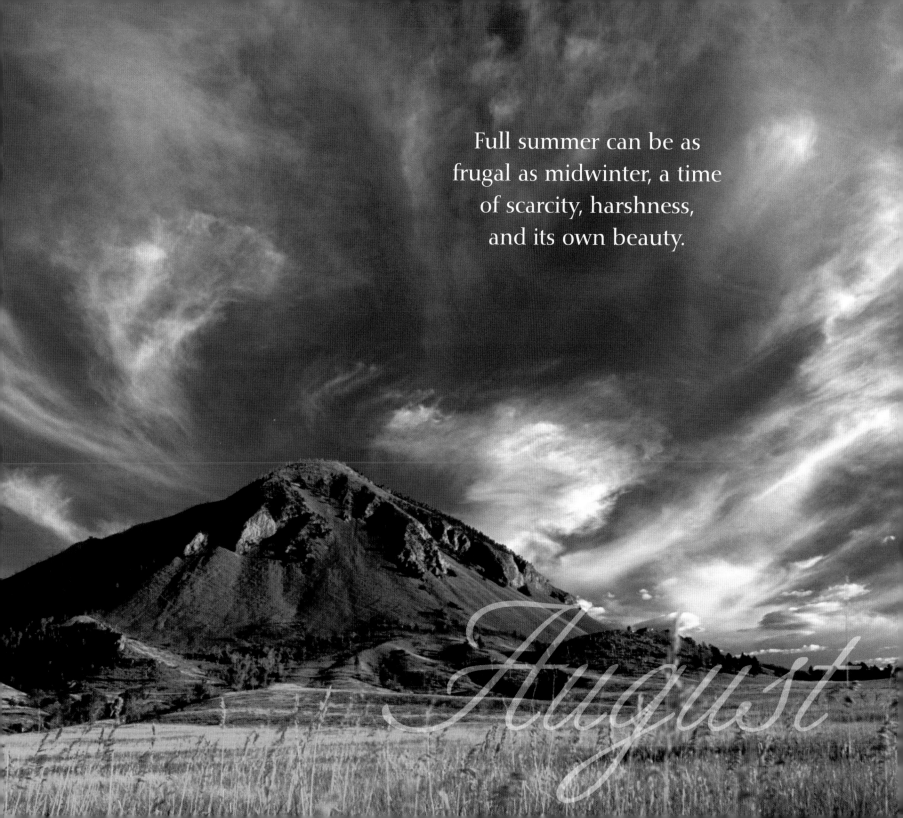

Full summer can be as
frugal as midwinter, a time
of scarcity, harshness,
and its own beauty.

August

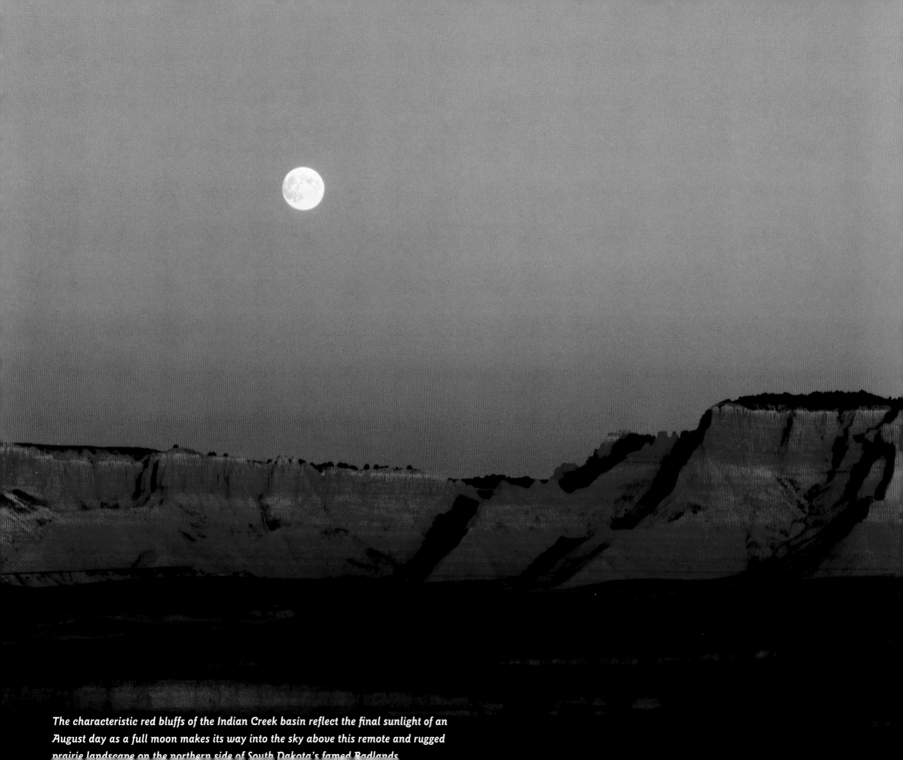

The characteristic red bluffs of the Indian Creek basin reflect the final sunlight of an August day as a full moon makes its way into the sky above this remote and rugged prairie landscape on the northern side of South Dakota's famed Badlands.

THE LANDSCAPE OF OUR MINDS

A rich, creamy full moon rises into the evening sky over sculpted red bluffs that project almost straight up from the roughly hewed and somewhat austere grasslands landscape. This August day, which has been warm but not baking hot, has turned into a cool, still, and cloudless evening. Atop a western ridge sits the sun, taking a final peek as it casts a soft, gorgeous light across the bluffs. The two orbs create a splendid and rare lighting combination, occurring no more than once every twelve to fifteen months.

This place is the Indian Creek basin, part of a nearly 40,000-acre tract locally known as the Indian Creek wilderness and administered by the U.S. Bureau of Land Management. Lying against the north boundary of the Stronghold Unit of Badlands National Park, the two together make up the largest block of prairie wilderness left in North America.

Isak Dinesen described Africa's Ngong Hills as "a landscape with no fat on it and no luxuriance anywhere." Such could be said of this land as well. For me, the harsh, rugged beauty of Indian Creek gives rise to the thought that this land could have been a testing ground for life forms. Whatever survives here will flourish most anywhere else.

The trees across this land are few—mostly gnarled, twisted cottonwoods that have lived through years of

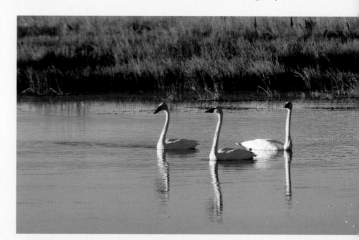

(above) Trumpeter swans like these three having a morning swim are frequent residents during summers at Indian Creek.

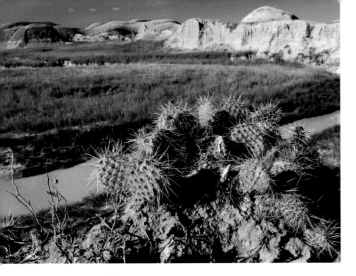

(above) Pricklypear cactus are one of many succulents that thrive in this rugged, dry land.

(right) A yucca plant grows horizontally out of a vertical bank along Indian Creek with its flowering stalk headed skyward, another statement of resiliency in this landscape.

(facing page) Wide pools in the creek and lush green tell the tale of a rare wet summer in the Indian Creek wilderness.

never-ceasing winds and long periods of drought. Yuccas rooted in the vertical walls rising above the creek send their flowering stalks out and upwards. Similarly, the gumbo lily, with its large, white blossoms, thrives in the dry, hard clay that is much of the soil here.

Indian Creek personifies many of the qualities of the high plains that have made them so much a part of our cultural heritage. The vigor and austerity found in lands like this one have long shaped our consciousness and given fruit to our imaginations.

This shaping is part of the phenomenon that author Barry Lopez calls "the landscape of our minds." Having spent much of the last three decades writing about the

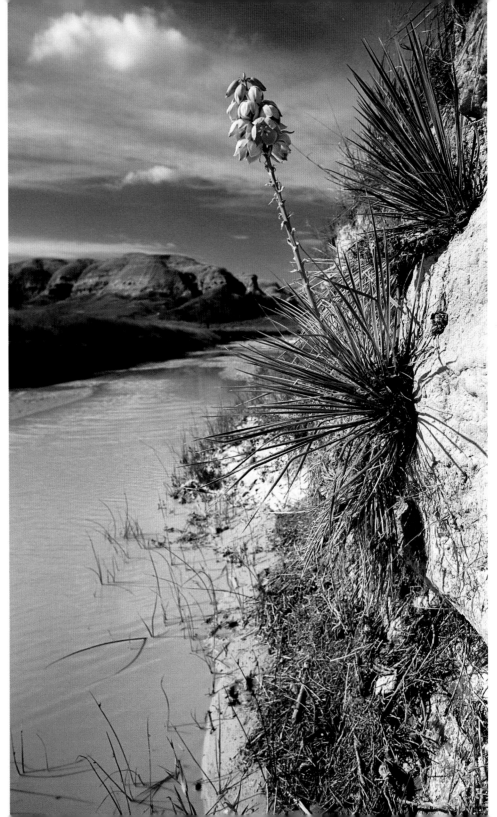

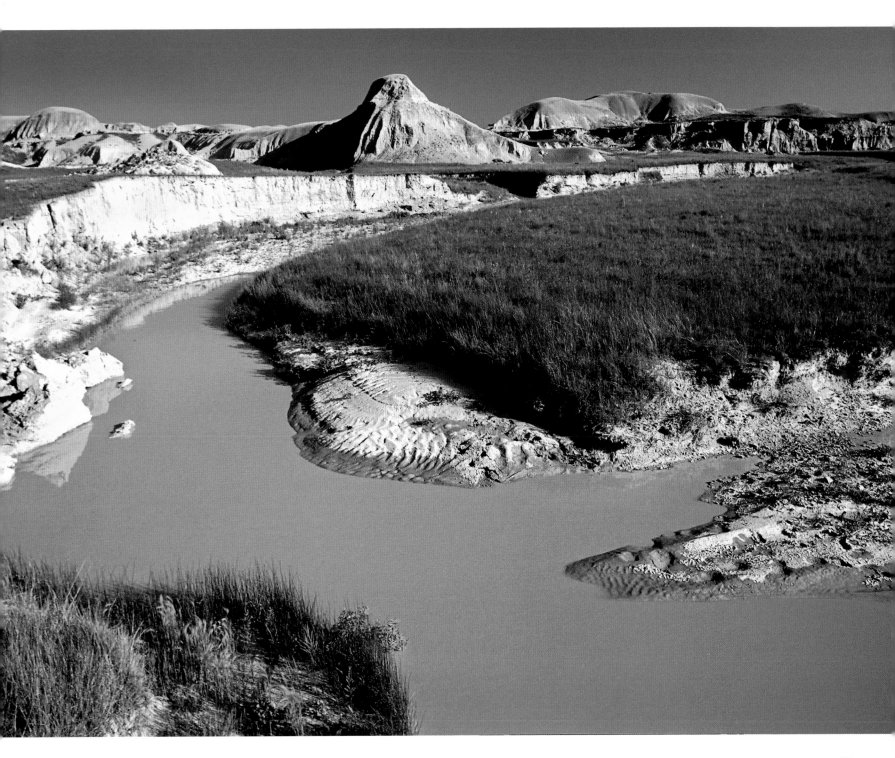

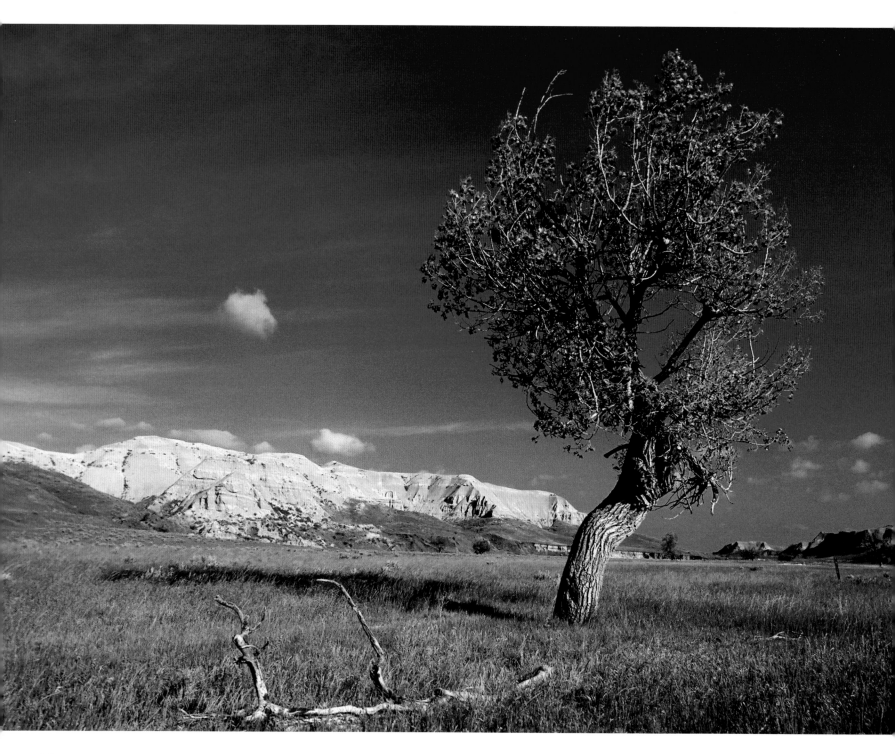

relationship between landscape and human cultures, Lopez is popularly known as a nature writer, though he prefers to call his particular craft "a literature of place." While many assume that this is a comparatively new type of work, he believes that the "impact which nature and place have on culture is one of the oldest—and perhaps most singular—threads in American writing."

Lopez thinks of two landscapes: "one outside the self, the other within. The external landscape is the one we see—not only the line and color of the land and its shading at different times of the day, but also its plants and animals in season, its weather, its geology, the record of its climate and evolution. . . . The second is an interior one, a kind of projection within a person of a part of the exterior that is more rooted to relationships that are uncodified or ineffable, such as winter light falling on a particular kind of granite, or the effect of humidity on the frequency of a blackpoll warbler's burst of song. The shape and character of these relationships in a person's thinking are deeply influenced by where on this Earth one goes, what one touches, the patterns one observes in nature—the intricate history of one's life in the land, even a life in the city, where wind, the chirp of birds, the line of a falling leaf, are known."

Lopez wishes to contribute to a legacy of hopefulness. "Optimism and hopeful are two different things," he says.

(facing page) Fallen branches around this gnarled but not old cottonwood tree speak of of Indian Creek's long, harsh winters and hot, dry summers.

(right) A pronghorn buck stops at a pond for an early evening drink. His species is one of Indian Creek's most successful mammals.

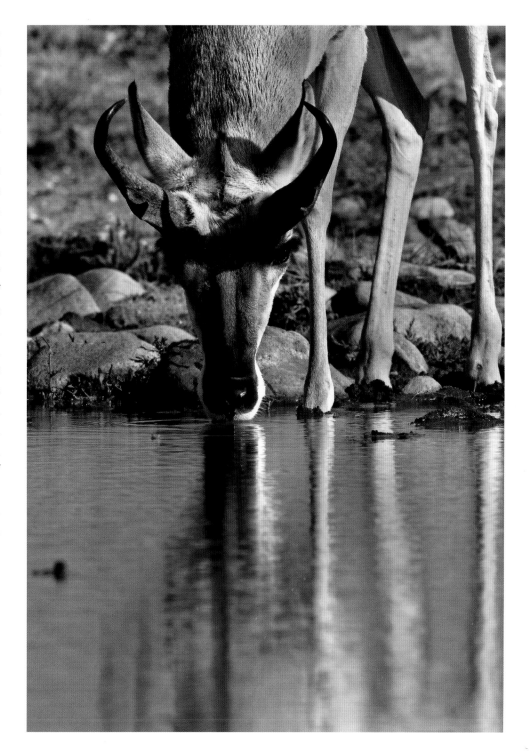

"Optimism is based on the logical, the analytical, whereas hopeful comes from elsewhere—having to do with our imaginations, reconnecting with our possibilities and our dreams. In individual dreams is the hope that one's own life will not have been lived for nothing."

The wild and remote lands of the high Arctic and American West are frequently the settings for Lopez's works, and he sees Indian Creek as having the same qualities he finds in an Arctic landscape. "This place has that same big, open stillness that makes the Arctic an easy place in which to think, a place where I can recover my own sense of possibility."

Close by from where I sit this evening is a small watering hole. A pronghorn buck and two does are taking a long drink while a small group of mule deer stand in the near distance, grazing as they wait for their turn. I imagine myself waiting the same way on an African savanna millions of years ago—not quite a modern man yet, but no longer just an ape either. Already, I am probably making regular use of a couple of crude and rudimentary tools. But as I await my turn at the watering hole, I am still just another animal immersed in the unforgiving business of survival, a process that involves cooperation at least as much as struggle, maybe more.

A sunset at Indian Creek does inspire some interesting thoughts and should be experienced for many reasons, not the least of which is watching life celebrate itself.

(right) The tufted evening primrose, or gumbo lily, grows well on the area's dry buttes and clay banks.

(facing page) Clouds gather over these sculpted buttes in the evening light as another day gets set to close on Indian Creek. Ceaseless winds carve these spectacular formations.

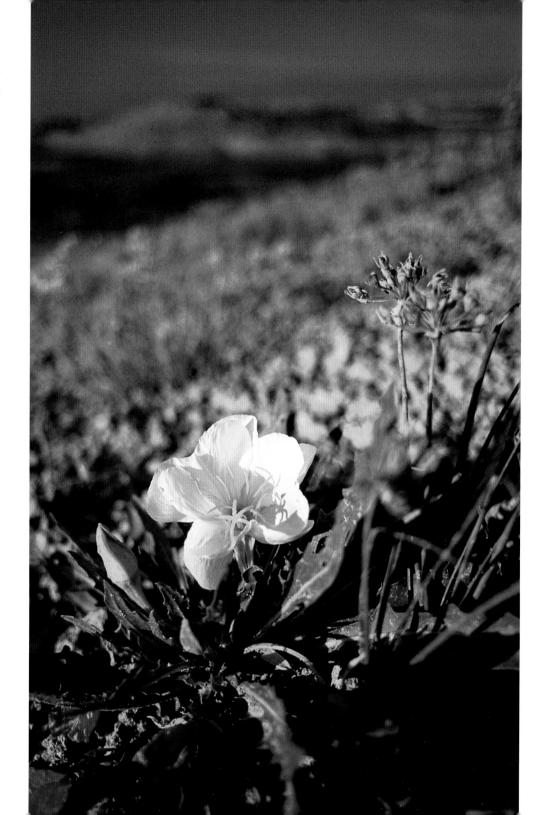

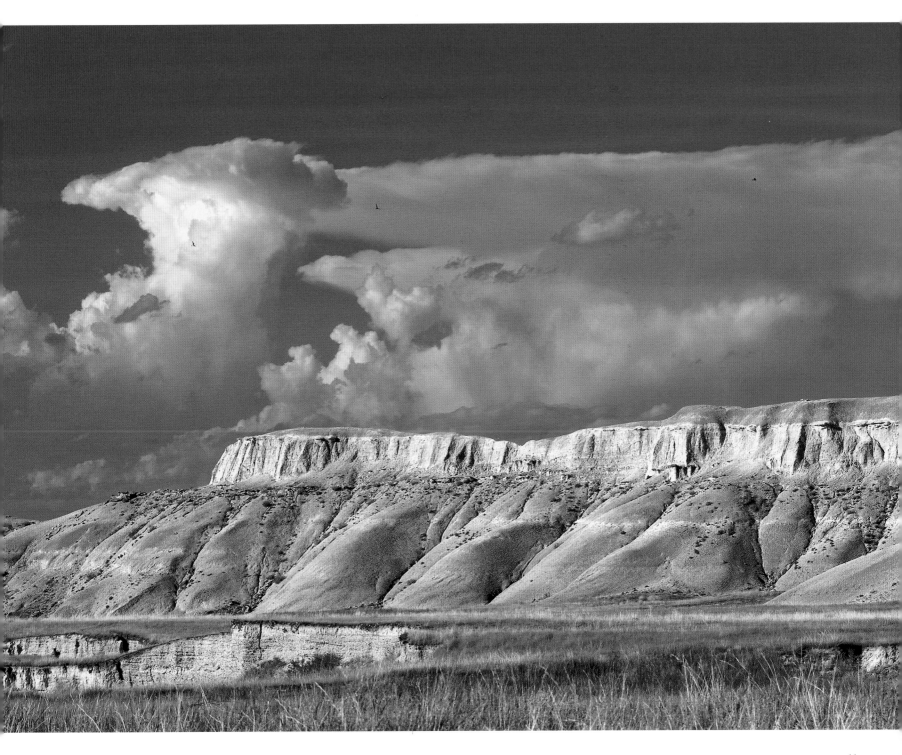

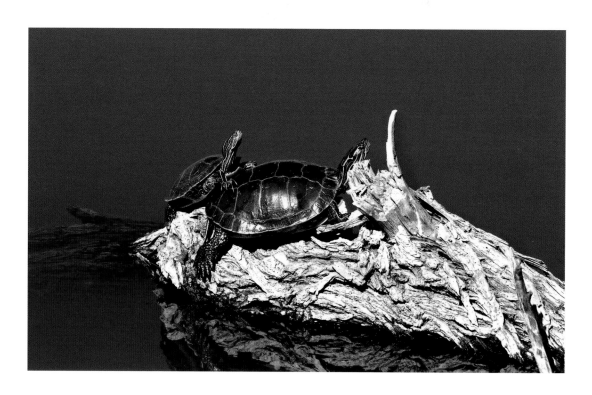

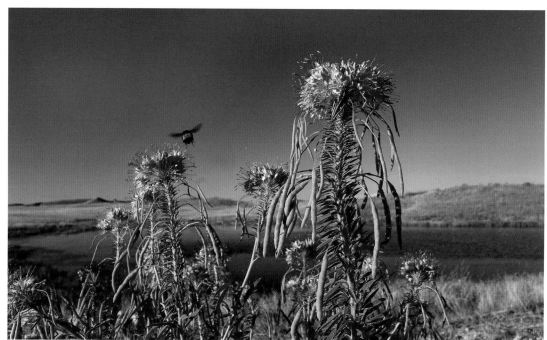

(above) Red-eared slider turtles lounge on this old tree trunk that has fallen into a prairie pond.

(right) The Rocky Mountain bee plant is common here and attracts many insects, including bees.

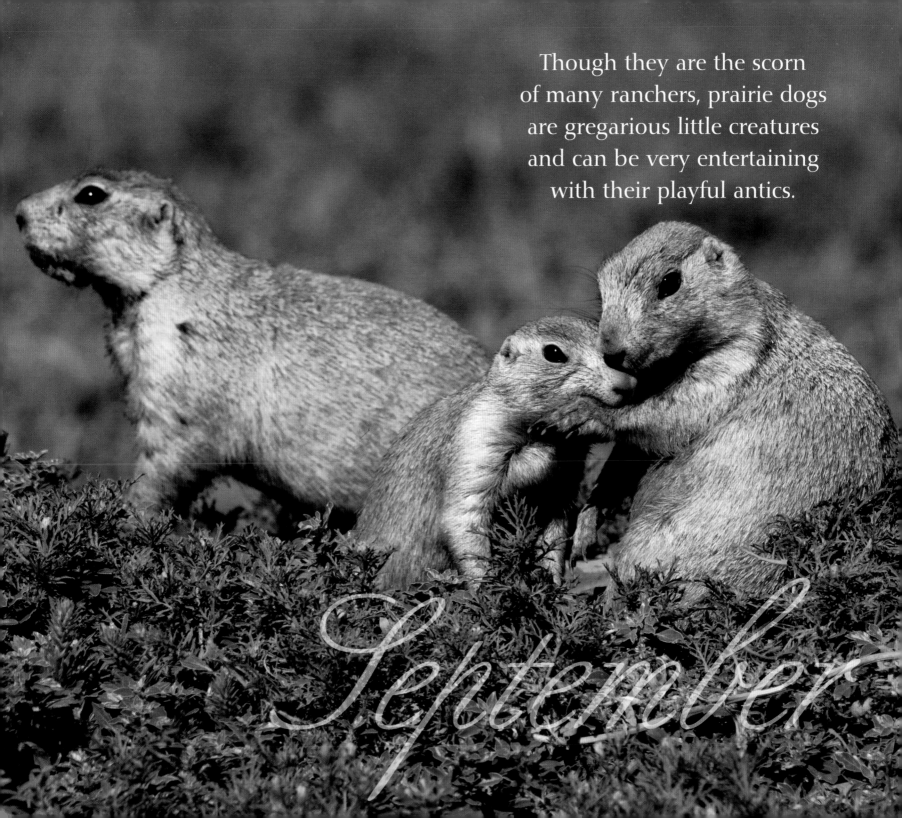

Though they are the scorn of many ranchers, prairie dogs are gregarious little creatures and can be very entertaining with their playful antics.

September

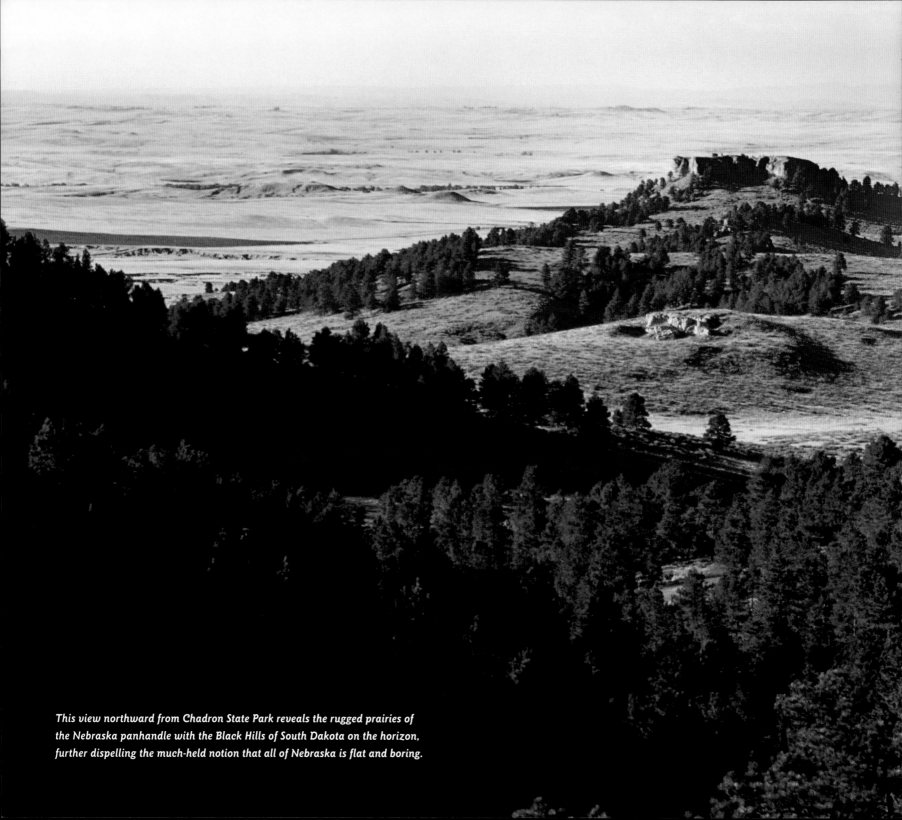

This view northward from Chadron State Park reveals the rugged prairies of the Nebraska panhandle with the Black Hills of South Dakota on the horizon, further dispelling the much-held notion that all of Nebraska is flat and boring.

A SORT OF HOMECOMING

The lad strained to see as far as he could through the cramped window of the DC-3 airliner, trying to take in the vastness of the prairies below. Part of what used to be known as a treetop airline, the aircraft set down in another town about every forty-five minutes, never getting high enough to diffuse its own shadow. The lad was amused as he watched that shadow float across the terrain.

Opening before him was the Nebraska panhandle, its panoramic landscape one of a fresh and vigorous beauty, seemingly endless. Looking to the horizon, the lad marveled at how the land changed from river valleys to rolling prairies to mesas and high plateaus. Occasionally, there was a small town or the checkerboard patterns of a farm's cultivated fields, but nothing man-made ever dominated this wondrous vista. It dazzled his eyes.

Ahead, nestled in the rugged butte and pine ridge country of Nebraska's northwest corner, was the town of Chadron. And Chadron State College. Settling back into his seat, the lad pondered the events of the last two days. The previous morning he had walked down the loading ramp to a huge jetliner at Rhein-Main Airport in Frankfurt, Germany, eagerly anticipating all that lay ahead. Recalling his mother's tearful face as she watched her firstborn leave home, he felt a tinge of guilt for all his enthusiasm.

It was a time of momentous change—though change was nothing new to this lad's young life. Before he was ten years old, he had already lived on three continents,

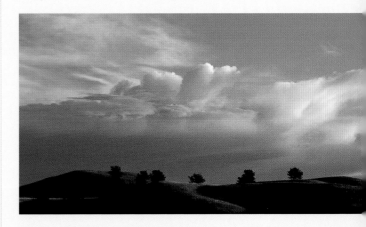

(above) Autumn color and light abound across the gathering clouds of sunset over a prairie ridge.

65

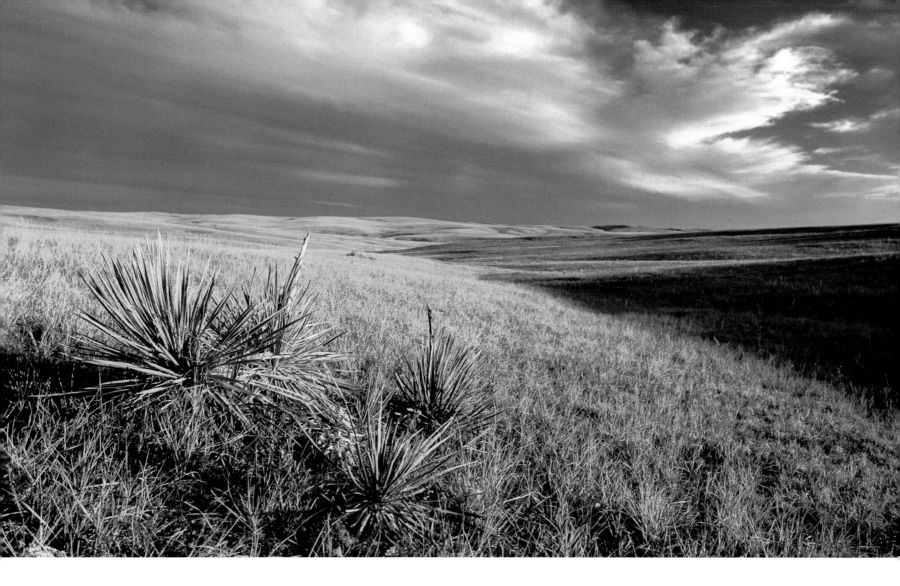

owing this to his father's work with the U.S. government. Diverse places such as Munich, Tokyo, London, the Philippines, Washington, D.C., and many more had been familiar ground.

This change was different. Being the first the lad had selected by himself and for himself, it marked the beginning of that transition from youth to adulthood—a time when one gradually ceases to be his parents' person and becomes his own.

The lad wondered about basing one's first adult decision on a childhood dream, for that was in fact what he had done. By age ten, he had set his sights westward—the American West. Even before he had seen any portion of it, he had become engrossed in the idea of spacious prairies, vibrant deserts, jagged mountain peaks, and especially the wildlife of this unmatched land. He was sure it was the place for him. Well, maybe not completely sure at the moment. Culture shock was nothing new to

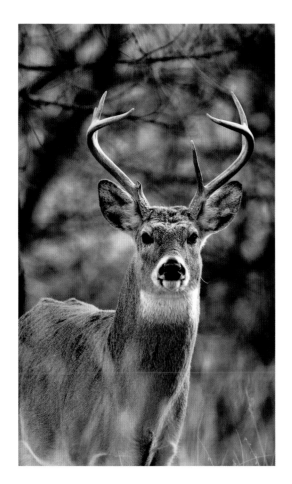 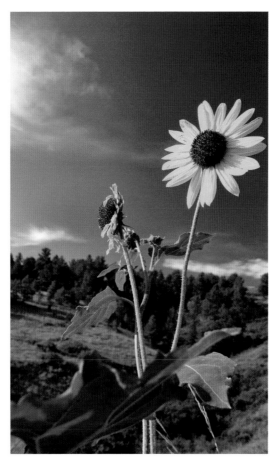 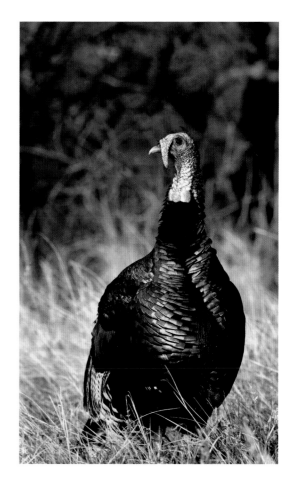

*(this page) So much of Nebraska's dynamic beauty imprinted in the lad's mind with sights like
this white-tailed buck, this sunflower along the Pine Ridge, and a wild turkey near Rushville.*

*(facing page) Like a theater's curtain, the shadows of dusk slide across Nebraska's
Oglala National Grassland as the day takes a final bow.*

the lad either, but it always leaves one feeling alone and a bit self-conscious.

Glancing about the airliner's small cabin, the lad's focus shifted to the other three young men who had boarded with him in Omaha—all bound for the same place, all freshmen. There was Jack Murphy, an Irish kid from Boston; Louie Santoro, an Italian kid from New York City; and Neal Rabinowitz, a Jewish kid from Atlantic City. With no obvious, strong ethnic background like the others, the lad felt as though he lacked identity, was personally somewhat generic.

And where should he say he's from? Germany? That would be misleading. He'd lived there longer than he had in any other place, but he wasn't German. Maybe Washington, D.C. Well, it was more familiar to him than any other part of the USA.

The lad's attention soon drifted back into conversation with his new acquaintances. Their discourse was typical for men of their age and day: girls, music, sports, girls, the war in Vietnam, the draft, girls, college majors, girls, etc. Music conversation centered around the Beach Boys and the Beatles. Sports talk was mostly about a brash young NFL quarterback named Joe Namath; they all thought he was "very cool." Santoro, the New York kid, kept wondering about the boy-girl ratio at the college. Priorities.

Their conversation was interrupted by the voice of the pilot over the cabin intercom, announcing yet another

(facing page) A prairie pond reflects the color of the sky as geese fly overhead at sunset in the Oglala National Grassland north of Crawford, Nebraska.

(right) A September moonrise lights the sky above the Pine Ridge of the Nebraska panhandle.

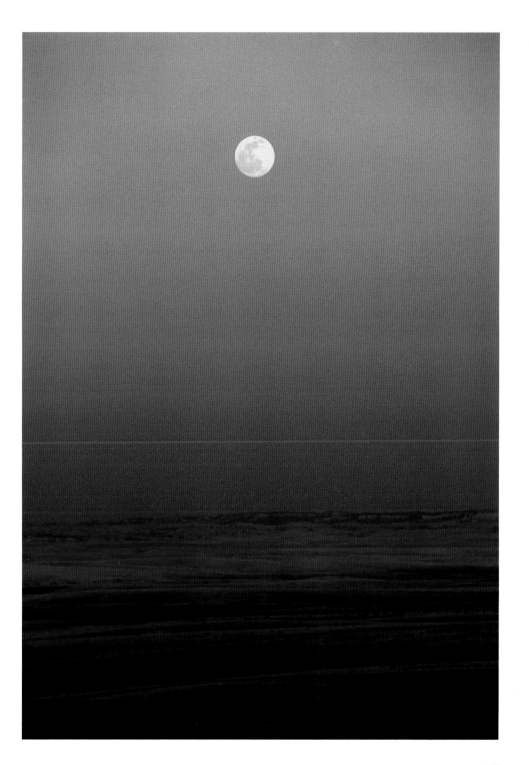

landing, the sixth since leaving Omaha. This time it was Chadron.

In a short time, four very bewildered young men stood on the tarmac of the Chadron airport, such as it was, watching the DC-3 taxi down the single runway. There were two buildings: an aging white hangar that looked like something out of the old barnstorming days, and a small hut about the size of a one-car garage, the terminal. One man ran the entire operation, from baggage to tickets to air-traffic control. In every direction was wide-open space and not the slightest sign of any kind of town, much less a college. The lad began to wonder what he had done as the four looked at each other and their surroundings again.

"You think we got off at the wrong place?" asked Murphy. "Nah, how the hell many places could there be in this place?" shrugged Santoro.

"Maybe we should talk to that guy," suggested Rabinowitz, gesturing to the airport manager who was scurrying about with his duties. "Does anybody speak the language?" At once, the others all looked at the generic lad. He knew he was elected, probably because he had lived in foreign countries.

Once again feeling a bit self-conscious and out of place, the lad approached the manager as he was headed back into the terminal. "What can I do for you?" the man asked cheerfully. "Well, uhh . . ." began the lad. "We're looking for Chadron State College," he said finally. "Oh sure, it's in

(right) *Autumn leaves gather along the banks and in the waters of Soldier Creek.*

(facing page) *Late afternoon light washes across the grasslands and rocks of the butte country in the Soldier Creek Wilderness of Nebraska's northwest corner.*

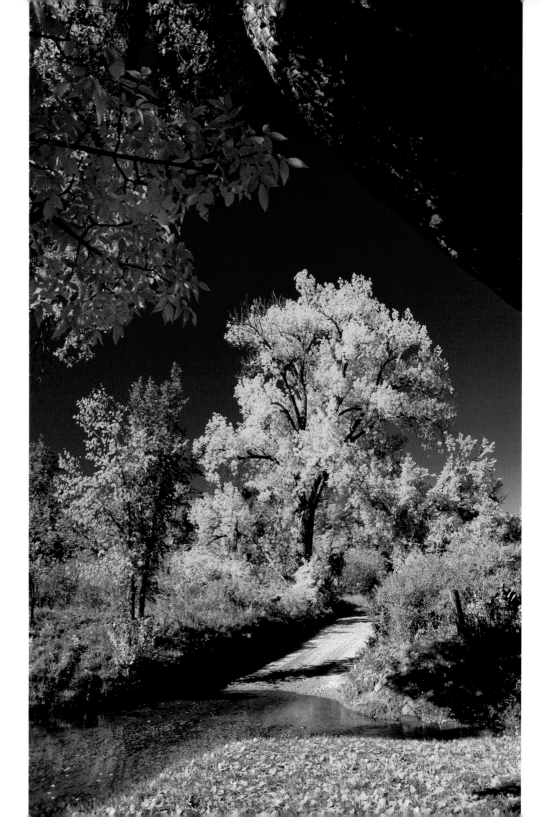

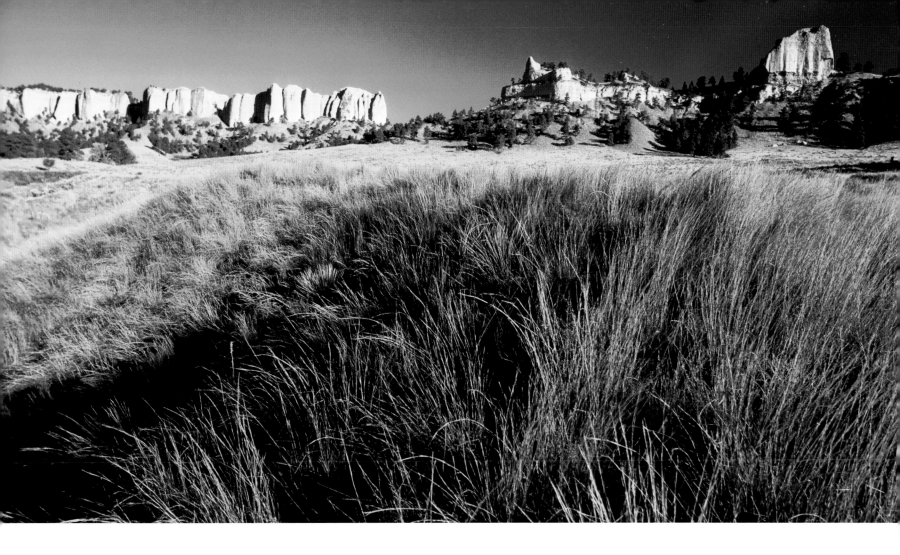

town," the man chuckled as he pointed eastward to open prairie. "About five miles that way."

The lad looked hard in that direction, thinking maybe he'd missed something. "Uhh . . . how do we get there?" he stammered. "Just give me a couple of minutes and then I'll call the cab," came the reply.

THE cab? Those words went through the lad like a sharp knife. As he shuffled back over to the others, he actually found himself trying to catch his breath. He also remembered that he had been accepted to the University of Maryland as well, and suddenly it was looking pretty good.

In about thirty minutes THE cab arrived. It was a 1955 Nash Rambler, the type that looked like a speedboat with wheels. The driver was a small and very elderly man without any teeth. His lips quivered as he gummed words to his dumbfounded audience. "You boys want to go to town?" Rabinowitz leaned over to the lad's ear and said quietly, "This guy better not be the dean too or they're gonna have to get that goddamn plane back here!"

Glancing over his shoulder, the lad caught sight of the airliner, now only a speck in the distant sky. Maybe he could transfer after the first semester.

Well, the old cabby wasn't the dean, and the lad never gave any real thought to transferring after that day, although there were some new experiences in culture shock during the next couple of weeks. Funny how, even though we seek change, we rarely know what we're really in for until it happens.

Certainly the start of college is a pivotal experience in anyone's life, but the lad had come in pursuit of more than just college—and he found it in the West. Not the wild and woolly myths of John Wayne movies or Zane Grey literature, but coherence with the land and an unquenchable curiosity for how life works within it—a foundation for his own sense of landscape and imagination. From the rugged prairies of western Nebraska to the Black Hills, the Rocky Mountains, and far beyond, the natural world opened up to him, exciting him in just the way he had anticipated.

And there was also a serendipitous discovery, a connection that we all need in one form or another: roots. Chadron, that little village on the prairie, became the hometown the lad never had, a place where he would always feel that he belonged, a place that would always reflect the sights, sounds, and experiences of that first autumn in Nebraska now so long ago.

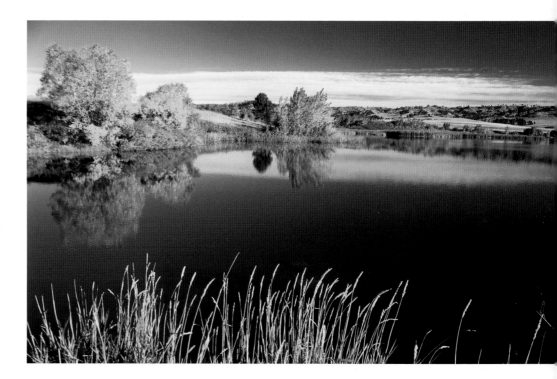

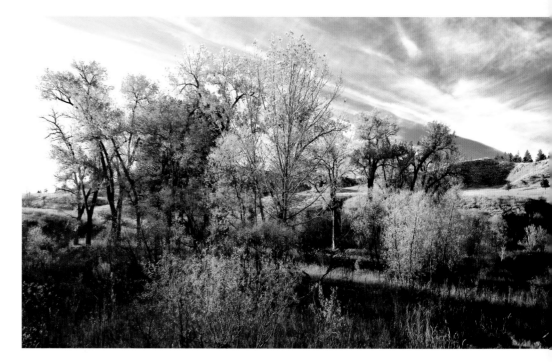

(above) Autumn color and light abound at Johnson Pond in the vicinity of Fort Robinson, Nebraska.

(right) Streaks of clouds foretell a change in the weather.

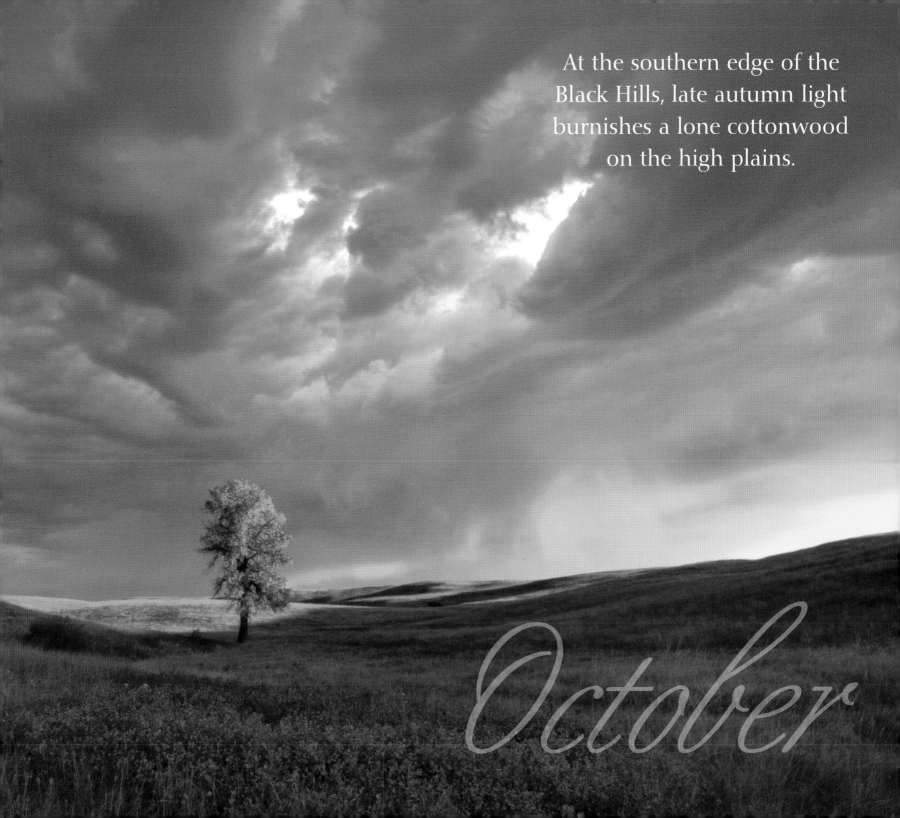

At the southern edge of the
Black Hills, late autumn light
burnishes a lone cottonwood
on the high plains.

October

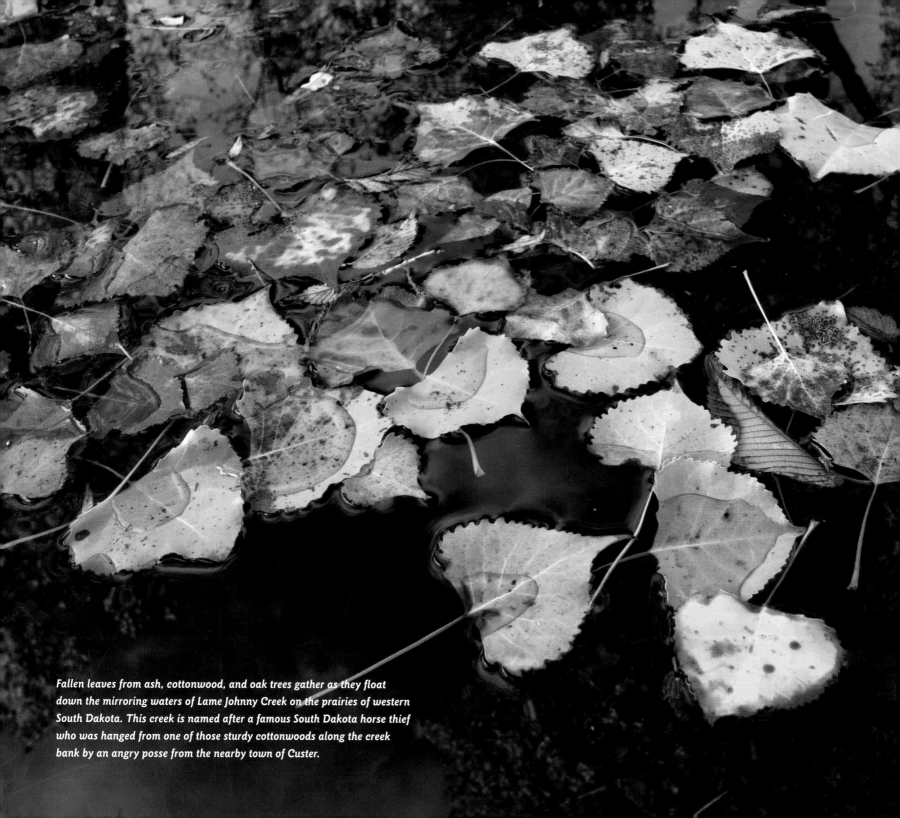

Fallen leaves from ash, cottonwood, and oak trees gather as they float
down the mirroring waters of Lame Johnny Creek on the prairies of western
South Dakota. This creek is named after a famous South Dakota horse thief
who was hanged from one of those sturdy cottonwoods along the creek
bank by an angry posse from the nearby town of Custer.

WALKING IN
THE HONEY WIND

Inspired by the wind, the golden leaves of autumn dance in whirlwind patterns through the azure blue above. While the fallen leaves crunch beneath my feet, others still in the encircling treetops sound out a rhythm as though playing their swan song to this huge aspen grove before the inevitable takes its course.

The drawing of a deep breath brings the final evidence. There it is—a divine nip in the air that fills me with a spiritual vigor and almost escapes description. The honey wind.

I first heard of the honey wind back in my college days, in a song crooned by Glenn Yarbrough. The melody is still clear, and on days like this one I'll catch myself whistling it, even singing some of the words as long as I'm sure no one can hear.

The wistful lyrics remark on the change of seasons, the passing of years, and love lost. But they also hint at acceptance, even a savoring—in the form of the honey wind—of the natural cycles as our world makes its yearly lap around the sun.

Funny how certain idioms simply become forgotten, ceasing to suggest any picture to most. The honey wind. Oh, I have no trouble recognizing its natural sensations. They are easily grasped by the physical senses while standing in the middle of an old aspen grove on a crisp

(above) *The leaves of a small sycamore tree decorate a hiking trail in the northern Black Hills.*

75

(above) Decorated with droplets of morning dew, these aspen leaves adorn the top of an old, moss-encrusted stump.

(right) The wind sweeps golden aspen leaves back into the canopy of this large grove in the high country of the central Black Hills just south of Deerfield Lake.

(facing page) Cottonwood trees are known for large, horizontally growing branches like this one at the southern edge of the Black Hills.

and breezy autumn morning. But there is something more in the honey wind—a message that I think goes much deeper and yet is often missed by many of us.

It has always been a puzzle and rather sad to me when I think of the number of people I meet at this time of year who have such a dread for the coming changes. So much of their energy seems spent fighting off depression, while seeing autumn and the coming of winter as merely the death of summer.

We see in spring a time of renewal and reinvigoration, but forsake the same in autumn when it is probably an even more important time for the continuation of life. We ignore nature's lessons that are so often right under our noses.

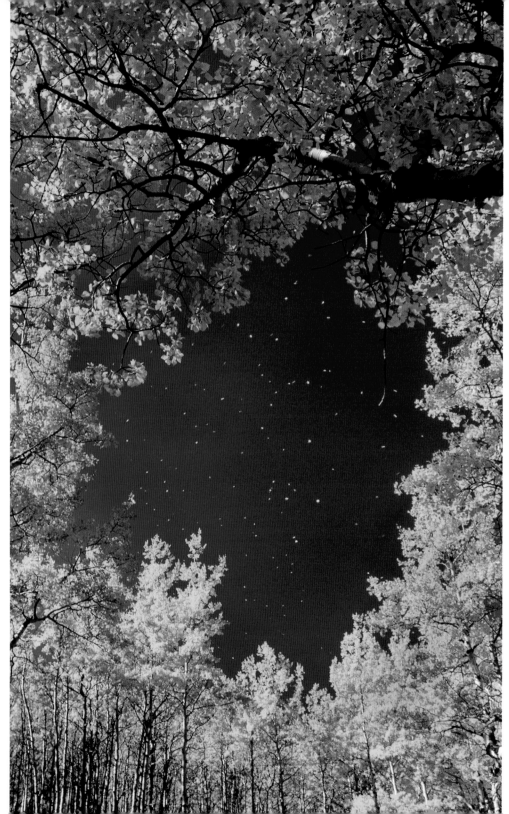

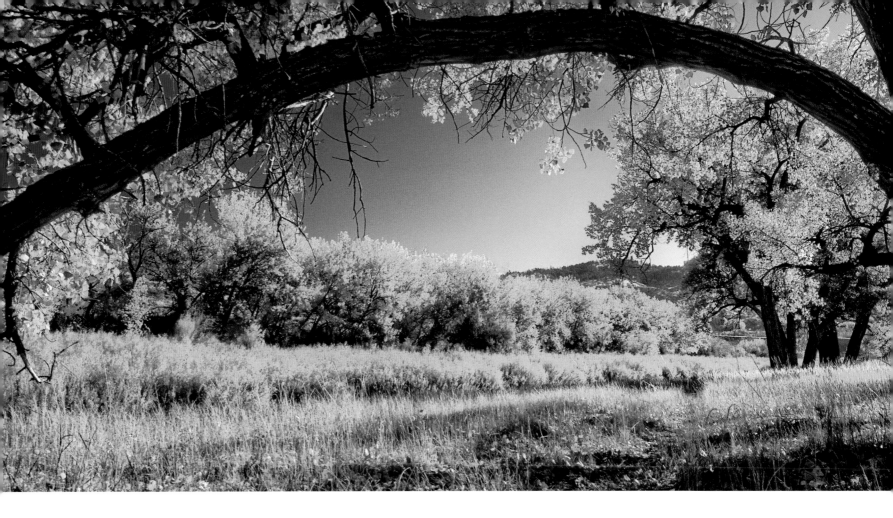

The first and foremost rule of nature is change. Nothing is forever.

Autumn is change, and change can only be viewed as opportunity. The pronghorn buck and elk bull see the possibilities as this is the time of the year in which they sow their own seeds for the future. Observe the oak dropping its acorns or the ponderosa pine shedding its cones to ensure future generations. They all do this even before providing for their own survival through winter.

We are the products of a planet that works in cycles. And working successfully within a cycle does not mean to lamenting the time or season of the year, but seeing how it fits within the scheme of things and making the most of it.

The cycle of the leaves is nearly complete. The boughs of aspen stands and cottonwood groves now hang almost bare, shorn of that harvest of gold that was ubiquitous only a couple of weeks ago. Now, November approaches—depressing to some, but to others a brief interlude between autumn and winter.

The leaves, the leaves—everywhere they lie, in a bounteous array, and yet I am lost to keep my hands from them. Along the dark and moody banks of a thousand woodland streams and prairie ponds, their myriad colors embellish and warm—a perfect companion to the stark

and lonely blue of waters visited only by a midday sun. Decaying, moss-enshrouded tree stumps now wear them as crowns, as though reminiscent of their time as monarchs of the forest. I think they often represent more than we know.

I remember, as a boy, family visits to my grandmother's home in Iowa at this time of year. Her huge yard was strewn with fallen leaves and I gleefully spent countless hours raking them. Needless to say, nobody tried to discourage me as I filled the wheelbarrow time and again.

The leaves were fascinating to me. I examined them, contemplated them, and even counted them as though I was a farmer summing up his harvest. How was a city kid like me to know?

I still stop on my excursions everywhere to examine the leaves, to note the differences, the colors, and the shapes. To me, it is still a harvest—a season's worth of nature's finest artwork. I think it's not surprising that so much poetry and prose has been written about this time, from Keats to Frost. They knew this period was one of reflection and reinvigoration.

Glorious October. A time to contemplate the leaves—not just of the fields, but the leaves of our lives. The time of the honey wind.

(right) Full autumn color is reflected in the lazy waters of the Cheyenne River as it flows through Hell Canyon at the southern edge of the Black Hills.

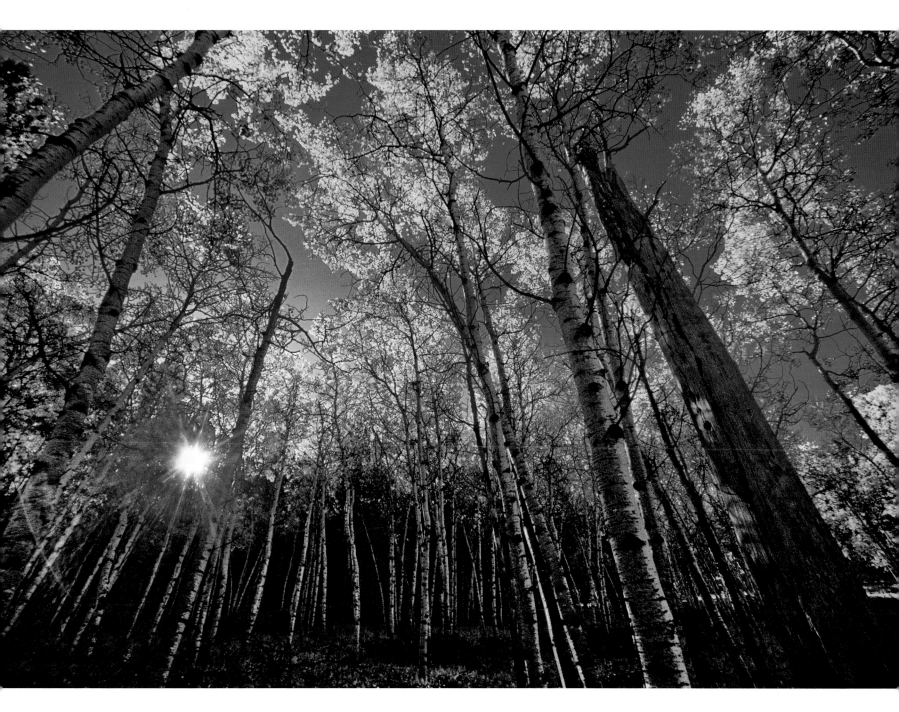

(above) A dawning October sun lights this grove of aspen high in the central Black Hills near Rochford. These trees will be bare and fully dormant in another week or so.

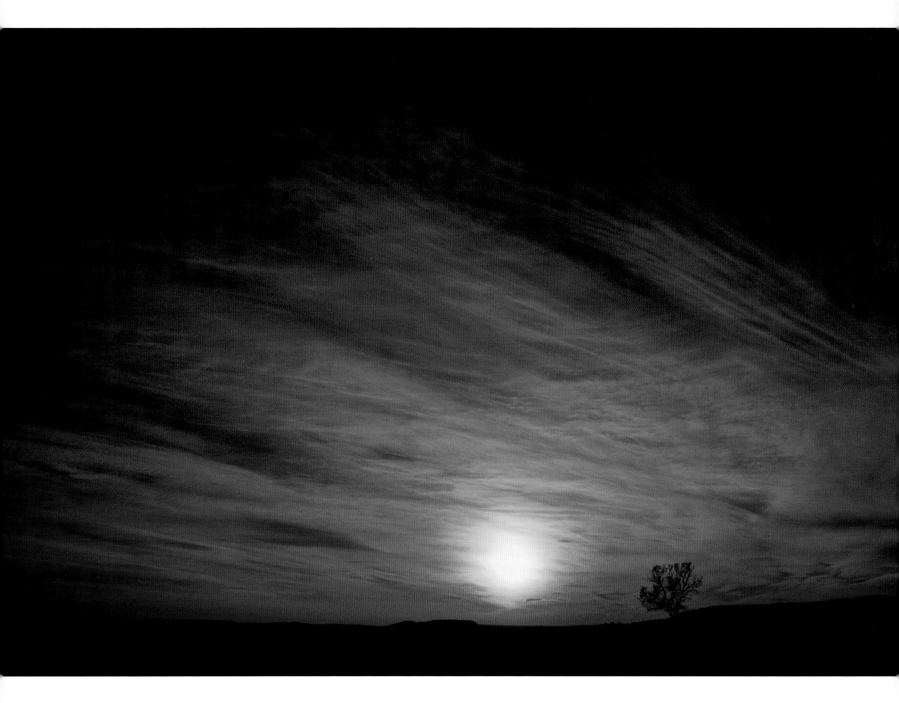

(above) With branches recently gone bare in the chill winds sweeping across the prairie, this cottonwood tree takes a final bow for autumn as the sun sets on Red Shirt Table near the Cheyenne River.

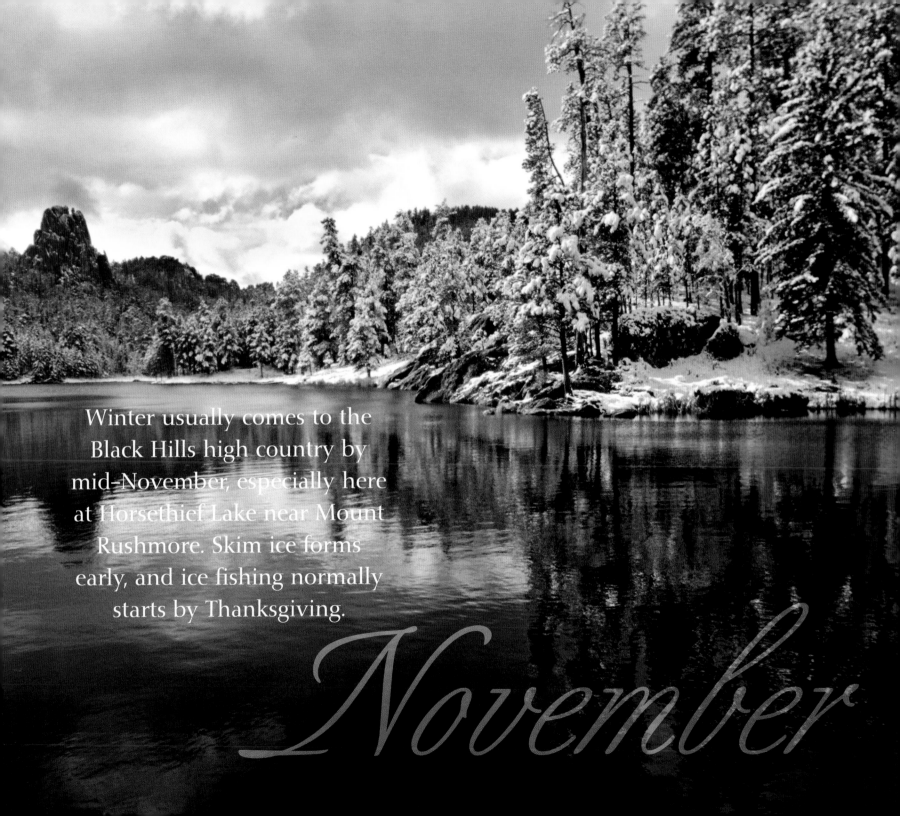

Winter usually comes to the Black Hills high country by mid-November, especially here at Horsethief Lake near Mount Rushmore. Skim ice forms early, and ice fishing normally starts by Thanksgiving.

November

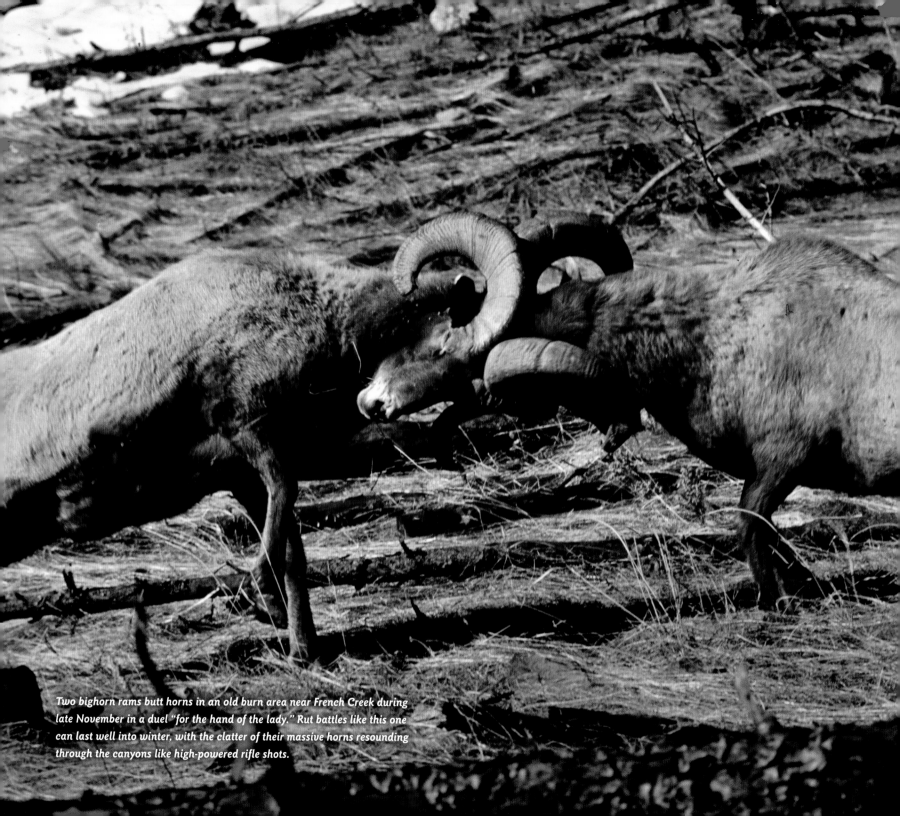

Two bighorn rams butt horns in an old burn area near French Creek during late November in a duel "for the hand of the lady." Rut battles like this one can last well into winter, with the clatter of their massive horns resounding through the canyons like high-powered rifle shots.

A CLASH OF CENTURIONS

The two great creatures cast hard and intense stares at one another as they stepped around the rocks and fallen timbers, like ancient gladiators each sizing up the other's potential. A soft morning light accented the huge curved horns adorning each challenger's head. With their rippled and massive bodies of nearly 300 pounds poised and ready, both rams stood about ten feet apart as tempers grew. The chilly November air filled with tension.

Then one animal extended his head to the sky, baring his teeth as his eyes filled with fury. The other grunted and stamped his front feet—the cue. Rising slightly on their immense hind legs, the two fired out at each other like football linemen, almost faster than my eyes could follow.

As bodies stretched out full, their armored skulls crashed together, sending a resounding crack echoing across the walls of this central Black Hills canyon. Quickly the two recovered their legs and stood nearly in each other's faces, apparently egging one another on again. Then one lowered his head and began to rub his horns against the neck of the other, a temporary peace. This duel would be repeated many times throughout the day.

Early winter months in the Black Hills are special,

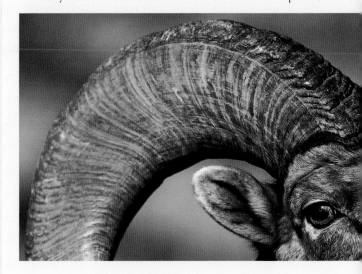

(above) To some extent, a ram's age can be determined by counting the number of more pronounced cross-ridge rings on its horns, with each of the more rugged rings equaling a year. The ram above is probably a four-year-old.

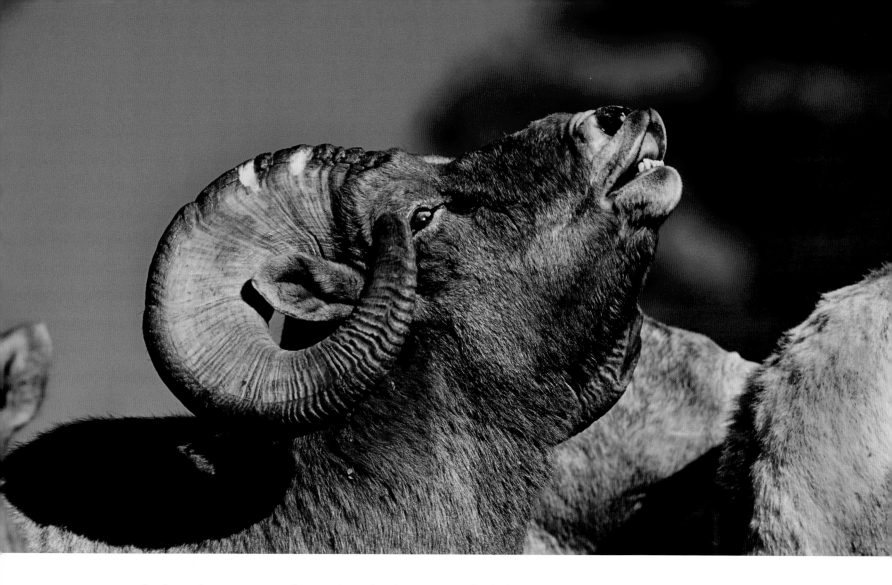

allowing witness to one of nature's truly dramatic shows—the rut of the bighorn sheep. Wild sheep in general and bighorns in particular have long been a source of fascination for humans and continue to be so today, whether the trophy hunter carries a rifle or a camera.

For most of the year, these rams have roamed the hills in small harmonious bachelor groups, living and feeding side by side with little or no conflict and generally avoiding contact with any other species. Ewes and lambs have spent the summer in day care groups feeding in high-country pastures, ever watchful for predators such as cougars and golden eagles. About mid-November, something in all of them awakens. Changes.

Bighorn sheep of both sexes and all ages gather in various groups at certain spots. Soon, high-country canyon floors like this one become gladiatorial arenas as jealous rams bludgeon one another in battles for breeding rights with ewes, answering one of nature's most primal

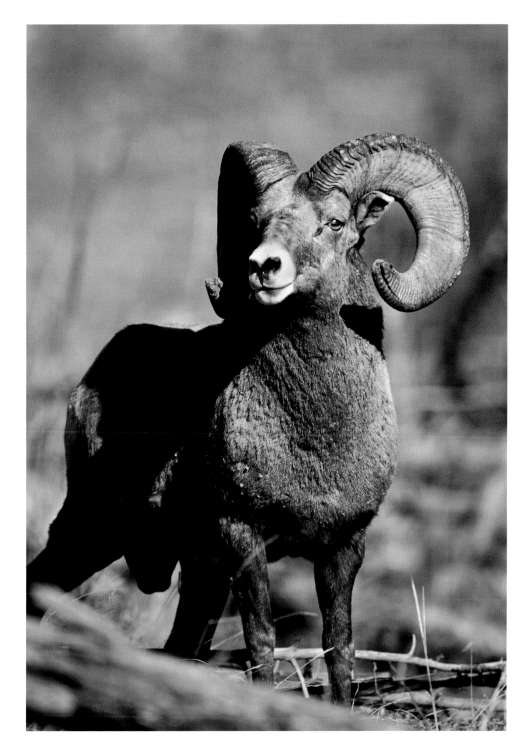

(facing page) While showing chipped areas on his horns from previous battles, this ram curls his lips in a behavior known as the flehmen response, where he activates certain glands, sniffs, and determines the stage a ewe is in her estrus cycle. During the rut, the sheeps' body language is remarkably elaborate.

(left) This ram is six or seven years old and at his prime.

(below) During the rut, rams tend to gather in groups of comparable size and age, standing so close that they resemble the huddles in football games.

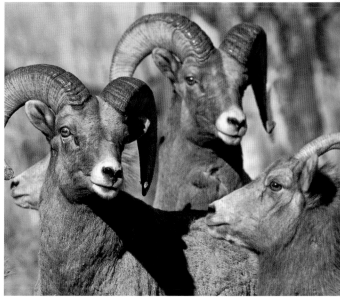

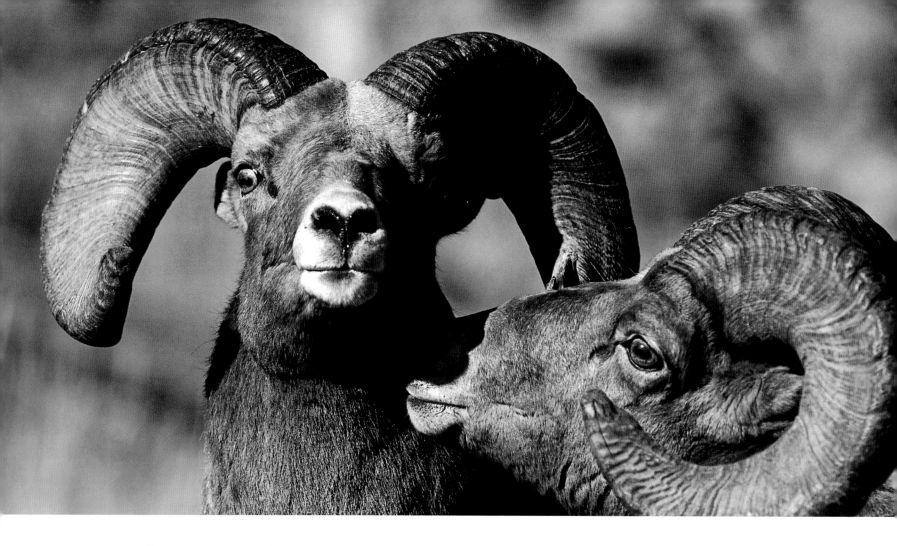

callings—perpetuation of the species. So ingrained are their instincts at this time that each group of sheep usually returns year after year to the same area to play out this ancient drama.

North America's wild sheep evolved from ancestors that crossed the Bering Land Bridge from Asia during the Pleistocene Era around 700,000 years ago. They have since diverged into two distinct species—Dall sheep (*Ovis dalli*), which inhabit Alaska and northwestern Canada, and Rocky Mountain bighorn sheep (*Ovis canadensis*), ranging from southern Canada to Mexico.

The Rocky Mountain bighorn is the largest of these wild sheep, with rams weighing 300 pounds or more. They stand over forty inches at the shoulder, with massive, tightly curled horns that can weigh thirty-five to forty pounds. Ewes are much smaller, weighing 125 to 150 pounds and with smaller and shorter horns that are only slightly curled.

As the Pleistocene drew to an end, the sheep were joined by yet another species migrating from Asia—*Homo sapiens*. Us. Wild sheep soon became entwined in the lives of early North American humans, both culturally

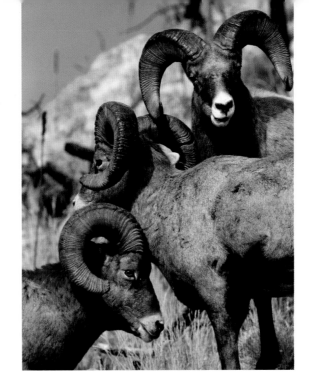

(facing page) After several titanic clashes, the ram on the right finally concedes defeat to his huge rival. His submission is accepted, and peace returns to the gathering—for the moment.

(right) In a behavior known as horning, the over and under rams pay tribute to the dominant animal by rubbing their horns against his face and body, hoping that he will permit them some participation in the procreation process.

(below) And still, some disputes are settled the "old-fashioned way."

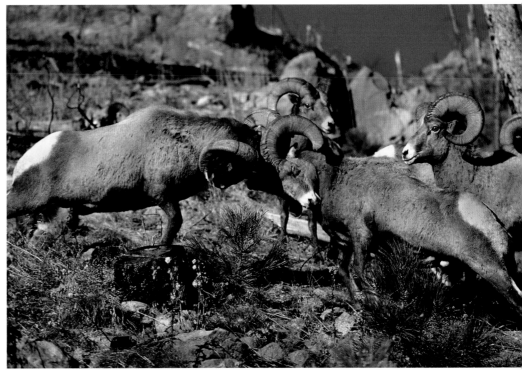

and economically. They are among the most prevalent of animals depicted in hunts on ancient petroglyphs and cave paintings. Sheep also represent one of our earliest successes at animal domestication.

By the time these ancient peoples had developed into the familiar Native American cultures that were here when European exploration and migration began, mountain people like the Shoshone and Crow had become as dependent on wild sheep as Plains cultures such as the Lakota and Cheyenne were on bison. Sheep provided them with everything—food, clothing, and the makings for tools of all kinds. These animals were prominent characters in the people's oral traditions and lore as well, making them equally important spiritually.

While the Europeans' arrival greatly reduced the continent's wild sheep population at first, in most areas the species has rebounded to safe numbers; sheep are

by no means endangered. Regulation by federal, state, and private groups has definitely brightened the future for wild sheep. Contact with livestock, especially domestic sheep, probably rates as one of the greatest dangers for wild sheep, as they are quite susceptible to livestock diseases.

I have been with this group for more than two hours this morning, and, as is typical, the rams are so involved with their own issues that they hardly notice me now, even though they frequently pass within ten to fifteen feet of me. An occasional curious glance, but little more. Just being able to join the herd without disturbing their routines is exhilarating enough, but getting a show like this one today is a rare gift. I feel fortunate.

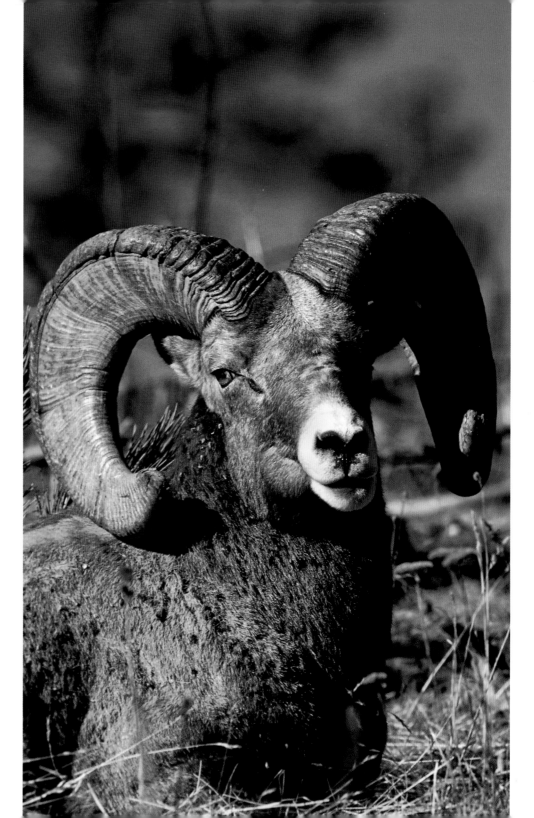

(right) After several weeks of having everything their own way, dominant rams like this one take on a seemingly benevolent attitude and allow some of the younger rams a turn with the ewes (facing page).

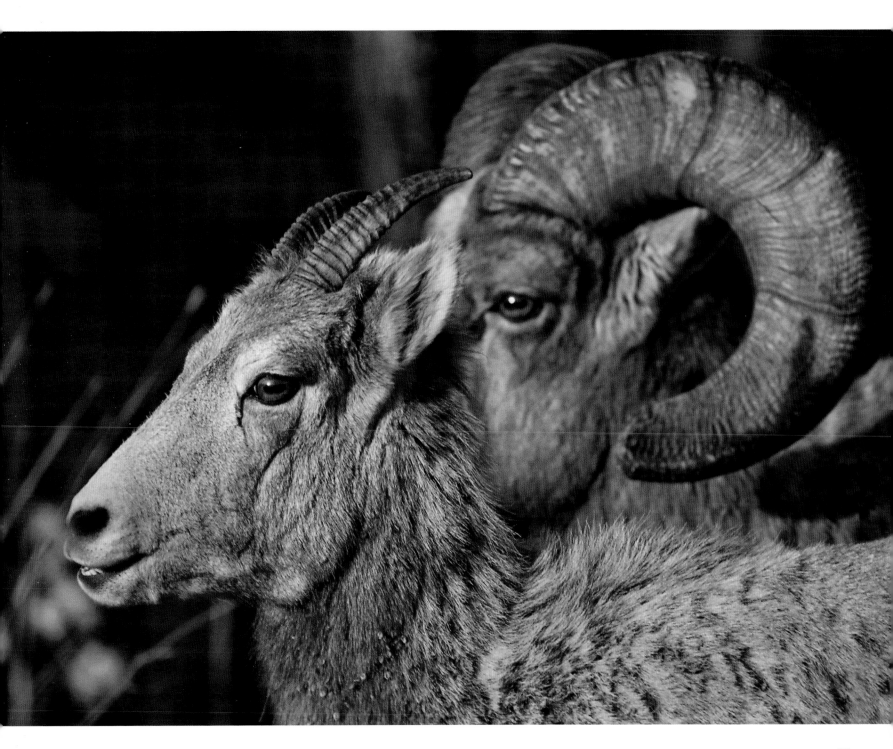

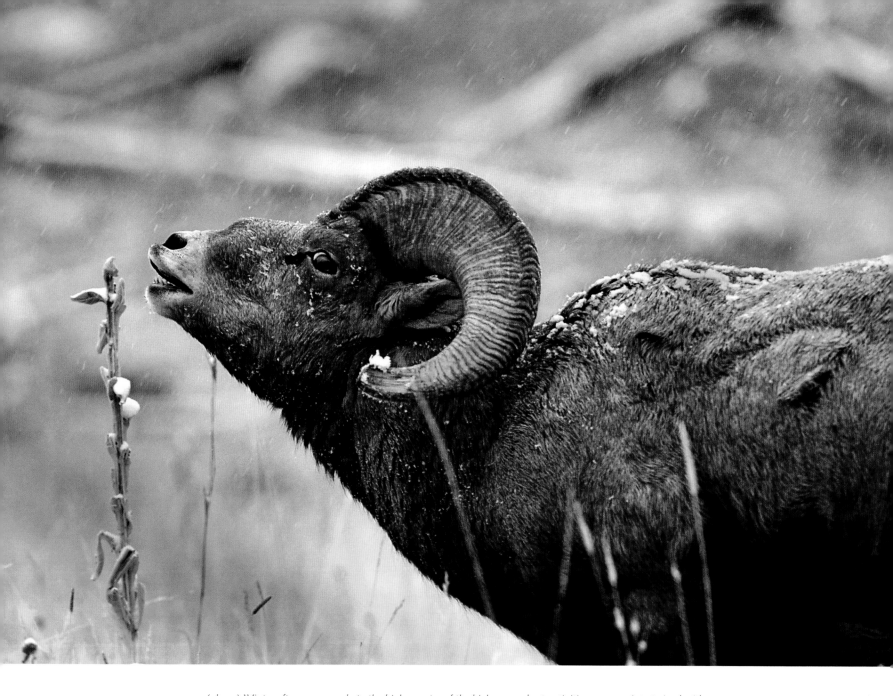

(above) Winter often comes early to the high country of the bighorn, and rut activities are soon intertwined with the business of preparing for the cold—building fat reserves. As they feed in the falling snow, a ewe indicates her readiness to this ram; he responds with a low stretch, a behavior meant to accent the size of his horns.

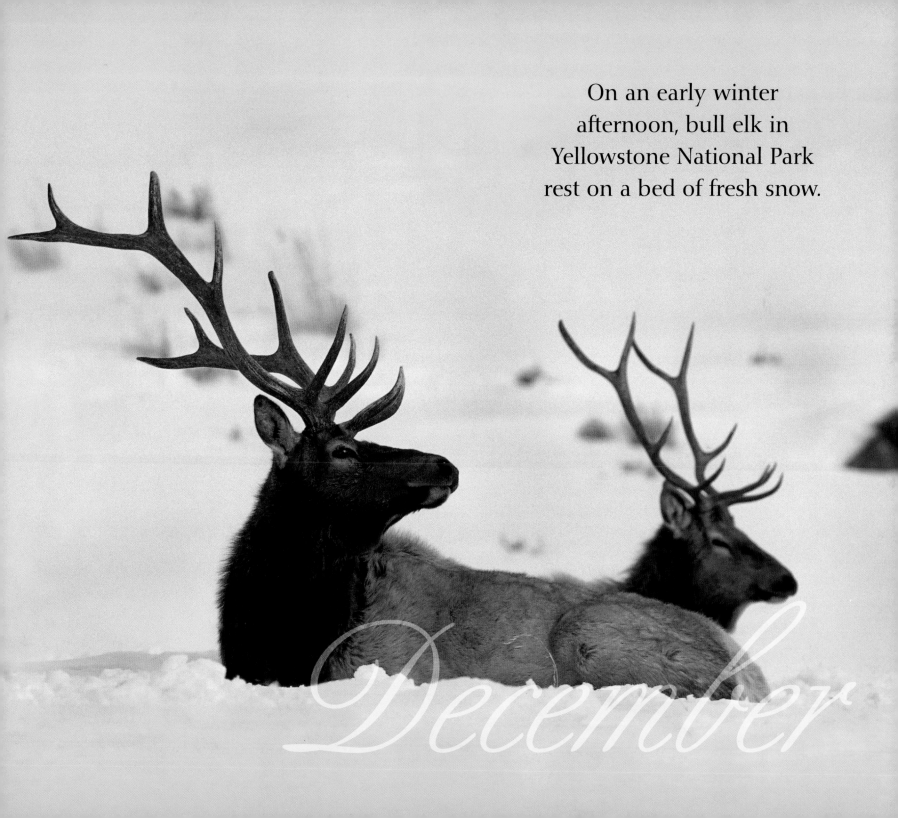

On an early winter afternoon, bull elk in Yellowstone National Park rest on a bed of fresh snow.

December

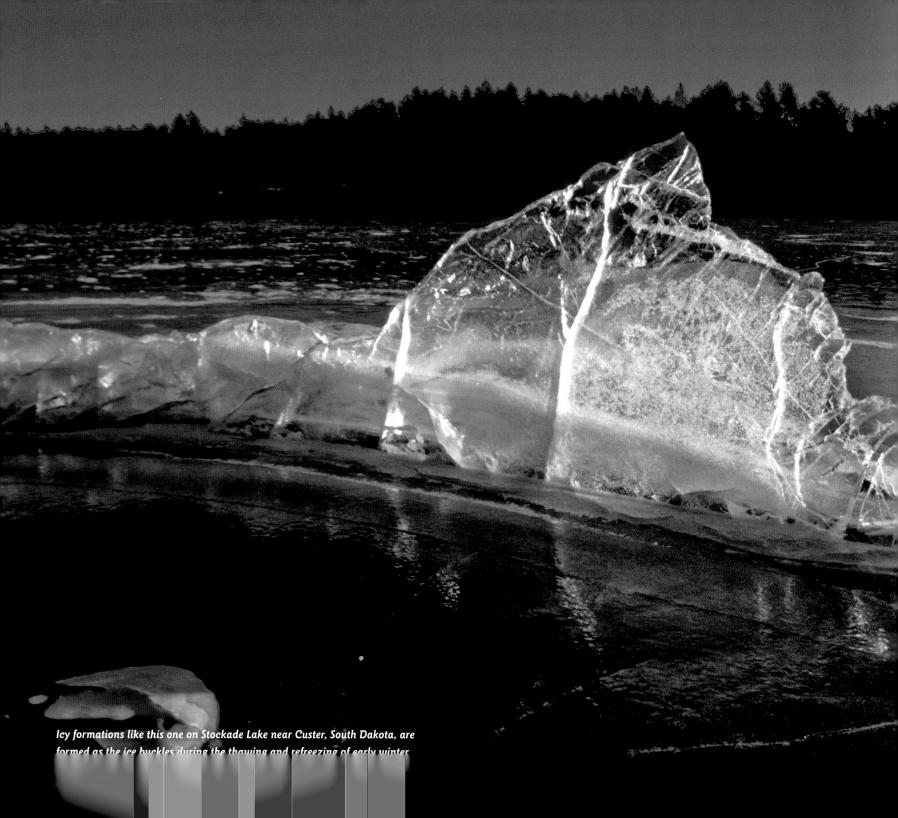

Icy formations like this one on Stockade Lake near Custer, South Dakota, are formed as the ice buckles during the thawing and refreezing of early winter.

CHASING AN ICY BEAUTY

The arc of the sun falls noticeably lower in the sky each day, and falls sooner. The days grow shorter and colder. Life slows . . . and slows. What it must have seemed like to early humans as each day told more of winter's approach when winter survival was not a simple thing. How uncertain this time must have been for them.

The lengthy afternoon shadows continue their journey across the snowy plain, growing longer by the minute as a winter's day approaches conclusion. The squeaking sounds of my footsteps through freshly fallen snow seem almost melodic, very appropriate to the occasion as they herald the official advent of a new season. Once again it is the winter solstice, the shortest day of the year.

Ahead and awash in the tawny light of the sun's finale are the distinct pillars of a national landmark called Slim Buttes, adorned with a crown of clouds and color. The Buttes are a splendid example of the vigorous and varied prairie landscapes that one finds throughout Harding County in South Dakota's northwest corner. The evening's

dramatic side light causes them to stand out against the darkening eastern sky like church steeples.

A geological text describes this region as "massive limestone uplifts that formed when the earth's crust

(above) As the day ends, a gorgeous afternoon light illuminates a winter sky over Slim Buttes, a remote Harding County landscape in the northwest corner of South Dakota.

(above) A row of delicate icicles is slowly sculpted from an ice bank by the lapping waters of Soldier Creek in the Nebraska panhandle.

(right) Chunks of ice float down the North Platte River near Bridgeport, Nebraska, as this pool begins to freeze solid.

(facing page) These willow branches along Iron Creek are completely encased in ice as winter takes over in Spearfish Canyon.

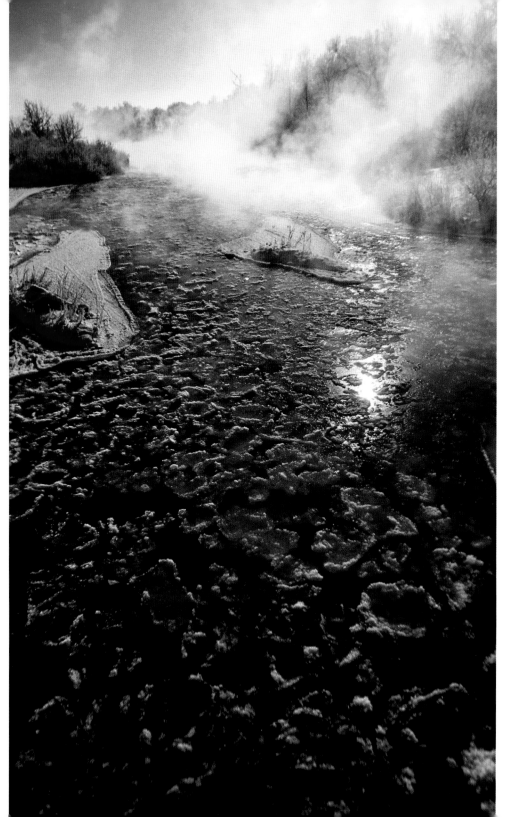

buckled from the pressure of the north and south forks of the Moreau River. Wind and water did the rest." The words of geology depict very well how an event transpires, but sometimes do little justice for its aesthetic results. In fact, Harding County gives final rest to that frequent misconception that all prairies are flat and boring, especially at this time with the accents of winter's light.

Here and all across the northern plains, the sun's low arc around the time of the solstice keeps its light soft and delicate throughout most of the day, adding so much to the visual magic of this season. The quality of light is not only one of winter's great attributes, but one of the great dramas of nature. Seldom is there such a vibrant clash between darkness and light as during this time. The hues of a winter sky defy description.

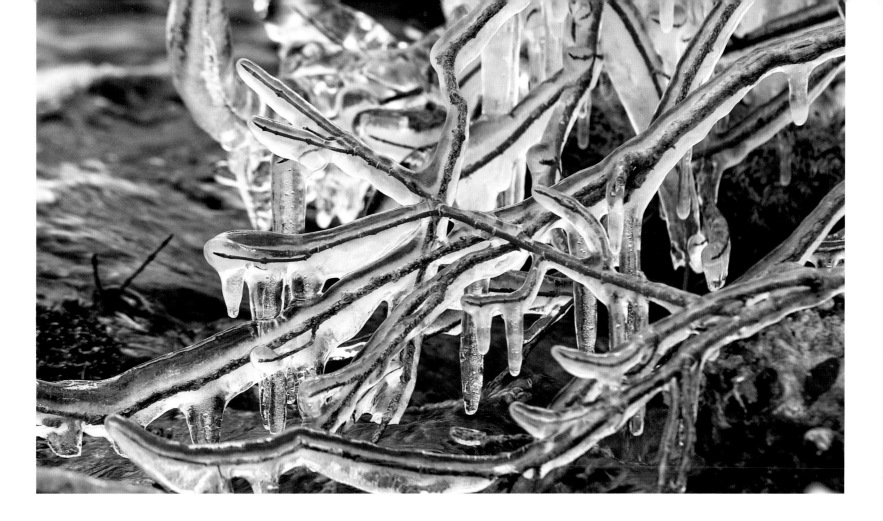

Anthropologists are unsure as to when humans actually began to recognize and understand the winter solstice. Yet an overwhelming majority of cultures throughout the world have observed it in celebration and festivity for thousands of years. Of course, at the root of these ceremonies was the ancient fear that the falling sun would not return unless humans somehow invoked some supernatural intervention by the gods.

As their knowledge of celestial movements and cycles grew, fear was replaced with understanding. The ancient cultures began to design and build their most sacred architectures—tombs, temples, and such—so that they were in alignment with the solstices and equinoxes. Examples are found in Stonehenge, the Egyptian pyramids, the work of the Aztecs and Incas, and more. Even many medieval Catholic churches and cathedrals were designed to include solar observatories.

Today, humans still observe many of these ancient festivities and rituals in their culture. It was about 1,600 years ago that the Christian celebration of Christmas began to merge with the winter solstice observances of ancient Rome. The Romans staged a huge festival for the god of agriculture, Saturn. While businesses, courts, and schools were closed, people feasted, gave gifts, and

decorated their homes with greenery and other trimmings. Sound familiar?

Sad that so many contemporaries are still beset with gloom, even depression, as winter makes its entrance. I wonder if this tendency isn't something left over in our psychological make-up from those early and prehistoric times when we genuinely feared whether the sun would return, and mere winter survival was a factor much more critical than it is for most of us today.

Now we have the luxury of just being able to appreciate the magic and resplendency of this season. Be it here among the wind-sculpted pillars of Slim Buttes, along the banks of the Platte River, or beneath a prairie moonrise almost anywhere, the light of winter is reason enough for celebration and optimism. Winter can and should be a time of contemplation and introspection, when we search within ourselves as vigorously as we search outward.

The author Caitlin Matthew writes that winter "is a season when we learn from nature how to honor the darkness of Life's Mysteries without losing faith . . . how to recognize the seeds of growth and to nurture them in our own inner warmth until the Light returns . . . once again we learn even in the darkest moments that health, serenity, and healing energy are available when we focus on them with positive intent."

And we also know that once again the meadowlark will sing its song of spring.

(right) Some of nature's finest artwork can be found in the etchings on tiny icicles such as this one.

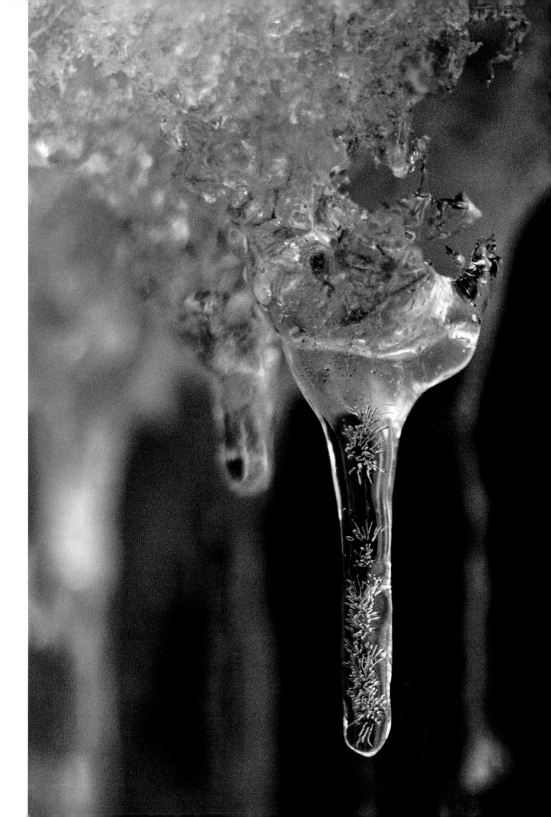

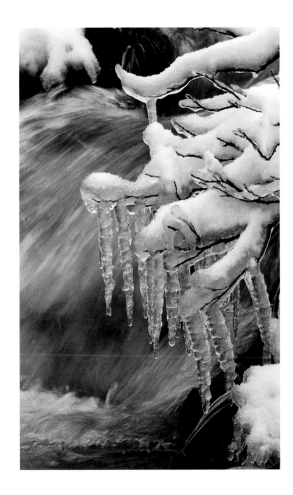 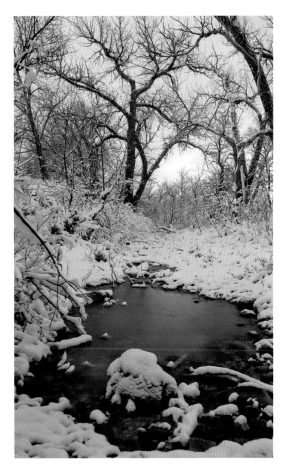 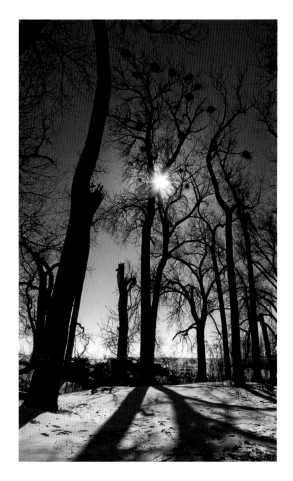

*(left) The waters of Spearfish Creek cascade over
the rapids between rapidly forming ice floes.*

(middle) Snow rings the last opening in Lame Johnny Creek.

*(right) Empty great blue heron nests await the return
of their owners to this rookery along Spring Creek.*

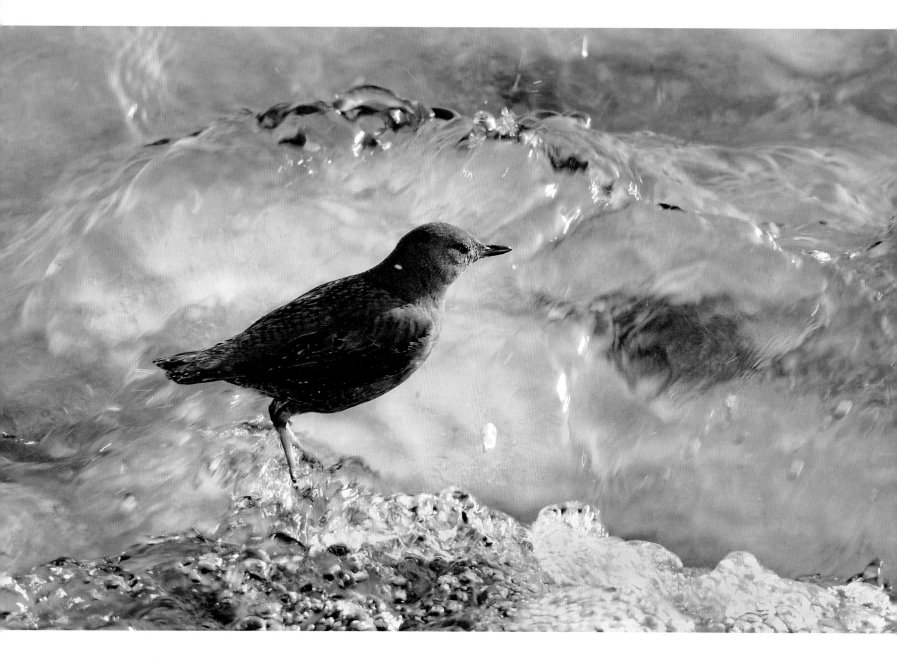

(above) The American dipper is a remarkable little bird that can survive winter temps of thirty below zero as it continues diving into and swimming under fast-moving waters after prey that includes aquatic insects, mollusks, and small fish. A large preen gland allows their feathers to be heavily waterproofed during dives that can last thirty seconds. The underground thermals of Yellowstone National Park keep waters like these of Pebble Creek open and full of food throughout most of the winter.

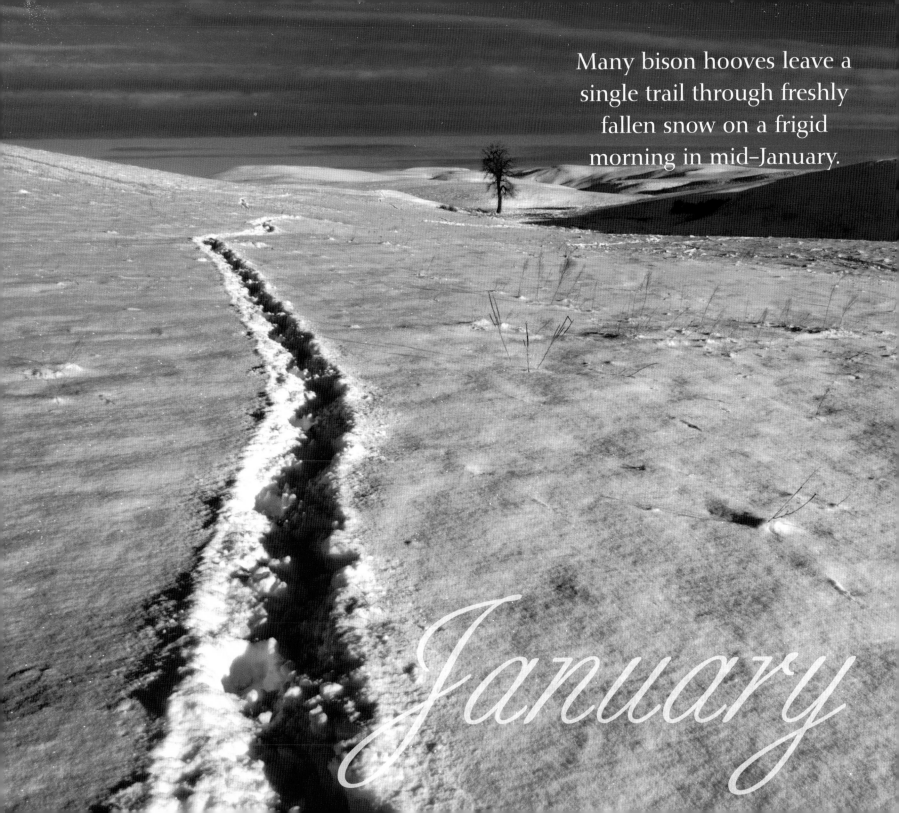

Many bison hooves leave a single trail through freshly fallen snow on a frigid morning in mid–January.

January

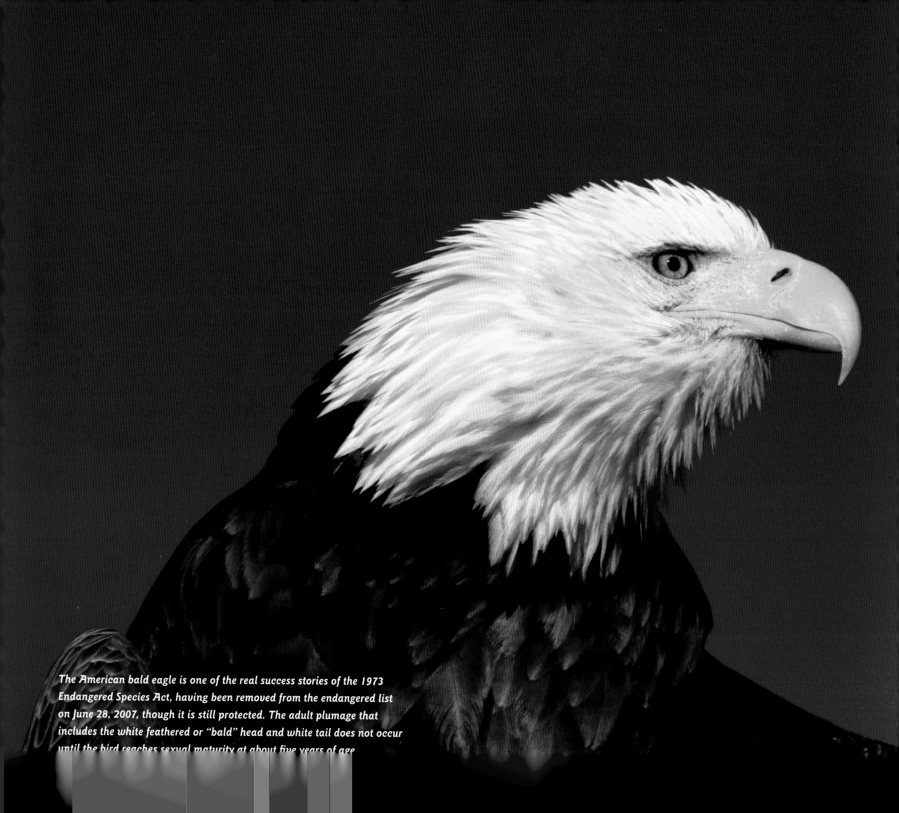

The American bald eagle is one of the real success stories of the 1973 Endangered Species Act, having been removed from the endangered list on June 28, 2007, though it is still protected. The adult plumage that includes the white feathered or "bald" head and white tail does not occur until the bird reaches sexual maturity at about five years of age.

THE BIG SHOWOFF

Descending from the azure blue of a winter morning sky, the great winged creature circled the high, bare branches of an old, dead cottonwood tree standing alone on the prairie. As he glided lower and passed behind the tree, a chorus of yips and howls rang out from the nervous and scurrying inhabitants of a prairie dog town that stretched about a half mile in all directions. The alarm was sounded.

Again the huge bird banked sharply back behind the tree and then lit on one of the higher branches. As his sharp talons found a grip on the bark, he extended his massive wings and flapped them a couple of times before drawing them in. While he strutted about on the branch, I blipped off several frames. As usual, he displayed no fear of me and seemed to revel in the attention. Still just a big showoff.

This bird is an old acquaintance, one that I have photographed for about three years now. I recognize him as he returns each winter first because of a telltale deformed left foot, and he always hangs out around this large prairie dog town that straddles the border between Wind Cave National Park and Custer State Park in the southern Black Hills.

Generally, bald eagles—as well as most other birds of prey—are wary of human approach. This bird has always

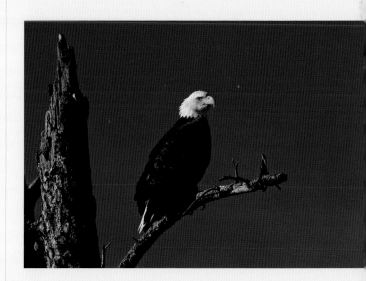

(above) With their keen eyesight, bald eagles favor perches in tall trees, often in dead snags overlooking open water.

been different. I've wondered if maybe he was found injured by knowledgeable people, nursed back to health, and released back into the wild. That could explain the foot as well as his habituation to human presence.

Most bald eagles seen in our region are winter tourists that will be gone by early spring. They are semi-migratory, meaning they migrate southward until they find a reliable source of food for the winter, be it prairie dog towns, winter-killed animals that are not snow-covered, or bodies of water that don't freeze over completely. Cold is not really a problem for the eagle because its 7,000 feathers provide it with ample insulation and weatherproofing.

As my cooperative companion of this morning strutted on his perch, posing this way and that, he seemed more like a studio model than a wildlife subject. It was easy to understand why so many Native American cultures held this magnificent creature in such reverence, often giving it human characteristics as well as judging it by human principles.

The Mohawk believed that the creator chose the eagle as the master of the skies. Since eagles fly higher and see farther than most other birds, they regarded him as a messenger who had the honor of carrying the prayers of humans in the world of earth to the world of the spirits where the creator resides. Other tribes such as the Lakota and Cheyenne used eagle feathers, talons, and skulls in their ceremonies and religious practices.

And of course many modern nations have chosen some kind of eagle to be their national symbol, with our own country selecting the bald eagle as such in 1782, despite the well-known objections of Benjamin Franklin.

(right) Through annual molting, most eagles attain full adult plumage between their fourth and fifth year. Similarly, the beak gradually changes from black to gray to bold yellow.

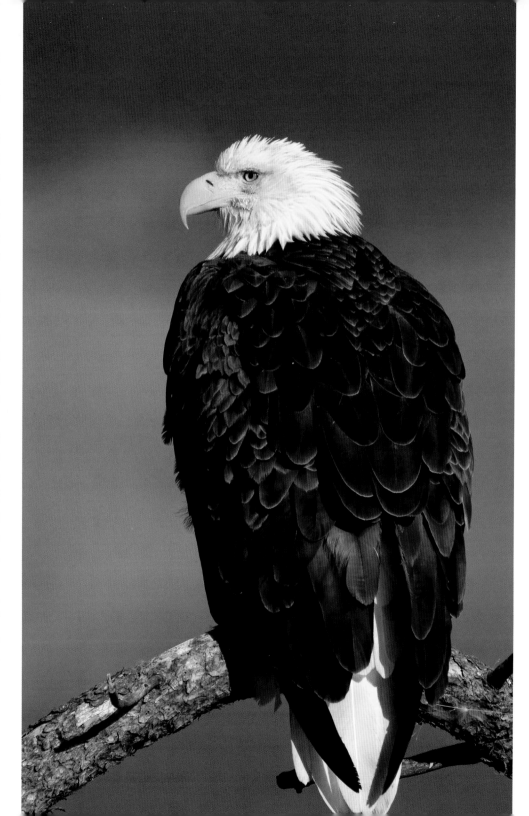

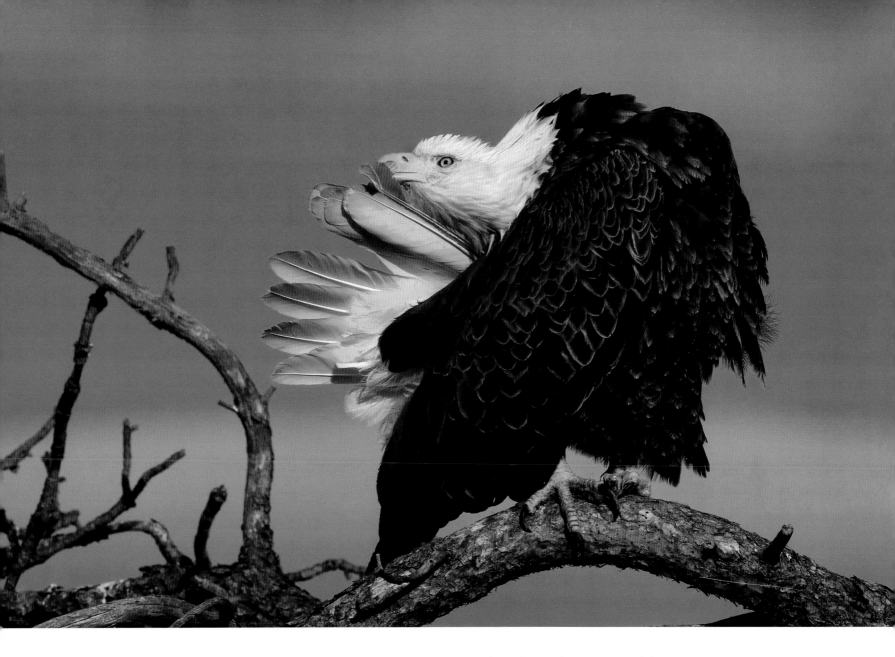

(above) Feather care is of critical importance for birds the size of a bald eagle. This one preens and cleans its white tail feathers that serve as a rudder for stabilizing flight movement. Rounded at the tip and widely spread, the primary or wing feathers control lift and directional mobility during flight. The strength of these flight feathers is remarkable, particularly the follicle holding each feather while enduring atmospheric pressure. Layers of feathers across the eagle's body trap air to insulate the bird against cold and protect it from rain. Like our hair and fingernails, the eagle's feathers, beak, and talons are composed of keratin.

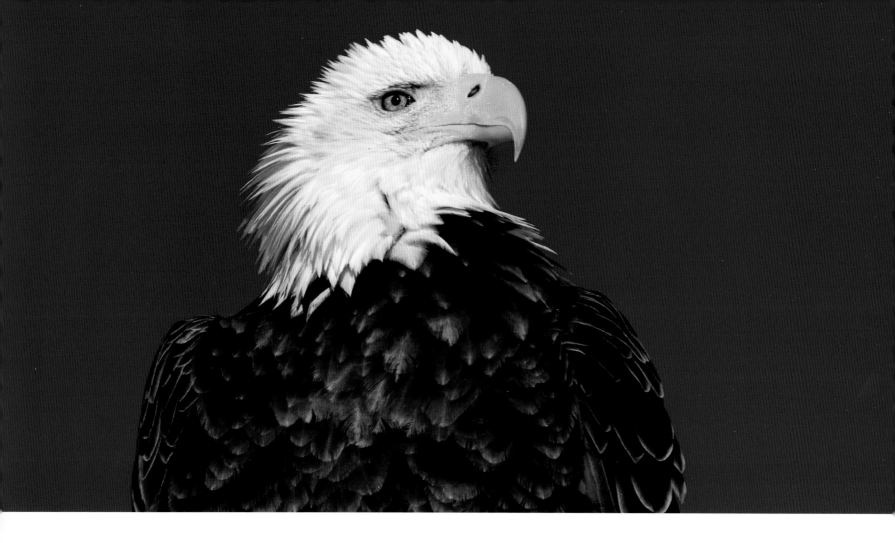

Preferring the wild turkey as our national emblem, Franklin regarded the bald eagle as "a bird of bad moral character who does not get his living honestly—often stealing from other birds—and a rank coward because he allows smaller birds to attack him boldly and drive him out of the district." Apparently Dr. Franklin also tended to judge this creature by human principles.

While it is certain that the bald eagle does steal food from other birds, it confines most of its thievery to other bald eagles and an occasional osprey. Though classified as a bird of prey—killing other animals for food—the bald eagle is more often a scavenger, choosing to feed on carrion. Its talons are actually better suited for such. Even with its preferred diet of fish, it will generally select whatever is easiest, such as a floating dead fish. The eagle is not so much a bird of prey as a bird of opportunity.

However, the powers of the eagle's vision are not mythical. Their eyes have two centers of focus, known as foveae, which allow them to see both forward and to the side simultaneously—a built-in wide-angle lens. Almost as large as a human eye, the sharpness of the eagle's eye is at least four times that of a person with perfect vision.

(facing page) As with all eagles, balds are renown for their excellent eyesight. They are capable of seeing fish in the water from several hundred feet above while soaring and gliding. This is quite an extraordinary feat since most fish are counter-shaded, meaning they are darker on top and thus harder to see from above. Eagles also have an inner eyelid called a nictitating membrane. Every three or four seconds, this membrane slides across the eye from front to back as it cleans dirt and dust from the cornea. Almost as large as a human eye, the sharpness and perception of an eagle's eye is at least four times that of a person with perfect vision.

(right) A bald eagle's voice is shrill, high-pitched and twittering. They have no vocal chords and produce their sounds from the syrinx, a bony chamber located where the trachea divides before going into the lungs.

(below) Eagles do not sweat, but cool themselves by perching in shade, panting, and holding their wings away from their body.

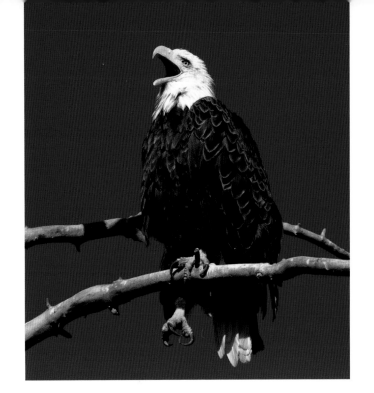

They say the legendary racehorse Secretariat seemed to pose for photographers, as though he knew what was going on. I have always had the same feeling about this bird. He has become my "go-to guy" for those head-and-shoulder portraits that are difficult to obtain of a wild bird, even with the ultra-telephoto lenses that people like me employ. The images of the big showoff are almost studio-like. He even seems to know his best side, like any good model.

Now if I can just get him to pose in flight, all will be perfect. Wildlife photographers are also creatures of opportunity.

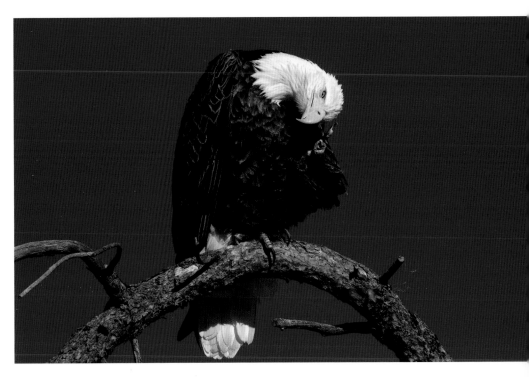

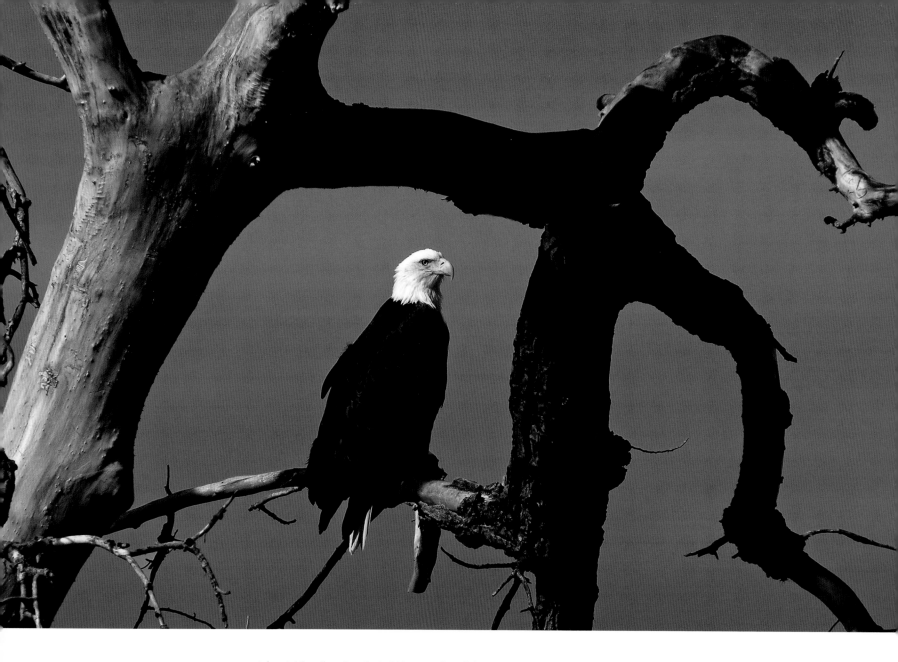

(above) Like all eagles, the bald is a member of the Accipitridae family that includes hawks, kites, and old-world vultures. With a wingspan ranging from seventy-two to ninety inches, they can reach altitudes of 10,000 feet while achieving flight speeds up to thirty-five miles per hour. They generally weigh ten to fourteen pounds, with females being slightly larger than males. Their lifespan in the wild averages fifteen to twenty years.

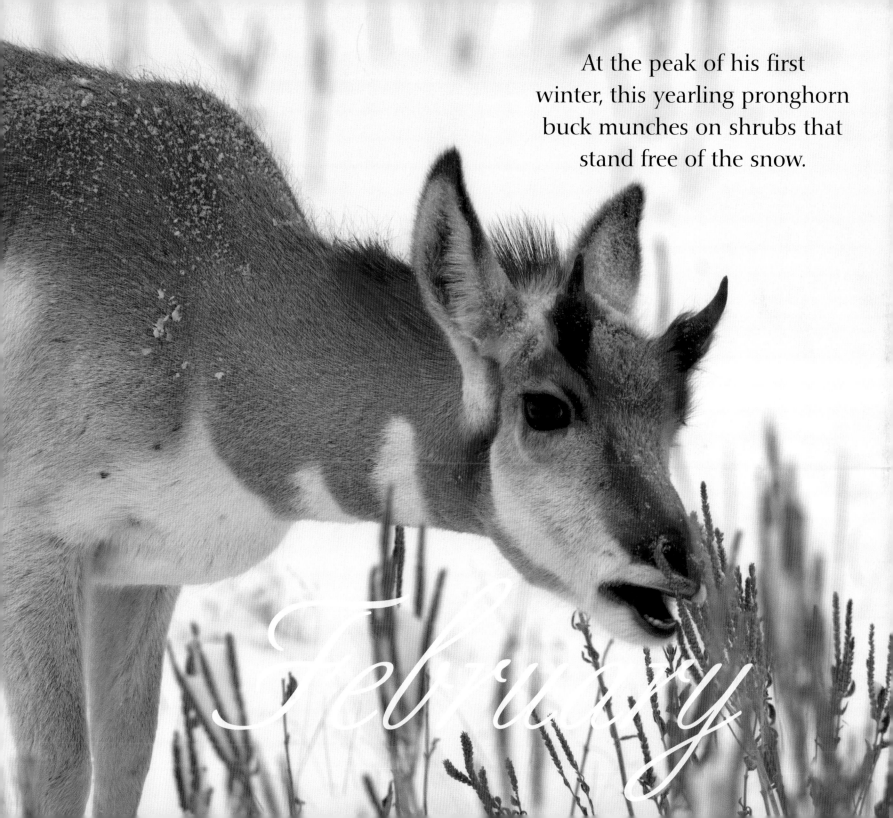

At the peak of his first winter, this yearling pronghorn buck munches on shrubs that stand free of the snow.

February

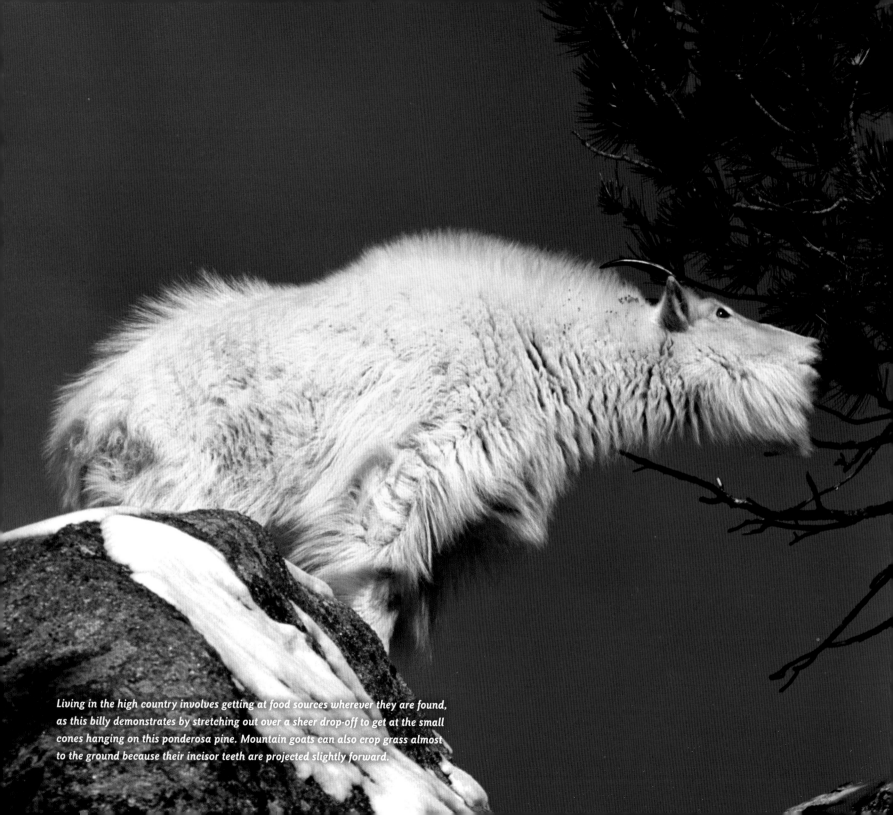

Living in the high country involves getting at food sources wherever they are found, as this billy demonstrates by stretching out over a sheer drop-off to get at the small cones hanging on this ponderosa pine. Mountain goats can also crop grass almost to the ground because their incisor teeth are projected slightly forward.

LIVIN' THE HIGH LIFE

Gingerly, I spread my hands and knees out across the slick, black ice covering the sloped, flat surface of a huge boulder, nearly the size of a small house. I was not comfortable.

I'd had enough trouble just getting myself up onto the rock, which ended right behind me with a sheer drop-off six feet into drifting snow below. Overhead, another boulder extended out from the side of the mountain, like an awning with two-foot icicles hanging from it.

Twenty feet up the rocky surface, standing among the icy stalagmites, was "The Kid," a six-month-old mountain goat billy poking around for food on this wintry morning. It was obvious that he, unlike me, was completely at home in this frozen environment.

He glanced at me now and then, but more out of curiosity than fear or caution. He was probably laughing at me, and I'm sure I looked ridiculous to him. I reached a point on the slippery surface where I felt comfortable trying to stand. Holding the camera firmly against my ribs, I rose up on my knees and then slowly to my feet.

"Well, this isn't so bad," I thought. "Let's try walking." I put one foot out a few inches and then shifted my weight to it. Hey, try the other. As I set my second foot down on the gleaming surface, it kept right on going . . . with the rest of me right behind. I had just enough time to grab the

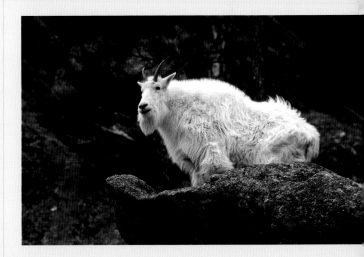

(above) Along the highway passing the Mount Rushmore memorial, goats are frequently observed on the cliffs above.

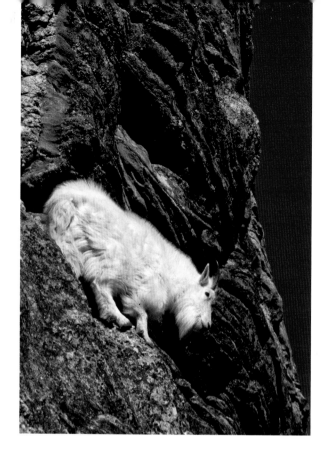

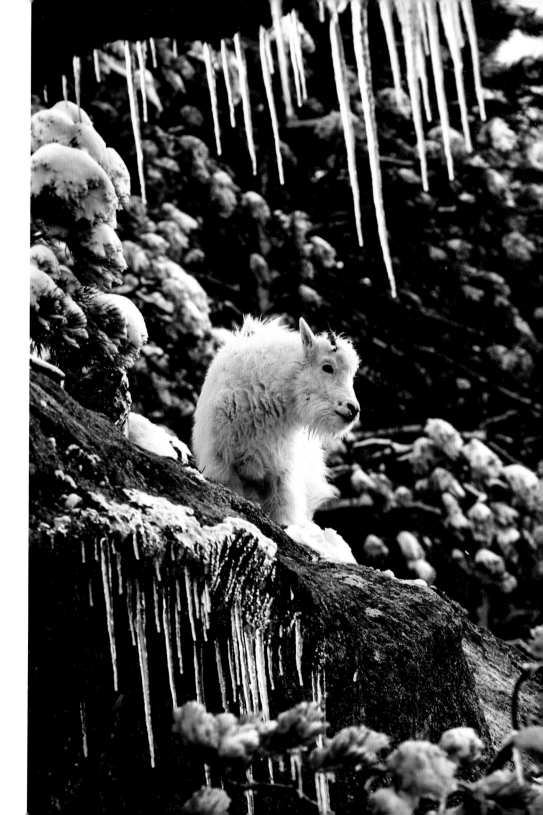

(above) Steep vertical walls are no problem for this young billy as he nimbly makes his way down, using narrow ledges for pathways.

(right) Already completely sure of himself in a slick, icy, and vertical environment, this six-month-old billy feeds on lichens that grow on the granite surfaces of the Black Hills high country.

(facing page) Under his mother's close supervision, a yearling billy learns some of the skills necessary for survival in his world.

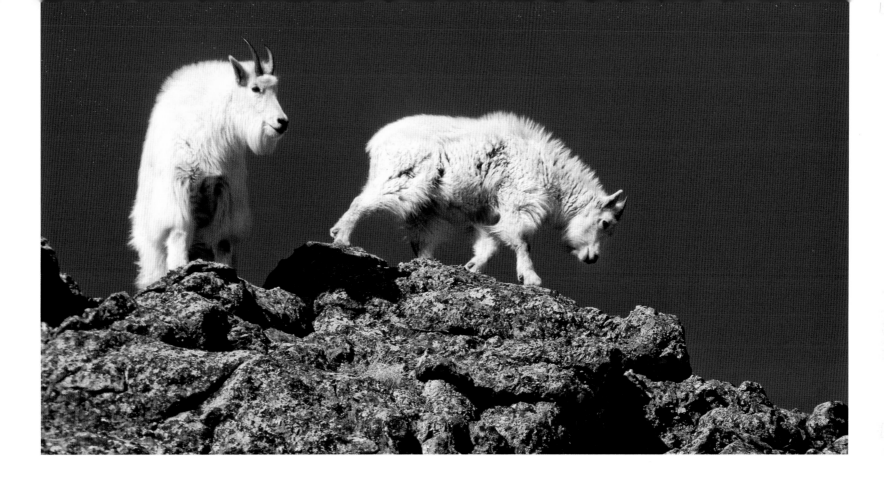

camera and a deep breath before I was airborne, both feet abruptly shooting skyward. I landed, gluteus maximus first, smack on the ice and kept on going, closing my eyes as I shot off the rock into midair. I hoped there was a lot of soft snow where I was headed.

Thump.

With great hesitation, I opened my eyes to discover I was sitting in the middle of a snowdrift up to my armpits. Amazingly, I held the camera in my two hands out in front of me, dry and unharmed. "What about me?" I thought as I got to my feet. Everything was fine—except for my poor, aching butt.

I turned to see if all the commotion I caused had spooked the kid. No, he continued about his business,

munching the lichens growing on the rocks while stepping about the icy surfaces with complete assurance. After watching me "slip sliding away" across that rock, he was probably thinking, "who's the dummy that can't walk?" Well, if I was as well equipped as a goat, I could be cocky, too.

Wherever the mountain goat lives, it is first and foremost a climber, being perfectly suited to a vertical environment due to several characteristics of its physical makeup. First, there are its two-toed hooves. Equipped with a special rough-textured traction pad that protrudes just past the nail, this hoof provides a considerable amount of friction that gives the goat added stability on smooth rock and ice. Also, the two toes can spread far

apart (as wide as the hoof is long), giving this animal a wider grip on ground or rock when descending a slope. Those same toes can grip around a rocky edge to help the goat haul itself up during an ascent.

And just above the ankle are two dewclaws that actually are small, crescent-shaped versions of its toes, providing the goat with additional stability and drag during dangerous descents. Even the mountain goat's long, white hair is an asset to its climbing skills. The coarse surface of overlapping scales on individual hairs creates friction and adds still more traction that comes to bear when the goat uses its rump and lower rear legs to brake on descents. In short, this stocky creature is one of nature's ultimate mountaineers.

Mountain goats are not native to the Black Hills but were introduced in June of 1924 when six were brought in and initially kept in a small, fenced enclosure. Within a few days, a thunderstorm toppled a tree onto the fence and released all six into the wild, where they have flourished ever since.

Those original six have grown into a stable population of around 400, making the Black Hills the lowest elevation habitat in the United States to harbor mountain goats. Here they are found only in the highest areas of our region, with the granite spires around Mount Rushmore and Crazy Horse Mountain being ideal. Early morning is the best time to catch sight of them on the crags, performing their amazing feats, but remember you will have to use your own legs to access this high, rugged country.

(right) The curiosity of mountain goats is undeniable as they are frequently observed peeking over a cliff or from behind a rock to get a second or even third look at people like me, a characteristic that makes my job easier.

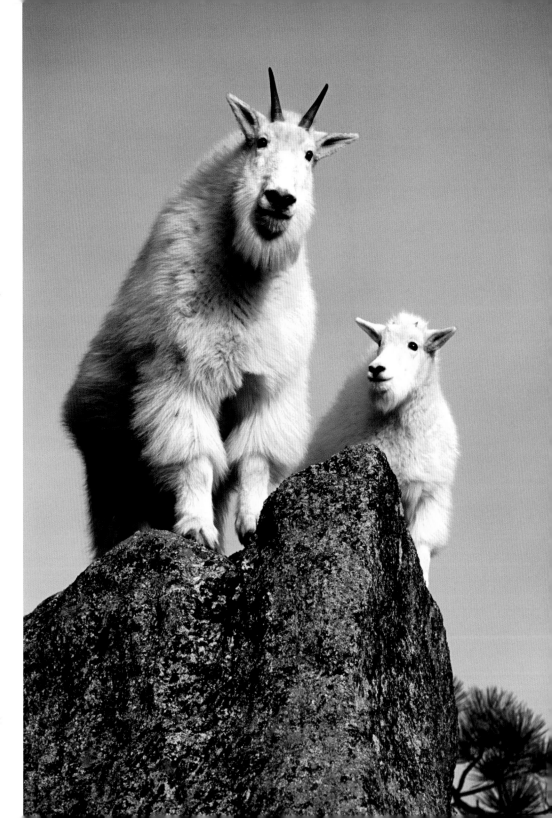

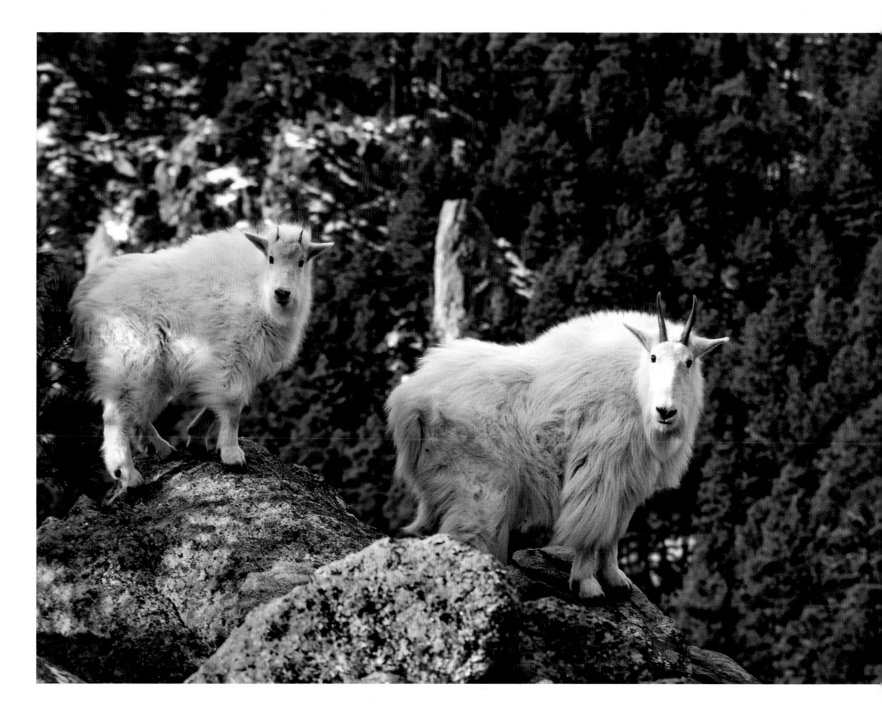

(above) The granite spires and deep gorges of the central Black Hills high country have proved to be an excellent environment for mountain goats like this nanny and her kid.

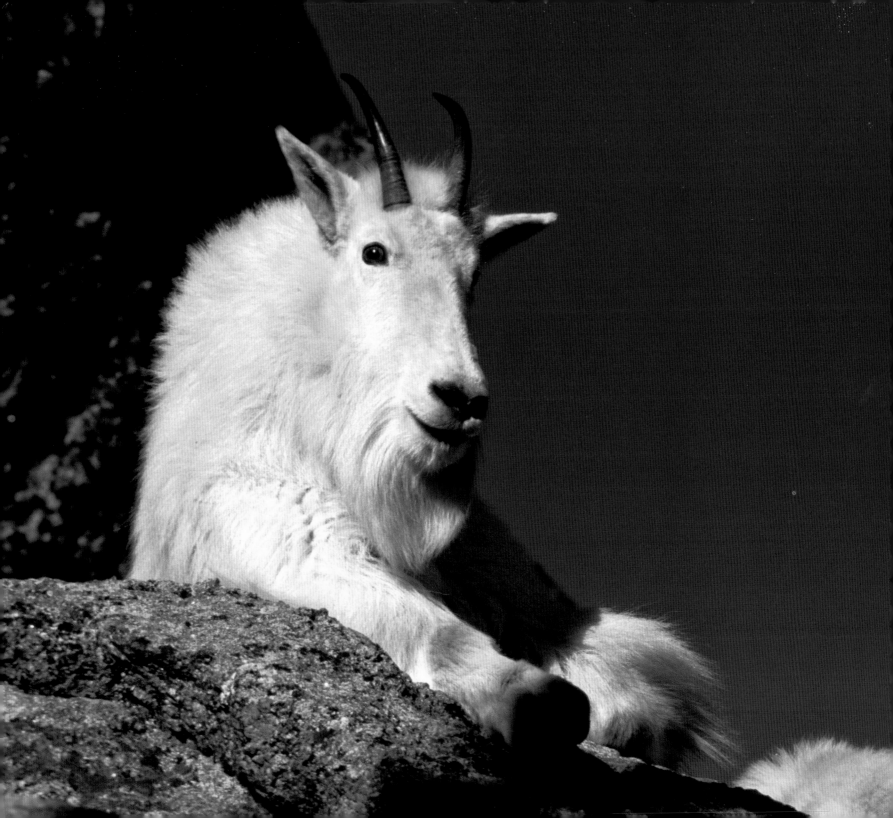

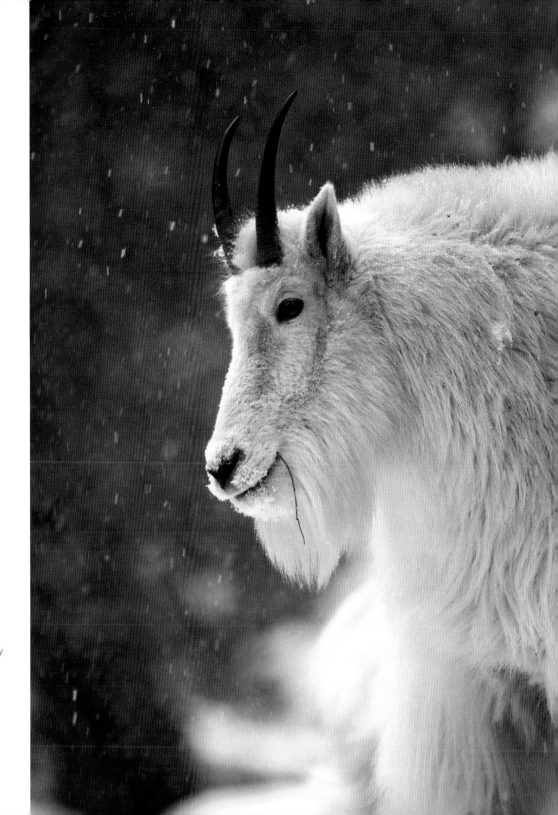

(facing page) A wide ledge makes the perfect place for this nanny
to soak up some afternoon sun on a clear winter's day.

(right) Falling snow gathers on the face of a billy as he greets
the winter morning. Outside of the rutting season, billies prefer
to break off in bachelor groups of four or five, or as individuals.
November will find them rejoining the nannies as the rut begins.

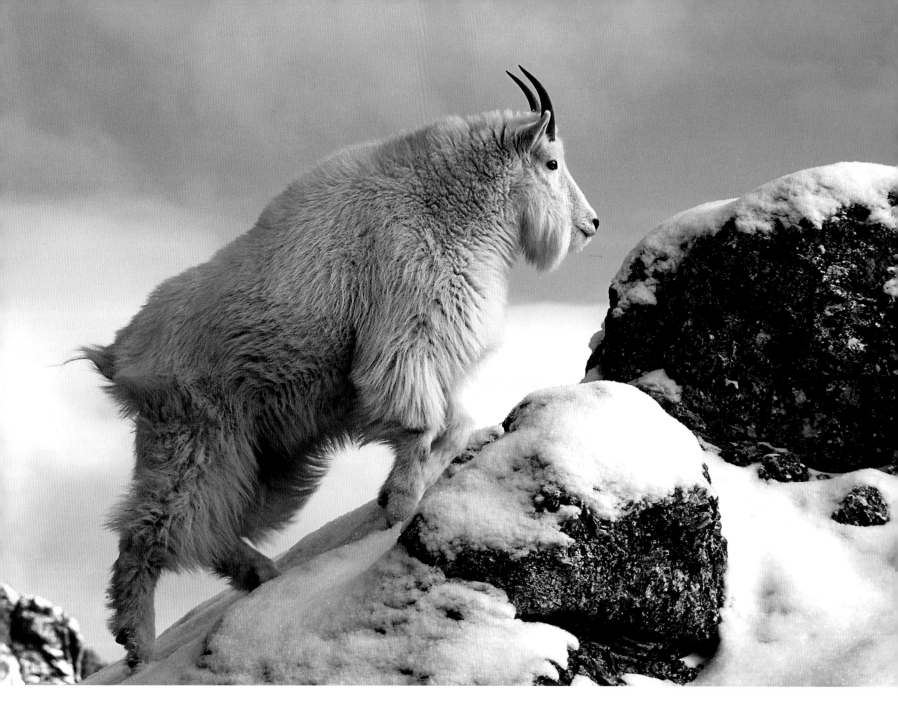

(above) A large billy heads up into the snow and clouds gathering around this granite peak in the Black Hills. Adult billies stand about forty inches at the shoulder and weigh 150 to 225 pounds. Nannies are smaller, at about thirty-seven inches and 120 to 160 pounds. The mountain goat's lifespan is twelve to fourteen years.

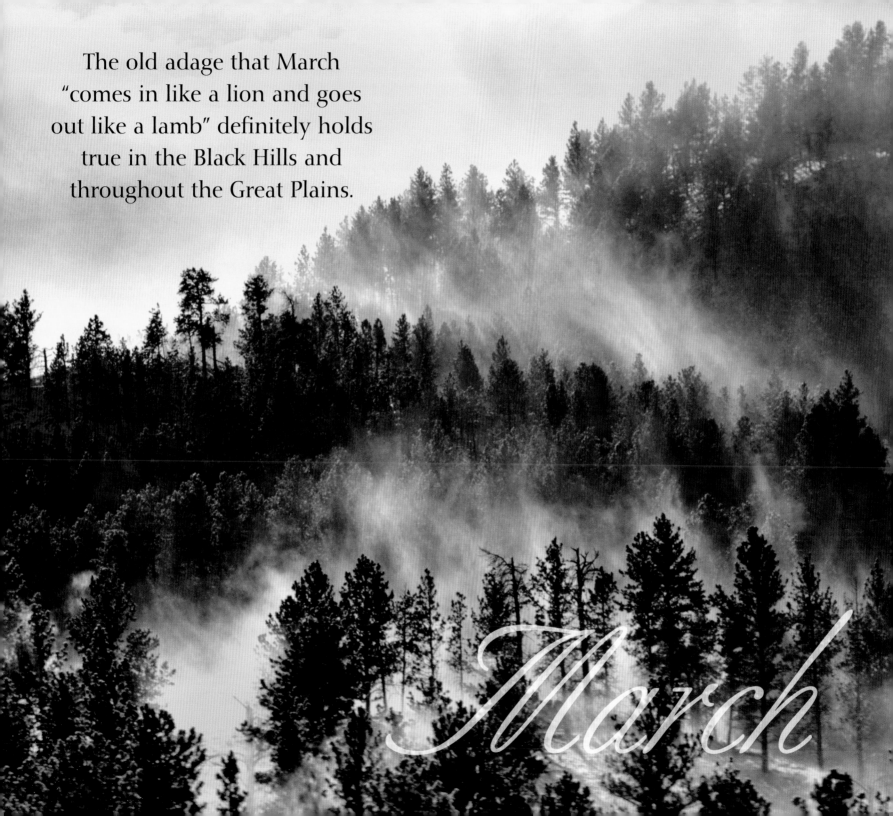

The old adage that March "comes in like a lion and goes out like a lamb" definitely holds true in the Black Hills and throughout the Great Plains.

March

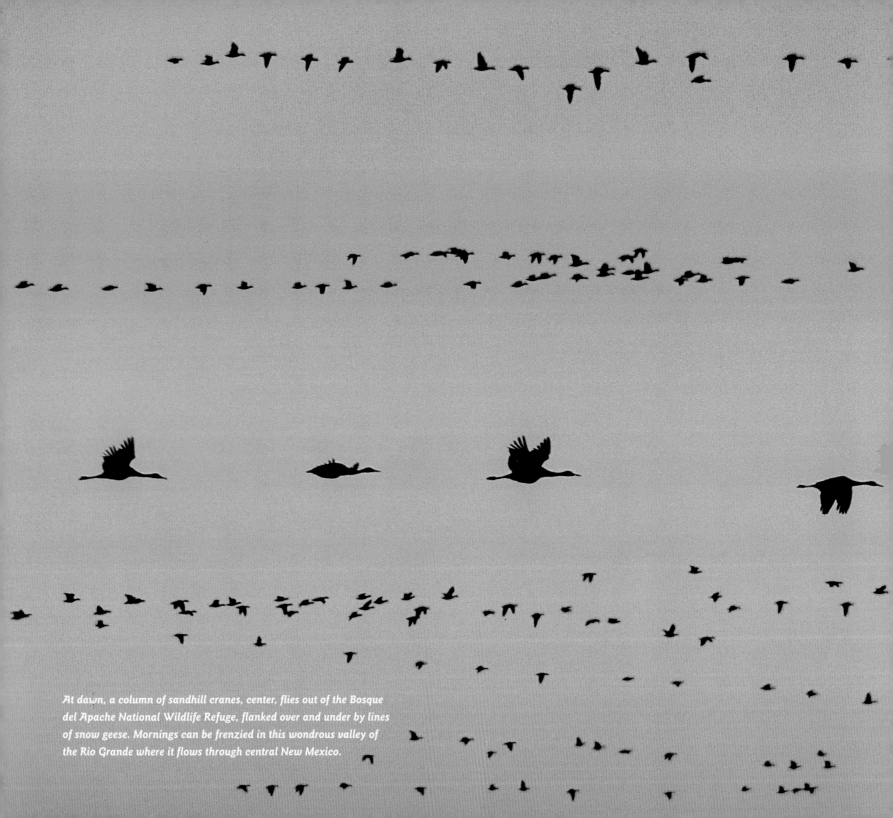

At dawn, a column of sandhill cranes, center, flies out of the Bosque del Apache National Wildlife Refuge, flanked over and under by lines of snow geese. Mornings can be frenzied in this wondrous valley of the Rio Grande where it flows through central New Mexico.

AN ISLE OF TRANQUILITY

The amber glow of dawn light intensifies over the horizon of an eastern sky that is already filled with the clamor, commotion, and cries of life, abundant life. Once again, it is the miracle of the birds . . . the birds . . . the birds . . . pervading the sky as they engage and fill every one of my senses.

So assuring is their dependability. Every year from thousands of miles away, they come. Down from the Canadian Arctic, across Minnesota lakes, over Nebraska's Platte River and the Missouri of the Dakotas, they come. And always, they find this soothing place where life flourishes, this isle of tranquility surrounded by desert in the valley of the Rio Grande.

The Bosque del Apache National Wildlife Refuge, or "Woods of the Apache," has become one of the nation's most successful preserves, although its mission is nothing new, having existed for some 10 million years. Every November, this 57,000-acre haven snuggled between the Manzano and Magdalena Mountains of central New Mexico becomes a wintering ground for tens of thousands of migratory waterfowl and wading birds. Until early March, this nine-mile stretch along the river is filled with snow geese, Canada geese, sandhill cranes, and countless species of ducks. Overhead, flocks of birds, sometimes a mile long, command the sky for as far as one can see, especially at day's beginning and end.

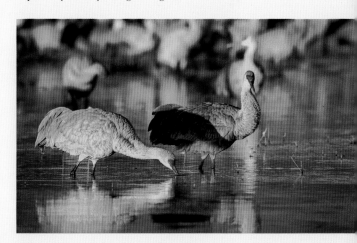

(above) The growing morning sunlight highlights a group of cranes feeding in the marshlands.

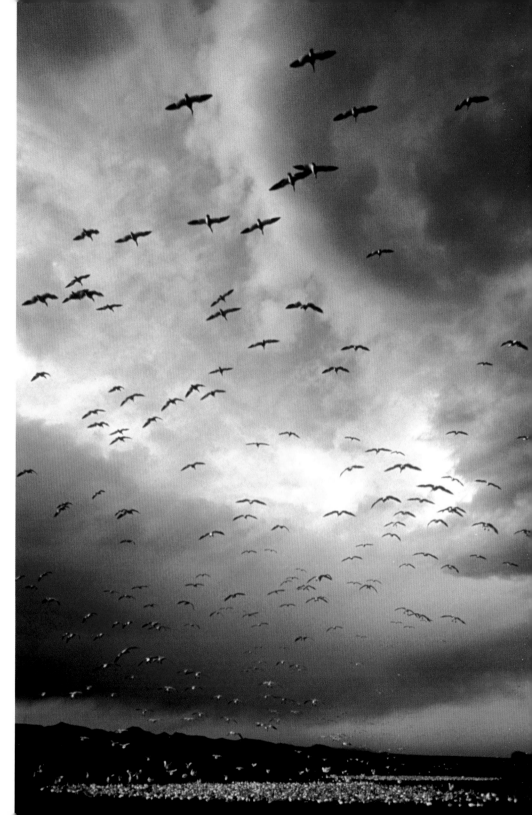

(above and right) More than 35,000 snow geese spend the winter at the Bosque del Apache, feeding in the marshes and surrounding stubble fields following the autumn harvest.

(facing page) Like most waterfowl, snow geese are very gregarious. Even in mass ascensions like this one, collisions and accidents are rare.

Purchased by the U.S. government in 1936 after years of heavy grazing and overuse, the refuge saw a complete rebuilding process during the ensuing years. Habitats were restored, new dikes were built, and irrigation water was diverted to develop and maintain new forests and marshes.

Local sharecroppers were hired to till and farm parts of the refuge, growing corn, sorghum, winter wheat, and alfalfa, with about one-third of the crop going to wildlife consumption while sales of the remaining two-thirds provided a substantial income for those farm families. And with large numbers of bird watchers, artists, writers, and others also visiting the Bosque during the autumn and winter months, business revenues for nearby towns like Socorro and San Antonio have also been enhanced, thereby creating a win-win situation for all.

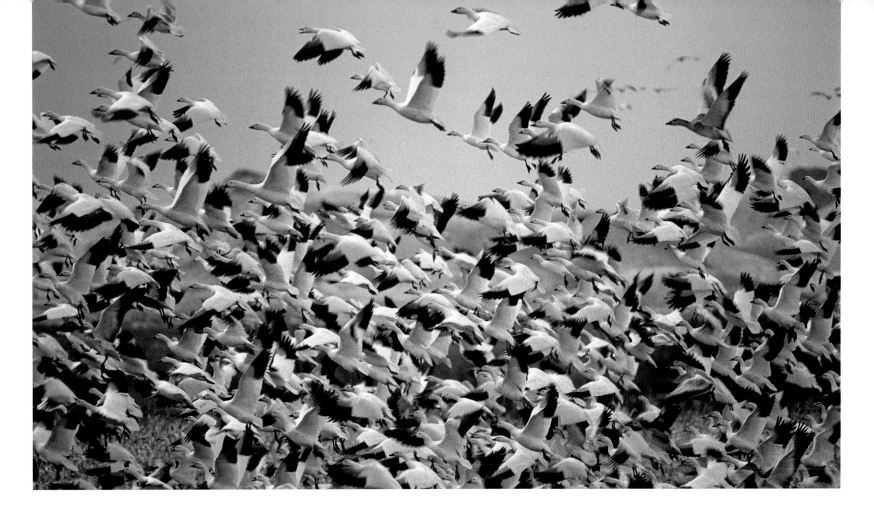

The rapidly falling temperatures of early morning have formed skim ice on the shallow backwaters and marshlands of the river, while mist rises from some of the tributaries, adding even more to the enchantment of this storied and mystical valley.

Everywhere the birds awaken, but the snow geese always seem anxious. In massive and sudden upheavals numbering in the thousands, they rise from wetlands into the sky as they head out to feed in the adjoining wheat and cornfields. The resulting commotion is one that does not overpower, but soothes.

Much slower to awaken are the sandhill cranes.

Silhouetted in the river shallows, standing with their heads customarily tucked into their wing feathers, they look more like large mushrooms with skinny stems. These comical and fabled creatures have long captured the imagination of our own species, having been the subject of ancient folklore from the Inuit people of the Arctic to the Pueblo people of the American Southwest, and continuing today as a frequent focus of writers, photographers, songwriters, and other artists.

Watching the cranes as they shake off the night's slumber, it's easy to see why we identify so strongly with them. They stir . . . they fuss and argue among themselves

. . . they frequently stick their heads back into their wing feathers for a little extra shut-eye. And finally, in groups of twos, threes, and fours, they scamper clumsily across ice-covered water until great wings spanning more than eighty inches carry them into the morning sky. Suddenly they are no longer comical, but the epitome of grace and precision.

It is now nearly three hours since dawn as the last of the cranes depart from the marshlands. What a therapeutic experience it might be if each member of humanity could spend just a couple of days a year sitting here. As you become absorbed in the harmony and synchronization that is ubiquitous in the lives of these soaring creatures, little room is left for vexation and torment. Like a hot pack on a festering sore, they simply draw it from you. The birds have never heard of road rage or the office bully.

Early March. Soon the miracle of the birds will resume as a signal comes from deep within their tiny brains and bids them "go." In whirlwinds of white and smoky gray, their sturdy wings will lift them in mass ascensions from the Bosque wetlands as they soar off into a timeless sojourn that will span most of North America.

In a matter of weeks, the clamor of the birds will fill the skies above the Great Plains of Nebraska and the Dakotas during brief stopovers at wayside stations like the Platte River and Sand Lake. Their journey will soon continue to the nesting grounds above the Arctic Circle as they answer one of nature's most primal urges: procreation.

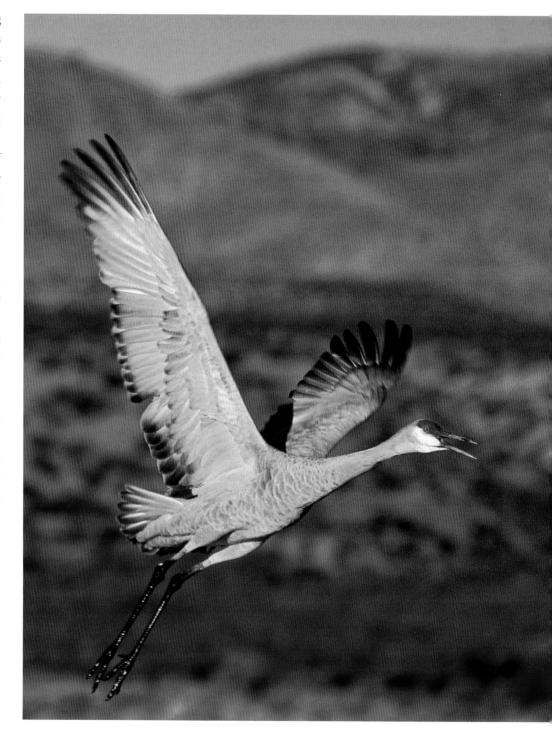

(right) A sandhill crane uses its full six-foot-plus wingspan for takeoff.

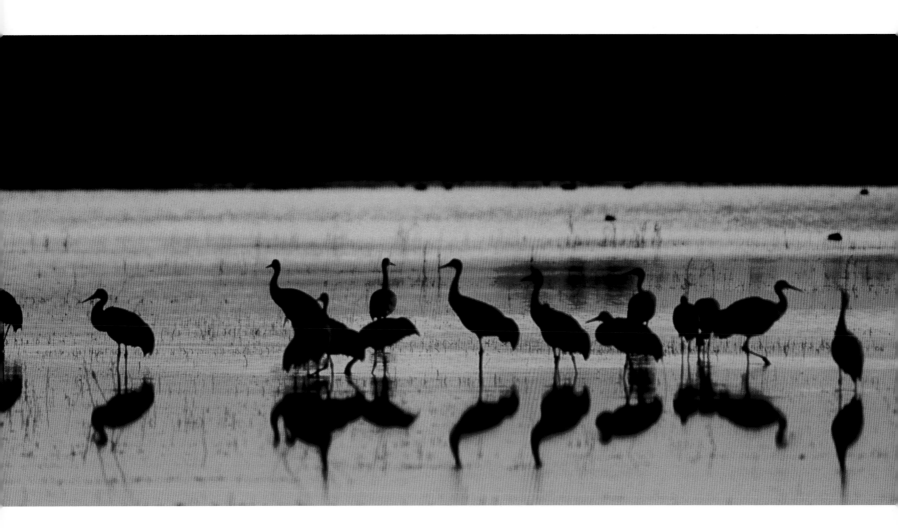

(above) Sandhill cranes awaken at dawn as the sun's glow lights the river marsh.

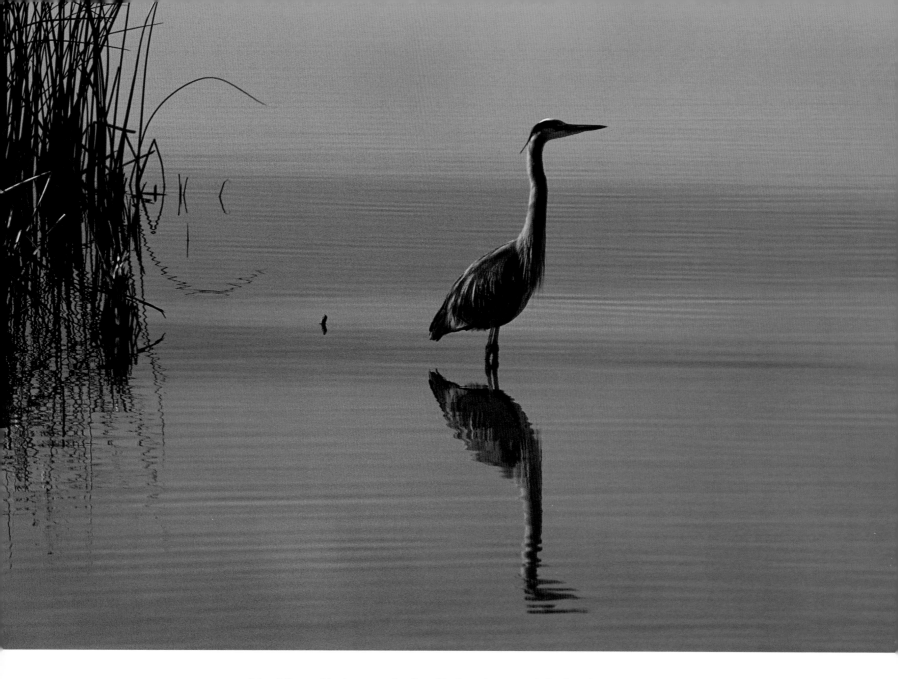

(above) A great blue heron stands reflected in the early morning light along the river bottoms.

124

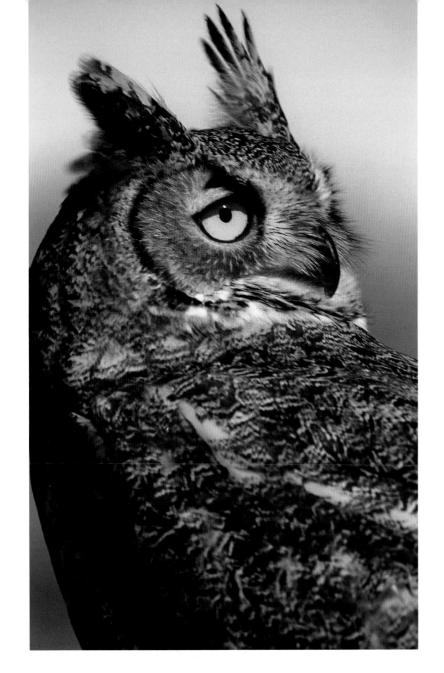

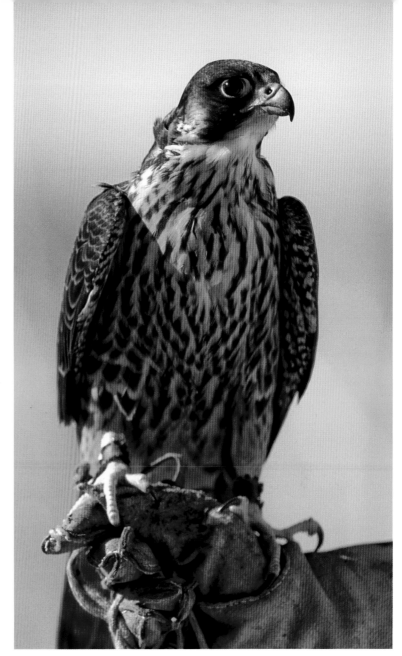

(left) Other residents of the Bosque throughout most of the year include this great horned owl along with numerous other birds of prey such as eagles, hawks, and falcons.

(right) This injured peregrine falcon was found by refuge personnel and nursed back to health. Minutes after this photo was made, he was released back into the wild, much to the chagrin of the refuge ducks that number among his favorite foods.

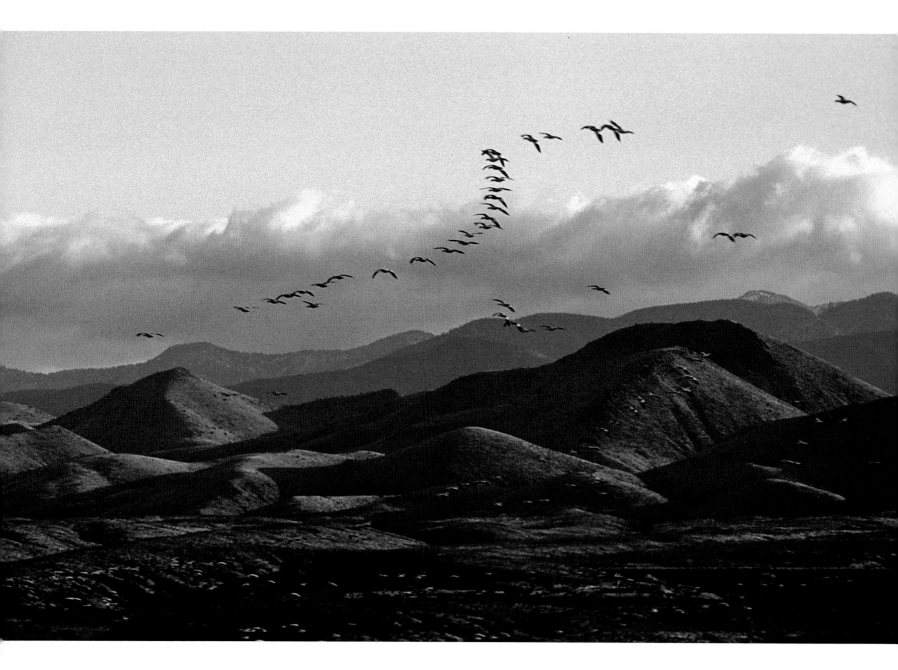

(above) *As the day draws to a close, sandhill cranes fly back into the Bosque past the Manzano Mountains overlooking the valley.*

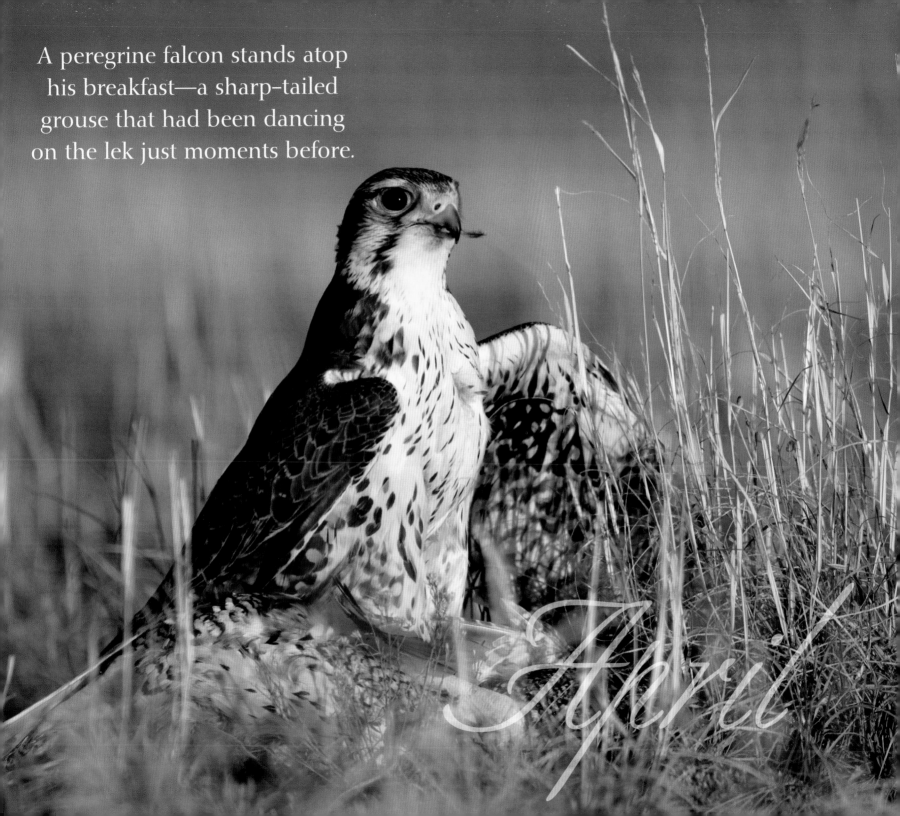

A peregrine falcon stands atop his breakfast—a sharp-tailed grouse that had been dancing on the lek just moments before.

April

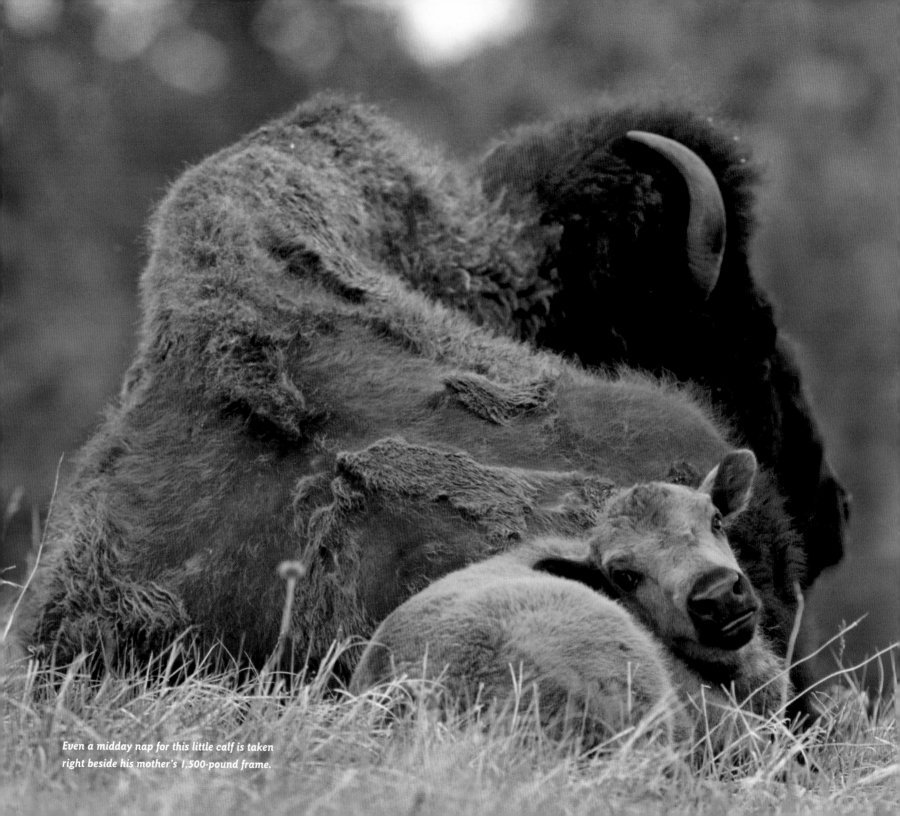

Even a midday nap for this little calf is taken right beside his mother's 1,500-pound frame.

LINGERING CAUTIONS

I can feel their fixed stares closely following me as I move from the front end of my pickup truck around to the back, even as I quickly climb into the box. The eyes remain set on me for a couple of minutes while I ready my cameras for the morning's work. Completing my preparations, I turn one of the cameras around to study this wall of shaggy beasts firmly entrenched about forty feet away.

Those eyes belong to a group of nervous bison cows, most of them mothers of calves no more than ten days old. As is their custom, the cows have encircled an area twenty to thirty yards wide in which are confined a dozen or so of the little golden tykes, protecting them from potential predators. Now most of the young are napping. As I pan my lens past each set of eyes, there can be little doubt as to the fate of any creature foolish enough to attempt entering this circle.

This procedure of "circling the wagons" has been in use by cows like these since the days of the last ice age to reach this far south more than 20,000 years ago. The North America of that day was roamed by large and numerous predatory mammals like the short-faced bear—nearly twice the size of today's grizzly—the saber-tooth cat, the dire wolf, and a lion the size of the current African big cat. An American "false cheetah" (of the genus *Miracinonyx*), was also on this roster.

(above) These cows stand together, forming an encircling wall that protects the newly born calves from predators.

129

Nearly all of those ancient marauders became extinct during the retreat of that last ice epoch, leaving creatures like the timber wolf and cougar as the main predatory threat to bison, with most of that predation confined to calves and sick or injured adults. And even that pressure was severely reduced as wolves and cougars were largely eliminated from habitats where bison typically roam.

But time has yet done little to dull a bison cow's instincts. Here this morning, they continue to defend against predators that haven't existed for 10,000 years, still responsive to ghosts from the past.

Activity begins to stir within the circle as dawn light creeps across the grasslands. A little golden calf, now fully awake from her long night's slumber, lifts her head upward to the sky and draws the morning's freshness into her lungs. A multitude of scents and sounds greets her infant senses as she glances around at a world that still shows her something new and different at practically every turn. Curious eyes only a few days old search the empty grasslands that stretch far beyond the bovine enclosure.

About ten feet away, her mother quietly browses in the mixture of dry winter grass and the deliciously green

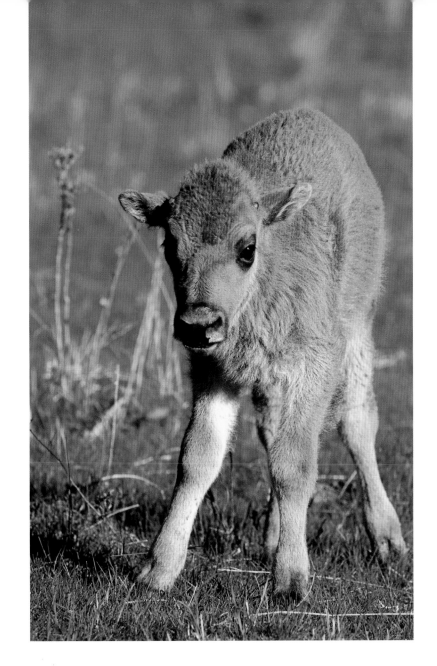 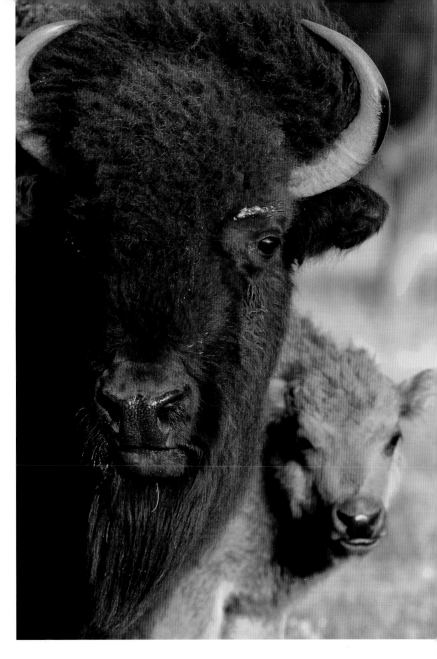

(left) Now a few days old, this little calf seems more sure of legs that were weak
and wobbly at first. She was about sixty pounds at birth.

(right) A young calf glances from behind his mother as she casts a stern look at the stranger in their midst.

(facing page) Even as the herd moves to another area, the young calves are rarely far from their mothers' sides.

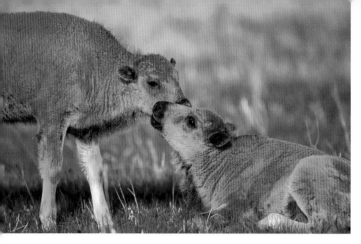

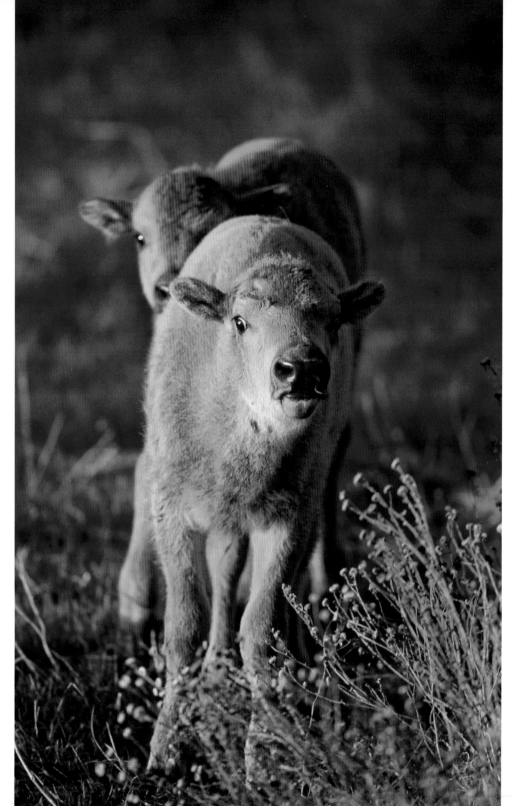

(above) Bison are extremely gregarious animals. Socializing begins immediately between the young.

(right) Two newfound friends look a bit apprehensive as they reach the outer perimeter of the protective circle and ponder their next move.

(facing page) The howls of a distant pack of coyotes break the morning solitude and send the young calf dashing back to the safety of the herd and Momma.

shoots of spring. The rest of the herd spreads out along the banks of a small stream winding through the bottom of a prairie ravine. Pangs of hunger call as the little calf ambles over to her mother's side. The familiarity of the cow's musty scent is reassuring as the tot suckles the warm sweet milk that fills her mother's udder. Soon the cow gently separates the youngster from her swollen teats and moves down to the stream for a drink.

With her belly full, curiosity once more engages the little one's attention—she sees her chance to explore. Now intent on meeting some of the other juveniles that she has previously only observed from a distance, she begins to wander along the stream's banks, away from Momma's protection. Youth must have its day.

Almost immediately her inquisitive eyes are met by yet

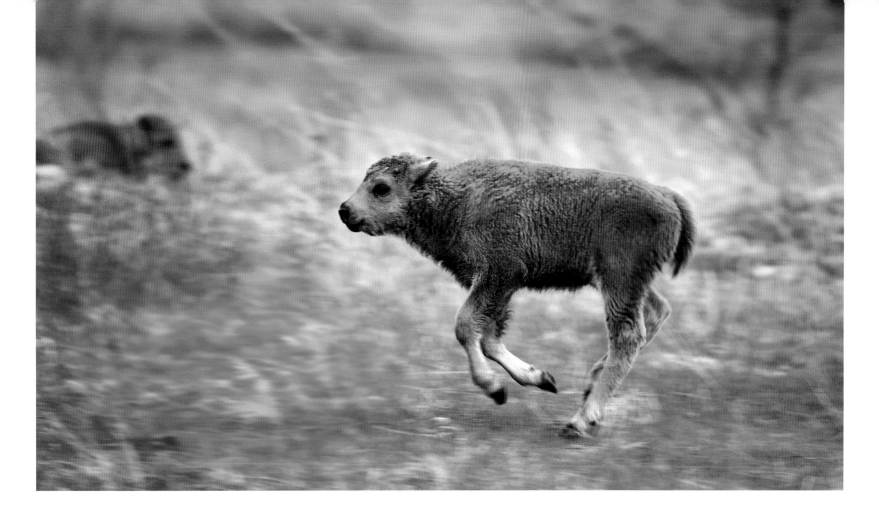

another pair of exploring pupils, belonging to a youngster like herself. The two golden toddlers stand only a couple of feet apart, each studying the other with a mixture of eagerness and uncertainty.

The little calf cautiously inches forward for still a closer experience with her new acquaintance. The two slowly lower their heads, making contact as their noses reach the ground. Both flinch and step back for a startled second, but are soon touching again.

Now the instinct for youthful play takes over as the two sucklings push each other about in this grassy playpen. Friends. Side by side with her newfound partner, the little calf is now confident that they will soon be masters of this vast world. The two set out together for greater glory.

Presently the youthful pair find themselves at the circle's outer perimeter, pondering what might lie beyond that tall grass now awash in amber sunlight. With supreme overconfidence, the little calf begins to wander away from the refuge of the herd, into the unknown. Her partner, not nearly so cocky, turns and quickly heads back into the herd's interior.

Suddenly the morning quiet is broken by a sinister and piercing howl followed by a full chorus of the same. Coyotes! Terror shoots through the little one's heart,

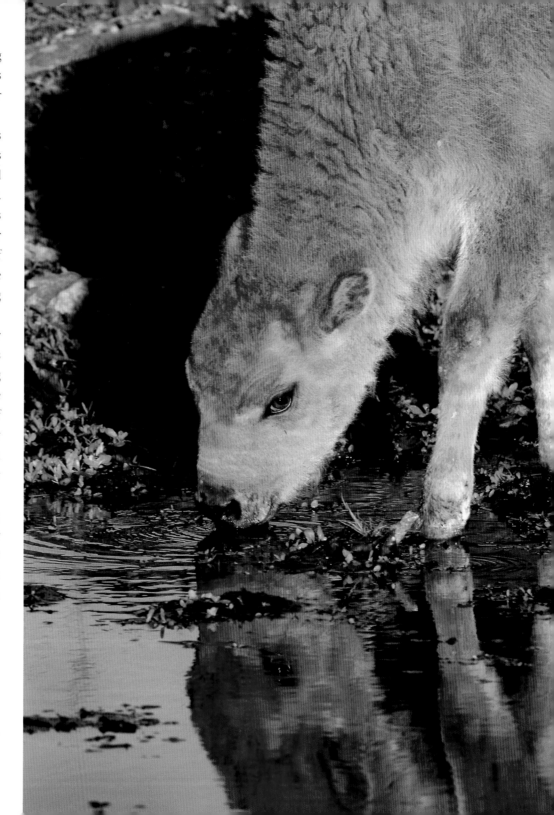

though coyotes are but a small threat even to the young of her species. Her ears flatten to the back of her head as she bolts in blind panic back into the herd, crying for her mother, now lost from her sight.

Standing on the stream bank, the cow lifts her head as the little one's cries reach her ears; she bellows out across the herd in reply. The infant reaches her mother's side and nearly buries her terrified face into the cow's thick coat. Soon the little calf is assured that all is well once again as she partakes of the sweet milk and her mother's familiar scent. With her belly full once more, the little golden calf settles down into the grass for a long nap right beside Momma. There will be no more exploring or conquering of new worlds today.

Again the cautious cows move to close up the inner circle, once more guarding against the "ghosts of predators past" as they display their determination that the young will remain unharmed. I have only to recall my one negative encounter with a bison for a good reminder of this instinctive tenacity—I was once chased by a new mother cow and ended up diving under an old fallen cottonwood tree to escape her reach. It was, of course, my own stupid fault.

This morning will present no such danger, however, as the cows relax and go about their business, caring for and interacting with the young. And while seated safely in the box of my truck, I go about my business, which is creating images of these great beasts of the North American prairies.

(right) A little bull calf casts his reflection in the waters of a prairie pond as he takes a long drink.

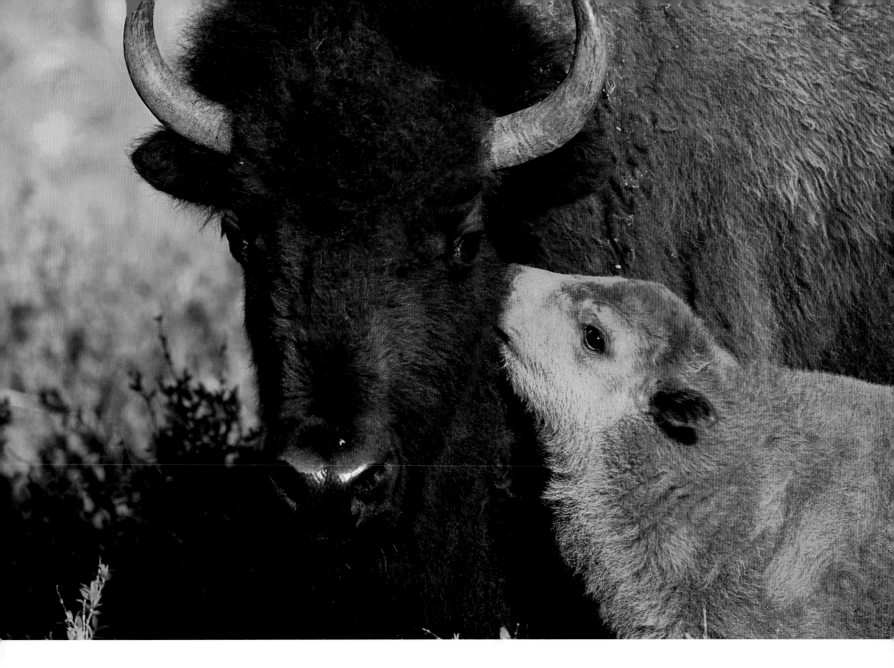

(above) This little calf snuggles against her mother for reassurance and some bonding..

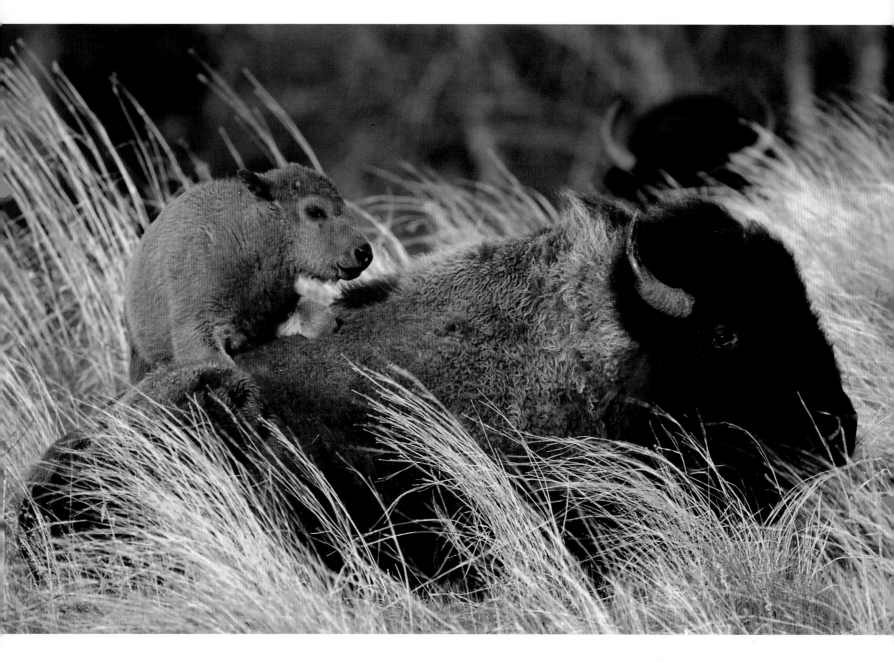

(above) It seems that youngsters of most species can find ways to annoy their parents, like this little
calf pestering her mother for more milk in the grasslands of Custer State Park on an early spring morning.
At least 300 of these little golden tykes are born here every year from mid-April to June's end.

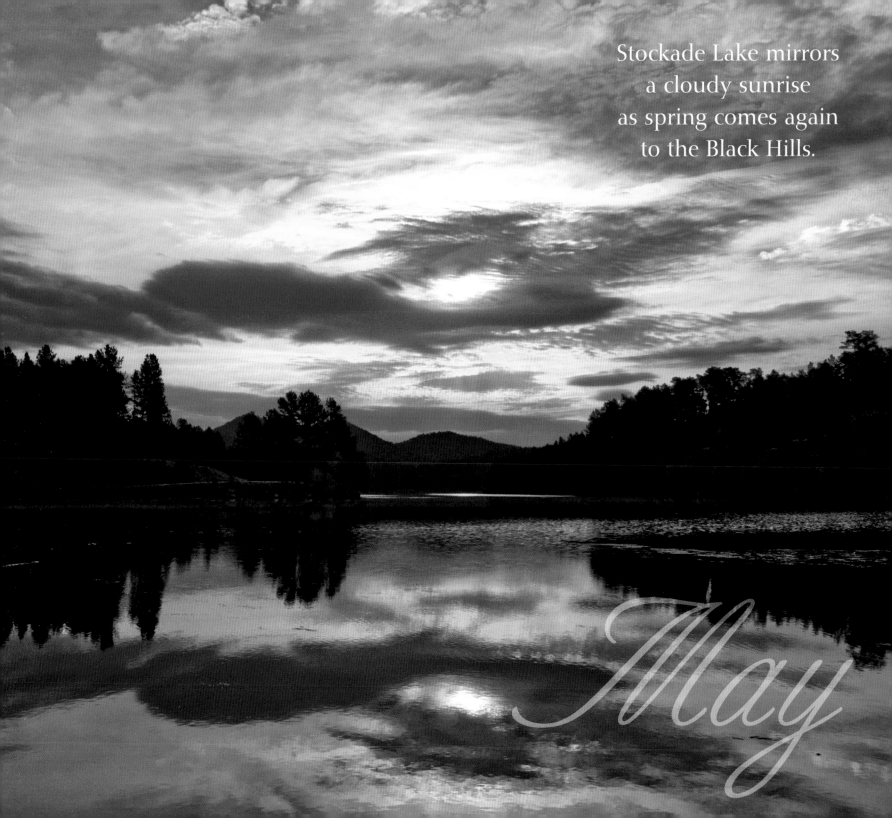

Stockade Lake mirrors
a cloudy sunrise
as spring comes again
to the Black Hills.

May

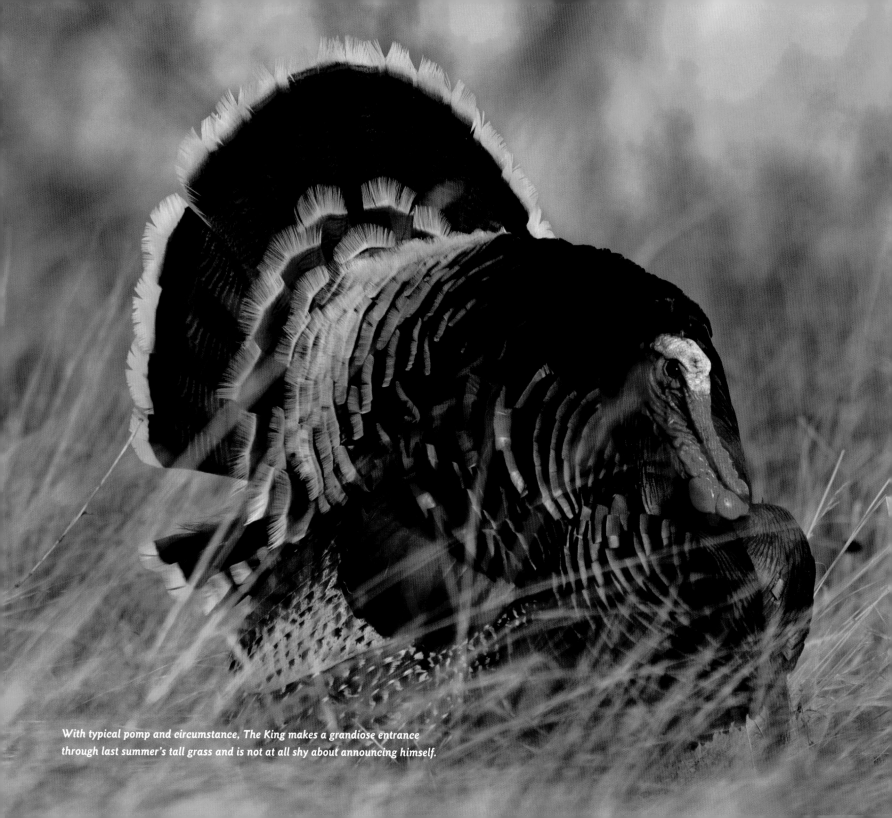

With typical pomp and circumstance, The King makes a grandiose entrance through last summer's tall grass and is not at all shy about announcing himself.

AWAITING THE KING

The light is just beginning to turn that wonderful honey amber color of early evening, right about six o'clock, with maybe an hour of daylight left. It has been a wonderful spring day—temperatures in the high 60s, sunny, and no wind. The days grow noticeably longer at each twilight.

A delightful chorus of bird song and calls fills my ears and resonates from all about: meadowlarks, robins, crows, mourning doves, turkeys, and red-winged blackbirds. It seems as though everyone is applauding the day, giving it a standing ovation. Fitting how at sunset life is content to just rejoice in itself, for its own sake.

Keeping me company with my thoughts is a group of eleven turkey hens busy feeding on the cracked corn that I throw out in an area of prairie grass and cottonwoods about thirty yards from the house. The corn is equally for their enjoyment and mine. I'm awaiting the arrival of the toms. They should be along soon as they are now at the peak of their display period. Already some of the hens have disappeared to begin building nests and laying eggs. Most of my turkey pictures come from this bunch as they all go about their business in several areas surrounding the house.

This past winter brought change with these birds. During previous years, they disappeared in early November despite my cracked-corn meals, and we didn't see them again until early March. This year, they wintered

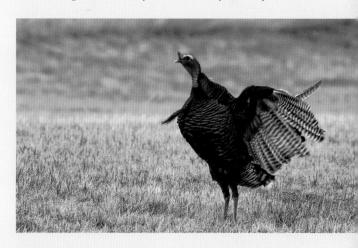

(above) A tom rises up and flaps its wings as it gobbles in a variation of the strutting behavior.

with us as well, roosting in the tall cottonwoods nearby and staying plump on the corn.

I have no idea what changed their pattern, but after a winter of daily feeding, they have become so habituated to me that I'm not sure I can call them wild turkeys anymore. In fact, when I walk out with my coffee can full of corn and begin shaking it, these birds follow after me like barnyard chickens. I no longer use a blind to photograph them.

My attention is drawn back to the birds as I see the toms striding up and out of the creek ravine. This bunch now includes four males: two large and mature ones and two younger that were jakes (immature toms) until this spring. Noticeably absent is the largest of the toms—one I call The King—but I know he will be along. Typically, he makes his entrance only when all are present to observe.

The King is in fact one of the most photogenic toms I have ever seen—never a broken or missing feather in his fan. He is huge and stately, with a bushy beard so long that it literally drags on the ground when he feeds. Perfectly proportioned in every way, his display is nothing less than gorgeous. Each of the other toms falls off just a bit. They still make for nice images, but they are not this bird. And now that he has chosen to winter here, there is even less chance that a hunter will take him, something that I have feared each spring.

The toms begin to display as they approach the feeding hens, showing smaller fans with the middle feathers standing taller and stubby beards. How they pale in comparison to The King. The older tom in this group gobbles a bit, but soon all three birds are distracted by the corn and settle in with the hens to take advantage of this supper.

Breeding gobblers frequently have little time to feed because of the competition for mating privileges. Toms must follow the hens and concentrate their efforts on

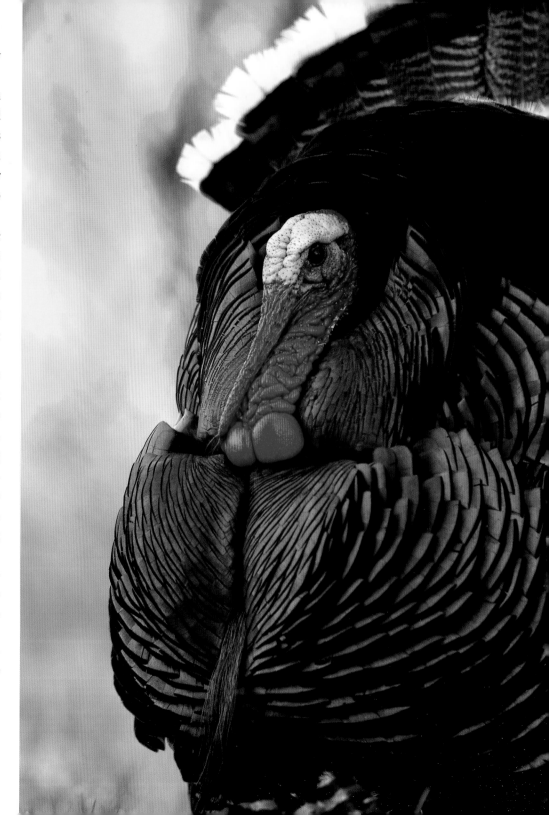

gobbling and strutting or they run the risk of losing hens to another gobbler. Nature has alleviated part of this problem by providing mature males with a large fat reserve called the "breast sponge." Gained by heavy feeding throughout winter and early spring, this body cache can weigh as much as three pounds and is especially easy to metabolize.

After mating, hens usually become very solitary and move away from their wintering grounds to nest. Generally, they will seek a grassy fencerow or the dry part of a creek bed and then wait three or four weeks before starting to build their nests and lay.

A loud and unmistakable gobble resonates from within the cottonwood trees, grabbing the attention of the other birds before me. All three toms gobble back as I see movement coming through the tall grass. Enter His Haughtiness, The King.

The other toms step aside to make way as this grandiose entrance is made. With typical flair and pomposity, the great bird strides forth to greet his subjects, making the usual drumming sound as his secondary wing feathers drag across the ground. His huge fan turns one way and then the other as the lumpy folds of skin under his throat—the dewlap—turn fire engine red and his head takes on a complex pattern of white and bluish-purple.

Elvis has entered the building.

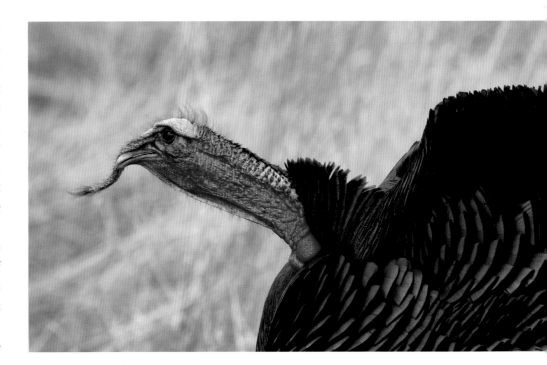

(facing page) The turkey's brilliant plumage is shed once a year—usually at midsummer—except for the beard, a tuft of long, bristle-like feathers that grows from a gobbler's breast and is permanent.

Gobbling by the male turkey (above) is a long-distance call and is meant to attract hens. Occurring mostly at dawn, the gobbling can be heard by human ears more than a mile away. The renowned strutting antics (right)—feathers puffed up and tail widely spread—are generally saved for when hens are present.

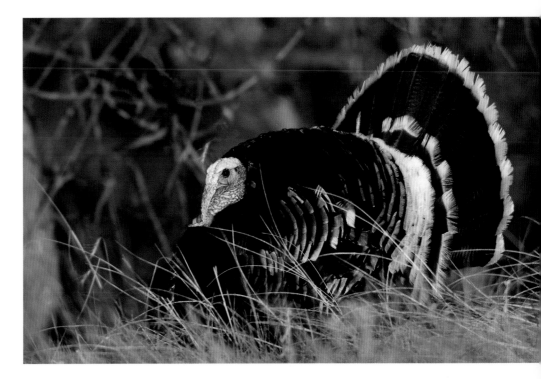

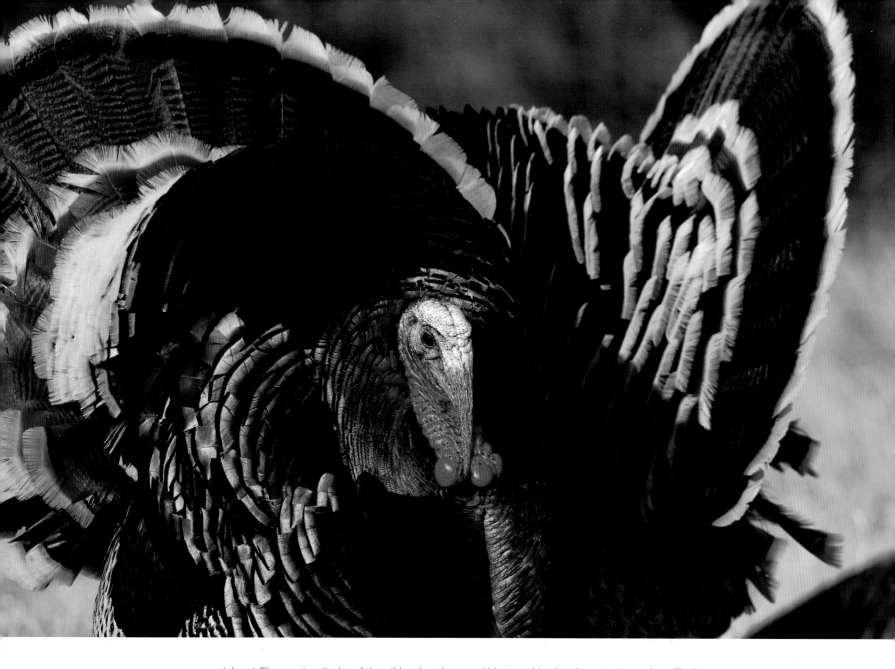

(above) The courting display of the wild male turkey or gobbler is nothing less than stunning as he ruffles his body feathers, fans his huge tail, and quickly changes his head colors from red to white to bluish-purple. His feather colors are a dark, glossy, metallic bronze mixed with golden, bluish, reddish, and greenish iridescence. In certain light, his plumage seems to contain all the colors of the rainbow.

142

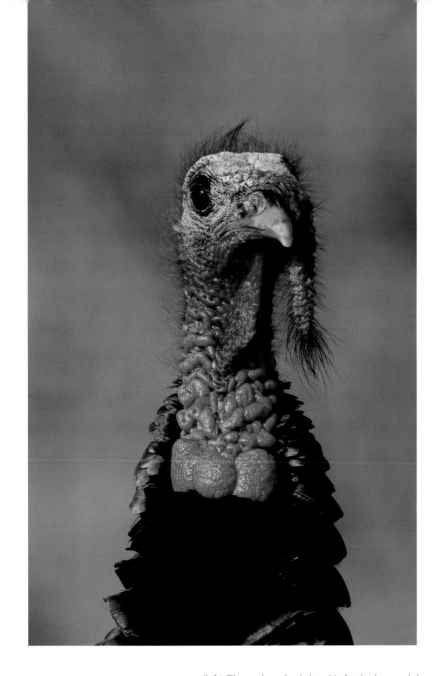 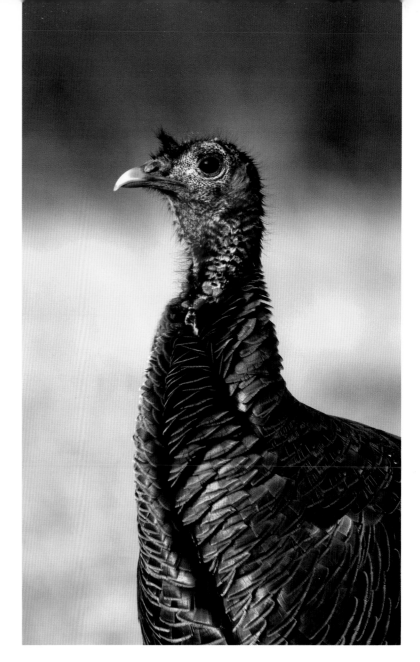

(left) The male turkey's head is featherless and decorated with bright red and blue warty skin, including a
fleshy protuberance called a snood hanging from the forehead. Color changes in the head can occur in seconds.

(right) The hen is somewhat smaller than the male, with more feathers around her neck and,
like most ground-nesting birds, a duller plumage. This allows her to better
blend into her surroundings while she is nesting. Her snood is tiny.

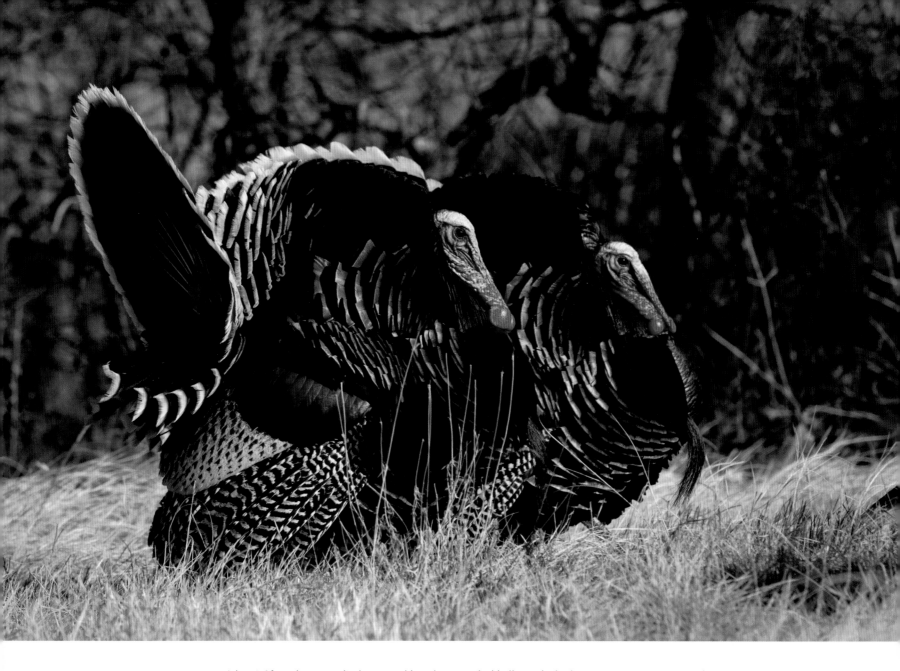

(above) Often, the spring displays resemble a choreographed ballet as the birds seem to move in unison with each other. Other times, the encounters take on the look of prizefights, although this group has always been peaceful for the most part. Some males are content to play a subservient role to a more dominant gobbler, such as here—gobbling with him and even acting as his bodyguard. Sometimes three or four gobblers will form a temporary mating alliance, but only the most dominant bird, such as The King, will do any of the mating.

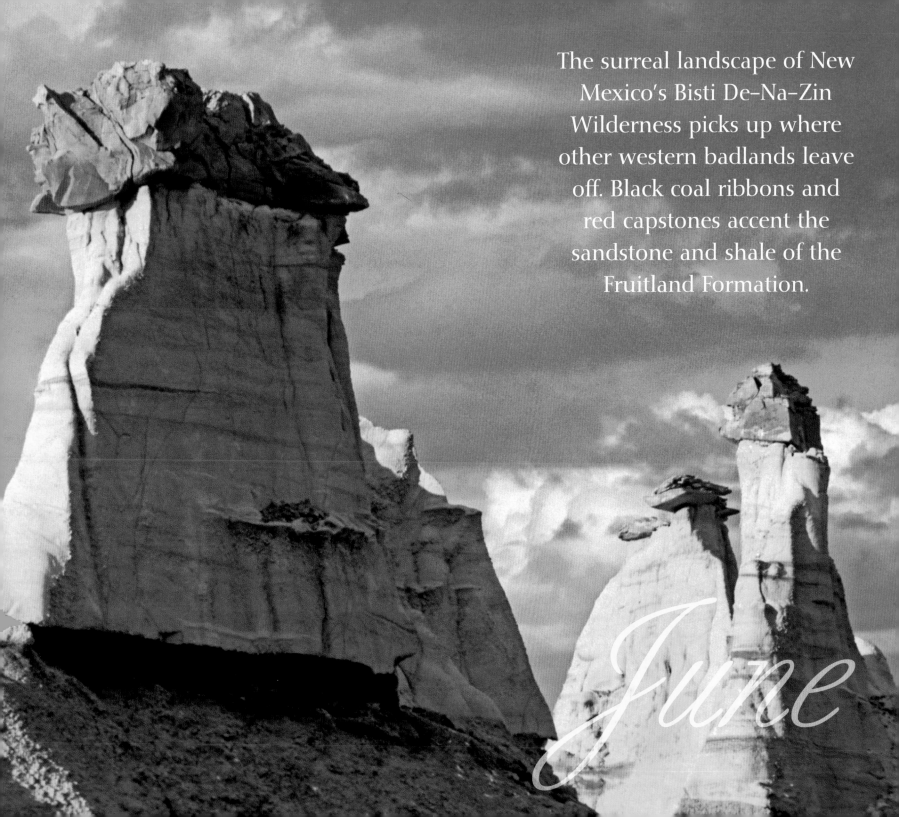

The surreal landscape of New Mexico's Bisti De–Na–Zin Wilderness picks up where other western badlands leave off. Black coal ribbons and red capstones accent the sandstone and shale of the Fruitland Formation.

June

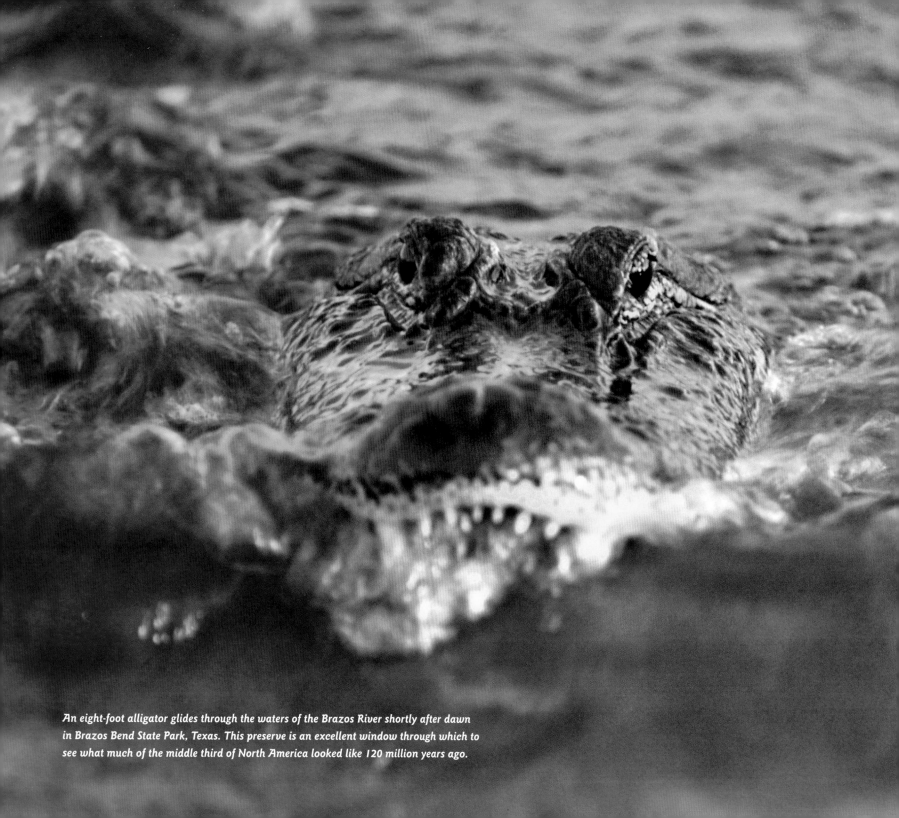

An eight-foot alligator glides through the waters of the Brazos River shortly after dawn in Brazos Bend State Park, Texas. This preserve is an excellent window through which to see what much of the middle third of North America looked like 120 million years ago.

AMONG THE ANCIENTS

His huge eyes seem riveted on me as the creature glides effortlessly against the current of this tributary stream from the Brazos River, heading right in my direction. Though I really have nothing to fear, something about those eyes still makes me a bit uneasy—those eyes of another world.

I am stretched out across a small wooden bridge that hangs about three feet over the water's surface. Surrounding me on this morning is a diverse realm of bayous, lakes, ponds, hardwood bottomlands, and tallgrass coastal prairies that are Brazos Bend State Park, one of the most abundant wildlife preserves in the state of Texas.

The heavy and aromatic fragrance of the rich soils here fills the senses. Everything feels and smells so fresh, so new—as though all of it was created overnight and is just now revealing itself to human beings for the first time.

Already my terrycloth headband is wet from sweat as the thick, humid air rules this June morning. All across the river bottomlands life is busy. Dew gathers on wildflower petals and spider webs, while hummingbirds and huge butterflies dart from one blossom to another in search of a sweet reward. White-tailed deer feed among the live oaks draped with Spanish moss. The high-pitched chirp of the anhinga, a large fishing and wading bird, resonates through the swamp with the familiarity of a Tarzan film soundtrack.

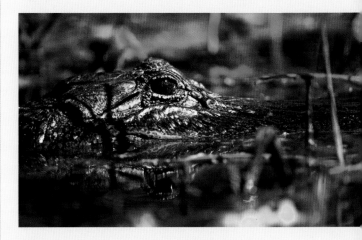

(above) Gators spend much of their time lying low in reeds, waiting for prey.

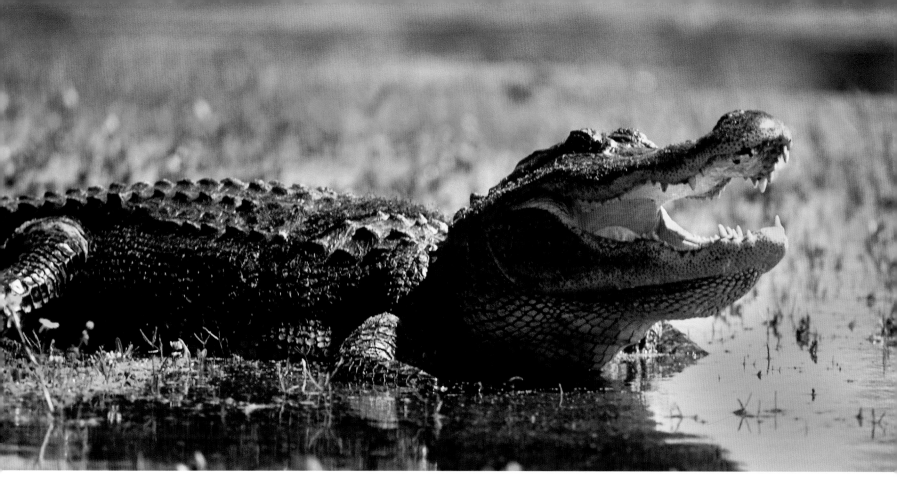

(above) This fourteen-foot male gator gives out its mating roar while basking in a Brazos swamp on a warm morning.

(facing page) An alligator's teeth, usually numbering around twenty on each side of each jaw, are constantly replaced as they get old or worn. Differing from crocodiles, a gator's lower teeth fit into sockets in the gums of the upper jaw. Having no pore system, alligators ventilate themselves by panting, much like dogs.

The eyes continue their approach as I keep my lens focused on them and shoot. They belong to an American alligator, this one about eight feet long—not particularly large for members of his species that regularly grow to more than twelve feet. But as the fearsome-looking reptile reaches the bridge with teeth showing, I'm thinking that an eight-foot alligator could probably ruin my day if he so decided. Oh well, nothing to do now but just sit tight.

An electrifying thrill rips through my chest as the gator passes right under the bridge—and me—though paying little attention to my presence. Still breathing heavily, I watch him head down the stream, probably to a basking spot in the growing sunlight or to one of the swamp's deep pools to lie in wait for prey.

Dating back more than 120 million years, the alligator is a remarkable link to the Cretaceous Period, an ancient

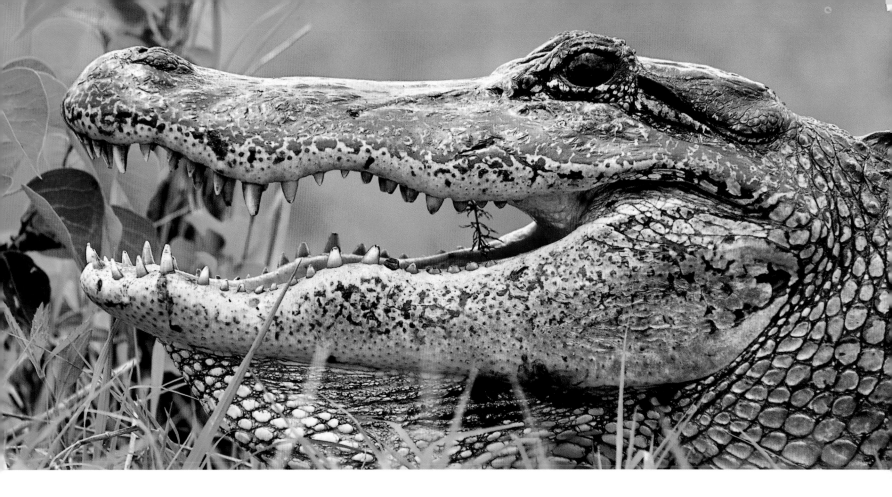

world of reptilian glory within another era in the life of Earth. It was a time of high sea levels around the globe, with a greenhouse climate engulfing much of North America. What is now the American Southwest was largely a shallow inland sea with an extensive tropical shoreline. There were no Rocky Mountains as yet, nor even a Grand Canyon.

Beyond that tropical shore lay a vast delta plain, a coastal belt of swamps with river mouths and steamy tropical forests. Vegetation was everywhere. Huge conifers rose above a jungle of ferns, palms, and other flowering plants. The stench of rotting plant matter filled the ponds and swamps, while huge river channels flowed slowly

to the sea. Like Brazos Bend today, these waterways were choked with life. There were worms, insects, clams, oysters, snails, bony fishes, rays, salamanders, frogs, and turtles, with crocodiles and alligators ruling the aquatic food chain.

Around those giant waterways, dinosaurs dominated the landscapes. There were plant-eating and amphibious hadrosaurs or duckbills, horned ceratopians, and heavily armored ankylosaurs. Above the forest flew the birdlike pterodactyl and pteranodon, hunters of small game. Lurking in the dense undergrowth were turtles, snakes, lizards, and small opossum-like creatures—the rudimentary beginnings of Mammalia.

Standing at the top of this food chain was the ferocious *Tyrannosaurus rex.*

This Gulf Coast region lying about fifty miles south of Houston saw little human settlement until after the Texas Revolution of 1836. Then the Brazos River became one of the principal commerce routes for early Texas. More recent times saw these abundant bottomlands used for cattle grazing and pecan harvesting until 1984, when this "bend in the river" was established as a Texas state park.

In a sense, Brazos Bend itself is a remnant of the Cretaceous Period, though most of its present-day inhabitants, save the alligator and a few others, bear little resemblance to those of that ancient time. This landscape is not one that my imagination embraces. I am a prairie person and cannot imagine living without that vast open space that is the Dakotas, Nebraska, and Wyoming.

However, each time I visit here, I try to drift back and visualize that time when much of the contiguous United States looked similar to the vista before me this morning. For the Brazos landscape is exciting, and part of that exhilaration lies in understanding what a diversified life our planet has led and is leading. Even my beloved prairies once looked more like Brazos. And who knows that they may not take on that look again some day.

(right) A great egret's reflection is cast in this lagoon as he preens feathers under one of his wings.

(facing page top) Common on the Mexican and Texas Gulf Coasts, the black-bellied whistling duck is unique with its high-pitched, four-note whistling call.

(facing page bottom) About the size of a barnyard chicken, the brightly colored purple gallinule is commonly seen in the swamps and marshes of Brazos using its very long toes to walk on lily pads and up into low reeds.

150

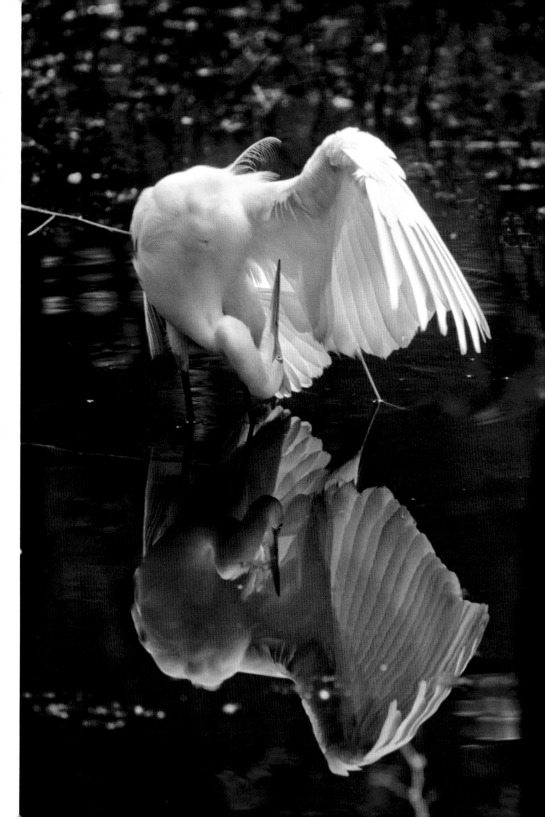

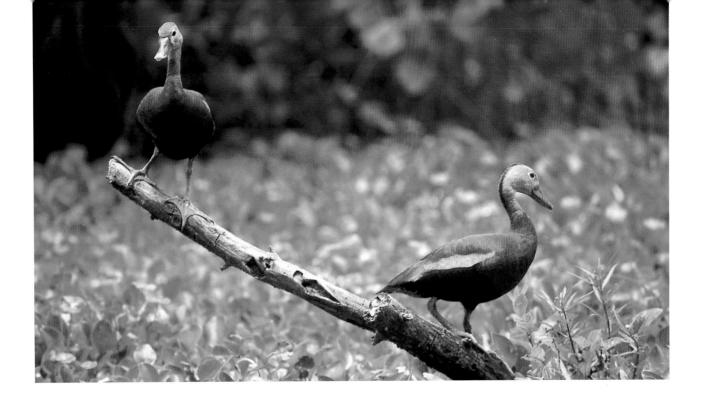

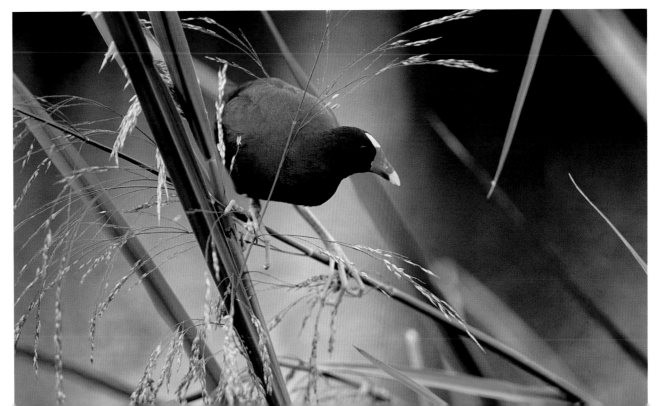

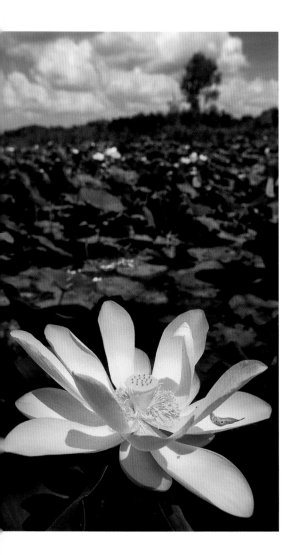

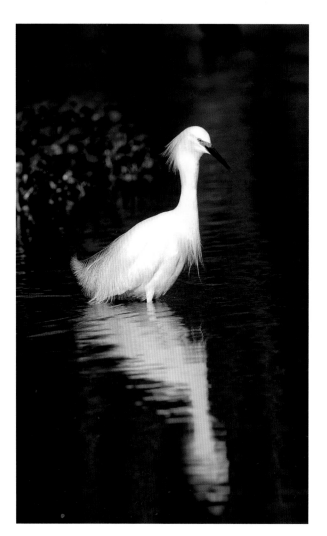

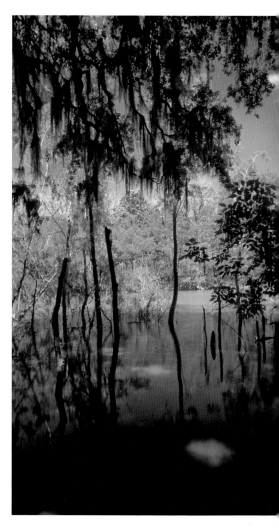

(left) American lotus blossoms are huge, growing to more than one foot in diameter.

(middle) Snowy egrets were pushed almost to extinction for their long, lacy plumes, popular for hat decorations during the nineteenth and early twentieth centuries. Protection has revived numbers.

(right) Spanish moss hangs from tree branches above this deep swamp pond.

(facing page) A red-eared slider turtle makes its way down a log and into the water.

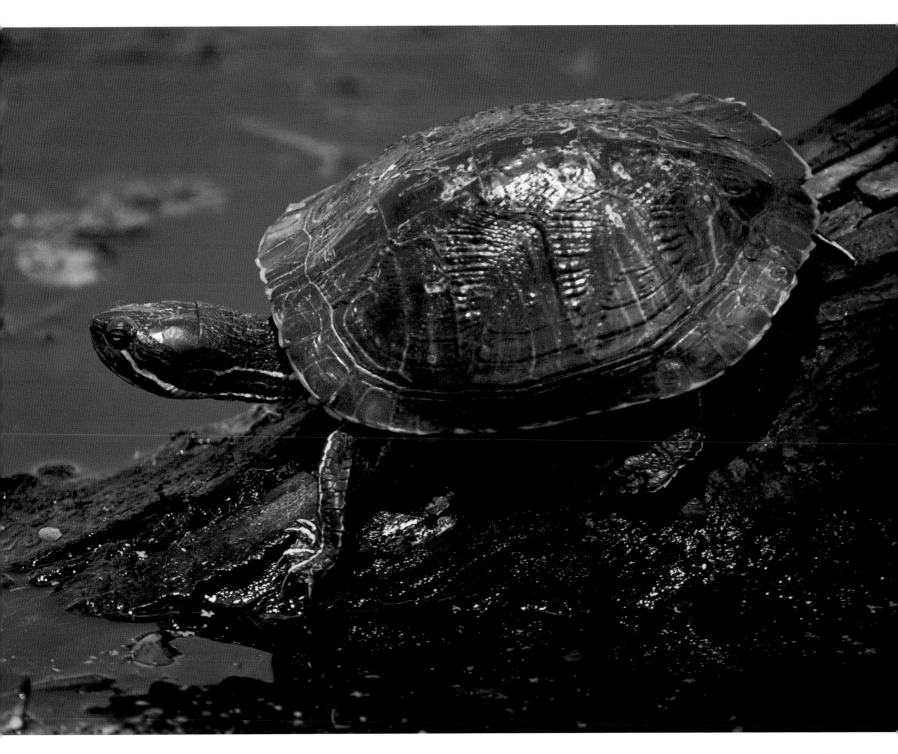

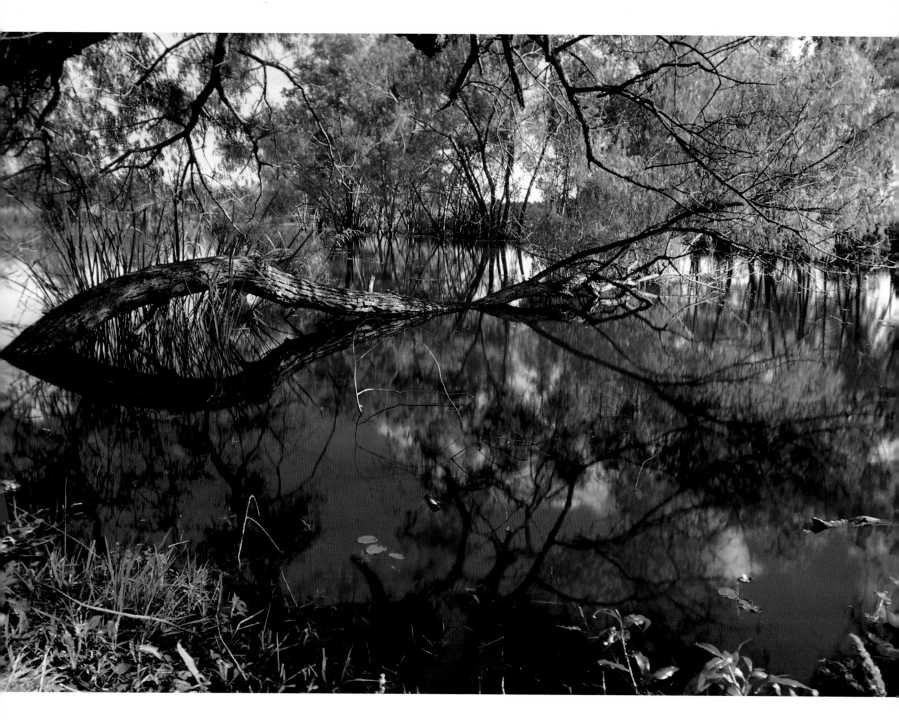

(above) Live oaks do well in wet and flooded lands, living very long lives.

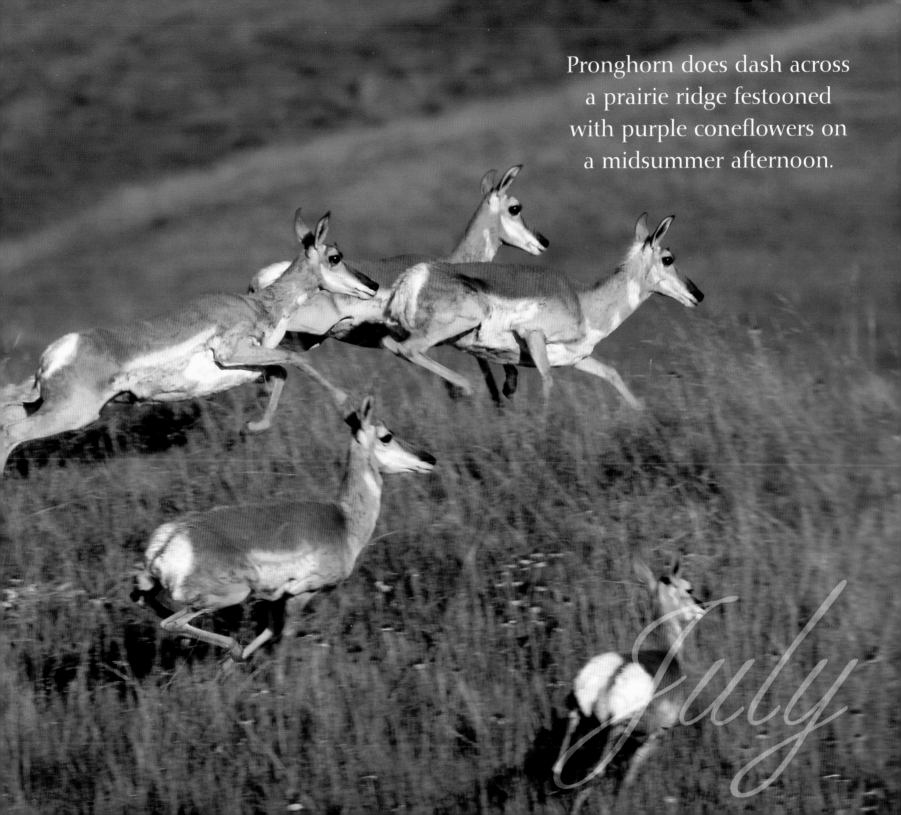

Pronghorn does dash across
a prairie ridge festooned
with purple coneflowers on
a midsummer afternoon.

July

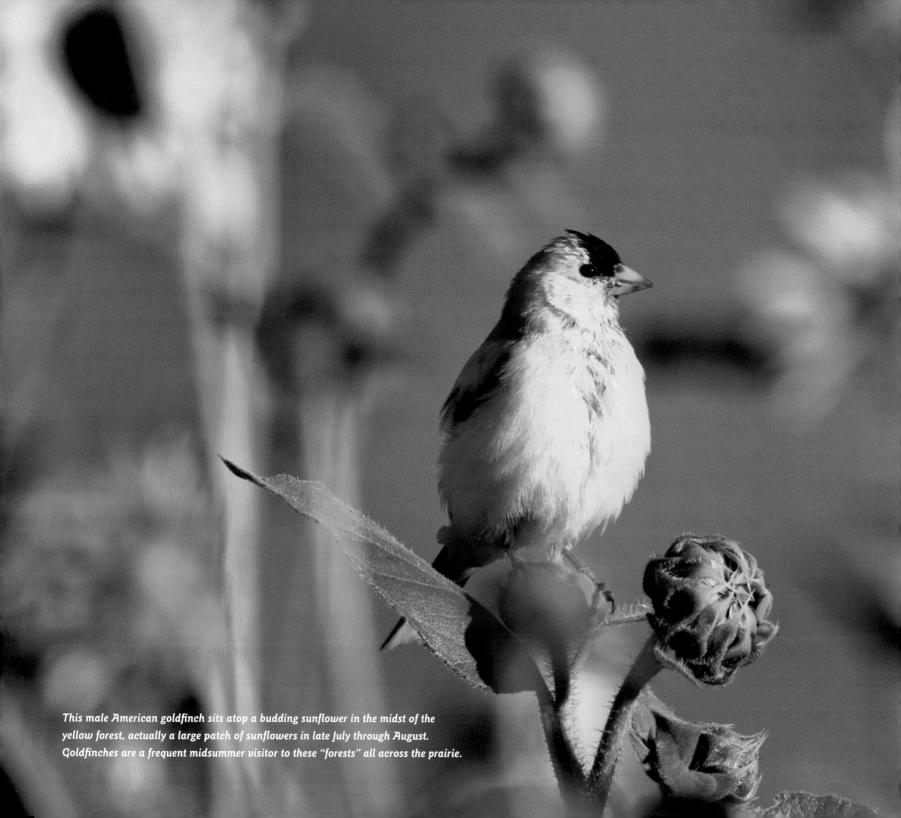

This male American goldfinch sits atop a budding sunflower in the midst of the
yellow forest, actually a large patch of sunflowers in late July through August.
Goldfinches are a frequent midsummer visitor to these "forests" all across the prairie.

THE COLOR OF OPTIMISM

The morning light slowly creeps across the grasslands as the sun makes its emergence from behind a distant ridge and begins to illuminate the interior of what I affectionately call the yellow forest. Scattered clouds enveloping the eastern horizon periodically hide that sun, causing the intensity of the dawn light to rise and fall on this day in late July. Already, life is busy throughout the forest with its buzz, chatter, and clamor filling my ears.

The air is refreshingly cool and damp this morning, having been finally made so by the rains from the last few nights. The dampness is much welcomed in a summer that began all too dry, but hopefully will end better. The heat of midday will feel a bit humid, but only by our standards of course. They would surely laugh at us in places like Minnesota and Iowa for even suggesting that we know anything about humidity here on the arid and shortgrass prairies.

"The yellow forest" is my own term for the very large sunflower patches that typically make their appearance here and across the high plains during late July. This is the season of yellow as that wonderful color begins to dominate the scene everywhere. Funny how, as the rich greens of May and June begin to brown and fade, the prairie actually puts forth some of its brightest and largest

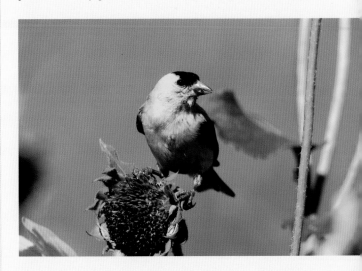

(above) At this time of the year the male goldfinch is a brilliant yellow so as to attract a mate. These birds are late nesters, timed to match more abundant food supplies.

157

(this page) Other insect visitors who make a living in the yellow forest include grasshoppers, honeybees, bumblebees, and wasps.

(facing page) A large monarch butterfly feeds on the sweet nectar of a sunflower on a hot July morning. Toward the end of summer, these vigorous, beautiful insects will migrate to an ancient wintering ground in the mountains of central Mexico.

perennials—as though consoling us for the approach of summer's end.

While the North American prairies are blessed with many stunning and beautiful wildflowers, I have long believed that the sunflower ranks first, being a marvelous accomplishment in composition, tonal range, and graphics. Improvement will be difficult, even for nature, as the sunflower is one of her finest works of art.

The blossoms of these huge perennials measure as much as five to six inches in diameter and sit atop stems often growing to several feet in height. Their glow in the early morning light more than demonstrates how the sunflower got its name. As sunflower patches spread across sandy ravines, hillsides, and creek bottoms, they give the appearance of the prairie being splashed with buckets of yellow paint. We see what the color yellow was meant to be.

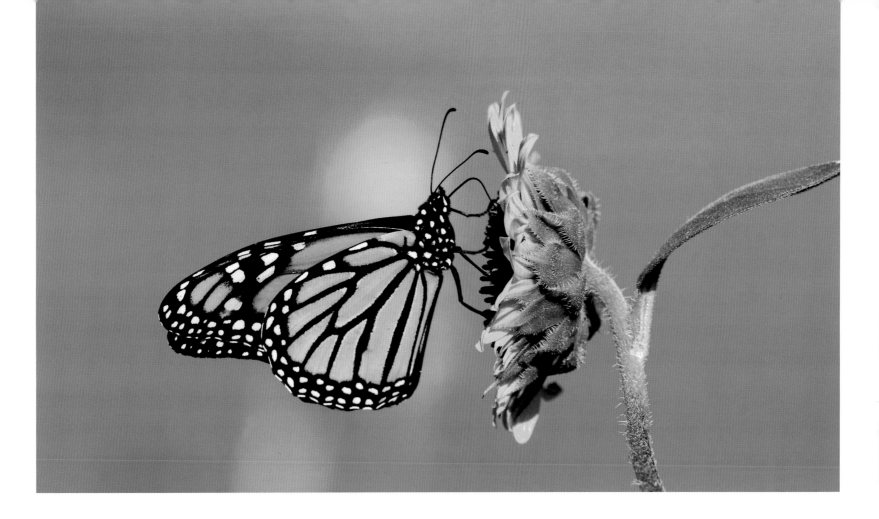

But not only is the yellow forest a study in color and composition, it's quite a little ecosystem in its own right. Throughout the day, there are numerous visitors, not just me. Monarch and swallowtail butterflies, bumblebees, honeybees, wasps, and several species of birds are among the many callers that make a living on the rich nectar and seeds of the sunflower blossom. Even an occasional coyote stops by in search of a rabbit.

My favorite of these visitors is the American goldfinch. Standing little more than three inches high, this tiny bird is most often seen here perched on the dried pods as it feeds on the seeds. With a conical beak in addition to agile and oversized feet that help it grip the stems of seed heads while feeding, these birds are particularly well adapted for seed consumption.

They seem to have little shyness or fear of humans. If I just sit quietly for even a few minutes, these happy little birds soon surround me as they jump, fly, and flit about. And their jubilant little warble only adds to the cheer of the yellow forest.

Like the sunflower blossom, male goldfinches are a vibrant yellow at this time of the year, mainly for the purpose of attracting a mate, as this time marks the beginning of the breeding season. The abundant food

supplies available now are thought to be the main reason the goldfinch's mating season comes later than that of most other birds.

The females are a duller yellow-olive that helps them blend better into their surroundings while sitting on the nest, less likely to attract the eyes of predators. In autumn, both sexes undergo a complete molt, turning a subdued grayish brown for the winter months.

But for now, yellow is found everywhere, dominant. I find this color to be one of optimism that instantly attracts and soothes not only my eye, but also my mind's eye. How easy it is to sit among the sunflowers for several hours, waiting for a butterfly or goldfinch to land or perch in just the right way, in just the right light. Such is a morning in the yellow forest; such is the power of yellow.

Ah Sunflower, weary of time,
Who countest the steps of the sun;
Seeking after that sweet golden clime
Where the traveller's journey is done.
WILLIAM BLAKE

(right) The relationship of creatures in the yellow forest is both cooperative and adversarial—sunflower blossoms are shared by a monarch butterfly with this small bug.

(facing page) A female goldfinch bends over to feed on the seeds of this sunflower blossom. As with many birds, females are more subdued in color—being a less brilliant yellow and brown—so that they blend better into their environment and escape the notice of predators while they are nesting. The goldfinch's conical beak and oversized feet that help them grip the stems and tops of seed heads make these birds ideal for seed feeding.

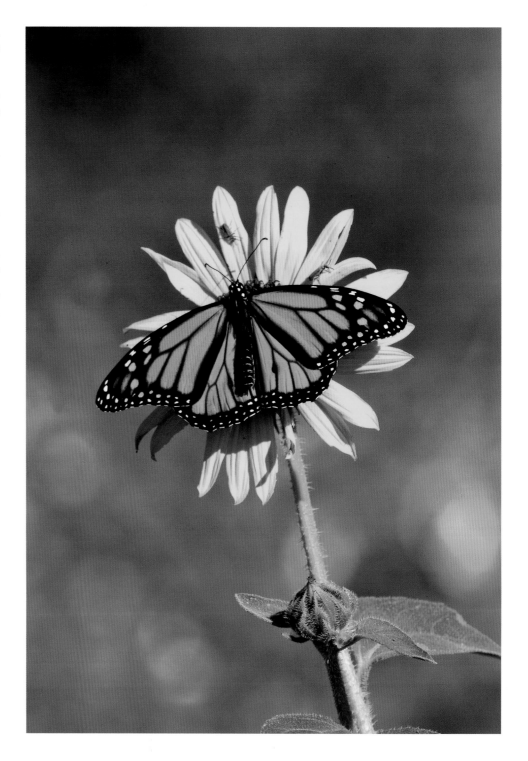

(above) The sunflower plant, an annual, is taprooted and can reach a height from two to eight feet. Blossom heads have seventeen or more rays or petals at least one inch long. These blossom heads are highly palatable and are grazed by both livestock and wildlife. Native Americans extracted oil from the seeds for hair dressing and cooking, while also grinding a meal from the seeds for making bread and thickening soups.

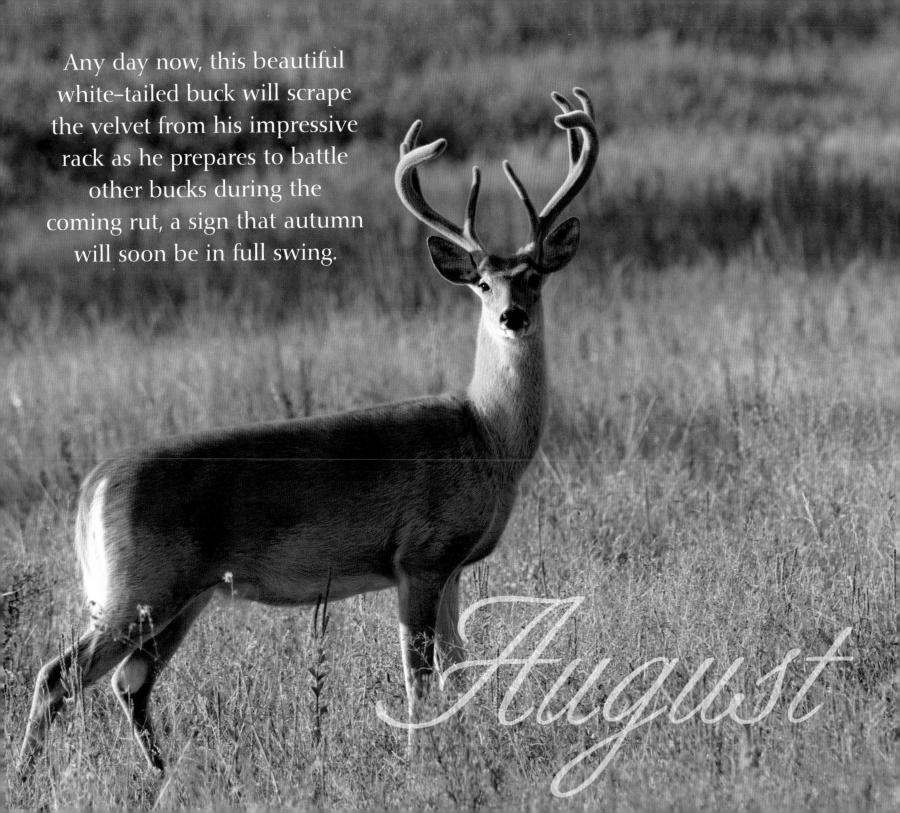

Any day now, this beautiful white-tailed buck will scrape the velvet from his impressive rack as he prepares to battle other bucks during the coming rut, a sign that autumn will soon be in full swing.

August

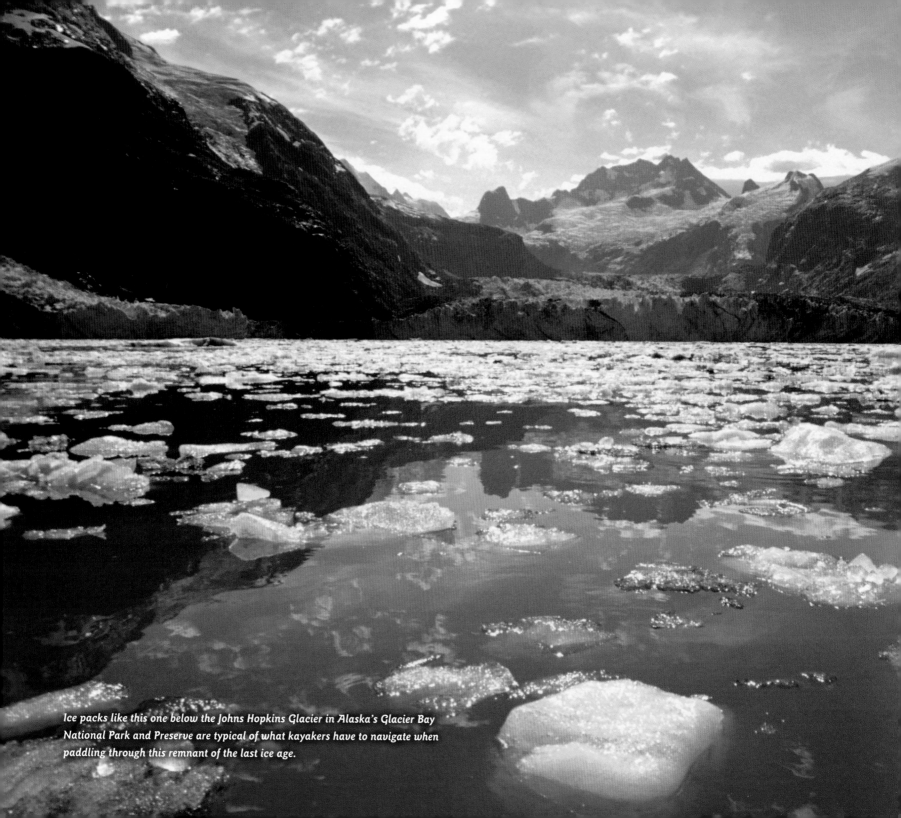

Ice packs like this one below the Johns Hopkins Glacier in Alaska's Glacier Bay National Park and Preserve are typical of what kayakers have to navigate when paddling through this remnant of the last ice age.

CATCHING
THE WAVE

Drifting chunks of ice scraped and nudged along the fiberglass hull of the sea kayak, sending nervous twinges up my spine. Then my entire body stiffened as the submerged section of an iceberg the size of a school bus touched the kayak's underside, making a screech like teacher's chalk on a blackboard.

I could hear Steve Yeager, my paddling partner, muttering anxiously behind me as he stepped down hard on the rudder's pedals and steered us sharply away from that imposing piece of ice. We both breathed a sigh of relief as we ran clear of the berg and toward open water. Though we had picked our way through ice packs more dense than this one, neither of us was very comfortable about it yet.

"You know, I keep having visions of the *Titanic* when we do that," remarked Yeager nervously. "Yeah, me too," I replied. "Hey, if ice could do in the *Titanic*, then how much trouble would this little kayak be?" That set poorly with Yeager as he retorted, "I don't wanna hear that. Jerk." We chuckled together, sharing our tensions.

The place was Glacier Bay, Alaska—a remnant of the last great North American ice age that is now a 3-million-acre national park and preserve. We had put in at a small cove off Lamplugh Point near the entrance to the Johns

(above) A single iceberg is lit by the final glow of a setting sun just two hours before midnight.

Hopkins Inlet. A few hundred yards down the shoreline stood the Lamplugh Glacier, its bluish face aglow in the darkening background on this August evening. The day was nearing end with only a whisper of light left on the surrounding mountaintops.

Our real interest here this evening was a 100-foot rise just behind the beach that seemed ideal for a base camp from which we could spend the next few days exploring the Hopkins Inlet. There was easy access to the top by way of a dry creek bed plus a glacial stream running nearby from which we could take fresh water. We had heard of this spot from a backpacker named Mark whom we had met that morning. He was the first human we had seen in nearly a week.

Carefully we grounded our craft on the gravel beach. With my cameras and lenses packed into waterproof bags, I turned and handed both bags to Steve. The plan was to unload the rest of our gear, then carry the kayak up and secure it in a place out of reach of high tide. To avoid stressing the hull, a kayak must be loaded and unloaded while in the water.

With bowline in hand, I was casually stepping about in the water looking for a place to tie off when the evening was suddenly shattered by an ear-splitting crash from the Lamplugh Glacier. That sound went through me like a lance as the hair on my neck stood up. Lamplugh

(right) Glacial stream waterfalls like this one are typical in Glacier Bay, many as high as skyscrapers, pouring down vertical walls.

(facing page) Two harbor seals eye their surroundings as they awaken from a morning nap on an iceberg in the Johns Hopkins Inlet. The seals also use this area and the icebergs for whelping their pups, usually during June.

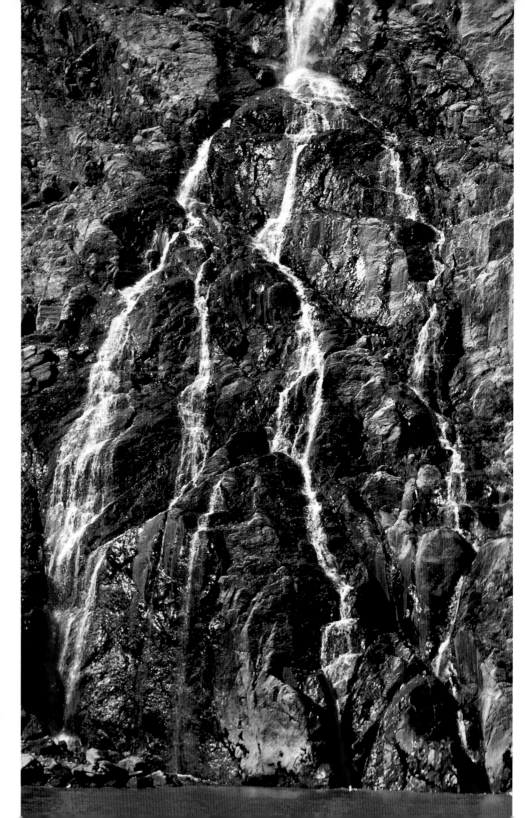

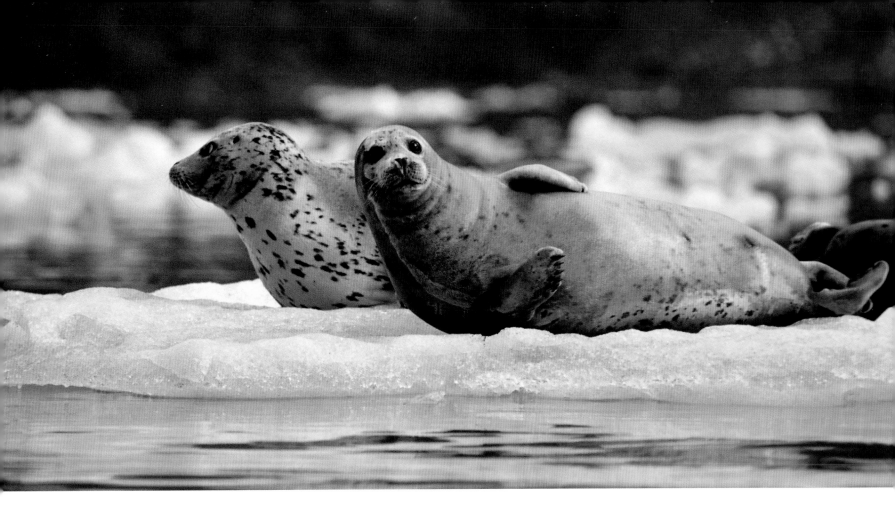

had dumped a gigantic load of ice into the fjord in a monumental iceberg calving.

In an instant, the water drew back along the entire shoreline as though taking a deep breath, drawing the kayak out with it. Clutching the bowline, I tried to dig in my heels as the force jerked me forward and off my feet. I was on my hands and knees in the surf when I looked up and saw it—a massive wall of water coming right at us. We barely had time for a good scream before the wave broke and was on us. "Oh-h-h shiiiiiiiiitttttttt!

I hauled on the bowline as the frigid water rushed over me, not having the slightest idea where the kayak

was. It seemed as if I was under forever. As the surf drew back again, I managed to get my feet back under me and my head above the surface, gasping and choking.

To my horror, the kayak—with Steve clutching the camera bags—was riding the crest of the next wave right at a cluster of large rocks along the shore. I pulled back on the bowline as hard as I could, desperately trying to keep the boat off those damn rocks, knowing it and Steve would be pulverized.

Again the wave broke, sweeping me forward as I fought to keep my head above the raging surf this time. Somewhat successful, I glimpsed the kayak slamming

against some of the smaller rocks. To my amazement it remained afloat, undamaged.

Once more the water drew back as I braced myself for what I thought might be the coup de grâce. To my relief the next wave came with considerably less force. Hauling back again on the bowline, I was able to keep the kayak off the rocks this time. Staggering over to the bobbing little craft, I dropped myself over the bow and steadied it as the water soon returned to relative calm.

Instantly, Steve and I went into the normal tirade of manly oaths as we glanced wildly about, dazed and scared. I was barely aware of being soaked as I stood in the frigid water. Then I noticed that Steve still held both camera bags—in a death grip. He hadn't lost a thing. I wondered how we could be so fortunate.

Pulling ourselves together, we were soon back at the business of unloading and setting up our campsite, while composing the usual promises of what we would say to Mark the backpacker if we ever saw him again. Of course it wasn't Mark's fault, nor is "the wave" a typical experience for Glacier Bay kayakers like us. But the story does demonstrate how easily and quickly the unexpected happens in a land where much of the landscape is in a constant state of flux. Advancing glaciers, retreating glaciers . . . calving glaciers.

(right) Johns Hopkins Inlet is typical of Glacier Bay's West Arm, with thick ice packs and advancing glaciers calving into the fjord.

(facing page top) Bedrock ravines like this one are also part of the West Arm, with young glaciers beginning to build.

(facing page bottom) The Lamplugh Glacier glows in evening light.

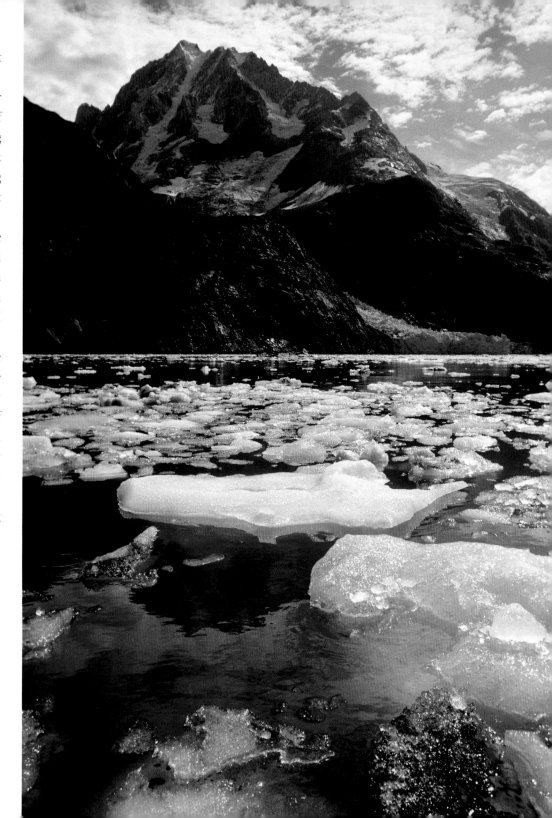

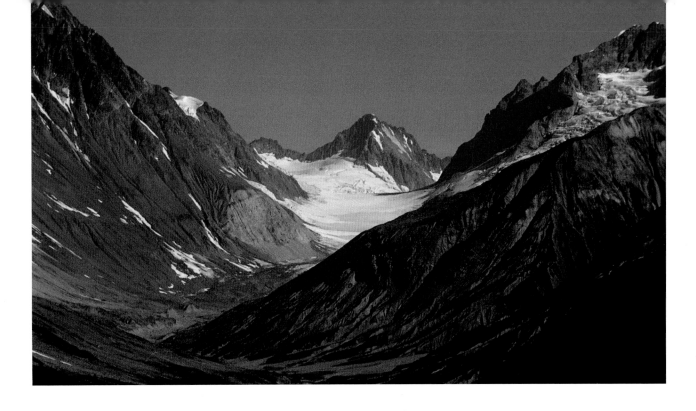

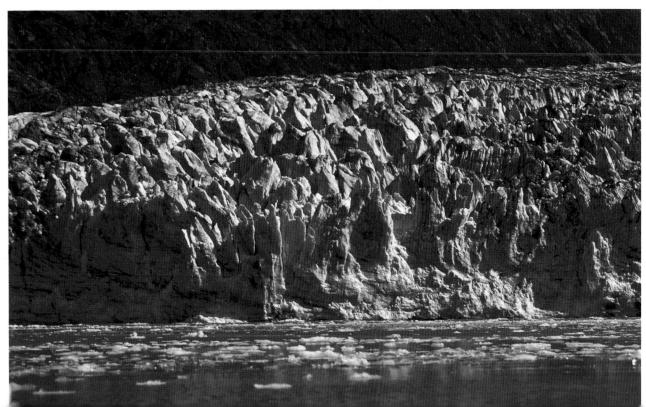

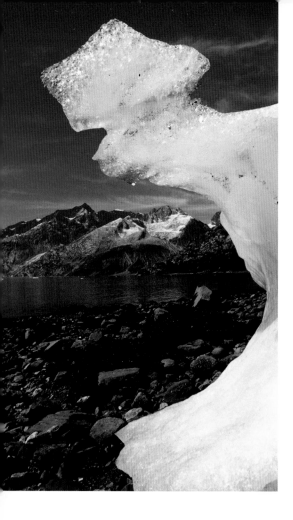 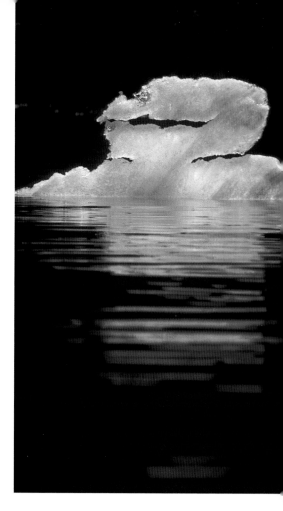

As with many places in Alaska, Glacier Bay can be reached only by boat or airplane. There are no roads to it or through it. Its few amenities include National Park Service offices at the park's entrance in Bartlett Cove, where there is also a small lodge and park tour boat. Beyond there, Glacier Bay is an experience for backcountry people.

Beginning as a single body of water, the bay divides at Tlingit Point into two bodies farther north, the West Arm and to the east, Muir Inlet. Most of the advancing glaciers are in the West Arm, while the Muir Inlet sports extensive vegetation and some glacial activity, showing the process of land being reclaimed from ice. This stark contrast makes Glacier Bay a priceless living laboratory for glaciologists as well as geologists and plant ecologists.

Two days after our experience with the wave, Steve and I were again picking our way through another dense ice pack in the midst of the dark waters of the 1,200-foot-deep Johns Hopkins Inlet. Our project for the day was photographing harbor seals. Throughout this ice pack were easily 300 of the big-eyed, cute-faced creatures sprawled across the icebergs in various sized groups or swimming about the fjord. Their barks and yips echoed through the pristine setting.

Ahead loomed the Johns Hopkins Glacier, standing

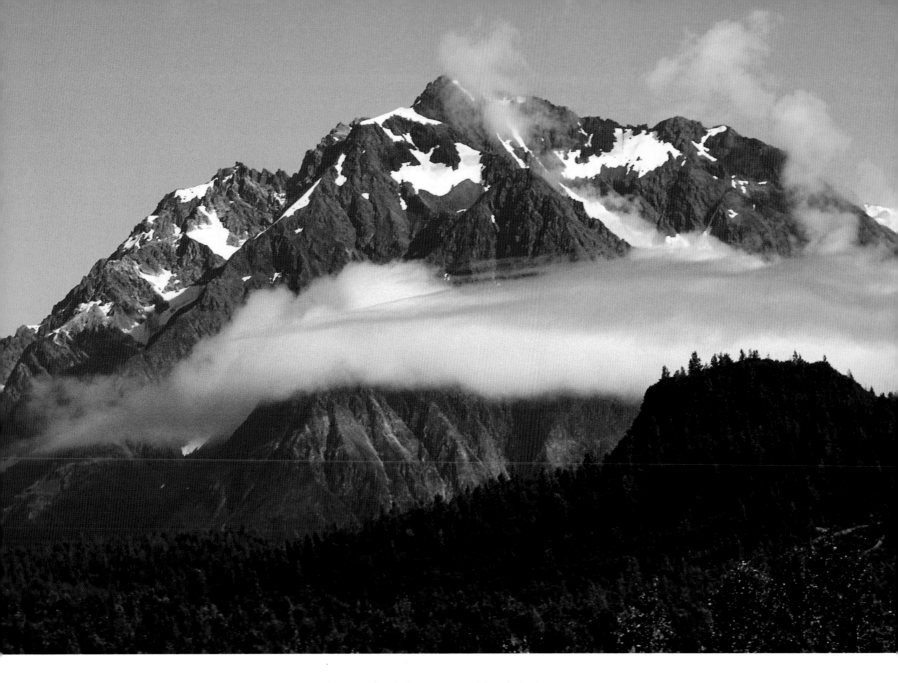

*(above) In the Muir Inlet of Glacier Bay, a still-bare bedrock mountain
stands high above a belt of Sitka spruce, with deciduous trees farther below.*

*(facing page) Carved by weather and water, ice takes
a myriad of shapes and textures.*

more than ten stories high and nearly a mile wide. Its icy spires glistened in the morning light like an array of a thousand church steeples. Colors ranged from stark white to sky blue with streaks of black and green. Distant rumblings could be heard from deep within the glacier, telling of constant shifts and movements in that rapidly expanding ice factory.

Mountains rose straight up out of the deep fjord with little or virtually no shoreline. Glacial streams and waterfalls poured down from hundreds of feet above. Some of the waterfalls divided into threes and fours like pitchforks of lightning in thunderstorms.

Glacier Bay is one more of those special places that speaks of another time in the life of North America and of our Earth. This voice comes from about 14,000 years ago. The last great ice age of the Pleistocene Epoch has peaked and begun to recede. After covering more than 5 million square miles of North America, including most of present-day Canada and the northern continental United States, the massive Laurentide Ice Sheet is in full retreat.

Corridors and paths are opening through the glacial ice that allow passage from Asia to North America and vice versa by huge mammals like mammoths and mastodons, along with camels, horses, and large predators like the saber-toothed cat, the dire wolf, and the short-faced bear, which is twice the size of the present-day Alaskan grizzly. Also included in this list of sojourners are strange

(right) Muir Inlet of Glacier Bay is an excellent area for observing and studying the land reclamation process following the retreat of glaciers or an ice age. Here hemlock forest is reflected in the waters of a wetland formed from melted ice.

(facing page) Heavy moss mixed with seabird droppings spreads across this rock island.

creatures from Asia, setting foot on North America for the first time. Humans.

Over the next few millennia, most of these predators and large mammals will become extinct in North America, the horse and camel among them, surviving only in Asia and Africa. Much debate continues among the scientific community as to what caused these extinctions.

The human migrants, or Paleo-Indians, would eventually settle all across the Americas as they developed into the various Native American cultures that European explorers began to encounter during the sixteenth century. The bedrock ravines flanked by glacial walls that surrounded us this morning are similar to the landscapes through which these early Americans would have passed.

Amid the large ice pack, we halted our craft about a half mile from the face of the towering Hopkins Glacier. While watching for iceberg calvings along with the entertaining seals, we enjoyed an early lunch in that cathedral of ice.

*(above) A young glacier winds down this nearly vertical bedrock wall
into the deep, ice-choked waters of a fjord.*

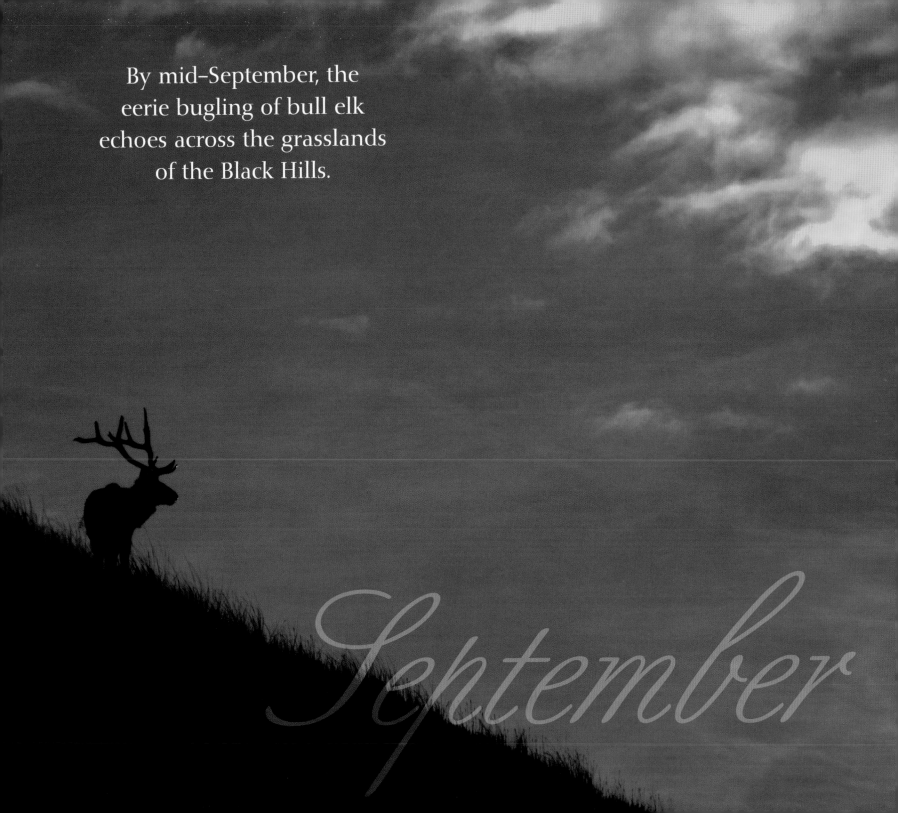

By mid–September, the
eerie bugling of bull elk
echoes across the grasslands
of the Black Hills.

September

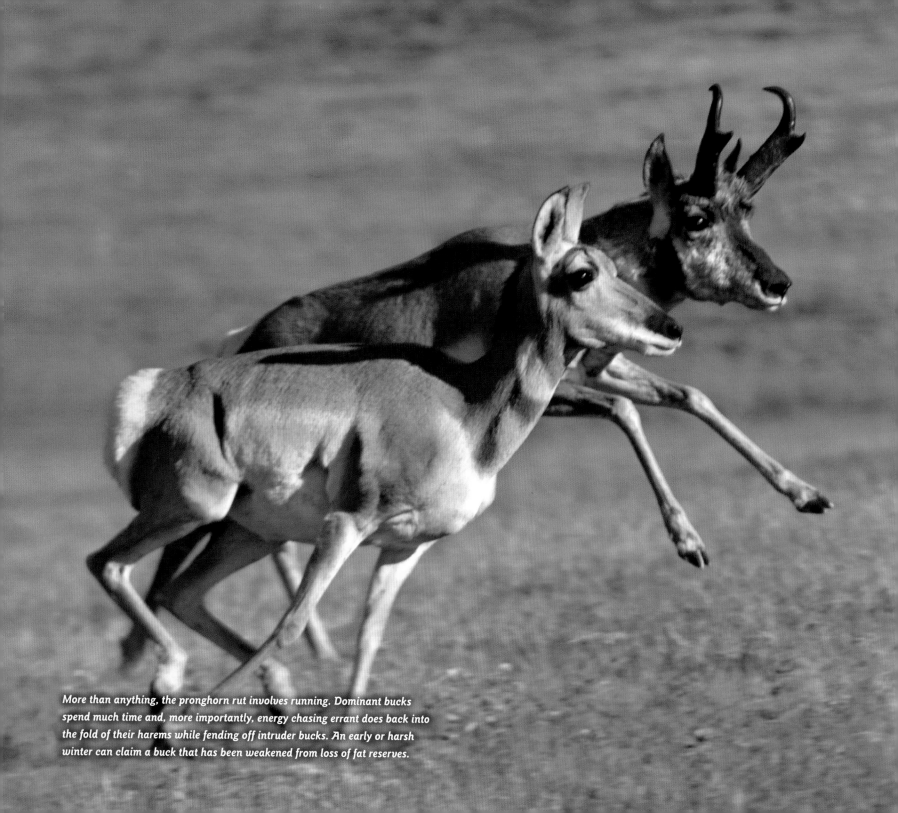

More than anything, the pronghorn rut involves running. Dominant bucks spend much time and, more importantly, energy chasing errant does back into the fold of their harems while fending off intruder bucks. An early or harsh winter can claim a buck that has been weakened from loss of fat reserves.

BUCK FEVER

The brawny pronghorn buck leapt to his feet, clearly outraged at the audacity of these intruders who dared violate the sanctity of his clearly marked domain. Raising his proud head, he curled back his lips and began to huff and puff, his entire body rigid like wrought iron. Who were these pugnacious infidels?

Not satisfied with mere protests, the incensed buck broke into a flamboyant prance, slowly encircling the group of five does who continued to feed on the shrubs of this high prairie plateau, apparently indifferent to the new presence. The gatecrashers stood on opposite hilltops, one about thirty yards away and the other about one hundred yards off. Their intentions were clear and obvious.

No other creature captures the essence of the North American prairies in the way the American pronghorn or antelope does. They are simply beautiful. The extraordinary design of their heads, the light tans contrasting with the jet black of their noses and snowy white cheek patches are unequaled in visual resplendence. Watch the dawn light accent those great, high horns that adorn the head of a mature buck. See him stand erect as the sun's glint catches in his huge dark eyes that can detect the slightest movement in the midst of a vast prairie landscape. This is perfection witnessed.

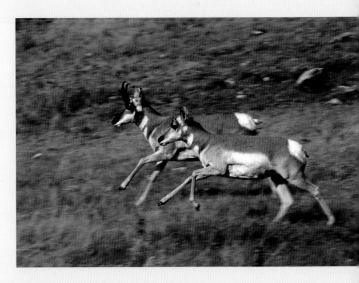

(above) The race is on as the buck chases down the doe, trying to turn her back into his fold.

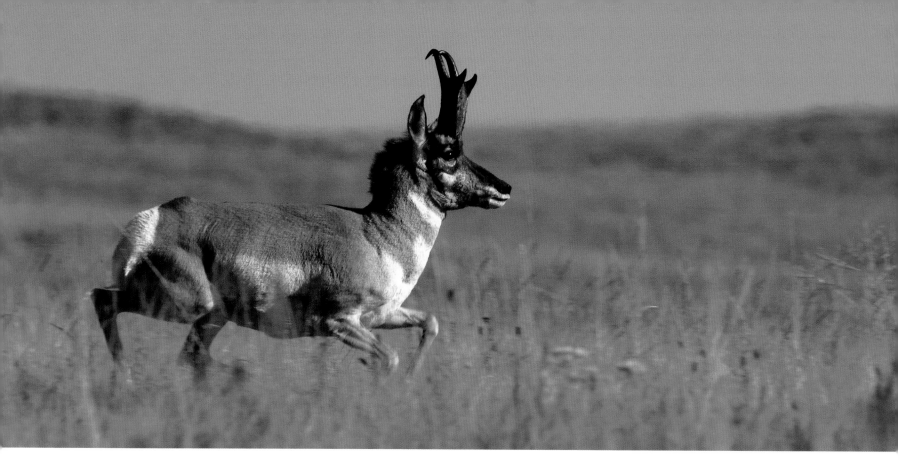

(above) A territorial buck leisurely trots through a prairie ravine in mid-September on a routine patrol of his ground. Pronghorn have made running an art form; field biologists have documented thirteen different gaits, from the "very slow diagonal walk" to the "lateral gallop."

(facing page) The early part of the rut is the most intense. Battles like this one between a territorial buck (right) and a challenger can get pretty serious, though most occur only when a doe in estrus is immediately present. These dangerous encounters can sometimes result in bucks suffering severe wounds from antler points, including the loss of an eye.

Both names—antelope or pronghorn—have come to be accepted, although this creature is neither an antelope nor a member of the deer family as others assume. He's more closely related to goats.

Paleontologists believe that the pronghorn's ancestors—perhaps as many as twelve species of goats or goat-like creatures—migrated across the Bering Land Bridge from Asia during the Pleistocene Epoch around 20 million years ago. Those various species either adapted or were eliminated until finally one animal emerged—not quite a goat anymore, nor like any other animal on this planet. A highly social being with a large brain capable of adaptability and learning, it was a creature perfectly suited for life on the North American prairies. *Antilocapra americana.*

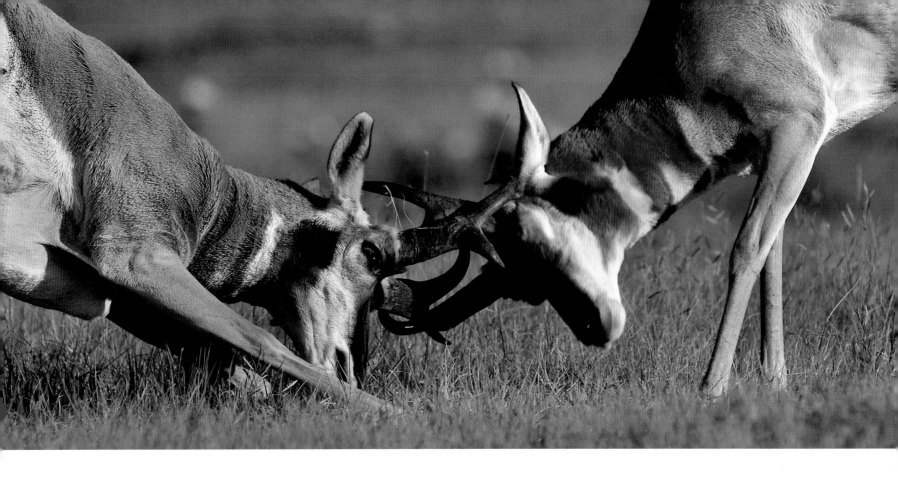

Yes, the elk is probably more regal, the coyote more cunning, and certainly the bison is a more widely accepted symbol of the American West. And yet this animal we call the antelope or pronghorn may be the most remarkable creature of an ecosystem that abounds with remarkable creatures. He is the Prince of the Prairie.

Throughout most of the year, a pronghorn male lives in some type of group, either the large mixed-gender groups of winter that can number fifty-plus or summer bachelor groups of ten to fifteen. Come the rut in September, things change. Mature or dominant bucks separate from their groups to adopt tactics for this intense and very competitive season. Some become territorial bucks. They mark and defend a ground against intrusion

from other bucks and claim all does that venture onto it. Others gather a harem of does that they vigorously keep together while excluding other bucks.

Bachelor groups are generally composed of younger animals where the young buck learns the way of things in his society. As the rut begins, some of the bachelors become satellite bucks like this morning's invaders, meaning they roam the perimeter of a territorial buck's ground like a satellite orbiting a planet, attempting to steal or lure away members of the harem.

Other species such as elk and bighorn sheep also form harems, but there is uniqueness among the pronghorn. Normally the elk cow and bighorn ewe will just stand by while the males dispute the question of "ownership"

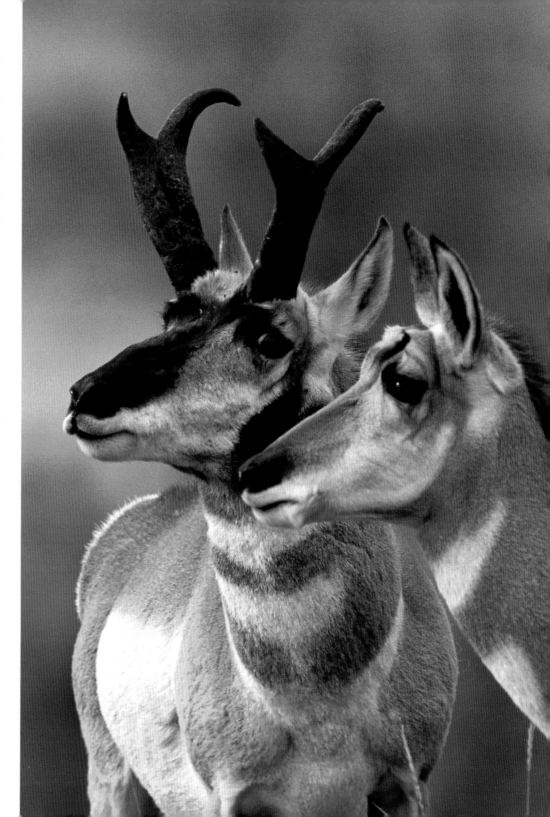

among themselves, accepting the terms of settlement with little question. Not so with the pronghorn doe.

Having little regard for the male viewpoint, she is going to mate with the biggest and best buck she can find, meaning she will check out all the possibilities regardless of what her self-appointed master may think. This policy would soon be evident this morning.

Now clearly fed up with his competitors, the territorial buck sprang forward and sprinted toward the nearest trespasser. Reaching the satellite buck, he chased it back up the prairie slope where the two quickly disappeared over the hilltop. The other transgressor realized his opportunity.

In that same flashy style as the territorial buck, he trotted down from the ridge toward a doe that glanced over her shoulder at his approach. Coming to within a few feet of her, he began to turn his head to one side and then the other as he continued his advance, displaying the dark subauricular glands on his lower jaw. If the doe does not turn or walk away, but sniffs at the buck's glands, then she has probably reached estrus and is ready to mate.

As he reached her, the doe trotted ahead a few feet and paused, looking straight ahead and then behind. Again the buck approached and once more she spurned his advance.

Reappearing on the opposite ridge, the territorial buck saw his dilemma. In what seemed only an instant, he reached the side of the intruder. Both began to paw at the ground, and then the big buck lunged at the younger one, locking horns with him and shoving him backwards. Gamely, the young buck tried to hold his own, but he was definitely outmatched and quickly overwhelmed. He soon broke off contact, heading back in the direction from which he had come with the landlord in close pursuit.

Now came the doe's opportunity. Off she headed in

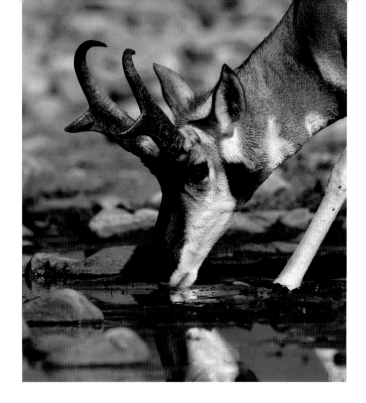

(facing page) While turning his head from side to side, this buck displays each of his scent patches to a doe as he makes his approach to mate with her. By standing still as he nears her and sniffing the patches, she indicates her readiness.

(right) After a warm morning of battling and chasing, a buck stops for a long drink in a shallow prairie pond.

(below) Another doe spurns the advance of a buck for now, either because she has not yet reached estrus or she is still checking out all of her options.

the direction of the other intruder as if such was her plan all along. Oh, so coy.

The territorial buck didn't think so. Whirling about, he flew across the grassland, quickly overtaking the errant doe. The chase was on. Dodging, turning, and sprinting once again, the two were almost a blur as they shot over the prairie, reaching speeds in excess of fifty miles per hour.

The chase was short lived on this hot September morning, and the doe was soon herded back into her "proper place." Again the territorial buck pranced about his harem, declaring his sovereignty with the same flamboyance as before.

The does casually went back to their feeding, still keeping watch for those intruder bucks, not having put other ideas out of their heads just yet. The territorial buck could be optimistic, but it was plain to see that he was not really in control here. Much work lay ahead.

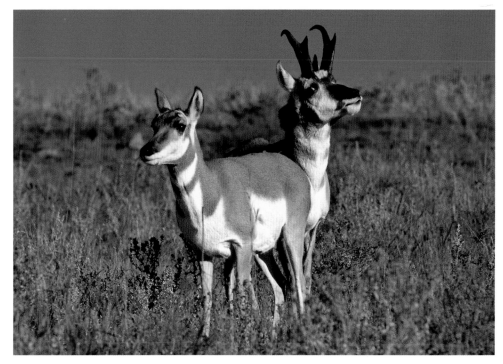

(right) Known as "thrashing," dominant bucks will slash their antlers through the grass, uproot plants, and wear them like crowns.

(facing page top) With harem group dynamics constantly changing, these two does dash off to check out intruder bucks on a distant ridge.

(facing page bottom) Satellite bucks like these two-year-olds will also spend much of their time running during the rut as they flee from angry, dominant bucks.

182

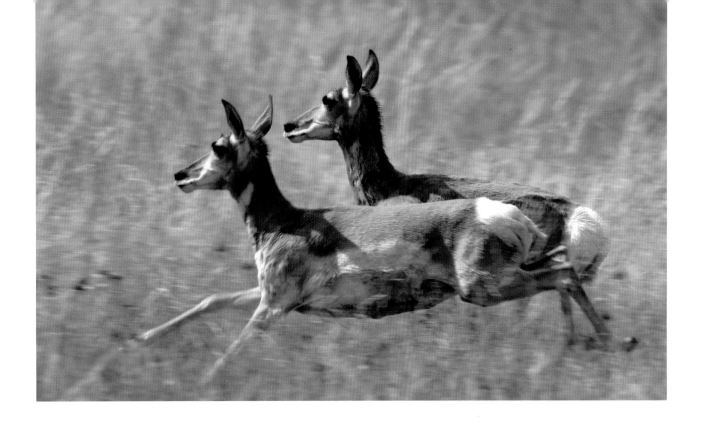

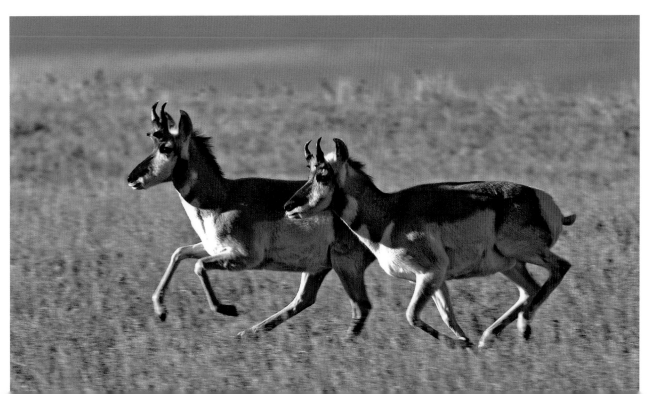

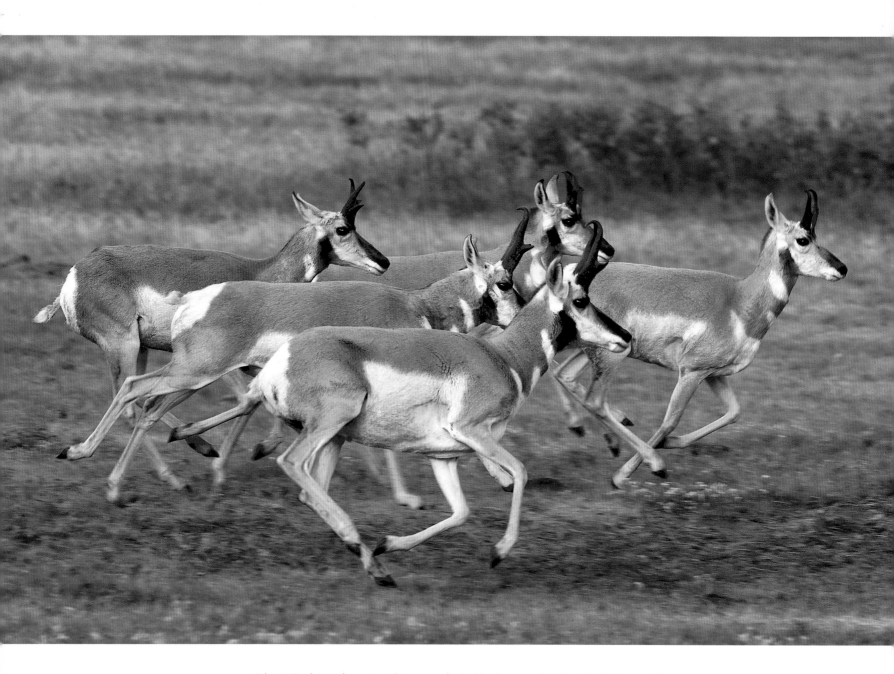

(above) As the rut draws to a close, young bucks like these may finally get their chance with some of the does, but the start of the annual horn shed will soon bring all rut activity to a halt.

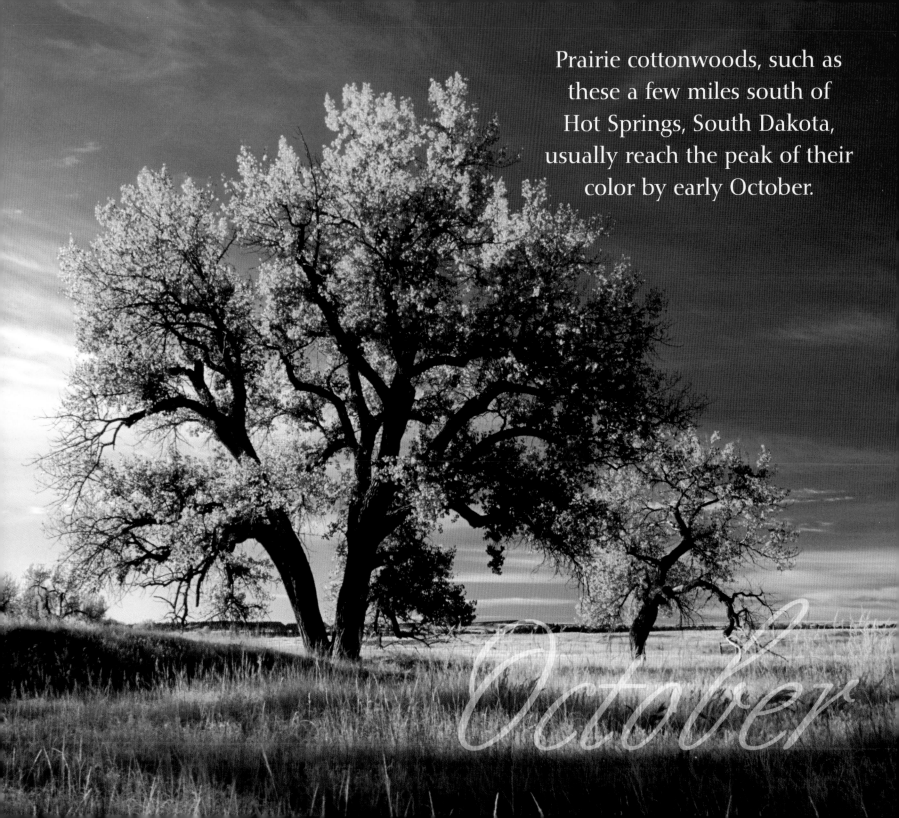

Prairie cottonwoods, such as these a few miles south of Hot Springs, South Dakota, usually reach the peak of their color by early October.

October

*A red-winged blackbird sits on cattails in amber light in
a tiny cove at Stockade Lake in the central Black Hills.*

OCTOBER'S SONG

A chilly, moist air fills my lungs in a thoroughly refreshing way as the fog crawls slowly across the lake's glassy surface. My paddle breaking the water accompanied by the distant calls of a few Canada geese are the only sounds that reach my ears as the kayak silently glides along. The stillness of this morning is overpowering.

The place is Stockade Lake, one of the Black Hills' most photogenic bodies of water, and today the lake is fulfilling its reputation. Through the tops of distant pines, the sun breaches the fog, casting shadows and reflections onto the water's undisturbed face as its illumination colors the scene.

Known as fog shadows, this phenomenon occurs when fog is dense enough to be illuminated by light passing through gaps in a structure or tree and yet thin enough to allow a large quantity of light to illuminate points beyond, thus giving a three-dimensional effect to the shadows. The mists of morn have arrived.

October is a special time in the Black Hills high country as we prepare for winter's advent and the grip that it will take on our land. It is an awakening for all. The lakes, valleys, and ravines are encased and defined by mists and banks of fog whose beauty not only treats the eye but

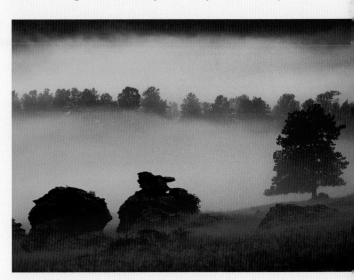

(above) Near the town of Custer in the central Black Hills, fog gathers over the trees and rocks of an area known to locals as the limestone country.

also invigorates the soul with its mystery, its color, and its absence of light. The time is one of reflection.

Somewhat less romantically, the encyclopedia tells us that fog is the result of water vapor condensing into tiny liquid water droplets in the air when a cool and stable air mass is trapped beneath a warm air mass—such as what is happening before me this morning with the sun heating the air over the chilly lake waters. True and good to know, but scientific definitions like this one seldom speak to the spiritual effects of a particular natural phenomenon, how it touches and feeds something within us. Emerson did it better.

Even more important, I believe, are the effects of this marvel or any other such marvel of nature on our imagination—how we perceive the landscape and ourselves within it. We are, to the best of our knowledge, the only species on our planet capable of appreciating the artistry of nature in this way.

And so on I go, gliding my small craft over the glassy lake waters as I collect images of the events that stretch out before me, ever mindful of their effects. For I do wish to experience the landscape, not just observe it. That's what the mists of morn are about.

> *Every natural fact is a symbol of some spiritual*
> *fact. Every appearance in nature corresponds*
> *to some state of the mind, and that state of the*
> *mind can only be described by presenting*
> *that natural appearance as its picture.*
> RALPH WALDO EMERSON

(right) *A full moon sets into the fog moving across the waters of Stockade Lake as dawn comes to the central Black Hills.*

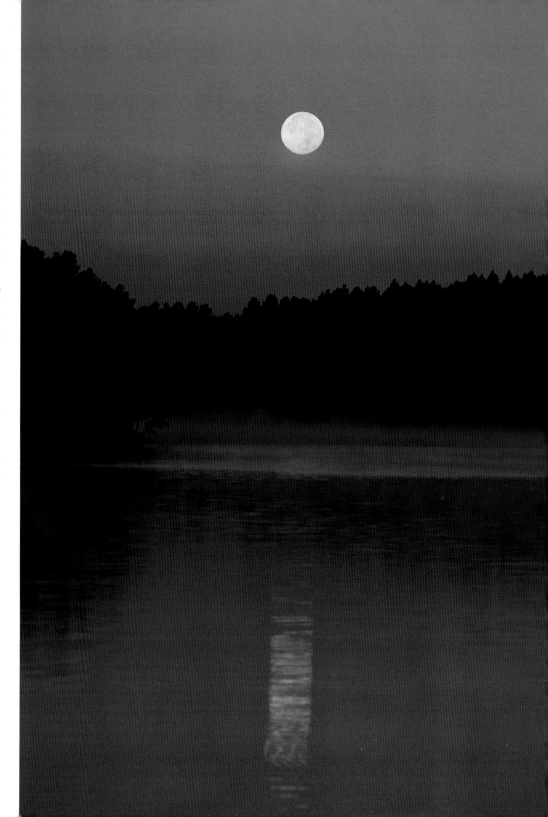

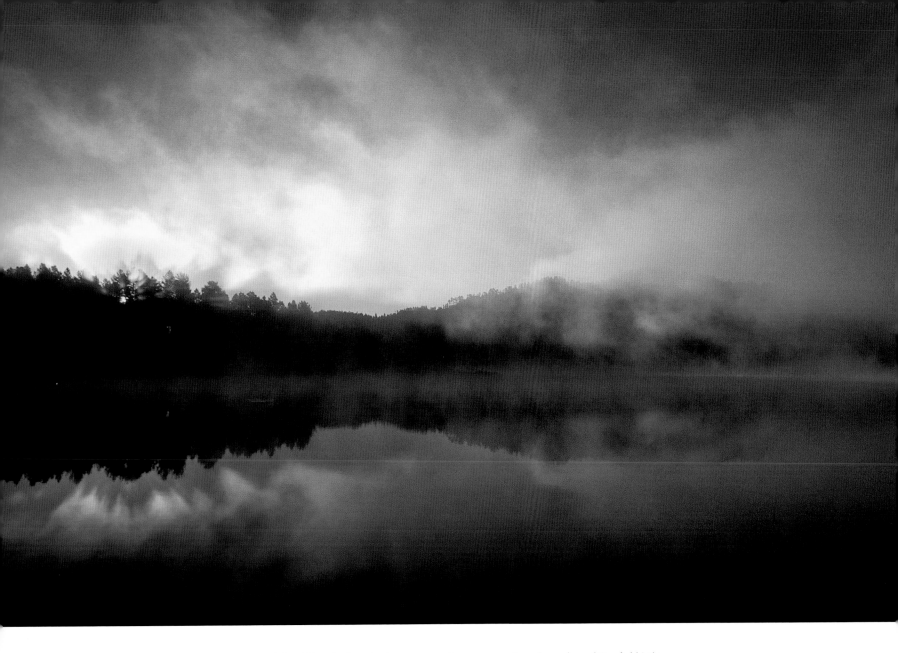

(above) Fog shadows begin to grow and creep across the calm surface of Deerfield Lake as the dawn light rises. A high-country lake like Deerfield makes a perfect canvas for the hues of this natural lighting phenomenon that gives a three-dimensional effect to shadows.

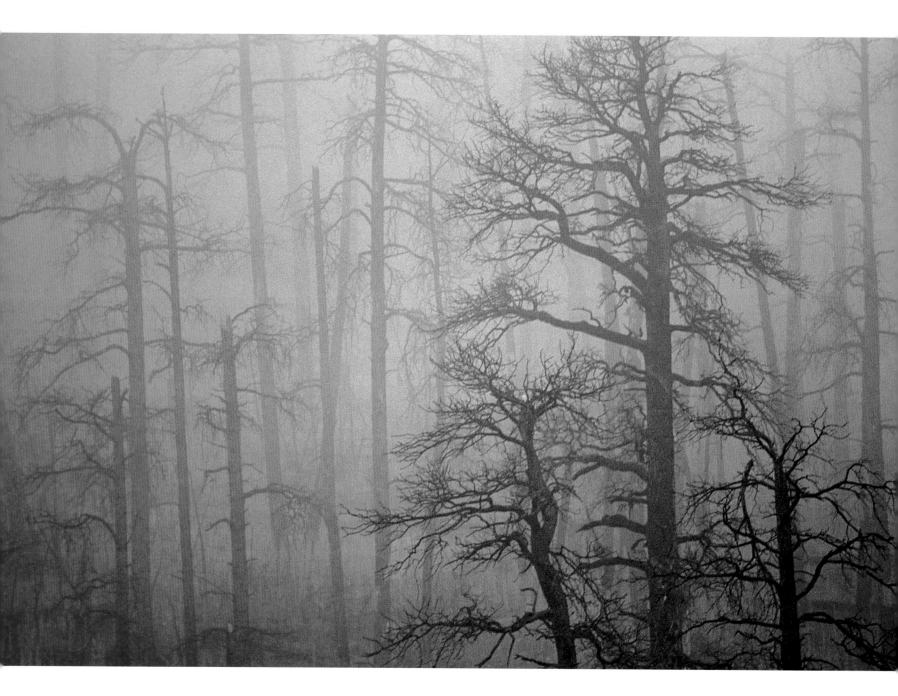

(above) When enshrouded in fog, old burn areas like this one near Coolidge Ridge in the central Black Hills actually take on that Transylvania look from an old Dracula movie.

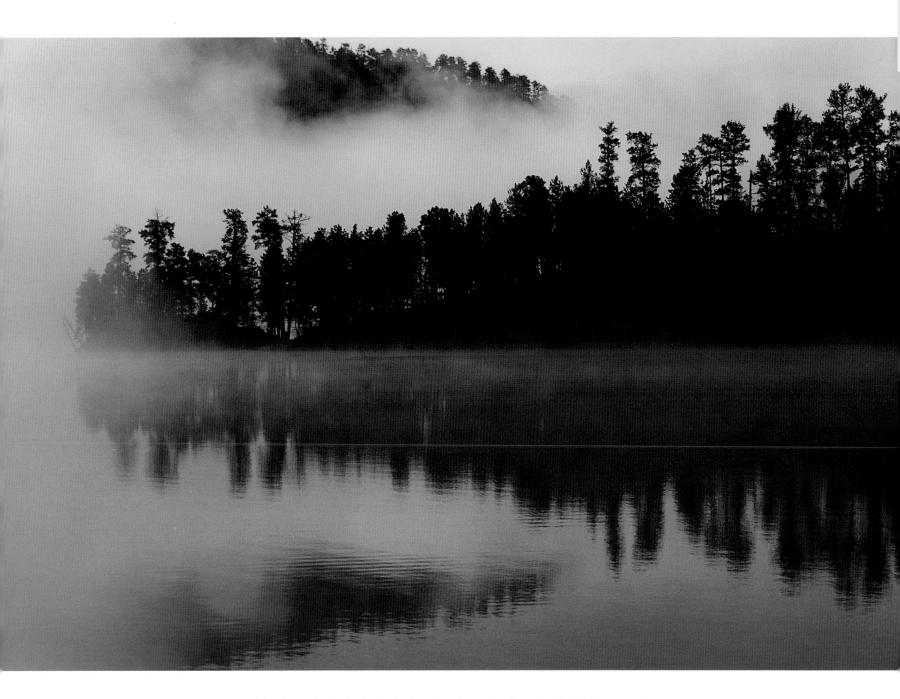

(above) A gathering fog bank slowly enshrouds a peninsula on Deerfield Lake, as mornings
become colder by the day. The highest of Black Hills lakes at nearly 6,000 feet, Deerfield in winter
sees overnight lows in the subzeros, with lake ice usually several inches thick by early December.

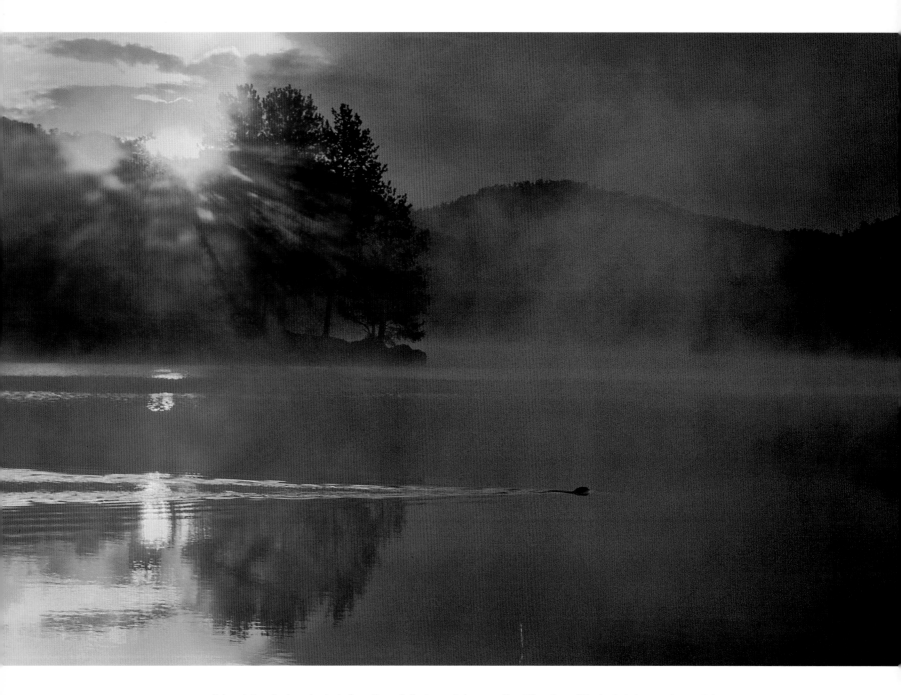

(above) Fog shadows begin to form through the trees at dawn on the still waters of Stockade Lake as a beaver takes a morning swim. In addition to mammals like beavers and golden marmots, this lake and its immediate surroundings are also home to birds like great blue herons that nest here in summer and bald eagles that winter here.

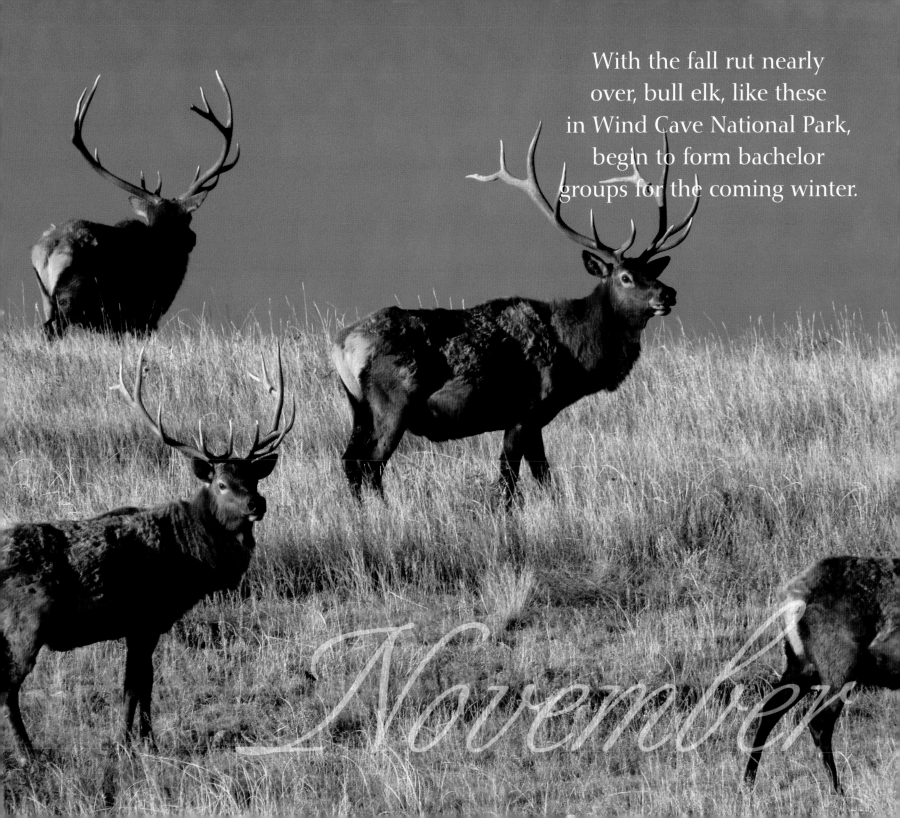

With the fall rut nearly over, bull elk, like these in Wind Cave National Park, begin to form bachelor groups for the coming winter.

November

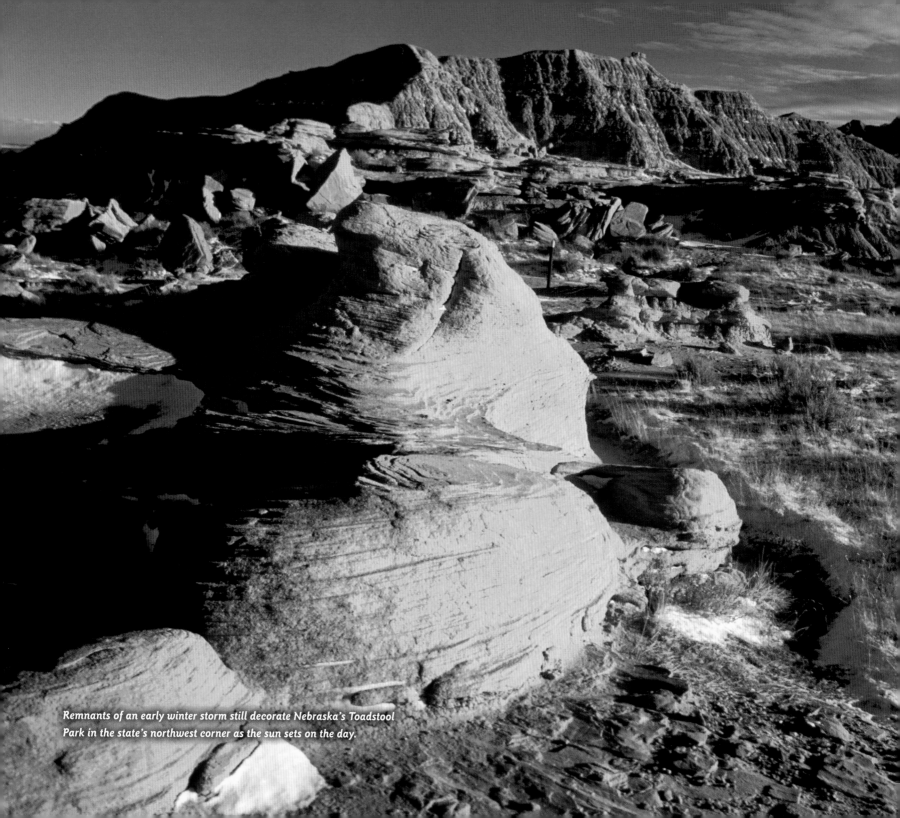

Remnants of an early winter storm still decorate Nebraska's Toadstool Park in the state's northwest corner as the sun sets on the day.

SPEAKING FOR SOLITUDE

The skim of early morning snow has already thinned under an emerging midafternoon sun that has quickly chased away the small winter storm. Once again, the late November sky is saturated with rich hues in the waning light of day. Yet there is no warmth—only a cold wind whipping across the lunar-like landscape, beating on the eerie rock formations like a blacksmith's hammer on his anvil.

Seated on top of a sandstone butte, I am waiting for the good light to return. Waiting is a big part of my job, one of the best parts, I think. I get to sit and simply feel the character of places such as this one—Toadstool Park in the northwestern corner of the Nebraska panhandle, set in the midst of the Oglala National Grassland. Some call it the Nebraska Badlands.

The processes that formed this haunting, surreal hinterland began about 30 million years ago. At that time, a broad shallow river washed over this region, with much of North America enveloped in a tropical or greenhouse climate. High sea levels, lush vegetation, and huge jungles dominated the globe. Then suddenly—on an evolutionary timetable—things changed.

The river, along with the tropical climate and much of the vegetation, dried up and disappeared, leaving only

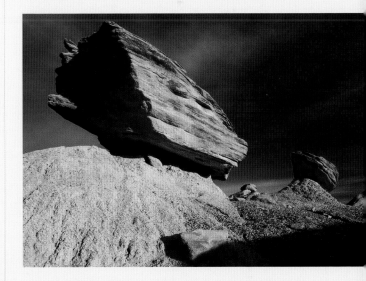

(above) Delicately balanced rock formations like these dominate this strange land that is commonly called "the Toadstools."

195

groundwater. Minerals carried by this groundwater mixed with the sand and it became more resistant to the effects of constant wind erosion than did the clays that lay beneath it. As this process continued over the eons, balls and plates of sandstone were left delicately balanced on narrow pedestals, forming the "toadstools" and other startling rock formations that we see here today. Eventually, nature would hew and sculpt herself a magnificent work of art.

Many times I have come to visit the Toadstools, but always alone—by choice. Such a strange land. I sometimes wonder why I am so attracted to places like this one, but then I really know. Here I can feel as though I may be the last human being left on the planet, witnessing not just the end of a day, but the end of an epoch. This place is a window, a time portal through which to view another age in the life of our Earth.

The park is astounding with its unearthly landscapes, dreamlike panoramas, and sandstone pedestals poised at seemingly impossible angles—shapes that don't seem to belong on this planet. The isolation and loneliness of this land is actually its allure and causes no despair or loss of heart. Surely ancient people came here for reflection and reinvigoration—and so too can we.

Toadstool Park is a place for those in search of solitude. It is the stillness that is most engrossing, almost frightening. There is the sound of the wind among the pillars and through the valleys, but all else is still—like the Cambrian quiet that can be "heard" in the Grand Canyon.

Over tens of thousands of years, a combination of groundwater erosion mixed with wind erosion carved the patterns on the faces of these rocks and the crevices between them (right) along with forming these balanced rock formations (facing page) lit by the setting sun.

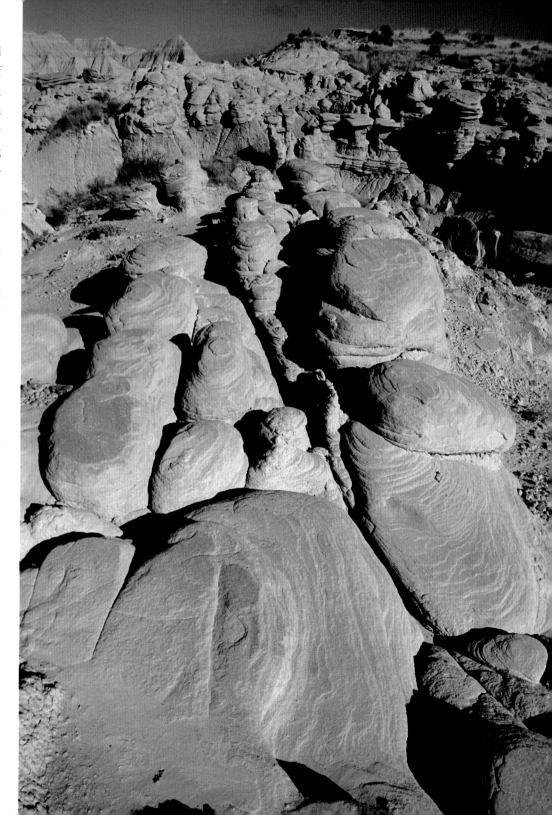

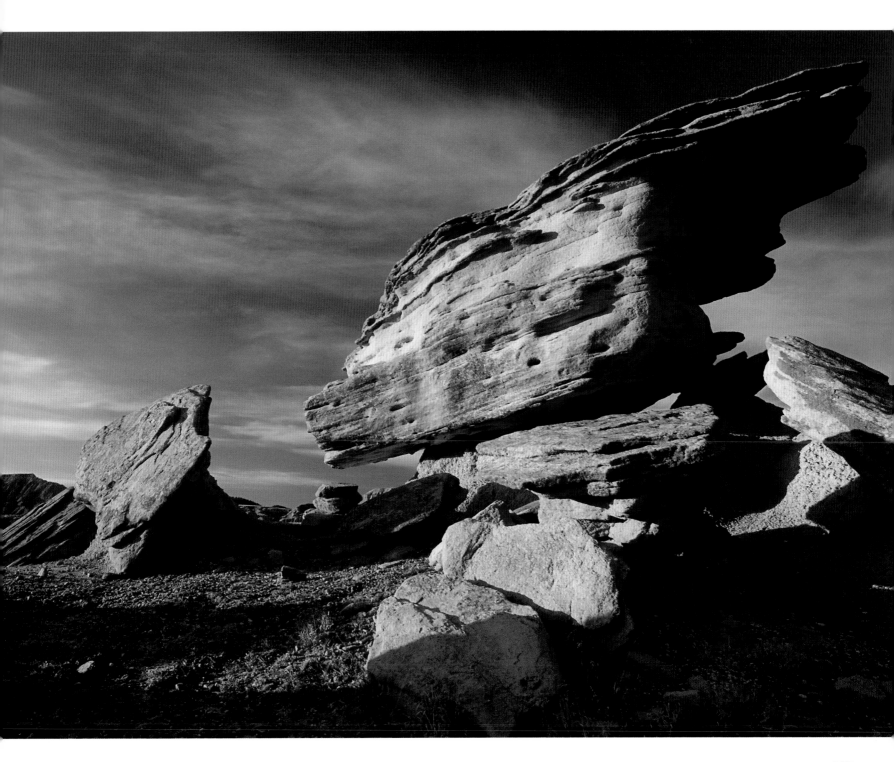

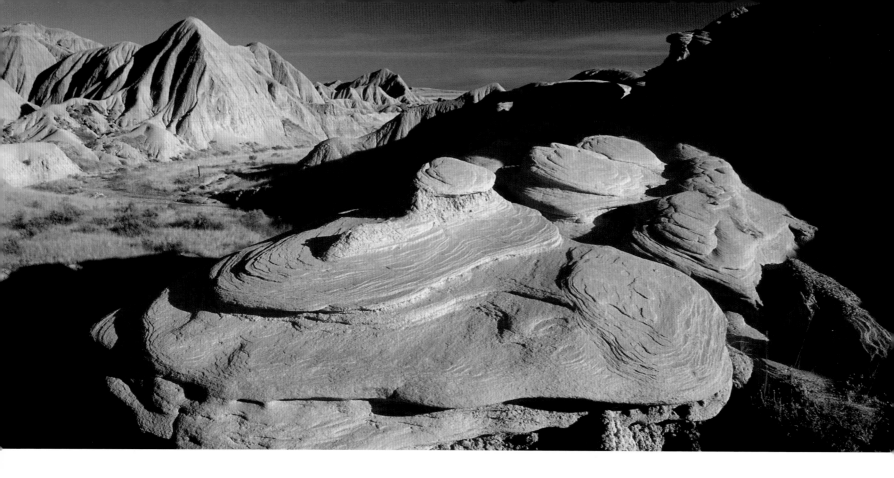

Nature's work here continues today. The numerous collapsed rocks and the afternoon's beating winds are evidence of the ongoing process that has formed this wondrous place.

As mere humans with our limited scope and time reference, we tend to look at a phenomenon of the natural world and see it as something completed rather than the work in progress that it always is—and that we are too, for that matter. A place like Toadstool Park dispels such a short-sighted notion.

I find it impossible to walk this naked, raw landscape and not sense the worlds that were here before ours, or not to imagine that other worlds will succeed ours. For we too are but another chapter in the story of the Earth.

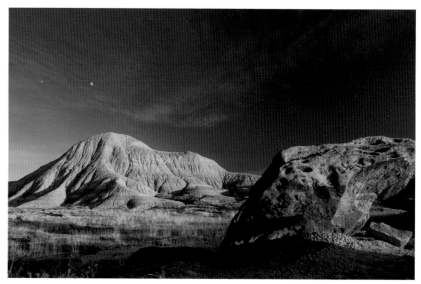

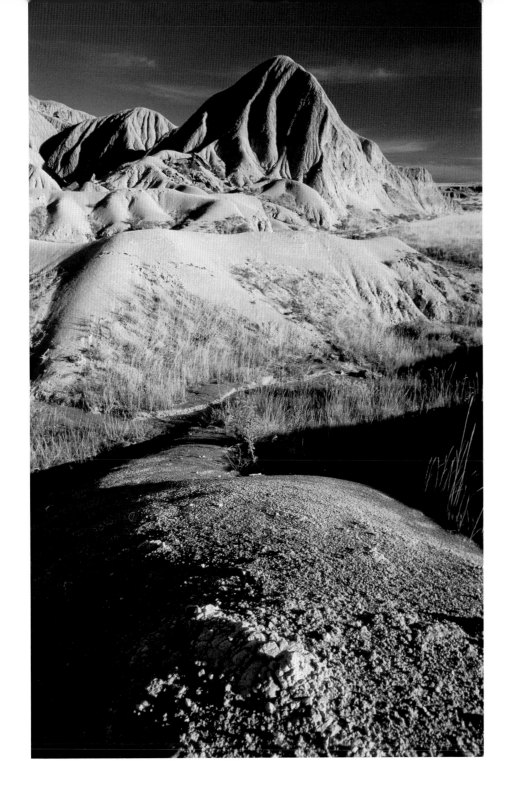

(these pages) The quality of light across this naked land can be absolutely overpowering, especially at sunset. That light seems to accent and emphasize everything that is unique about this park, even the moods and thoughts that come to mind during a visit.

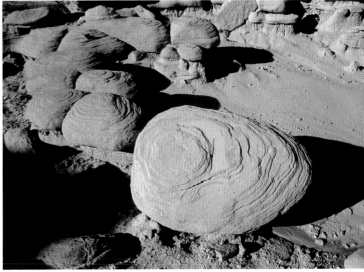

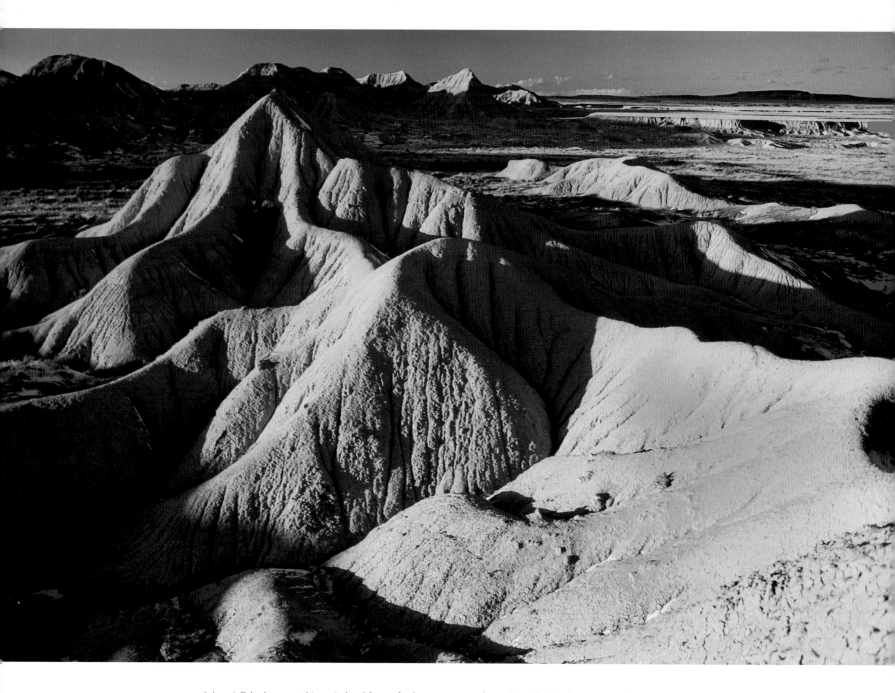

(above) A look across this eerie land from afar leaves you wondering how this landscape went from a lush, tropical one to the nearly lunar appearance that it has today—and if all of that can change back to what it was.

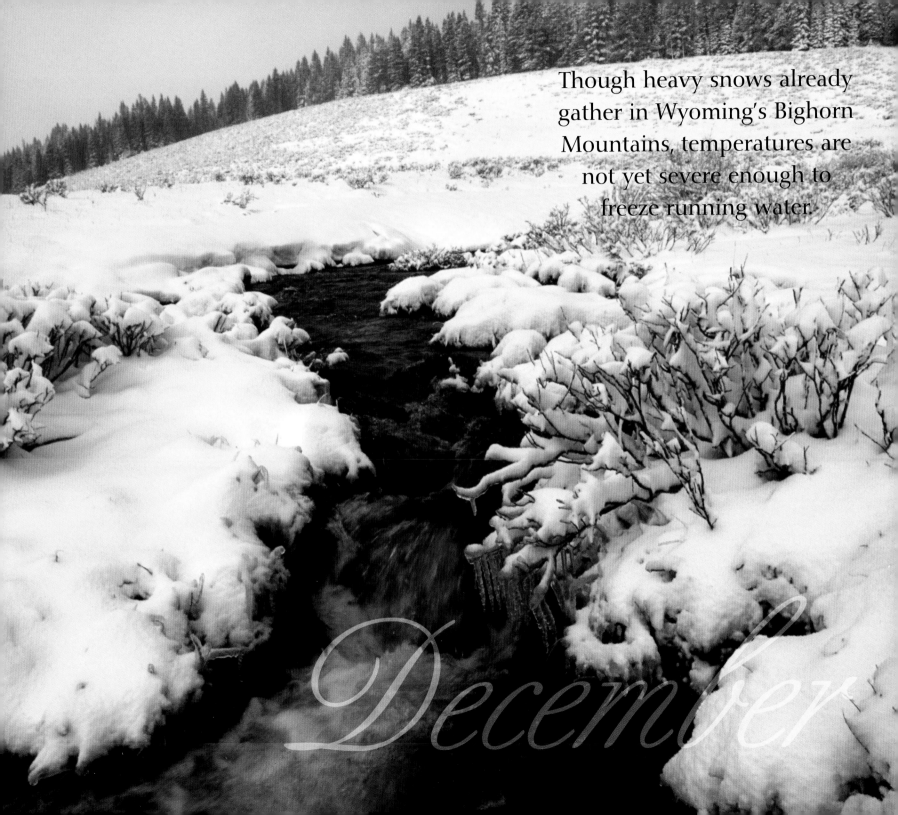

Though heavy snows already gather in Wyoming's Bighorn Mountains, temperatures are not yet severe enough to freeze running water.

December

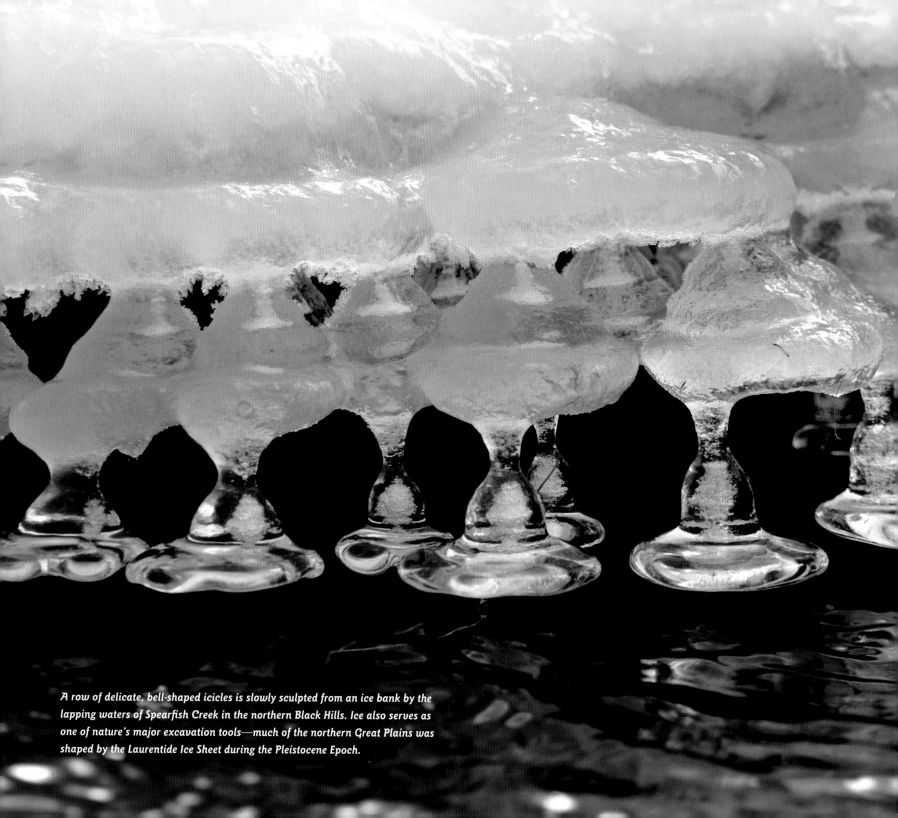

A row of delicate, bell-shaped icicles is slowly sculpted from an ice bank by the lapping waters of Spearfish Creek in the northern Black Hills. Ice also serves as one of nature's major excavation tools—much of the northern Great Plains was shaped by the Laurentide Ice Sheet during the Pleistocene Epoch.

THOSE WINTER WALKS

The great shaggy beasts goad and taunt one another as they toss their titanic heads about in the snowy sky of this winter afternoon. Their snorts and huffs reverberate throughout the snow-covered meadow.

Scratching and digging at the newly fallen snow, the 2,000-pound behemoths stalk and hound each other with their tails erect, flicking back and forth like the arms of a metronome. Suddenly, with heads lowered and faces dragging in the snow, they charge one another with an unexpected nimbleness, slamming their furry skulls together.

Flaring nostrils send puffs of steam floating above their hulking shapes as sharp, flying hooves kick up snow about them. And this is only play! Come next July things would get much more serious.

On this frosty day of early winter, I am with a group of ten bison bulls on Custer State Park land in the southern part of South Dakota's Black Hills. Seated atop a very large boulder, I am out of harm's way but still able to observe and shoot.

Most of the animals pay little or no attention to me, while the two engaged in roughhousing occasionally eye me up and down—not in a threatening way and certainly

(above) Two bison bulls engage in some playful roughhousing that is typical of their species at this time of the year. Come midsummer when the rut begins, antics like these will take on a much more serious nature.

not out of fear. Call it curiosity; I am merely an oddity. In this remote part of the park during winter, their only contact with humans is limited to an occasional skier or hiker like myself. We are just fellow travelers observing what we see along the way.

After awhile, as the bulls begin to move off, I slide down off the boulder and continue my own sojourn. Gently falling snow fills the dried prairie grass already bent over from a previous snow as the curtain descends on this wintry day. Only a few drab brown leaves remain on the otherwise naked branches of a nearby grove of cottonwood trees. But the day has been spared those chilly winds that bite at fingertips and earlobes, and the light has been pretty at times, despite the periodic snowfalls.

Usually I'm excited by winter's advent, but awakening this morning to falling snow set me back a bit. The grasslands were especially copious during this past summer and autumn, yielding many pleasing pictures—I wasn't yet ready to accept the inevitable onset of cold and dark.

Later in the day, I decided that the best medicine I could administer to myself was a nice long hike—the first walk in this new winter. Rather than sitting in the house lamenting over what is gone, I needed to check out the possibilities.

And now as the day nears its end, I'm feeling the reinvigoration that I sought. Once again, I realize that it's not possible to fully appreciate one season without the others for comparison. Whether it's watching a couple of bison roughhouse on a chilly winter's day or antelope chasing each other through the snow, the joy is no less than what I will feel watching a newborn fawn struggle to its feet in the spring grass of the prairie on a May morning. I find myself agreeing with Irish writer Edna O'Brien, who observed, ". . . winter is the real spring—the time when the inner things happen, the resurgence of nature."

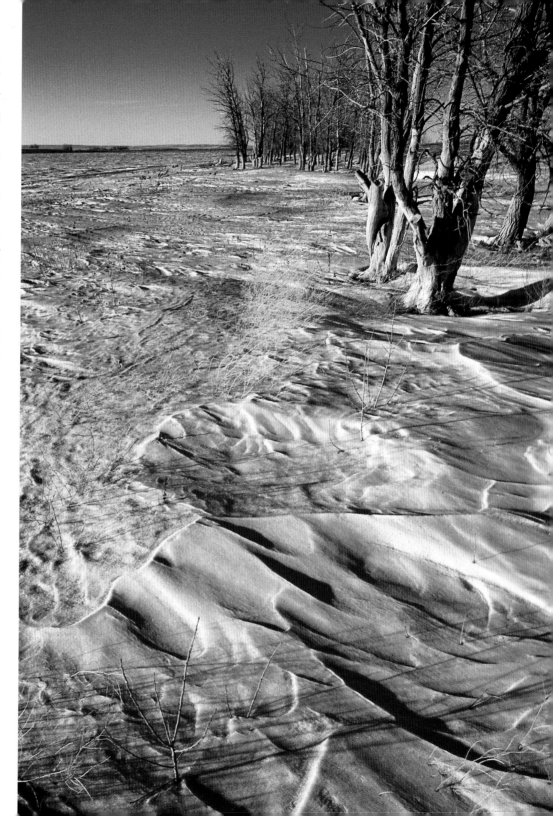

The textures of winter can be seen everywhere. Hoar frost mixed with snow hangs from a tree and grasses (right), while the wind sweeps patterns across the prairie snow (below and facing page).

Trekking through remote places during or on the heels of a fresh snowfall always pleases me. I see the opportunity to emblazon a new trail across a seemingly untouched and unexplored landscape, as though I were the first to leave my tracks across some distant, unknown frontier.

And during a winter's sojourn—unlike other times of the year when I opt for a circular course—I prefer to return by the way I came so that I may observe my tracks in the snow left earlier in the day. Every trek is a personal experience, even an art form to which my tracks are a signature. Nature leaves her own signature above the grasslands in the form of an unusual cloud formation as this winter day closes.

I suppose this is a form of vanity on my part, but a harmless one I think.

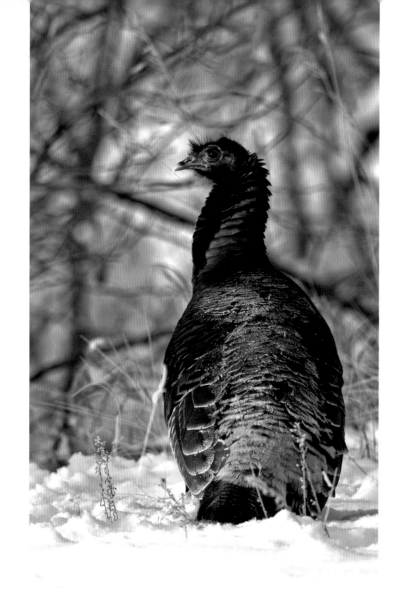
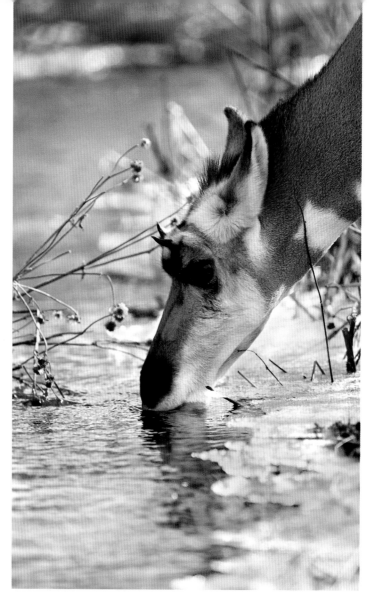

(left) Winter feeding for this turkey hen becomes a bit more complicated
as she must sift food from beneath snow.

(right) As this winter's day nears its end, a pronghorn doe drinks
at Lame Johnny Creek where the ice grows each day.

(facing page) A snowy-faced mule deer buck feeds on dried grasses in Wind Cave
National Park as an early winter storm descends on the region. Although a few mule deer
do wander in the Black Hills high country, this animal is largely a prairie dweller.

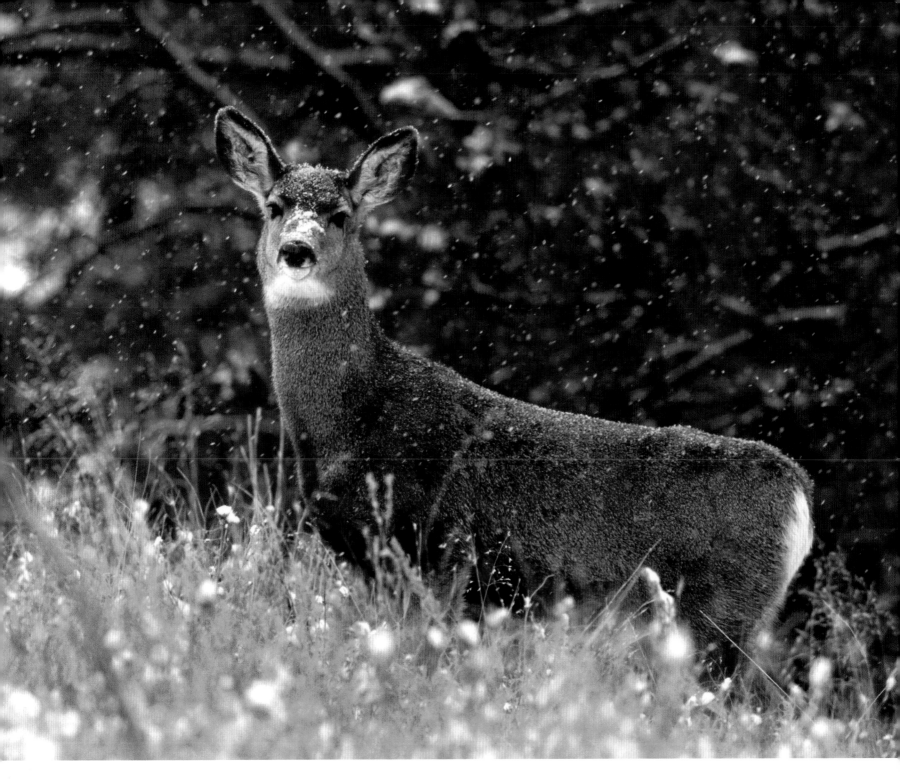

(right) A setting sun lights my earlier tracks on the Needles Highway as I head home.

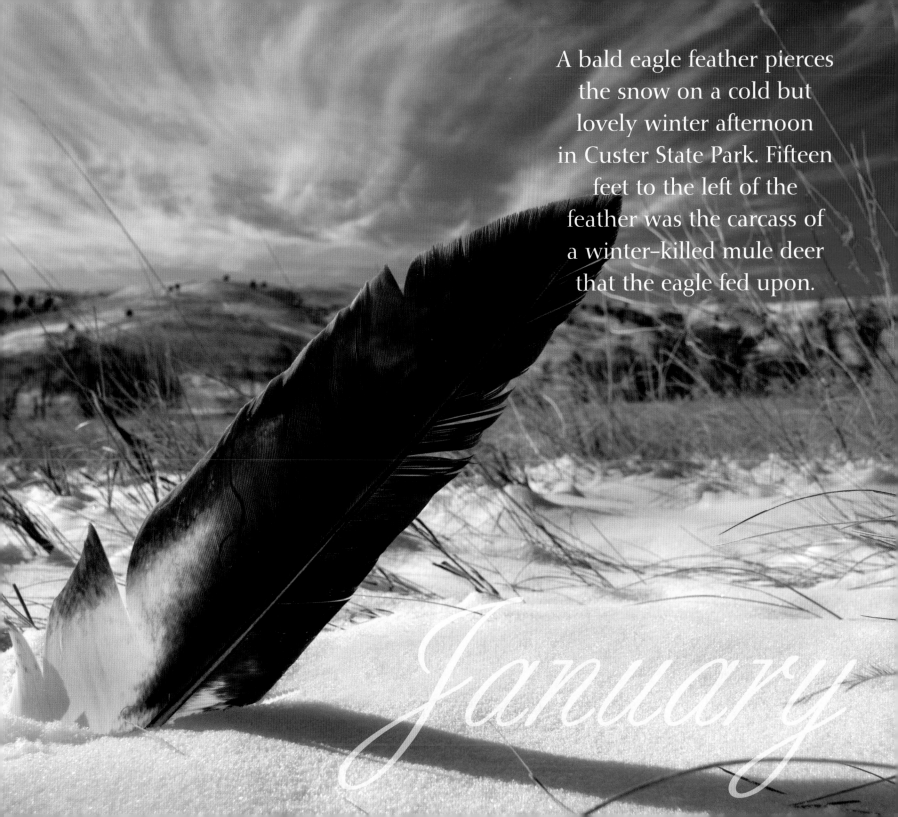

A bald eagle feather pierces the snow on a cold but lovely winter afternoon in Custer State Park. Fifteen feet to the left of the feather was the carcass of a winter-killed mule deer that the eagle fed upon.

January

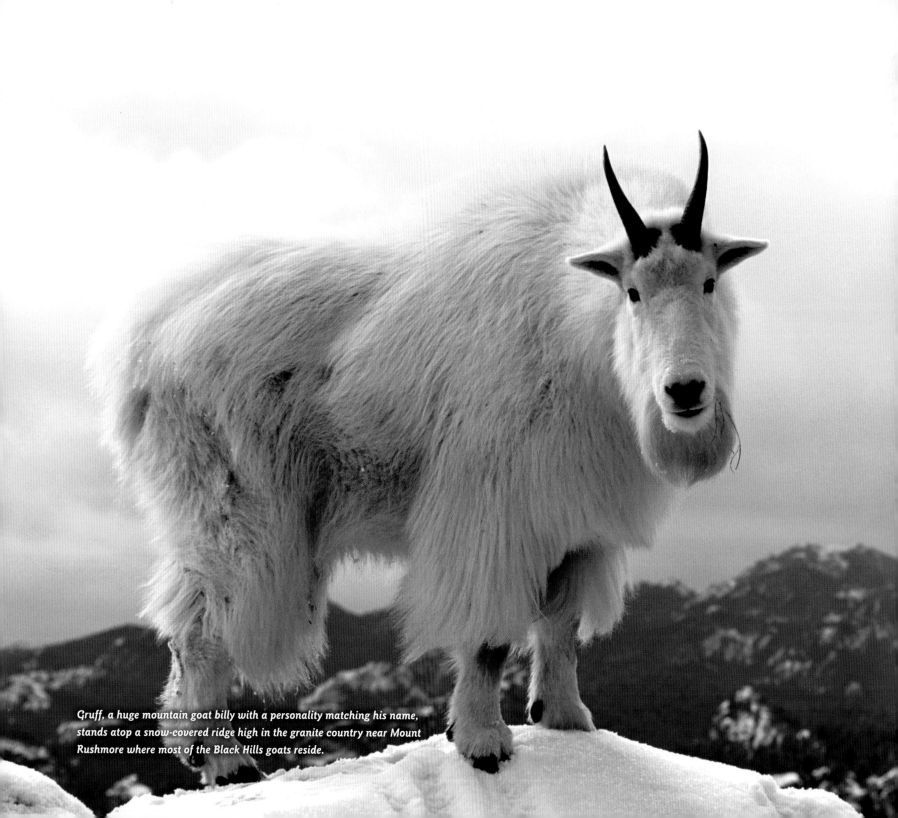

Gruff, a huge mountain goat billy with a personality matching his name, stands atop a snow-covered ridge high in the granite country near Mount Rushmore where most of the Black Hills goats reside.

CLOSE ENOUGH
TO SMELL HIM

The huge billy paced back and forth in circular patterns around the nanny as she continued to sift for food through the few inches of snow covering the rounded granite peak. Periodically he threw himself up against her, laying his massive head across the middle of her back or alongside her head. She tried to ignore him.

These two were part of a band of thirteen mountain goats dispersed across a cold and snowy knoll high in the granite country of the central Black Hills near Mount Rushmore. The group consisted of this pair, three younger billies, five nannies, and three kids. I had followed this billy for three days now and found myself calling him Gruff—mostly because of his disposition toward the other billies. The name probably was a bit clichéd.

Nearly surrounded by these goats, I sat about thirty feet down from the peak where the large billy and nanny stood, feeling good about the level of acceptance I seemed to have gained. It was late in the rutting season, and the smaller billies had no doubt as to who was the alpha male, although they still got occasional reminders.

The dominance issues had been settled earlier. Subordinate males deferred all matters of choice to Gruff.

(above) This curious yearling billy still keeps a safe distance.

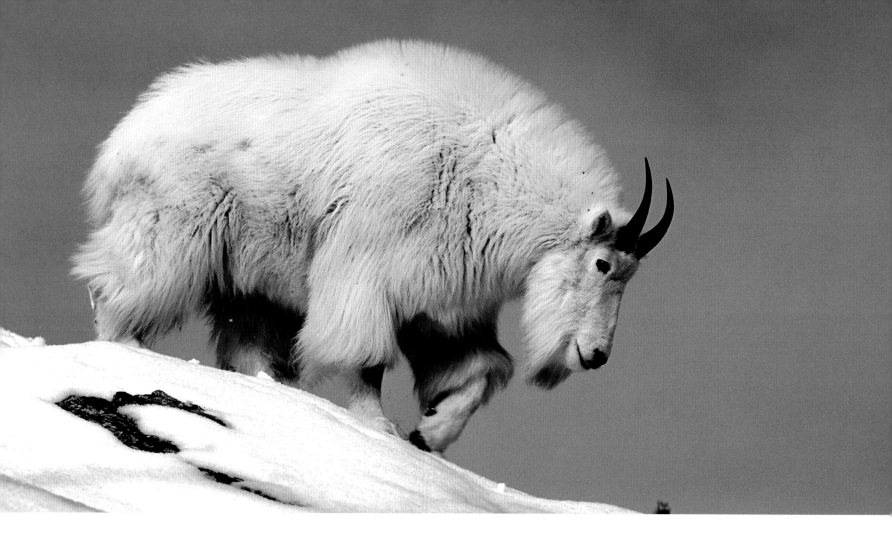

Having become too preoccupied with some of the pictures I was getting, I had paid little attention to some of the signs I was also getting. My mistake. The last couple of times that he had thrown himself against the nanny in a typical courtship display, he had also thrown a couple of threatening stares in my direction. I just assumed they were directed at two billies who stood about thirty feet behind me.

Gruff turned and started down the snowy slope heading in my direction—growling, snorting, and tossing his head in a way that accented those sharp, menacing horns. Again, I took for granted that he was merely headed over to the other billies to reassert his dominance, so I began shifting over to my right and safely out of his path. We'd done this before, I thought.

The white beast also shifted his direction and continued right toward me until finally halting only a few feet away— too close to focus either lens that I had with me.

Gruff dropped his head low to the ground and again gave me that cold, hard stare. Once more he began to pace back and forth, coming so close now that I could have reached out and touched him. The musty damp odor

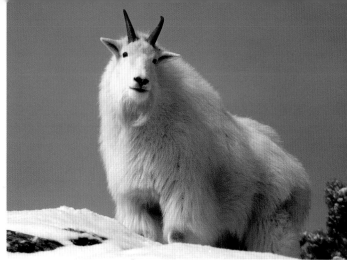

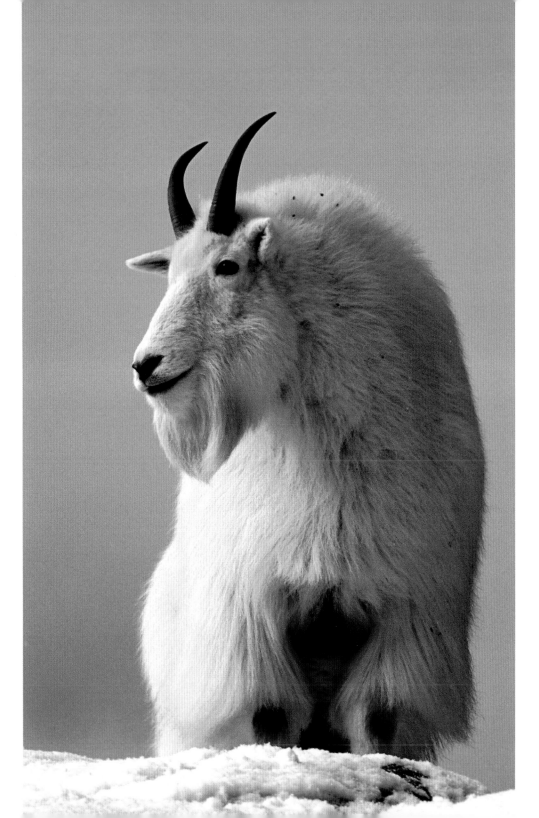

(above and left) Gruff moves through the pack, picking and choosing among the nannies while reminding the other adult billies who runs this show.

(facing page) In what turned out to be a potentially dangerous situation, Gruff starts down the snowy ridge to give me a stern reminder about who's in charge. Weighing close to 250 pounds, he is an above-average-sized billy and used to having his own way.

from his thick snow–filled coat filled my senses, along with his growls that were growing in intensity. Not good.

Looking as passive as possible, I began to back away in a low crouch, even leaving one of my two cameras behind. Gruff continued his advance and intimidating growls until he stood right over the camera. "Oh shit!" I thought. "What if he pisses on it! Well, I can't worry about that now."

Glancing over my right shoulder, I spotted a fallen aspen tree about eight inches in diameter, just a short distance behind me, with a couple feet of clearance underneath and the branches of the tree enclosing a small space. Directly beyond the fallen tree was another one of similar size, this one still standing.

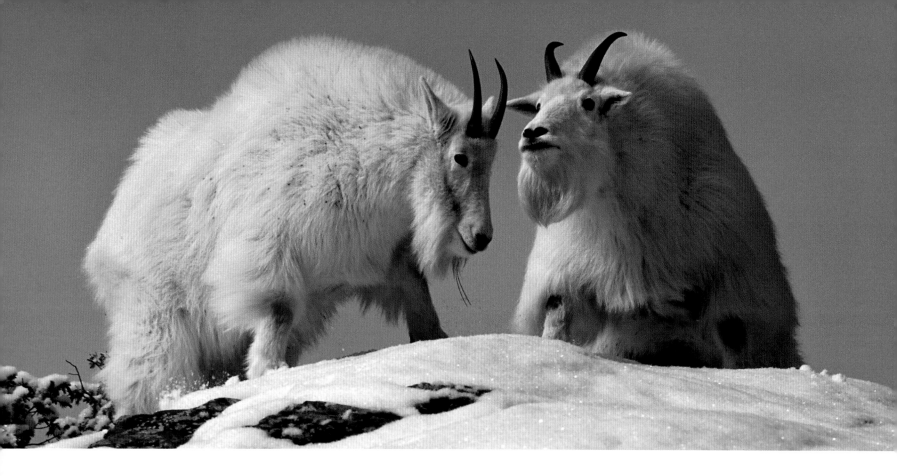

(above) While showing a couple of blood spots on his underside, no doubt from previous encounters with other billies, Gruff (right) makes his move on this nanny who has indicated her readiness for breeding. Most mountain goats reach sexual maturity at around thirty months. A typical lifespan for a billy is fourteen years, while the nannies live a bit longer, averaging about eighteen years.

(facing page) As he drops his head down across the nanny's back and shoulders, Gruff prepares to mount her, thereby completing the mating process. The usual gestation period for mountain goats is 186 days; most kids are born from late May to mid-June. Adult nannies are generally about two-thirds the size of billies, usually weighing less than 200 pounds.

I backed up to the fallen tree and crawled into the space underneath. Shifting around I lay back in the snow, drawing up my legs and keeping my feet out in front of me. If worse came to worst, I would at least have the thick soles of my snow boots between those rapier-like horns and me.

Tossing his head in that ever-threatening way, Gruff circled the tiny space in which I lay, seemingly looking for a way through my measly defense. Twisting and turning, I kept trying to keep my feet between us. As he circled back to the side of the fallen tree, I saw a chance and moved up behind the standing one. I began a sort of step-and-crawl

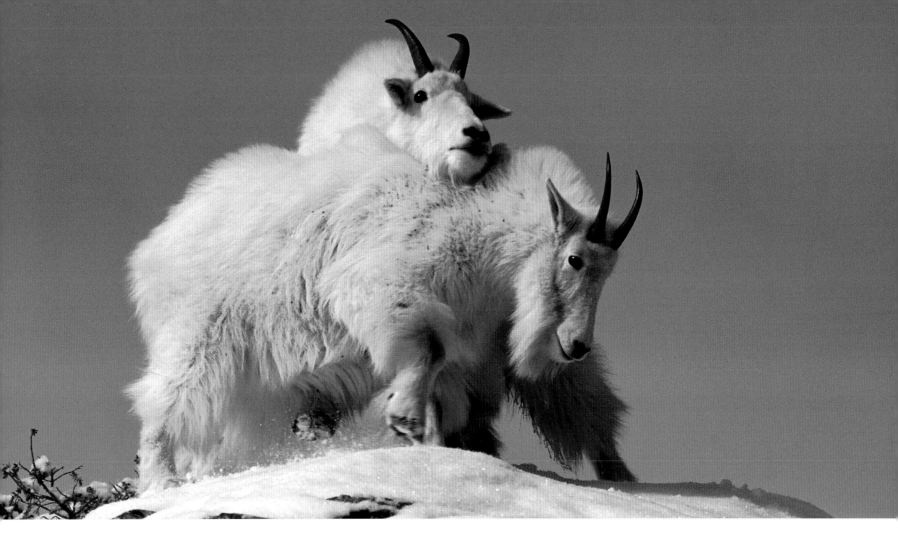

backwards up a small slope behind the tree, leaving my other camera behind as well. I didn't have the slightest idea what I would do if Gruff pressed forward.

Reaching the top of the slope, maybe twenty feet away from that angry billy, I found refuge in a small clump of trees where I waited it out, hoping to recover my cameras. It seemed I had done my "embedding" job a little too well. Gruff no longer saw me as a stranger or curiosity as most goats do, but as a subordinate member of the herd who had not acted in a subordinate way. A sure way to trouble in goat society.

Gruff continued to poke about and even sniffed at the camera that I had left under the fallen tree, but he advanced no further. After what seemed about thirty minutes, he settled down into a snowdrift near the nannies and was soon sleeping soundly. The younger billies saw their opportunity and began making their moves on the nannies.

Figuring this would also be my best opportunity, I quietly made my way down the slope, retrieved my cameras, and headed out, thankful that incidents like this one are very rare. But hey, at least he didn't piss on the cameras.

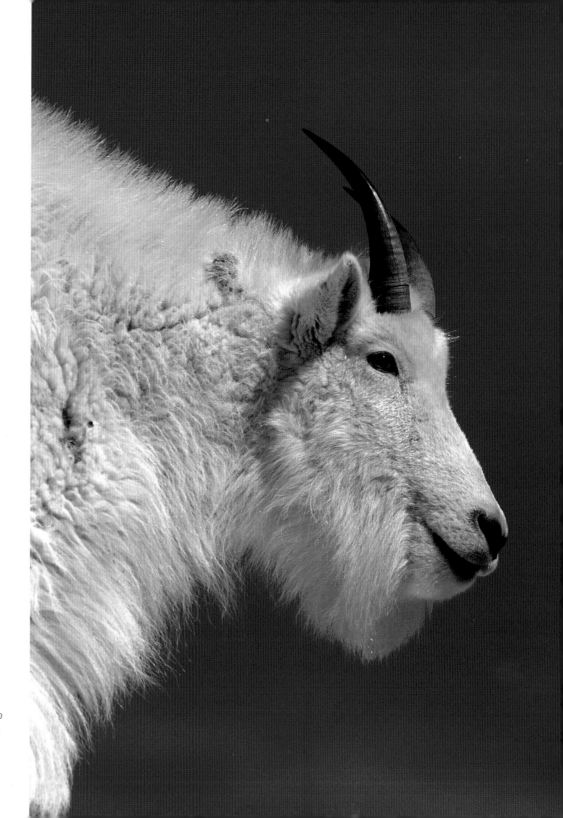

Though both sexes have horns, the billy's are a bit longer and larger at the base (right and facing page top). As demonstrated (facing page bottom), those horns are not only very efficient weapons, but also make excellent back-scratchers. The billies also have extra thick skin on their rumps to give them some protection from those rapier-like weapons during rut battles.

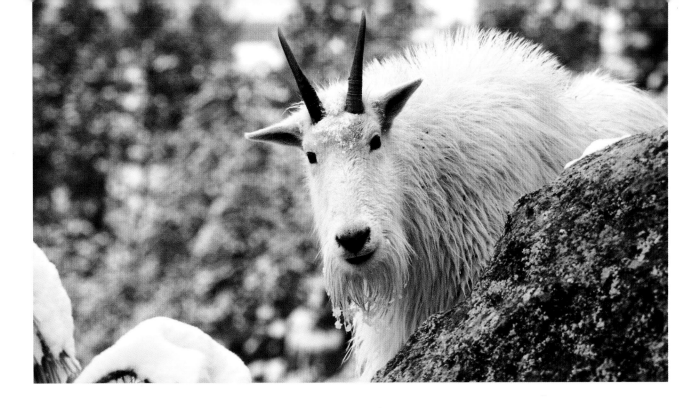

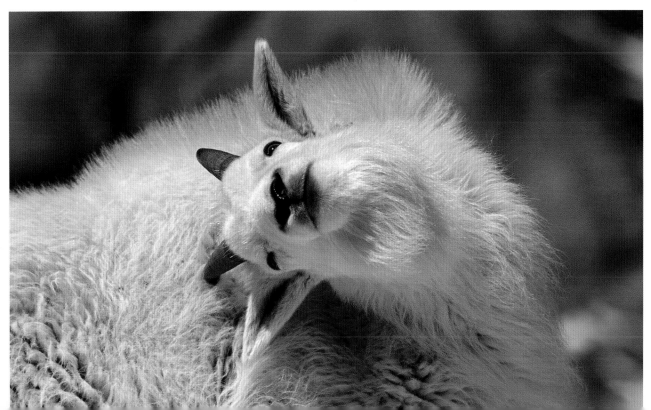

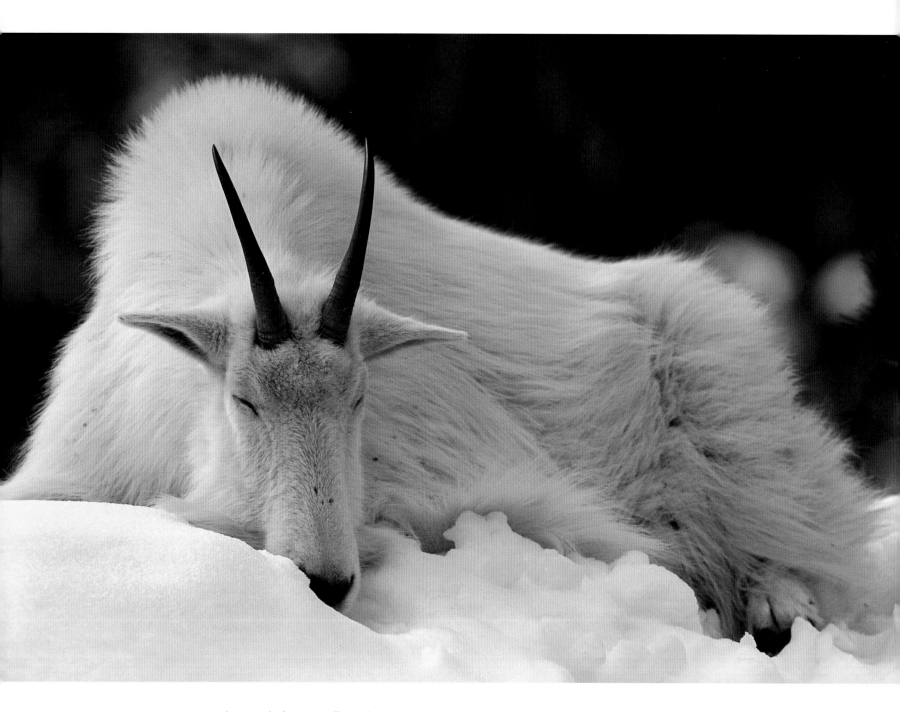

(above) Lucky for me, Gruff turned out to be a pretty heavy sleeper, allowing me to not only get out of the area without again incurring his wrath, but also to snap a few frames of him sleeping soundly here in a snowbank.

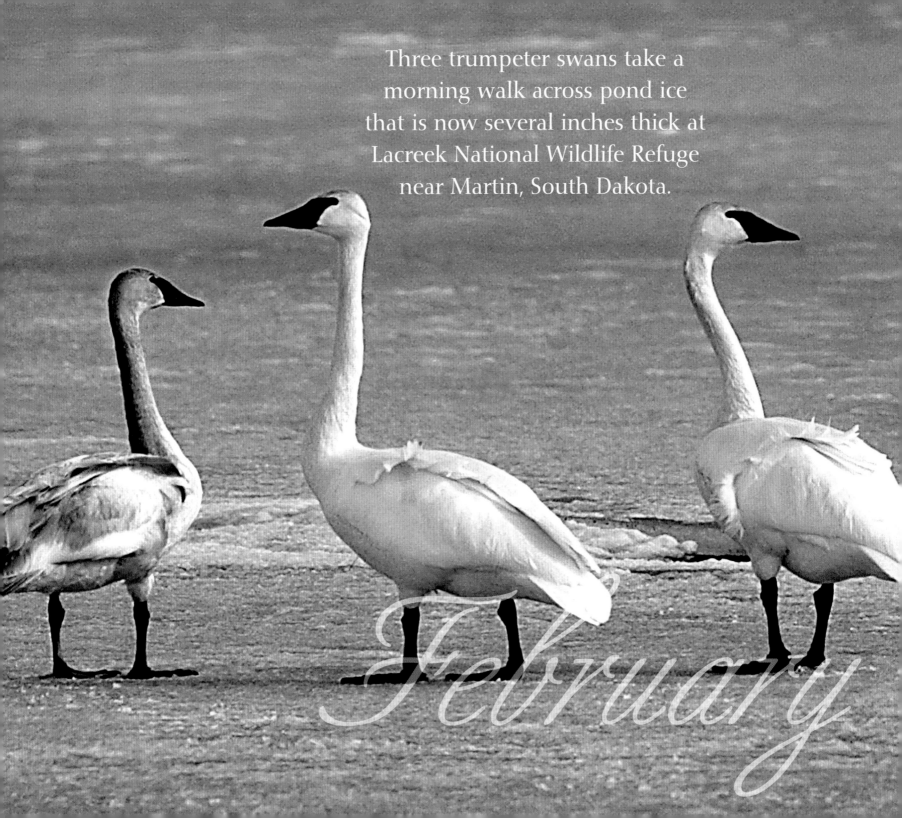

Three trumpeter swans take a morning walk across pond ice that is now several inches thick at Lacreek National Wildlife Refuge near Martin, South Dakota.

February

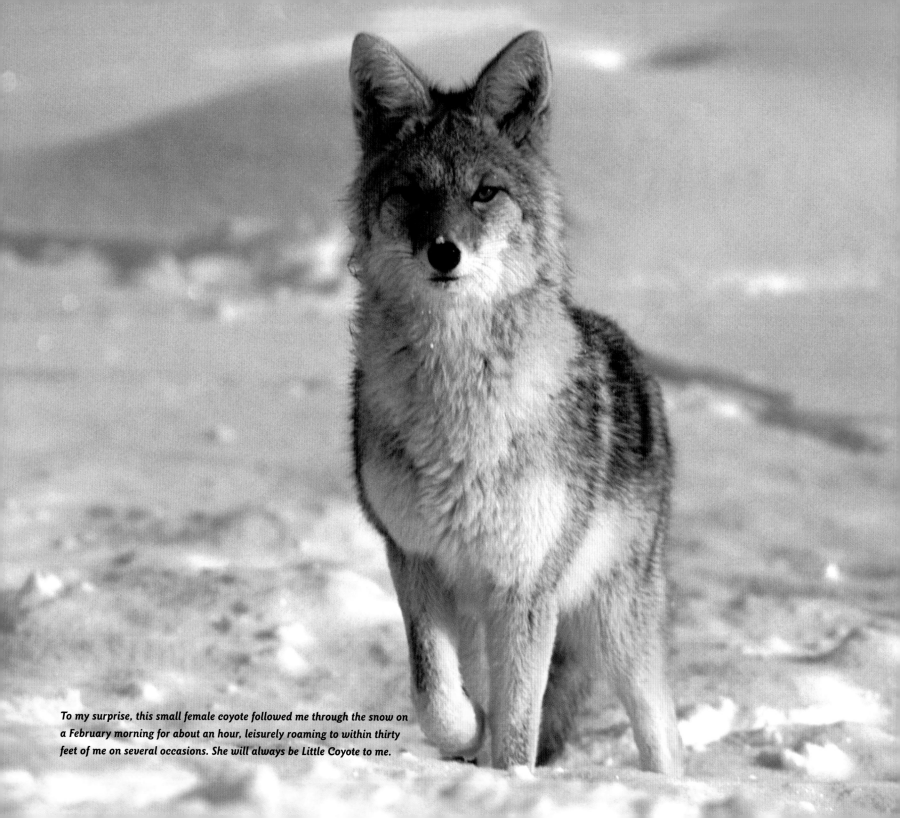

To my surprise, this small female coyote followed me through the snow on a February morning for about an hour, leisurely roaming to within thirty feet of me on several occasions. She will always be Little Coyote to me.

LITTLE COYOTE

Little Coyote lifted her head from the bank of fresh snow in which she had been poking and digging, probably hunting mice or some other sustenance. There seemed no urgency in her search—indeed, she looked well fed for midwinter—more like she was just going through the motions of a timeless habit.

She looked toward me, but not really at me, and without the wary caution typical of my encounters with her kind. Usually coyotes break into a quick trot away with a couple of quick glances back over their shoulders as they become nothing more than a speck in the middle of my camera frame. Then they disappear over a ridge or through some trees.

She was perfect! Not merely photogenic, but flawless. The soft sun of this winter morning cast an exquisite light on her bushy winter coat as she followed me through the freshly fallen snow of a storm that had come the previous afternoon and had broken up during the night. At times she almost seemed to pose, her stance biblical, her colors and glistening eyes striking against that white landscape.

She was easily one of the most beautiful wild creatures that I've ever seen. On the left side of her head was a tiny bald spot about the size of a dime—a reminder that nothing on this planet is really perfect, nor needs to be to still be magnificent.

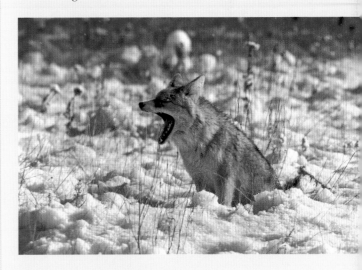

(above) Little Coyote lets out a sharp howl that turns into a yawn on this winter morning.

Little Coyote had found me a while earlier when she appeared atop a prairie ridge as I plodded across this meadow in Wind Cave National Park at the southern edge of the Black Hills. To my astonishment—and nervousness—she sprang forward, down the hill, and came at a dead run through the snow straight toward me. I wasn't quite sure what to do.

I suddenly remembered that I was a photographer and fumbled for one of the cameras hanging on me. Before I could do much else, she applied her brakes and came to an abrupt halt, sending snow flying all about. Another shot missed! Quickly I focused on her, hoping to get at least a couple of images before she beat the usual retreat, which I fully expected.

It was then that Little Coyote chose to lay her biggest surprise on me. She stood fast in the fresh snow. Not as though she was trying to intimidate me, but more like she wanted to communicate with me or—even more remarkably—nudge me to look at something differently than I had before.

I collected a few images and then felt the urge to continue my trek, just to see what she would do. Another surprise—she began to move with me. Over the next hour or so she would be my constant companion, moving parallel to me across the snowy plains. At times she approached to within thirty feet or so. When I stopped, she stopped. Twice I sat down in the snow and she did

(right) This curious little creature basks in an exquisite winter light that dominated the snowy plain on this morning.

(facing page) Little Coyote glances behind as she follows me through the freshly fallen snow, but not with the wariness that is typical of these creatures. It was as though she was just on a morning hike, like me, and we happened to be sharing the same meadow.

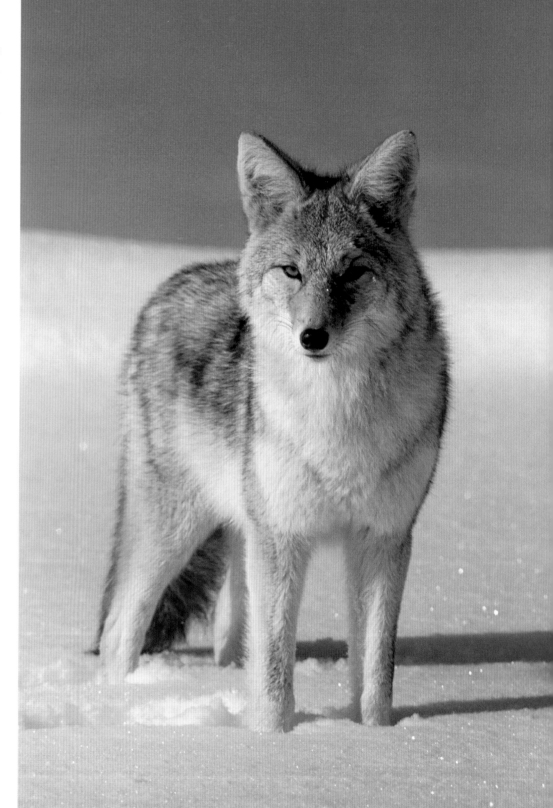

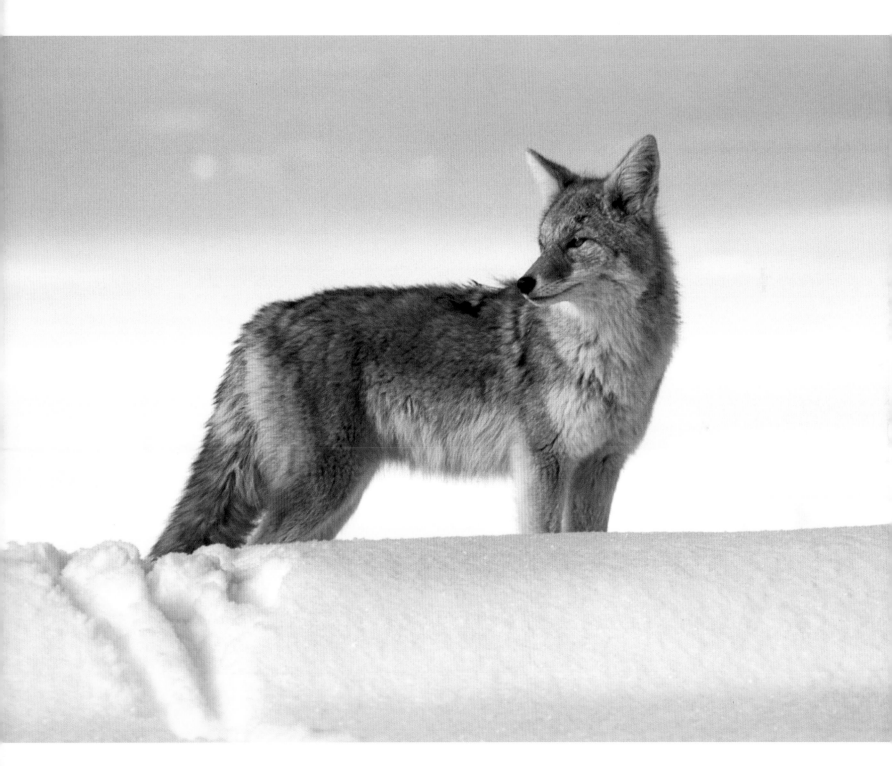

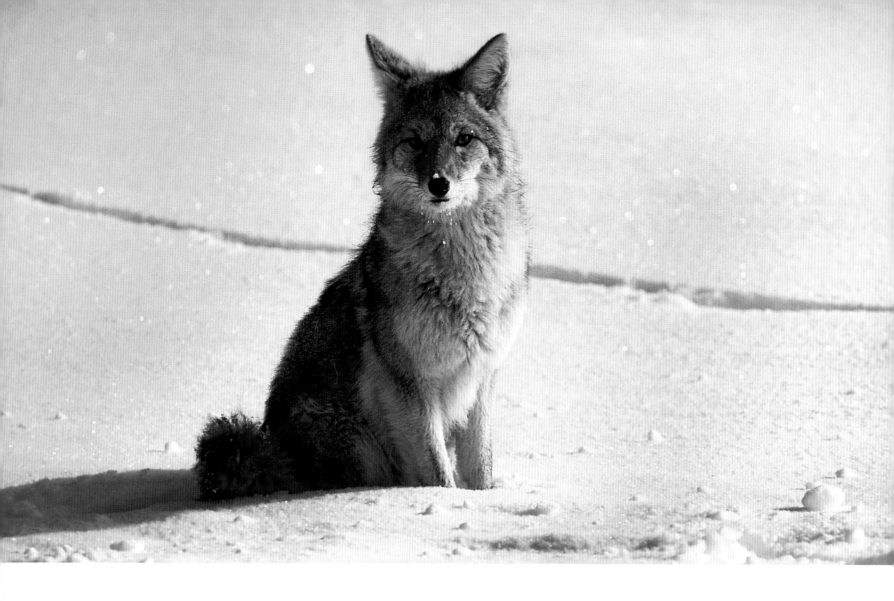

likewise. I could not dismiss the feeling that she was mimicking me.

There was something so human about Little Coyote, as though she were actually aware of the bewilderment her unusual behavior was causing me and reveling in it. Perhaps it was just her way of rubbing my face in the arrogance of my own species, telling me we just don't know as much as we like to believe.

I fancied that she would at any moment change her physical appearance, perhaps becoming some mysterious or mystical woman with an epistle from the creator, something that would forever change humankind's perception of the universe or our place within it.

There is a precedent in this idea. Coyote is a central character and personality throughout much of Native American folklore and oral literature, showing up in

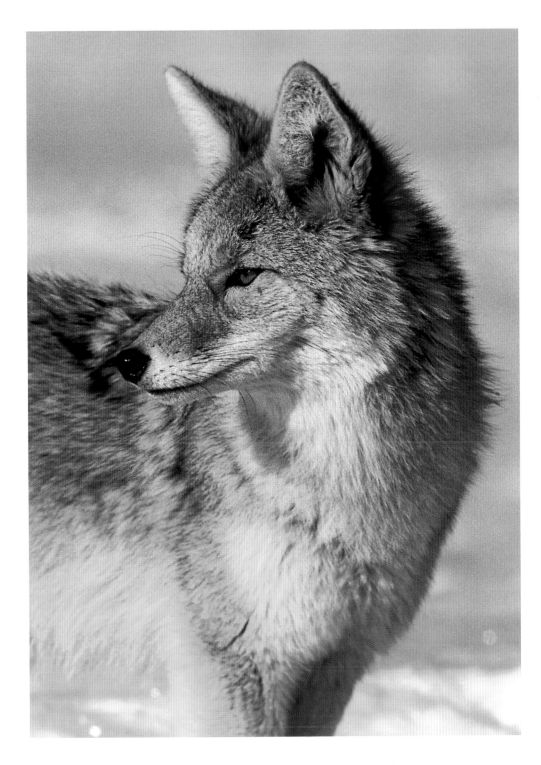

(facing page) Little Coyote actually seemed intent on puzzling me with her unusual behavior—going so far as to sit in the snow whenever I did—as though she were trying to make a point.

(this page) At other times Little Coyote appeared completely indifferent to my presence and paid me little attention.

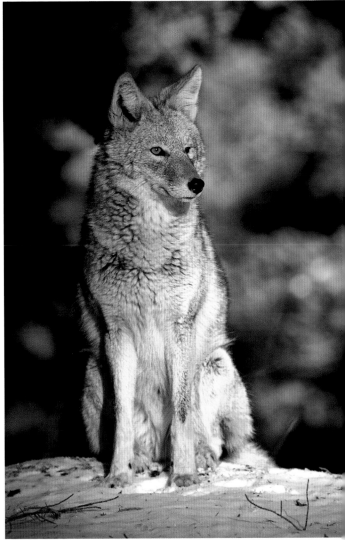

225

Cheyenne tipis, Mandan earth lodges, and Navajo hogans. This oral tradition served many purposes, from entertainment to explaining tribal origins to emphasizing the value of proper behavior. There were almost as many names for Coyote as there were tribes: Trickster, Imitator, Old Man, and Changing Person being only a few. And Coyote played everything from hero to fool.

Much of this cultural heritage has not translated well into the analytical structure of Western thought, but that is no reason for us to forgo the attempt to understand. In his book *Giving Birth to Thunder, Sleeping with His Daughter*, author Barry Lopez writes, "In the Coyote stories, I think, is more than we, with all our tools of analysis, will ever fathom. We should not feel either embarrassed for it or challenged. To touch them deeply would be like trying to remember the feeling of years of living in the open. We have passed it by, eons ago."

Perhaps that was the message Little Coyote was delivering to me this morning. Twice since that February day I have seen this furry little temptress again, recognizing her by the little bald spot on her head. Not once during those succeeding times has she approached me or allowed me anywhere near her as she did during our first encounter. She simply turned and ran away.

(right) The beguiling behavior of Little Coyote on this day made it easy to understand why this creature is of such importance in Native American folklore.

(facing page) After spending more than an hour with me, Little Coyote apparently decided that I had been endowed with enough of her presence and headed off in the direction from which she had come. Twice she stopped and looked back at me. I sensed this was not out of fear that I might follow, but as though she were saying, "Take a last look."

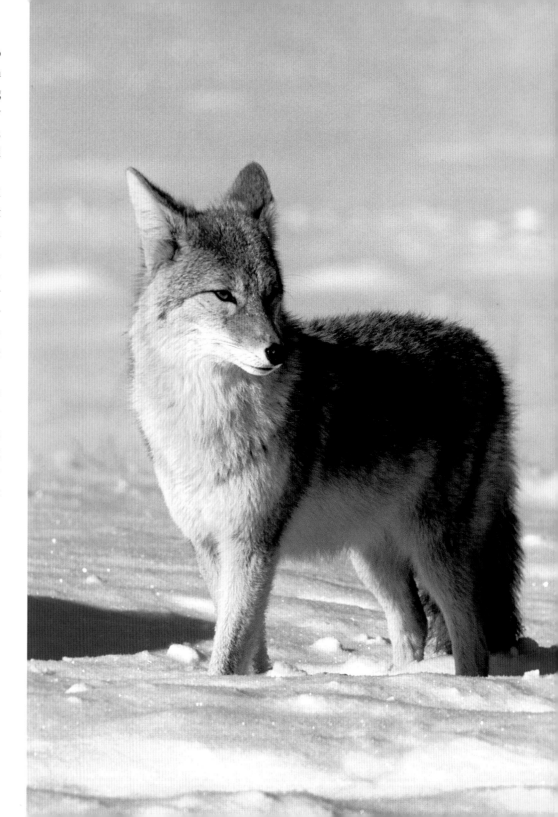

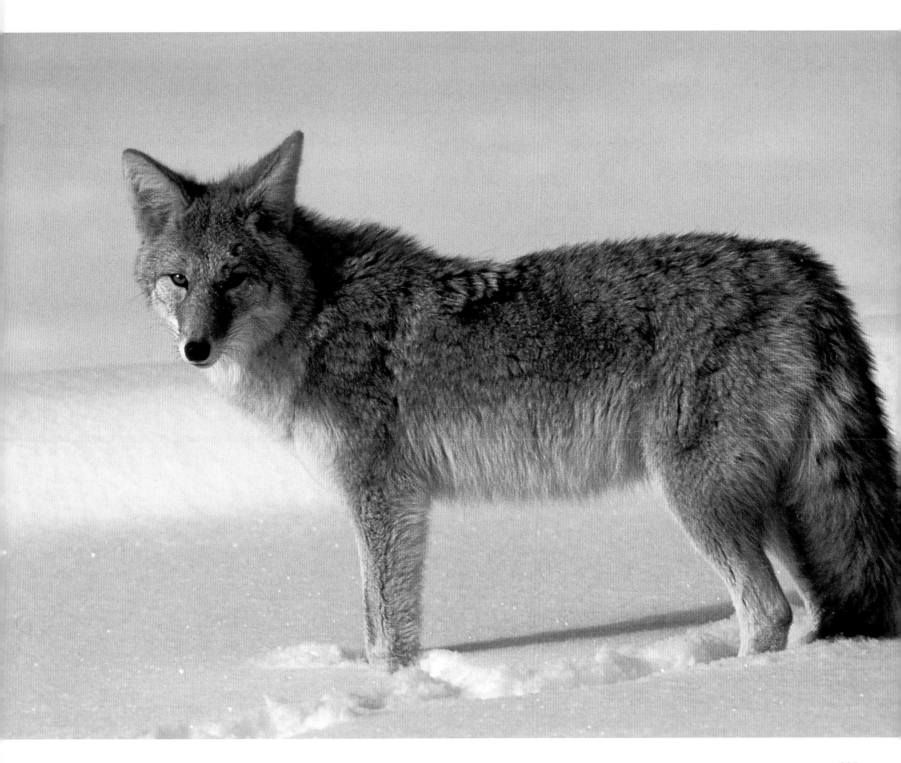

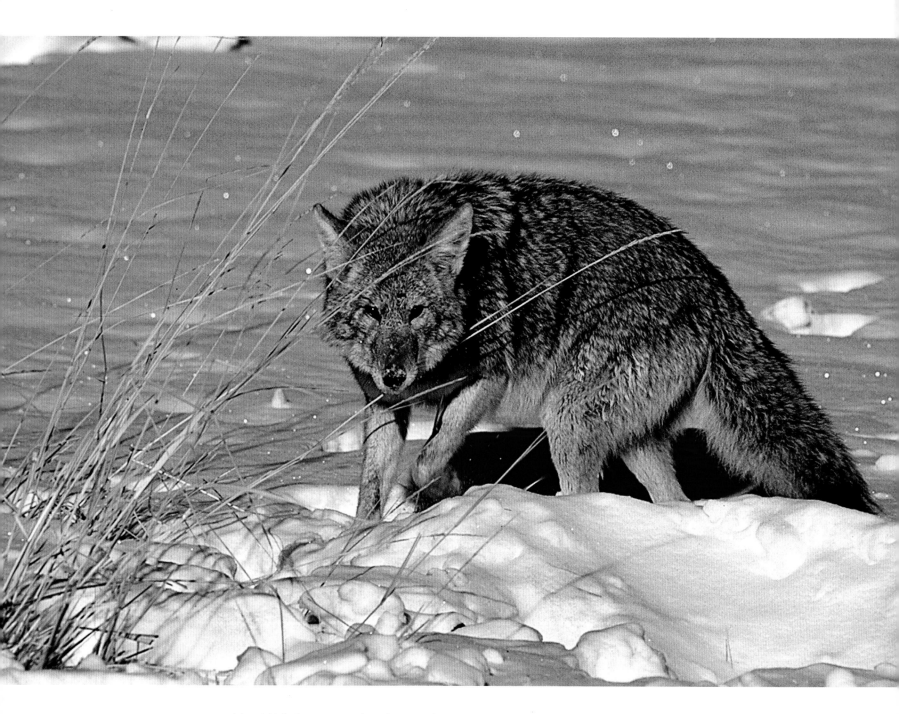

(above) Little Coyote pauses from digging in the snow to study me once again before resuming her day.

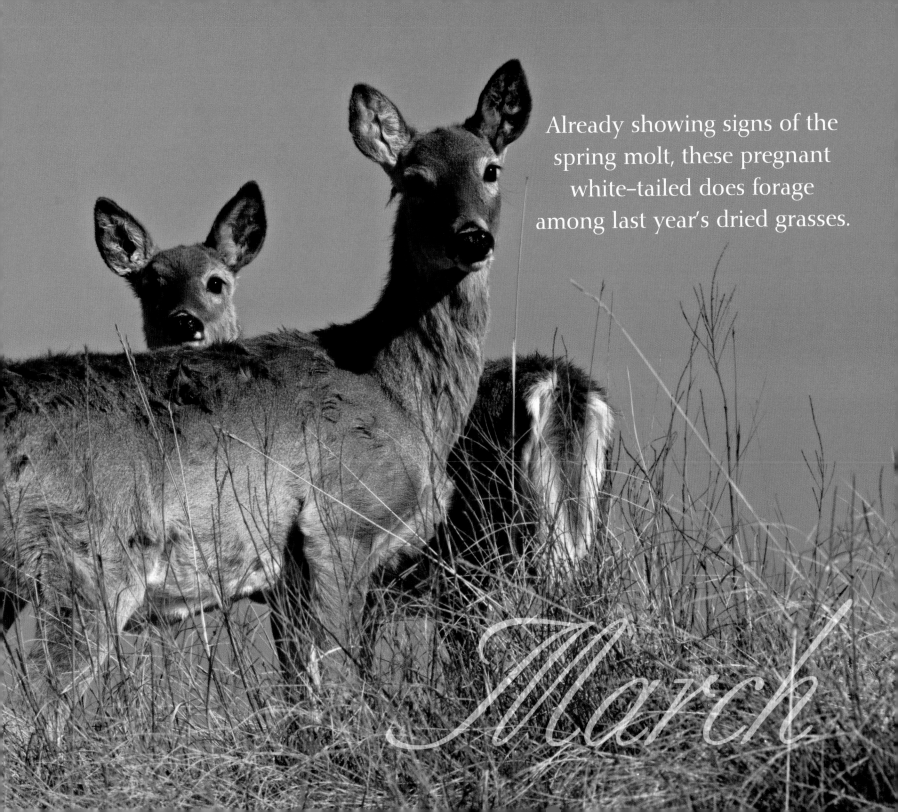

Already showing signs of the spring molt, these pregnant white–tailed does forage among last year's dried grasses.

March

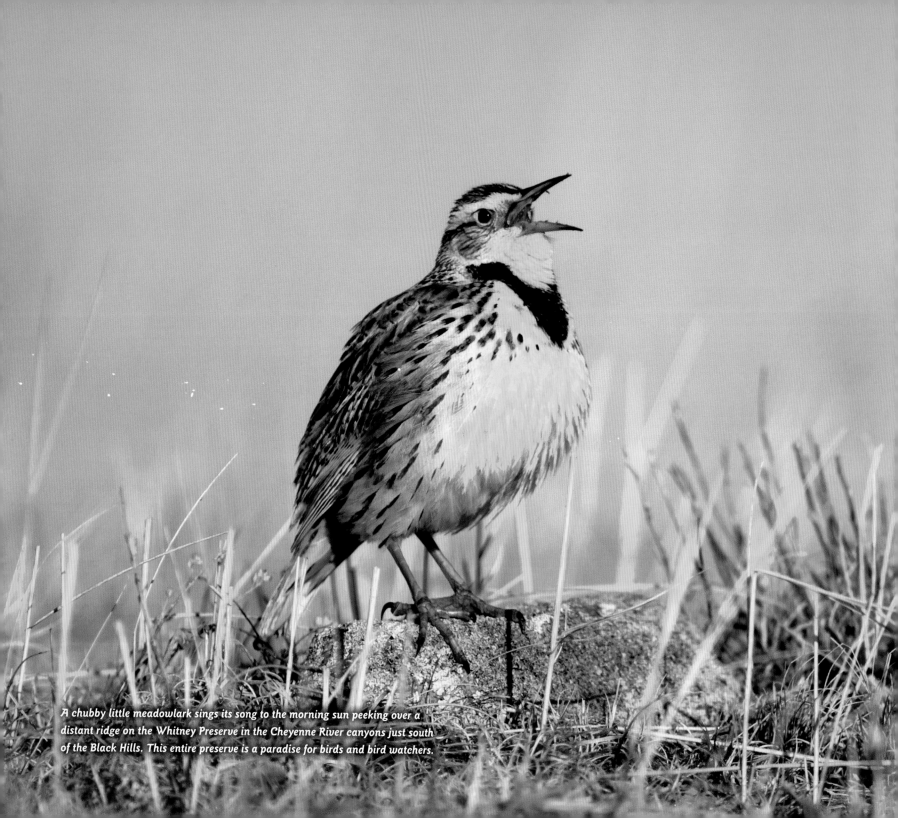

A chubby little meadowlark sings its song to the morning sun peeking over a distant ridge on the Whitney Preserve in the Cheyenne River canyons just south of the Black Hills. This entire preserve is a paradise for birds and bird watchers.

MOZART AND MEADOWLARKS

The serene, gentle strains of Mozart's Concerto for Clarinet and Orchestra float from the sound system of my truck as I slowly guide it down the crude, old ranch road that winds, dips, and rises across a high mesa top at the southern edge of the Black Hills.

This road—two gravel-filled ruts barely discernible in the darkness of the waning night—is not a thoroughfare. It goes nowhere, and yet it goes everywhere, like the byways of our minds.

I steer the truck to a point just off the road and halt it, facing southeast. With both windows down, I lean back into the seat, sip my coffee, and await the approaching dawn—simply experiencing the place, its sights, and its sounds.

The sky begins to hint at daylight with a trace of blue and the faint shapes of wispy clouds. Silhouetted against it are the occasional figures of a large tree or two rising above the meandering mesa, giving form and focus to the vastness of this land. On the distant horizon, I can make out a smattering of gray that is the Pine Ridge of the Nebraska panhandle, more than sixty miles away. The sunrise will be a memorable one.

This land is The Nature Conservancy's Whitney Preserve, located in the Cheyenne River canyons just southwest of Hot Springs, South Dakota. It is part of an area totaling more than 17,000 acres that TNC acquired in the late 1990s in an effort to keep wilderness sections intact and continuous.

Such wild parcels provide sanctuary from the noise

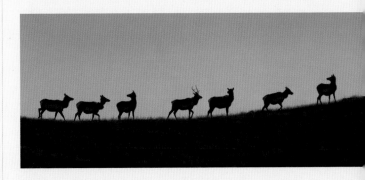

(above) A group of elk cows and one immature bull file across a skyline ridge at dawn.

231

and bustle of the developed world. "For unnumbered centuries of human history the wilderness has given way," wrote Aldo Leopold. "The priority of industry has become dogma. Are we as yet sufficiently enlightened to realize that we must now challenge that dogma, or do without our wilderness? Do we realize that industry, which has been our good servant, might make a poor master?"

Suddenly my ears detect the familiar warbling of a nearby meadowlark, heralding the start of the day from atop a small rock. He's the first I've heard this spring, and the timing couldn't be more fitting. Today is the equinox, the official start of spring, when daylight equals darkness. From now until the summer solstice in June, each day will grow noticeably longer.

In an effort to tease this little songster, I turn up the music a bit, as though giving him some accompaniment. He cocks his head, glances around, and then raises his own pitch as he sings again and again, apparently accepting my invitation. This land is one for both Mozart and meadowlarks.

The sun is now beginning to peek over a far ridge, highlighting the clouds as its light washes across the sky and introduces the day. Time for work. I turn off the music and slip out of the truck with my cameras as my little friend takes to the sky.

Though the morning is not cold, I keep my heavy vest on just so I can enjoy the sun's heat growing on my back as I hike across the prairie. Winters like this last one always make me swear that I will never again take for granted a warm summer's day. Naturally, that perspective will change after a couple of baking hot August afternoons. I will then utter fresh oaths. So it goes.

(right) A pronghorn buck dashes across the land, silhouetted by a setting prairie sun.

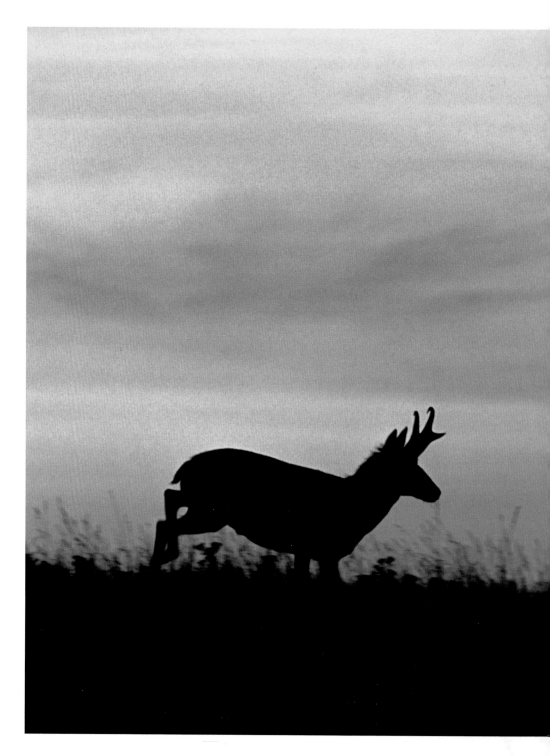